OSHA
IN THE REAL
WORLD

HOW TO MAINTAIN WORKPLACE SAFETY
WHILE KEEPING YOUR COMPETITIVE EDGE

JOHN HARTNETT

SILVER LAKE PUBLISHING
LOS ANGELES, CALIFORNIA

OSHA in the Real World
How to maintain workplace safety while keeping your competitive edge

First edition, second printing (October 1998)

Copyright © 1996 by Silver Lake Publishing

Silver Lake Publishing
2025 Hyperion Avenue
Los Angeles, California 90027

For a list of other publications or for more information, please call (888) 663-3091. Outside the United States and in Alaska and Hawaii, please call (213) 663-3082.

Library of Congress Catalogue Number: 96-079499

Hartnett, John

OSHA in the Real World
How to maintain workplace safety while keeping your competitive edge.

Includes index.

Pages: 391

ISBN: 1-56343-113-0

Printed in the United States of America.

Acknowledgments

Workplace safety is a difficult, technical issue. OSHA compliance is a universe unto itself. Making these things sensible to people with better things to do than read the Code of Federal Regulations has been a tough job.

I would like to thank the following people for helping make this book come together:

Kimberly Baer Design Associates;

Luisa Beltran, Cynthia Chaillie, Ginger McKelvey, Khanh Ngoc Nhan, Huy Van Nhan, Mimi Tennant, Megan Thorpe and Jim Walsh;

also special thanks to Milton Terrel and Joseph Dear.

OSHA in the Real World is the fifth title in Silver Lake Publishing's "Taking Control" series of books, which seeks to help employers and business owners deal with the host of extraordinary risks facing the modern business enterprise. Upcoming titles will cover business insurance, employee compensation, customer service and other topics. To keep these projects—and the series as a whole—well focused, the editors at Silver Lake Publishing welcome feedback from readers.

John Hartnett

OSHA IN THE REAL WORLD
TABLE OF CONTENTS

Introduction

The Challenge of Making Work Safe

You're probably reading this book because you are responsible for ensuring the health and safety of workers at your company. Chances are you are an employer, safety professional, or just some unlucky overachiever who was so good at doing what you were hired to do that the boss figured you could probably work the same magic with "this safety compliance thing."

The responsibility of ensuring the health and safety of workers at your company also includes meeting workplace safety requirements as set forth by the Department of Labor's Occupational Safety and Health Administration (OSHA).

In an effort to protect the safety and health of every worker, Congress passed the Occupational Health and Safety Act on December 29, 1970. The Act requires every employer engaged in business affecting commerce to comply with OSHA regulations and to provide a safe and healthful workplace for his or her employees. These provisions of the OSH Act of 1970 are commonly known as the General Duty Clause and appear as follows:

a) Each employer

1) shall furnish to each of his employees employment and a place of employment which are free from recognized hazards that are causing or are likely to cause death or serious harm to his employees;

2) shall comply with occupational safety and health standards promulgated under this Act.

b) Each employee shall comply with occupational safety and health standards and all rules, regulations, and orders issued pursuant to this Act which are applicable to his own actions and conduct.

Shortly after the OSH Act was signed into law, the Department of Labor formed the Occupational Safety and Health Administration (OSHA) to develop safety regulations, to inspect workplaces and to enforce compliance. One of OSHA's first official acts was to adopt a handful of existing national consensus standards from the American National Standards Institute (ANSI), the National Fire Protection Association (NFPA), and provisions from the Walsh-Healy Act of 1936, which included health and safety standards for federal contractors.

And now, 25 years later, what was once a handful now fills a regulatory barrel. OSHA has more than 4,000 regulations on the books, roughly 2,000 inspectors in the field and an operating budget of almost $300 million.

Every employer must comply with OSHA. The Department of Labor employs hundreds of compliance officers throughout the United States to insure that employers follow the rules, regulations, standards, and the General Duty Clause of OSHA. These OSHA compliance officers will enter your work establishment without a search warrant for the purpose of finding violations of the Act or its standards.

For employers, OSHA's regulatory zeal has made the protection and the safety and health of their workers a full-time job. According to market analysts, Richard K. Miller and Associates, in 1994 employers spent $17.4 billion on workplace safety products and services including consultants, employee training, personal protective equipment, indoor air quality, ergonomics, and medical surveillance. OSHA compliance has become big business and much more complex than it should be.

But bear in mind that OSHA is in a state of transition—an agency caught in the middle of a partisan reform battle between pro-business Republicans who seek to strip OSHA of its enforcement muscle and Democrats who believe employers will only implement workplace health and safety programs if the threat of OSHA enforcement is real. And even as the OSHA reform battle continues in Congress, OSHA itself has begun to reassess its role in the workplace and has taken steps to strengthen its position and authority in spite of drastic budget cuts and harsh criticism from lawmakers, industry and other stakeholders.

Will OSHA go away in the next few years? Don't count on it. Although OSHA's regulations are sometimes characterized as being too broad, too complex, or out of date—overall, they still provide a solid foundation for virtually any workplace safety and health program.

This book will give you the tools to understand OSHA's policies and procedures, to prepare for OSHA inspections, and to determine which OSHA regulations apply to your business. There are several key apppendices which provide a list of free consultative resources, a plain English explanation of each OSHA 1910 and 1926 regulation, and a chart to identify training, written, inspection/testing, monitoring and medical requirements for each 1910 and 1926 regulation. This information alone will carry you far down the road to creating a safe workplace and complying with OSHA standards.

A final caveat: This book does not attempt to function as a comprehensive analysis of the Occupational Safety and Health Act. It provides only an overview to the Act. OSHA's influence on American business is so far reaching that a detailed examination of the Act's provisions and its effects would fill a large volume. Readers should consult with an attorney on specific problems relating to the Act, the Occupational Safety and Health Administration and the Occupational Safety and Health Review Commission.

A solid foundation for a safety and health program

3

CHAPTER 1

A POLITICAL HISTORY OF WORKPLACE SAFETY

Introduction

The Occupational Safety and Health Administration has never been a popular agency in some circles. But OSHA had never received as much criticism at it did from the 104th U.S. Congress— the Republicans who took control of Capitol Hill after the 1994 elections.

Some enthusiastic new members of Congress proposed eliminating the agency. Others took a more measured approach—proposing merely to slash OSHA's budget and to trim its enforcement power. The goal of these proposals remains consistent: to limit the agency's regulatory power to an extent that would greatly diminish its efforts in the private-sector workplace.

Throughout the debate over these new limits, there were many misrepresentations of the agency's activities—stories about OSHA banning everything from meetings with employees to chewing gum on rooftops.

Another common canard: Some critics insist on portraying OSHA as an agency bent on collecting fines for its own benefit.

In testimony before the new Congress, Joseph Dear, assistant secretary of labor and OSHA administrator, said:

Many employers have complained that OSHA cares less about worker protection than about meeting perceived quotas for citations and penalties. While OSHA has never used quotas, it has in the past used inspections, citations, and penalties as performance measures.

But, in the mid-1990s, even this approach has begun to change. Dear sees OSHA's relationship with Congress as both an offensive and a defensive campaign—and he started concentrating on defense after the 1994 elections.

Part of the defense is what Dear calls "the reinvention of OSHA." He and other agency supporters see reinvention as the path most likely to produce the greatest gains for employers and workers.

Dear argues that the gap between OSHA's mission and its resources—a budget of $312 million in 1995 likely to shrink in subsequent years—compels OSHA to reinvent itself in a way that will allow it to leverage its resources. He says:

> Many of the new OSHA initiatives are designed to find opportunities to leverage. The goal...is for employees not always to come to OSHA, but perhaps to use other resources—internal health and safety committees, private sector consultants, non-profit organizations, trade associations, or other groups to get advice. This would allow employers to be able to tell OSHA that they have effective programs, and that they want a new kind of relationship not a traditional enforcement relationship.

This defensive position is unusual for an agency that has embodied the expansion of federal regulations that began in the early 1970s. In order to understand how OSHA came to this position, we should take a quick look at its past.

OSHA's mission and history

OSHA has been an effective workplace regulator. Since its creation in 1970, the workplace fatality rate in the U.S. has declined 57 percent. Undoubt-

edly, the lower fatality rate has improved the lives of America's workers. Standards issued and enforced by OSHA have affected millions of working people.

Joseph Dear sees the primary mission of OSHA as a righteous pursuit of safety for workers:

> OSHA's mission, mandated by the Occupational Safety and Health Act of 1970, is "to assure so far as possible every working man and woman in the nation safe and healthful working conditions...."

> Today, this is a huge responsibility, there are currently over 6 million worksites in the U.S. under OSHA's jurisdiction, employing almost 100 million workers.

> ...Every year work-related accidents and illnesses cost an estimated 65,000 lives. That is more than we lost in battle during the entire nine-year Vietnam War. On an average day 18 workers will be killed in safety accidents and an estimated 137 more will die from occupational disease.

> Both the human and economic toil are staggering. Accidents alone cost the economy over $112 billion a year.

The workplace safety movement began in the beginning of this century. It's always been based on an assumption of solutions that require government intervention.

In 1912, the Bureau of Labor Statistics produced its first full-scale survey of safety and health conditions in American workplaces. The survey focused on industrial accidents in a single industry—iron and steel production.

Other BLS studies of individual industries and safety and health topics followed. However, it was not until the late 1930s that injury record keeping was sufficiently uniform to permit the collection of nationwide work injury data.

Once the American standard method of measuring and recording work injury experience was ac-

OSHA's primary mission: the righteous pursuit of safety

The first generation of reports had major problems

cepted by employers and statistical agencies, the BLS launched an annual nationwide survey of work injuries that resulted in death, permanent impairment, or temporary disability. Spanning three decades, these surveys proved useful in measuring and monitoring injury frequency and severity.

However, the first-generation BLS surveys had some major limitations. First, work injury data were compiled only from employers who volunteered to record and report that information. Second, only disabling injuries defined in the standard were counted. Numerous work injuries that required medical treatment but did not result in a full day away from work were excluded from survey estimates, as were—with a few exceptions—occupational illnesses.

In 1936, the Walsh-Healy Act, a New Deal bill designed to regulate private employment relationships through the administration of government contracts, was passed. With this Act, the BLS issued health and safety standards for federal contractors.

BLS had no research division at the time, so it relied on the recommendations given by private and somewhat public organizations.

The standards of the Act were seldom enforced—and then, erratically. Of some 75,000 establishments that were covered by the Act in 1969, only about 2,929 worksites were inspected. Of the 33,378 health and safety violations discovered, only 34 formal complaints were actually filed—and only two companies were punished.

The Walsh-Healy Act eventually failed because it was not administered well and, as a result, was not taken seriously by most employers.

Concern for workplace health and safety issues resurfaced during the late 1960s, when the New Deal had given way to the Great Society.

In 1968, Lyndon Johnson's administration proposed a bill which would have empowered the Labor Department to establish and enforce occupational safety and health standards for workplaces

that were not already regulated by other federal agencies.

That year, Republican presidential candidate Richard Nixon proposed a number of his own occupational health and safety initiatives, in an effort to lure blue-collar voters away from Johnson and the Democrats.

The problems that plagued the Walsh-Healy Act were finally addressed in a major piece of safety legislation passed by the Congress in the waning days of 1970. This was the Occupational Safety and Health Act—or OSH Act—which created OSHA, the Occupational Safety and Heath Review Commission (OSHRC) and the National Institute of Occupational Safety and Health (NIOSH).

On December 29, 1970, Nixon signed the OSH Act into a law.

During this time, there was also a struggle between the Democrats and Republicans over industry-sponsored workplace safety bills. The parties struck a compromise by lodging a Labor Department standard and setting the authority in OSHA by setting up the OSHRC to adjudicate whether the Act had been violated.

OSHA then set up two kinds of advisory committees to help with the issuing of standards. The committees were set up to provide any outside technical expertise that was needed.

There were many shifts under different administrations and the major players behind OSHA, often reducing the agency into nothing more than a political football. According to Dear, "OSHA's history of setting standards priorities has been haphazard. Priorities constantly shifted, it took many years to issue a regulation, and much of the regulated public was frustrated with both the process and the outcome."

The early administrators

In the early 1970s, Nixon chose George Gunther— the former president of a small hosiery company who had been serving as head of Bureau of Labor

The initial collection of industry consensus standards

Statistics—to run OSHA. He was appointed with strong support from the steel industry. Gunther was mainly remembered for his "Gunther Memo." In the memo, he suggested to the companies that were regulated by OSHA that, in return for their contributions to Nixon's re-election committee, he would slow the implementation of proposed standards.

On the operational level, the first thing Gunther did was promulgate the national consensus standards mandated by Congress as part of the OSH Act. This consensus turned out to be a slight variation on the old Walsh-Healey program—combined with input from groups like the American National Standards Institute (ANSI) and the National Fire Protection Association.

OSHA's initial collection of industry consensus standards came directly from suggestions provided by supporters of the OSH Act. Unfortunately, the agency embarrassed itself when it failed to review and assess those standards, many of which were deemed to be too obvious, impractical or just plain silly.

Once it was up and running, Gunther's OSHA administration proposed eight new safety standards. Of these, it finalized six.

Notably, Gunther's group proposed—and initiated—one health standard that was legally challenged. In early 1971, OSHA adopted a permissible exposure level for asbestos of 12 fibers per cubic centimeter of air. It soon became obvious that that PEL was inadequate to protect the 3.5 million workers that had been exposed to asbestos.

In December 1971, OSHA issued an emergency temporary standard that restricted a person's exposure over eight hours to the weighted average of five fibers per cubic centimeter of air. The following June, OSHA followed this standard with a permanent standard of two fibers per cubic centimeter of air. However, the agency's policymakers delayed the effective date for a total of four years because of a difficulty with industry compliance.

During this time, Gunther tried to delegate just as much power to the states. Soon after the OSH Act passed, 44 states submitted their own plans for individual state workplace safety agencies. Gunther approved all of them for operation—even though some labor groups argued that many lacked the sophistication and authority to enforce useful rules.

The AFL-CIO and several steel unions—still basking in the light of political relevance and public policy influence—sued to stop the state authorizations. The federal court in Washington D.C. ruled that the authorizations exceeded the statutory authority granted Gunther by the OSH Act.

In January 1973, John Stender, a former union official and republican legislator from the state of Washington, replaced Gunther as head of OSHA. Stender promulgated seven relatively uncontroversial safety standards and another five—more controversial—health standards. Three of the health standards were challenged by congressional critics. Two were finalized.

One of the permanent standards that Stender was able to push through was a so-called "no detectable" exposure level for known cancer-causing substances in the workplace. OSHA translated this into a one part per million permissible emissions level of any known carcinogen.

By the mid-1970s, OSHA had promulgated standards affecting 14 carcinogenic substances, and began to rise as one of the most powerful regulatory agencies in Washington.

By the end of 1974, OSHA had a backlog of 20 NIOSH recommendations for new rule making initiatives.

However, as OSHA gained in strength and stature at the federal level, states with their own occupational safety and health programs were weakened when Stender decided to standardize staffing and funding to match federal benchmarks. This meant that the states' staffing requirements reflected OSHA's budget requirements—not the necessary

In the 1970s, OSHA gained regulatory power

number of inspectors needed for effective enforcement.

The AFL-CIO filed suit again, claiming that the OSH Act required each state to enforce standards that either met or exceeded that of federal OSHA. The question for OSHA was whether each state would have the "necessary" staff to inspect employers and enforce standards under Stender's policy change. The federal court of appeals in Washington—which has a great deal of control over regulatory issues—agreed with the unions and ordered OSHA to develop new criteria for determining state funding and staff levels.

After Stender, President Gerald Ford appointed Morton Corn as head of OSHA in late 1975. Corn had been a professor of occupational health and chemical engineering at the University of Pittsburgh. During his tenure, Corn completed two safety standards—ground-fault protection and farm machinery safeguards—and issued safety standards for commercial diving.

Under Corn's supervision, OSHA finalized one health standard—limiting emissions from coke ovens—and proposed one more which would have limited textile workers' exposure to cotton dust. Safety advocates took Corn to task for failing to address so few hazards, but Corn argued that his cautiousness reflected OSHA's lack of technical expertise in recognizing and enforcing workplace health and safety hazards.

One of the key problems: OSHA focused more on meeting inspection and citation quotas than on training its compliance officers. Under the previous administrators—especially John Stender—OSHA had established inspection and fine quotas for each inspector, placing a firm emphasis on the numbers of hazards—but not on the level of seriousness of each hazard.

Another problem: Most of OSHA's early enforcement efforts reflected its incorporated "national consensus standards," which had been intended as a preliminary framework meant to see the

agency through its start-up phase. Many of these were hopelessly vague—and some were flat-out ridiculous.

Nonetheless, overly enthusiastic inspectors continued to issue citations for nonserious violations of silly rules. And compliance officers had difficulty determining whether employers actually violated OSHA regulations because the language contained in most consensus standards was not legally binding. Consensus standards were initially developed to provide guidelines to employers and to made recommendations—many of the provisions contained words like "would" or "should"—not "shall."

OSHA also had difficulty enforcing a provision of the OSH Act which required the agency to conduct an investigation in response to an employee complaint if there were "reasonable grounds" to believe a violation had threatened "physical harm or imminent danger" to employees. Clearly, this left the door open to broad interpretation, and without proper clarification from OSHA, many inspectors rushed around investigating nonserious complaints.

The Carter years

OSHA's growing pains eased somewhat under the Carter administration. President Jimmy Carter appointed Eula Bingham, a professor and workplace health expert from the University of Cincinnati Medical School, to head OSHA.

Bingham's tenure focused on getting OSHA back on track by establishing more comprehensive training programs, providing better supervision for the compliance officers, revising a new policy for addressing complaints, and developing a more effective inspection targeting policy.

By the end of Bingham's administration, the number of compliance officers had doubled—from 750 to 1,400.

OSHA also developed a new, three-tiered policy

New policies lead to a drop in the number of complaints

for responding to the complaints which required OSHA area officers to investigate immediately any formal complaint that alleged an imminent hazard.

The policy also stated that all other formal complaints would be ranked according to the "gravity of the hazards" involved and would be investigated within three days—if they were serious. If nonserious, then they were to be investigated within 20 days.

OSHA responded to any other complaint by notifying the employer and allowing it 15 days to correct the alleged violation. If there was no change or no response from the employer, an inspection would be conducted.

Between 1978 and 1981, the new policy helped encourage a drop in the percentage of complaints that led to citations from 37.6 percent in 1978 to 23.4 percent in 1981.

Bingham also focused on targeting inspections in so-called "high hazard" industries.

Industries could be designated as high hazard in the following two ways: injury data supplied by BLS; or an OSHA evaluation that considered the quantity of chemicals a company used, the toxicity of those chemicals, and the number of workers exposed to the chemicals.

In an industry designated as high hazard, the inspection quota system was eliminated—as well as the nearly 1,000 "nit-picking" consensus safety standards. This ensured compliance officers that they would not be wasting their time enforcing unnecessary regulations.

As a result of better management of its field inspectors, OSHA, under Bingham's supervision, reported many more serious violations than its predecessors had. In 1975 (the year before Bingham took over) OSHA had reported 7,800 serious violations; in 1976, it reported 21,000; in 1977, 33,200; in 1980, 44,700. That was a six-fold increase in less than five years.

The amounts of proposed penalties for serious, willful, repeated, and failure-to-abate violations rose from $6 million in fiscal 1977 to more than $11 million in fiscal 1980.

Under the Carter administration, OSHA also cracked down on state programs. The agency started to withdraw prior approval of some state plans and threatened the same action with others. This particularly impressed unions and other labor organizations who argued that some states simply didn't have the muscle or the experience to effectively enforce workplace health and safety.

Finally, Bingham promulgated a number of health standards, often relying on the Emergency Temporary Standard (ETS) to quickly issue regulations intended to protect workers currently exposed to serious health hazards. These health standards addressed:

- exposure to DBCP,
- exposure to acrylonitrile,
- exposure to benzene,
- exposure to arsenic,
- exposure to cotton dust,
- exposure to lead,
- employee access to exposure and medical records,
- occupational noise, and
- a cancer policy.

Two new health standards were proposed (hazard communication and exposure to ethylene oxide) but were not completed until after the 1980 election.

OSHA also completed six safety standards. The most important—and controversial— of these was the new lead safety standard which was promulgated in November 1978. It established a PEL of 50 ug/m.

In what has become a rite of passage for virtually

Average penalties almost double in three years

A challenge to regulatory power

every OSHA regulation, several industry groups challenged the lead standard in court. The federal appeals court in Washington eventually upheld the lead standard but found that OSHA failed to adequately justify the feasibility of the standard for certain industries.

The court allowed a provision requiring engineering controls and work practices for high-hazard industries. This allowed OSHA to require employers to meet PEL requirements by providing respirators to affected workers. The court then gave OSHA six months to reassess the feasibility of the engineering controls for those industries.

By late 1981, OSHA sucessfully established that the standard was technologically feasible for most of the 46 industries previously identified as having high lead exposure levels. For the remaining industries, OSHA extended compliance deadlines slightly—and, for a few industries, required the use of respirators as the only means feasible to meet the standards permissible exposure limits.

OSHA took a long time to complete its Cotton Dust standard. Late in 1976, after a petition from the Textile Workers Union and several advocacy groups affiliated with Ralph Nader, OSHA issued a notice of a proposed rule suggesting a PEL of $200ug/m^3$. This resulted in a battle between OSHA and Carter's economic advisors who complained that the standard would negatively impact an important domestic industry. Carter supported OSHA and the final rule was issued.

The comprehensive standard for workplace noise was issued in mid 1978. Bingham issued a standard—first proposed in 1974, during Stender's term—on the last day of her tenure in 1981. The final standard continued the temporary exposure level of 90 decibels—but required employers to use engineering controls—rather than personal protective devices such as earplugs to reduce noise.

To demonstrate how the political winds can alter the direction and effectiveness of a federal agency, the noise standard was immediately removed when

the Reagan administration assumed the reins at OSHA in 1981.

As OSHA matured under Bingham, agency officials began to realize that limited resources, imminent court cases, politics and just plain bureacracy made it extremely difficult to regulate workplace hazards swiftly. One standard designed to eliminate one single health or safety hazard could take years to be issued as a final rule.

So, in an attempt to regulate more than one hazard in the same rulemaking, OSHA attempted to issue "generic" standards.

The agency's most far-reaching and innovative generic initiative was the generic cancer policy—or GCP—which came out in late 1977. It consisted of a four part system for categorizing workplace chemicals and a set of model regulations to match that system. The final rule was issued in January 1980 and contained the so-called "presumption-rebuttal" format.

By making generic presumptions, the rule put the burden of compliance firmly upon the shoulders of employers. Employers had to "fill-in-the-blanks" to determine what steps were necessary to meet compliance. Needless to say, the generic rule found its way into the courts.

The fate of the generic cancer policy was decided by the Supreme Court when it issued a ruling on another OSHA standard which controlled exposure to benzene. OSHA finalized this standard in 1978—and the petroleum industry immediately challenged it in court.

The Supreme Court held that OSHA had misinterpreted the OSH Act, because it failed to subject the benzene standard to a cost-benefit test. This test requires OSHA to determine whether or not employers can meet a standard's requirements without bankrupting their business in the process. The Supreme Court held that the agency skipped an analytical step when it determined that the exposure to carcinogens in the workplace should automatically be reduced to the lowest feasible

Issuing generic standards

level—a level which may not have been economically feasible to employers.

The Court further held that Section 3 of the OSH Act required the agency to determine the level at which current workplace exposures to a chemical give rise to a "significant risk" of harm. OSHA was ordered by the Court to apply this "significant risk" threshold test but given little instruction on how to actually conduct the tests.

OSHA concluded that it was required to employ so-called "quantitative risk assessment techniques" to determine whether specific workplace carcinogens posed a significant risk. However, the agency was not quite sure how to determine what degree of risk was significant.

Not taking any chances, OSHA published a final GCP that deleted all references to provisions requiring exposure levels for carcinogens to be established at the lowest feasible level. OSHA's decision to remove tougher regulatory language indicated that the agency did not have the ability to support its generic PEL requirements with substantial scientific research or detailed risk analysis. In a nutshell, the benzene case eliminated much of the GCP's bite.

One of Bingham's last acts was to implement an experimental "New Directions" program designed to incorporate the skills and experience of labor unions, trade associations, educational institutions, and nonprofit organizations to provide assistance to employers and employees in recognizing hazards, and to also provide training in employer and employee rights. In August 1980, OSHA earmarked $6.5 million to some 60 private organizations for training in hazard abatement. However, changes in the economy and White House priorities under Ronald Reagan, slowly suffocated the program before it had a chance to prove itself.

In the early1980s a recession hit the country, and the government began to reduce federal spending. Congress placed very low ceilings on spending and enacted many substantive law changes or

nonbudgetary actions—but it rarely abolished federal programs.

Pressure increased on the Carter administration to alleviate "excessive cost and compliance burdens" and to remove any unnecessary barriers to economic expansion. The administration complied by:

- returning the federal authority to the state and local governments;

- assigning various problems to the private sector; and

- keeping tight reins on the nation's money supply and reduced interest rates through the substantial power of the Federal Reserve System.

All of these efforts worked against OSHA's consolidation of centralized power in Washington.

The Reagan years

Ronald Reagan became President in January 1981, vowing to "take the government off the backs" of the people whenever possible.

Upon assuming office, Reagan directed all executive agencies to suspend for 60 days almost 200 so-called "midnight regulations," issued during the waning moments of the Carter administration. The moratorium would give the new administration opportunity "to ensure that they comported with the President's principles." The Reagan administration also wanted to force deep budget reductions on the agency.

Major changes followed the appointment of Thorne Auchter—a former construction executive from Florida—as Reagan's first OSHA head. Chief among these:

- the agency targeted for inspection industries and companies with the highest safety and health problems;

- it only performed brief surveys at companies with good records;

- it would pass over companies with active safety and health programs—if their programs generally met OSHA criteria for effectiveness;

- it reduced the number of follow-up inspections on the basis of controversial statistics showing that the vast majority of these didn't reveal failure to correct the violations;

- it gave regional directors the authority to negotiate settlements, in an effort to reduce its number of lawsuits in process; and

- it pressured states to assume more enforcement duties as part of the Reagan administration's philosophy of government.

Reagan filled key spots in and around OSHA with deregulators. Timothy Ryan—former private practitioner with a specialty in labor law, who would later be head of the Office of Thrift Supervision—was named Solicitor of Labor. Auchter hired another committed deregulator, R. Leonard Vance, to head the Health Standards Directorate.

Reagan took two significant actions to insure that OSHA's rule making complied with his promise to reduce government bureaucracy and unnecessary regulations.

A new central review process was initiated under the White House's Office of Management and Budget. The process required all federal agencies to prepare Regulatory Impact Analyses detailing the costs and benefits of all "major" rules. Agencies were not to undertake regulatory initiatives unless "the potential benefits to society for the regulations outweigh the costs." In typical acronym-filled bureaucratic jargon, no regulation could be proposed or finalized until OMB had approved its RIA.

OSHA was required to justify its rules. This gave OMB a powerful role in the promulgation of workplace safety standards.

Vice President George Bush, chairman of the Presidential Task Force on Regulatory Relief, sought to bring about a dramatic shift in the direction of

federal regulation. In March 1981, Bush's task force announced a "hit list" of 27 regulations it wanted to overturn—including OSHA's noise standard and carcinogen policies.

Bush had written letters to various business groups asking each for a list of ten regulations to be placed on the hit list and specific recommendations for "the ways you wish these changed." OSHA standards figured prominently in the industry response.

In the meantime, Auchter argued that a shift toward training and consultation and away from the "prevailing adversary spirit" of OSHA would reduce staff needs. He proposed cutting 298 staff people from OSHA's standards enforcement and 52 staff people in health and safety standards development. By fiscal 1983, Auchter wanted to reduce the number of field inspectors from 1,967 to 983. Congress resisted Auchter's proposed staff reductions, but ultimately approved deep budget cuts for the agency as part of deficit reduction legislation touted by Senators Gramm, Rudman and Hollings.

OSHA's appropriations were reduced by $11 million in 1982. In 1983, its $209 million budget was less—in real dollars—than its 1981 budget had been.

Although he cut OSHA's operations substantially, Auchter did not immediately eliminate Bingham's "new directions" initiative for educating workers about health, safety and rights under the OSH Act. His approach here was less direct. He cut the program's funding substantially and put severe restrictions on outlays to private institutions slated to provide employer and worker training.

The budget for the new directions program was cut from $13.9 million in 1981 to $6.9 million in 1982. By 1985, its budget had been reduced to $5.6 million. Rather than being killed dramatically, the program was bled to death until it gradually faded away.

Auchter's tenure resulted in only two new safety

Emphasis on consultation would reduce staff needs

The origins of the important hazard communication standard

standards (marine terminals and latch-open devices on gasoline pumps) and two new health standards (hazard communication and ethylene oxide).

The two new health standards came as a result of considerable outside pressure. OSHA promulgated the Hazard Communication standard in order to address the concerns of labor unions and workers who demanded to be apprised of all risks related to chemical exposure. The ethylene oxide standard resulted from a federal court order.

OSHA published a notice of proposed rule making for a generic hazard identification standard as one of the Carter administration's last minute "midnight regulations." This standard would require consistent and unmistakable labelling of hazardous materials.

When Reagan took over, OSHA withdrew the proposed rule and appointed a task force to come up with other alternatives. Unions objected, accusing OSHA of caving in to political pressure from Reagan's allies in big business who worried that trade secrets would be compromised if they had to provide information to employees about the chemicals used to develop products. Working around OSHA, the unions launched a campaign to get the states to enact their own "worker-right-to-know" legislation.

A number of heavy industries—particularly the chemical and manufacturing fields—reconsidered their opposition to a federal hazard communication rule. If the states and localities developed similar rules on their own, employers could face tougher requirements. They could also have trouble meeting requirements that could vary widely depending upon where they did business.

OSHA responded quickly and initiated a new labelling standard, which included the same core points that the standard written under the Carter administration had had. The quick draft was ready for OMB review in early 1982.

Then OSHA and OMB got in a political spat. OMB

issued a confidential memo to Bush's task force, claiming that "there was no direct evidence of need for universal labelling of chemicals." OSHA accused OMB of relying on shaky arithmetic and faulty assumptions. Bush eventually sided with OSHA and the proposal went into effect in March 1982 without any significant changes.

The proposal accepted the fundamental tenet that workers should be informed about workplace hazards but limited its application to the manufacturing sector of the economy. The proposal did not list the hazards it thought were dangerous—instead, it gave employers discretion to exercise their professional judgment.

Reagan's proposal differed from Carter's in that it required every manufacturer to obtain or develop a so-called "material safety data sheet" (MSDS), based on available literature, for each hazardous product it produced or used.

OSHA listed specific items that were to be included in every MSDS. It required employers to provide employee training in how to work with hazardous chemicals. This was one of the most important rules ever promulgated by the agency.

It was OSHA's decision to restrict the standard to manufacturing. The agency did, eventually, expand the scope of the standard—but only after a federal court ordered it to do so.

While Bingham had strengthened OSHA's inspection policy by targeting the most dangerous workplaces, Auchter modified this approach by limiting programmed inspections to the manufacturing and construction sectors.

Auchter also believed that the agency should only use the programmed inspections with the most dangerous individual firms in a given industry. He believed that the criteria use for the programmed inspections was only to inspect a site if a company's lost workday injury rate was below the national average of 4.9 days per 100 workers.

Under Auchter's OSHA, employers outside of the manufacturing or construction industries didn't

have a reason to fear an OSHA inspection. Auchter required inspectors to spend large amounts of time in their offices examining records rather than in workplaces searching for hazards (i.e., to determine an injury rate, an inspector had to spend hours going over company records). The policy shielded employers with the most dangerous workplaces from inspections.

Critics complained that companies that didn't feel an OSHA inspection threat didn't improve safety. They argued that employers with high fatality rates were no more likely to be inspected than other employers with no history of fatalities.

Auchter instituted policies which encouraged OSHA to settle complaints with the employers quickly—often in the employer's favor. Included in this group of policies was a rule that OSHA would not conduct a follow-up after an inspection. The employer only needed to send a letter stating that the hazards identified in the inspection had been abated.

Overall, the number of OSHA inspections declined from approximately 11,670 in 1980 to 1,602 in 1983—an 88 percent drop in three years.

The number of "willful" violations cited by OSHA dropped 90 percent from 1,238 in 1980 to 112 in 1982. During the first six years of the Reagan administration, the agency referred only 10 cases to the Justice Department for criminal prosecution.

By comparison, Bingham had referred 24 in three years.

Inspection numbers can rise and fall, reflecting the politics and temperament of the people running a regulatory agency. One of the most significant changes Thorne Auchter brought to OSHA was to shift the inspector's role from enforcer to consultant.

In March 1984, Thorne Auchter resigned as OSHA head. No final standard had been issued during Auchter's tenure for any previously unregulated substance.

A short, ill-fated appointment

In July 1984, Robert Rowland was named head of OSHA. Rowland, a Texas attorney, had been a state vice chairman of Reagan's 1980 campaign. But he wasn't just a politician—he had also been the chairman of the OSHA Review Commission since 1981.

Still, Rowland was characterized by people in the safety industry as "anti-worker." He came to OSHA under a conflict-of-interest cloud because he owned sizable investments in several petroleum and chemical companies that could be affected by OSHA decisions. He placed investments in a blind trust in late 1984, and was given a waiver from Labor Secretary Raymond Donovan which granted him the right to set safety and health standards affecting companies in which he owned stock.

Needless to say, the bureaucrats within OSHA—and the labor organizations that worked with the bureaucrats—didn't like Rowland's background. In April 1985, the Office of Government Ethics announced that it planned to investigate the situation. Republicans avoided confirming Rowland in the OSHA position until after the 1984 elections.

The confirmation hearings were never held—because Rowland was considered a political liability by Reagan's advisers. Rowland resigned in May 1985, ten months after being named to the job and a few weeks after being exonerated of the ethics charges.

During Rowland's ten months, OSHA failed to issue any new health or safety standards. In fact, Rowland denied a union petition for an emergency temporary standard to protect workers from exposure to formaldehyde. He also supported an OMB decision (over the protests of his own people) to forgo a proposed safety standard for the oil and gas well-drilling industry.

Perhaps Rowlands greatest negative impact on worker protection came with his refusal to develop a final rule to protect field workers from unsani-

One director caused a negative impact on OSHA

Farm standards were delayed for nine years

tary conditions. Most outdoor workers were protected by OSHA's general industry sanitation standard. However, about 5 million farm workers—including 1.9 million migrant workers—lacked federal protection.

By 1984, farm workers had been pressuring OSHA for 15 years to give them the same type of protection available to other outdoor workers. They demanded a standard that would provide such basic sanitary necessities as toilets and drinking water to reduce heat-induced injuries, infectious diseases, and pesticide poisoning. Several civil rights groups and farm worker organizations based their demands on internal Labor Department memos and a 1974 court order requiring OSHA to promulgate a field sanitation standard.

In April 1976, OSHA had published a proposed standard that provided for potable drinking water and sanitary toilet facilities. For the next nine years, though, the standard was stalled by a series of court battles.

In April 1985, Rowland ruled that a field sanitation standard wouldn't be adopted at all. He didn't want to divert scarce agency resources from the enforcement of other OSHA standards protecting workers from more life-threatening toxic exposures. Rowland believed agricultural safety issues were appropriate for individual state regulation.

Labor Secretary William Brock, newly appointed for Reagan's second term, rescinded Rowland's decision in October 1985. Brock reopened the record for public comment and set aside an 18-month period during which states could implement their own farm standards. If states representing a majority of unprotected field workers failed to enact sufficient regulations governing field sanitation by April 1987, Brock would commit OSHA to promulgating its own standard.

Still, there was the matter of the 1974 court order. Brock's OSHA believed it had fulfilled its required duties. A series of federal judges disagreed. Finally, in March 1987, the agency published a no-

tice of the secretary's determination to issue a final field sanitation standard.

A new perspective

John Pendergrass, an industrial hygienist by training, succeeded Rowland as OSHA head. Pendergrass was confirmed in February 1986. Under his direction, the agency issued more full-fledged standards than under any other director—though OSHA was compelled to do so by several court orders insisting that the agency act more quickly. The agency also completed 11 pending safety standards and four pending health standards at this time.

One of Pendergrass's first tasks was to respond to a lawsuit challenging OSHA's failure to extend its hazard communication to the nonmanufacturing sectors.

In the early 1980s, the United Steelworkers union had petitioned the federal court to force OSHA to promulgate an expanded hazard communication rule by a certain date. In May 1984, the court ordered OSHA to publish a hazard communication standard applicable to all workers covered by the OSH Act—or state within 60 days the reasons why the standard would not be feasible in particular industrial categories.

Because the court order imposed such a limited time constraint for coming up with the reasons why OSHA had to exclude particular industries, the agency had little choice but to propose that the standard be extended to all industries. The OMB asked for public comment on the record-keeping, notification, and other "paperwork" requirements of the standard.

The federal court that had issued the order also held that the paperwork requirements to which OMB objected were irrelevant to its regulatory oversight mission. In December 1988, the court affirmed OSHA's extension of the hazard communication rule to the nonmanufacturing sector.

The burden is on OSHA to prove "feasibility"

Pendergrass remained head of OSHA when George Bush was elected President following Reagan' second term. In June 1988, OSHA proposed a generic rule to toughen the existing PELs for approximately 100 substances, raise the PEL for 1 substance, and set new PELs for approximately 205 substances not then regulated by OSHA. Many of the substances were promulgated in 1971 from national consensus standards—and stakeholders felt that the current exposure limits were too lax to adequately protect workers.

The reaction to the proposal from trade associations and employer groups was mixed. Most were mildly supportive of the generic approach. The unions were not opposed to reducing the PELs to provide additional protection to exposed workers, but did object to the scattershot approach in which the PELs were determined.

Because OSHA lacked the scientific research to determine suitable PELs for each chemical, the agency relied upon recommendations submitted by NIOSH and the American Conference of Governmental Industrial Hygienists (ACGIH). Pendergrass hoped in the future to regulate each substance individually, based on more concrete scientific data.

Six months after the close of the hearing record, OSHA came out with a final rule reducing the existing PEL for 212 substances and setting new PELs for 164 substances.

OSHA tried to soften the economic impact of the new PELs by giving companies four years to use respirators—rather than engineering controls to meet the standards. There was no deadline for industries who were unable to comply because of unfeasibility.

OSHA's efforts weren't enough. Twenty-seven separate judicial challenges were filed against the agency by trade groups. These lawsuits were consolidated into one case tried in the Federal Circuit Court Of Appeals, and OSHA found itself face to face again with the OSH Act requirement to provide risk and feasibility analysis to each standard.

The trade groups prevailed. In July 1992, the Eleventh Circuit Court of Appeals vacated the entire standard—holding that OSHA had not supported it with a sufficiently detailed analysis of its risk and feasibility determinations with respect to all of the PELs set in the generic proceeding.

Pendergrass also attempted to issue a safety standard for methylenedianiline (which failed) and one for blood-borne pathogens (it passed). However, he passed on trying to regulate secondhand smoke exposure in the workplace, a controversial issue which has yet to be resolved by OSHA.

Pendergrass implemented changes to OSHA's inspection policies by taking a more scientific approach to employer selection. OSHA shifted from assessing workday/injury rate data to an employer's history of workplace fatalities. Every tenth programmed inspection in a high-hazard industry was a comprehensive inspection—regardless of the subject's lost workday rate.

An inspector could inspect a company with an above-average fatality rate if he or she detected discrepancies in the accident log, if an imminent hazard was in open view, if the record review indicated an unusual number of type or number of injuries, or if an employee representative filed a safety complaint.

Pendergrass reinstated the "wall-to-wall" complaint inspection policy. The agency imposed fines of $100,000 to $1 million against employers who deliberately failed to keep accurate records. It began the practice of so-called "mega-fines" for employers who acted in a flagrant or egregious manner. OSHA's egregious penalty policy allows the agency to fine employers who willfully violate regulations on an instance by instance basis or for each employee exposed to a cited hazard.

The advent of OSHA reform

A Comprehensive OSH Reform Act was introduced simultaneously in the House of Representatives and the Senate in late 1991. The legislation fol-

Fines for faulty recordkeeping increase

lowed a fire in a Hamlet, North Carolina, chicken processing plant that killed several dozen people. In the aftermath of the fire, inspectors uncovered numerous OSHA violations. The uproar soon turned away from the employer to the North Carolina State OSH plan and then to federal OSHA, the agency in charge of all the state OSH plans.

The Democrat sponsored reform bill designed to strengthen OSHA's enforcement powers and allow prosecution of employers who knowingly violated serious OSHA regulations was vehemently opposed by both the Bush administration and the business community. In both the House and Senate, the bill failed to reach the floor after the committee approval.

Bill Clinton's "New OSHA"

The House introduced a new version of the Comprehensive OSH Reform Act in March 1993, months after Bill Clinton had been sworn in as President. The new bill reflected Clinton's philosophy of "reinventing" government agencies by developing industry-sensitive regulatory guidelines—which still maintained regulatory authority.

The new reform bill established that all employers would have to develop and implement workplace safety and health programs. Employers with eleven or more employees would have to establish joint labor-management safety and health committees. A minimum of $1,000 in civil penalties would be assessed for serious safety and health violations.

Tougher criminal sanctions under the reformed OSH Act would be enforced. The scope of the OSH Act would be broadened to include approximately 7.3 million state and local government employees. It would also include specific provisions addressing safety and health issues in construction.

The new bill also considered several legal issues. It reversed the federal court ruling in *Gade v. National Solid Waste Management Association*—which defined and expanded a state's safety and health licensing abilities. The bill also reversed the fed-

eral court ruling in *AFL-CIO v. OSHA* that restricted air contaminant exposure limits. Finally, harkening back to Eula Bingham's ill-fated New Directions program, the reform bill established a revolving fund for consultation and technical assistance programs to raise $40 million for OSHA.

The bill never made it.

According to Dear—Clinton's choice for OSHA head—the agency has "instituted a new five-point regulatory strategy to identify priority issues, focus on key building block rules, eliminate or fix confusing and out-of-date regulations, emphasize plain language and use cooperative partnerships."

Dear spoke often of the "new OSHA," which embodied Clinton's image of reinvented government. He measured the new OSHA's performance by results— "by the impact we are having on reduction of injuries, illnesses and fatalities in the workplace."

This approach was self-critical. It considered such things as the percentage of programmed inspections that uncover significant hazards. Ultimately, the agency planned to develop programs that would allow its managers to measure the performance in even more specific ways. For example, Dear compared reductions in injury and illness at both sites OSHA visits and industry sectors in general.

In May 1995, Clinton announced three sets of regulatory reform initiatives for OSHA. The agency had been working on these proposals since 1993. Dear promised, "These initiatives will fundamentally change the way we do business."

First, OSHA would alter its basic operating method from one of command-and-control to one that offers employers a choice between partnership and traditional enforcement.

Second, OSHA would change its approach to regulations by identifying "clear and sensible" priorities, focusing on key building block rules, eliminating or fixing outdated and confusing standards and emphasizing interaction with business and labor in the development of rules.

Performance measured in terms of fewer injuries

OSHA does more than just enforce regulations

Finally, OSHA would alter the way it works on a day-to-day basis by focusing on the most serious hazards and the most dangerous workplaces—instead of worrying about the technical violations. "We will insist on results instead of red tape," Dear said.

In order to change the way OSHA operated, it was essential that reform begin with the agency's front-line workers—who dealt with the regulated community on a regular basis. To accomplish this, Dear developed a model office and pilot testing program in each of the agency's seven area offices. OSHA then used a Rollout Team, composed of internal staff and manager, to bring each office the improvements that had been developed in the pilot program.

"Our goal is to redesign federal enforcement by the fiscal year of 1997," Dear said. "OSHA's field Office Redesign Effort will change every aspect of our offices' operations. The basic philosophy underlying this effort is that OSHA's staff has the responsibility to reduce injuries, illness and deaths rather than simply enforce regulations. We will use Strategic Intervention Teams to identify the leading causes of workplace problems within a given area and then use a variety of techniques—enforcement inspections, investigations, education—to solve the problem."

He mentioned several examples:

- In Atlanta, a Strategic Intervention Team formed a partnership with a local steel company. In return for technical assistance at one site, the steel company agreed to implement a fall protection program with front-line accountability throughout the company. The company saw a reduction of 96 percent in its accident costs per man hour—and three lives were saved as a result of using fall protection techniques at sites never visited by OSHA.

- In Parsippany, New Jersey, the local OSHA office became aware of an increasing number of lead poisoning cases among bridge workers. The office formed a partnership with New

Jersey's Department of Health and Transportation—together they developed strategies for protecting the workers from increased blood lead levels (which are an indication of lead poisoning). OSHA sponsored training sessions for employers before they started working on a bridge or renovation project. It described to the contractors the on-site consultation program available in New Jersey—which provided free advice on ways to identify and eliminate workplace hazards. If an employer chose not to comply, OSHA initiated strong enforcement action.

Dear argued that many of his plans reflected the best parts of the decentralizing efforts begun under Reagan's OSHA administrators. He saw the New Jersey project as the most illustrative example of the new OSHA.

"Our office used enforcement, implemented a comprehensive medical surveillance program, and developed a lead safety plan for each worksite where lead exposure occurred," he said. "As a result of this intensive effort, the mean blood level among affected bridge workers dropped 25 percent between 1991 and 1994. The percentage of employees who had blood levels higher than one ug/m^3 dropped from 24 percent in 1991 to 2 percent in 1994. OSHA and the state of New Jersey, working with employers and employees, made major advances in protecting bridge workers from the hazards of lead."

Then again, many employers know to be wary when a bureaucrat talks about government agencies "working together." It sometimes means regulatory chaos; it usually means higher costs for those being regulated.

Another key point to Dear's efforts to reinvent OSHA was "a reduction in the time it takes to get a hazard abated as a result of a complaint from a worker about safety and health."

OSHA's offices in Cleveland and Peoria piloted an effort to reduce this time cycle. They began responding to complaints over the telephone and fax. Employers could respond by phone and fax

The agency streamlines safety and health procedures

to describe how the workplace danger was eliminated.

"It used to take almost fifty days for the Cleveland office to achieve hazard abatement," Dear said. "Now the time to abatement is 10 days. Peoria has cut its abatement time from 35 days to 8. This more efficient approach to handling formal and nonformal complaints will be used by all OSHA area offices."

OSHA streamlined other procedures. Historically, it had taken as much as two or three months for someone to receive a response to a request under the Freedom of Information Act. By better using available information technology, OSHA's Atlanta office reduced the time needed to complete a FOIA request from 60 days to four or five days.

The agency planned to remedy the problem caused by regulations that had been adopted in 1971— but had become outdated in the mid-1990s. Most of these regulations had originally been written in technical or engineering language that was difficult for the layman to understand. OSHA scheduled to re-write more than 500 pages in an easier-to-read format by the end of 1996.

"One of the standards of most concern to employers, particularly those with small businesses, is the Hazard Communication rule," Dear admitted. But he defended the rule:

> ...this regulation is vital because workers must be aware of the dangers they face from toxic substances in the workplace. We have requested that the National Advisory Committee on Occupational Safety and Health—which is composed of representatives from industry, labor, the States, and academia—identify ways to improve the standard. OSHA's goal is to focus on the most serious hazards, simplify the Material Safety Data Sheets which have been the source of numerous complaints about complexity, and reduce the amount of paperwork required by the Hazard Communication Standard.

Dear contrasted this point by saying that OSHA's field offices were becoming more efficient by changing procedures, making better use of computers and video cameras and forming partnerships with the private sector.

A new Congress targets OSHA

Throughout the 1990s, OSHA implemented a number of specific projects to ease the burden of complying with its plethora of regulations. In 1992, it introduced the OSHA CD-ROM—which provides all of OSHA's regulations and interpretations, its Field Inspection Reference Manual and OSHRC decisions. To provide special assistance for small businesses, OSHA worked with the National Performance Review to provide electronic access to regulatory information and services through the Internet.

These more accommodating approaches were born of necessity. In 1994, American voters reversed 40 years of political hegemony in Congress, electing Republican majorities in the House and Senate. Some of the most vocal of the new Republicans in Washington had singled out OSHA as the worst example of Big Government's regulatory excess.

According to Dear, "the changes we are instituting in OSHA will improve the agency's performance and help assure improvements in worker safety and health. All of OSHA's past and future success is threatened, however, by two pieces of legislation currently before the Congress."

The first was the fiscal 1996 appropriations bill for the Labor Department—passed under the watchful eye of new House Speaker Newt Gingrich. The measure cut OSHA's budget by 15.5 percent and slashed enforcement programs by 33 percent.

Dear—like his boss, Labor Secretary Robert Reich—argued that by slashing OSHA's budget the House would expose American workers to higher fatality, injury and illness rates. Dear said that this would impose "millions of dollars of additional

An appropriations bill threatens OSHA's future

The conflict between the new approach and old habits

costs on employers in the form of higher workers compensation payments, related medical costs, and employee turnover."

But Dear's pro-employer argument gave way—quickly—to more traditional bureaucratic complaints:

> In addition, the bill contains language that restricts OSHA from taking action on a standard for ergonomics and seeks to weaken the agency's rule on fall protection in construction.

> A 33 percent cut in enforcement would decimate the Agency's enforcement effort. It would result in a 50 percent reduction in inspections and an estimated 50,000 more injuries a year to American workers. OSHA's diminished enforcement effort would consist of responses to accidents, complaints and referrals with virtually no resources available to do provocative inspections of high-hazard firms.

The second bill that had OSHA worried was a reform plan being considered in the House Committee on Economic and Educational Opportunities. Dear insisted there is a "fundamental difference" between the House reform bill and Clinton's plan for a "New OSHA."

His analysis:

> Both approaches acknowledge that OSHA must find a new way of doing business. But the legislation would provide any employer—including those who choose to disregard worker safety—with exemptions and defenses against OSHA enforcement. In contrast, the "New OSHA" treats responsible employers differently from neglectful ones, offering incentives and cooperation to the former and applying traditional enforcement to the latter. The "New OSHA" offers employers a partnership with the agency that demonstrates a commitment to safety and health before being placed on a low priority inspection list.

> [The House bill] would represent a huge step

backward from the principle of prevention through enforcement: It would prohibit the Agency from issuing first instance sanctions unless workers are killed or seriously injured or an imminent danger is present. Employers would receive only a warning—even when they have ignored the most obvious hazards.

There would be little incentive for employers to protect their workers before OSHA gets to their workplace. In contrast, the "New OSHA" will continue to issue first instance sanctions where workers' safety and health is threatened but will adjust penalties for those employers demonstrating a sincere effort to improve their workplaces.

Among OSHA's specific complaints about the House bill: It would force workers to notify their employers before filing a complaint about unsafe working conditions with OSHA. Dear argued that this would apply "even when workers face an imminent danger on the job and possible retaliation from their employer." Therefore, he concluded, the bill would provide a disincentive for reporting hazards.

The bill would also eliminate penalties for violations of the General Duty Clause—thus removing a weapon OSHA had used for 25 years to require employers to keep workplaces free from hazards for which the OSH Act included no specific standard.

OSHA critics argued that the General Duty Clause was the sort of non-specific power that American Constitutional tradition prohibited. Dear preferred a more activist perspective: "The General Duty Clause is a legal recognition of an employer's obligation to protect his workers from conditions the employer recognizes to be threats to the employees' safety and health. Making this provision unenforceable would effectively repeal it."

That was, of course, Gingrich's point.

Dear argued that, without the General Duty Clause, OSHA could have issued a penalty of only

Workers notify their employer before calling OSHA?

An end to fines under the General Duty Clause?

$10,800 after the 1989 explosion and fire which killed 23 workers at a Phillips 66 oil plant in Pasadena, Texas. With the General Duty authority, OSHA proposed a penalty of $5.6 million "to an employer that did not live up to its obligation to protect its workers from a serious explosion hazard."

The second bill would also prevent OSHA from using its egregious penalty policy when it found a significant number of serious violations in a single workplace. "OSHA's ability to pressure low road employers, who shrink on workers' safety to gain competitive advantage, would be severely compromised," Dear argued.

Again, he pointed to a tragic example: If the bill had been in effect in 1987, OSHA would have been allowed to issue a penalty of only $125,000 after a construction collapse at L'Ambiance Plaza. With the egregious penalty authority, OSHA proposed a penalty of $5.1 million.

The General Duty Clause and egregious penalty authority also gave OSHA weapons for taking on entire industry sectors—at least ones that had records of safety and health problems.

The House reform bills also exempted from programmed inspections all businesses with fewer than 50 employees in certain industries—regardless of the conditions in the individual workplaces. Dear argued that his team had already begun to make similar changes in a more sensible way:

> The "New OSHA" is improving its inspection targeting methods to assure that, where data are available, inspectors go to the most dangerous workplace there is regardless of the overall industry safety and health record.

> There is a right way and a wrong way to reform OSHA. Slashing the agency's budget...is the wrong way. These actions would reduce protections for American workers and result in increased death and injury. Surely this is not what the American public expects from its government.

Conclusion

The notion of what the American public expects seems to be a relevant issue when it comes to dealing with OSHA in the real world. Is the bureaucratic head of government agency the best person to assume what the American public wants? If that assumption is the basis on which policy decisions are made, is it any surprise that the companies regulated by OSHA feel so much antagonism toward the agency?

Probably the most useful answer to these questions is offered—albeit unwittingly—by Joseph Dear. In the course of a long and ranging interview, he lands on the subject of how his agency fits in the bureaucratic pecking order of the Clinton White House:

> There is a tremendous competition to succeed at reinvention, in terms of recognition from the White House. OSHA has won three Hammer awards from the Vice President. Per capita that has got to be as great as anybody in the government.

This microcosm would inflate any regulator's notions of self-importance. Dear goes on to say:

> One of the great and most important distinctions between the New OSHA initiatives of the Clinton Administration and the wrecking ball approach taken by some members of Congress is that our initiative to develop a partnership depends on employers committing to health and safety before OSHA shows up in the workplace.

> I get fascinated when I visit high performance work sites [and] VPP award ceremonies that the integration of companies make of their safety and health is going to be between OSHA programs with continuous quality improvement processes.

These statements presume that OSHA has the stature to be the partner of the companies it regulates. Dear doesn't seem to understand that work-

Success depends on a commitment to safety

OSHA is only a minority partner

place safety—as important as it is—is only one of dozens of issues that business decision makers have to face every day.

As an employer, you know that making your workplace safe is both the right thing to do and the most cost-effective thing to do over the long term. But other issues are as important: selling your goods or services, hiring the best people, keeping good customer relations, buying materials at the lowest possible cost, watching cash flow...and so on down the page.

If OSHA—which regulates only one aspect of your business—is a partner, it's a minority partner.

Government regulators seem constitutionally unable to understand where they fit in a company's scheme of priorities. Dear warned:

> It is very important for people who believe in health and safety to understand that gravity of the threat to OSHA. I don't want to say, it is all going to work out okay. These things are so bad, they can't possibly happen. I also don't want to be overly pessimistic and leave people with the impression that they do not need to worry about their safety and health program, because the government is not going to ever come back to check on it.

The peril, he said, "is that the wrecking ball will swing through and destroy the program before the reinvention has had time to fix the real problems and find effective ways of leveraging OSHA's resources. The longer it takes the reform legislation to get through, the more opportunity there is to demonstrate the results workplace by workplace throughout the country—that the reinvention is genuine and effective."

The internal biases of a government regulator couldn't be more plain. The priority is to leverage his agency's resources. He focuses on jargon, making much out of a minor distinction between reform—bad—and reinvention—good.

Joseph Dear isn't an extreme example of a gov-

ernment regulator—in fact, by many measures, he's moderate and market-sensitive. The problem that he poses is one that gets to the core issue of regulation: The assumption that a handful of people in Washington D.C. are better judges of what the American public wants than you are.

With or without OSHA, you are the one who is in charge of protecting employees from safety and health hazards in your workplace. This book will give you the tools to understand OSHA guidelines and comply with OSHA standards. With this information, you can make the workplace safety decisions you choose. All the regulators and all the reinvention that Washington can muster can't force you to make the right decision. You're the only one who can do that.

Chapter 2

Who Is Subject to OSHA Regulations?

Introduction

When Congress signed the Occupational Safety and Health Act into law in December 1970, it required every employer engaged in business affecting commerce to comply with OSHA regulations and provide a safe and healthful workplace for his or her employees. The Act defines an employer as "a person engaged in a business affecting commerce who has employees, but does not include the United States or any state or political subdivision of state." And *person* refers to "one or more individuals, partnerships, associations, corporations, business trusts, legal representatives, or any organized group of persons."

In a nutshell, if you are an employer engaged in business affecting commerce, and you have employees but are not a government agency—you are covered by the OSH Act.

There is one small exception—but, for most employers, it's a longshot. If you're a member of an Indian tribe conducting business activities on a reservation, the OSH Act does not apply to you. The Occupational Safety and Health Commission ruled in *Secretary of Labor v. Navajo Forest Products Industries* that, because Indians are not specifically mentioned in the OSH Act, the Act can't be enforced in any way that would contradict treaty rights recognizing the sovereignty of the tribes.

Having one employee is enough to be regulated by OSHA

For those non-Indians who are uncertain whether or not their business affects commerce, keep in mind that Congress took a broad approach when defining coverage under the Act to make sure that virtually every employer was included. Any affect your business has on commerce, no matter how minimal, is enough to bring you under OSHA's jurisdiction.

For example, the owner of a 41-unit apartment building argued that his construction of a building addition did not affect commerce in any way so therefore an OSHA citation for a safety violation should have been vacated. An administrative law judge and the OSHRC agreed. OSHA appealed the case to the federal Ninth Circuit Court of Appeals.

In the resulting decision, 1980's *Usery v. Lacy*, the court reversed the review commission decision on the grounds that the apartment owner used Sears power tools, a Ford station wagon and Weyerhaeuser lumber to complete construction. Since those name companies were engaged in interstate commerce, the court reasoned that "the use of material that has at any point moved in commerce is enough to establish that a business affects commerce...."

Congress applied the same broad brush approach to define the scope of the Act with regard to employees—just one is enough to establish coverage under the Act. In *Secretary of Labor vs Mangus Firearms*, the administrative law judge ruled that even a "silent partner" could be considered an employee under the Act.

In *Mangus*, a retail gun store was operated and managed by its principal owner. The only other person who worked in the store was a silent partner who had invested money in the business and took in half the profits. The partner worked in the store approximately seven hours a week but did not participate in managing the business. The judge ruled that although the partner might not be considered an employee by common law standards, she was an employee under the Act.

Keep in mind that individuals or employers who subcontract work are responsible for the health and safety of those subcontract employees. Under the doctrine announced in *Hodgson v. Gills and Cotting, Inc.*, a general contractor has the responsibility for overall safety and accident prevention even though subcontractors are used.

OSHA views even informal arrangements in which work is handed over to another individual as an employer/employee relationship. In a 1974 case before the OSHRC, Elmer Vath learned this policy the hard way.

Vath—a small painting contractor boasting one employee—contracted to paint a commercial building. He later entered into an agreement with Leon Rodriquez, an unemployed painter, to paint the cornice across the front of the building for $240. The task could not be completed by one man alone, and it was understood that Rodriquez would have one man working with him—a man named Charles Pope.

Vath provided the paint and scaffolding material, and the men would supply their own brushes and scrapers. A few days into the job, a state of Iowa Bureau of Labor field safety technician inspected the site and noted that there were scaffolding safety violations. He talked to Rodriquez who stated he was employed by Elmer Vath.

The technician detailed five separate scaffolding safety requirements on a Construction Safety Report issued to "Contractor Elmer Vath Co." Among other items, this report noted absence of railings and safety life belts. Rodriquez took the report to Elmer Vath who then supplied a 2x4 for a bag rest and a safety belt for the employee.

Soon after, Pope fell 60 feet from a scaffold when one of the beams from which it was suspended slipped. He had been wearing a safety belt but had unhitched it minutes prior to the accident. Because Vath did not consider Pope to be his employee, he did not report Pope's death to the OSHA area director. A subsequent OSHA inspection revealed several violations and Vath was fined.

Even informal arrangements constitute employment to OSHA

Vath contested the citations. His case was brought before the OSHRC. Although the commission acknowledged that Vath exercised no control over the details of the work, it did recognize that Vath furnished the material and necessary appliances— a circumstance which lends support to a master-servant relationship at common law.

The commission also reasoned that painting contractors do not customarily sub-contract portions of a job to unemployed painters who lack the materials or means to accomplish the work. The fact that Vath did or did not withhold Social Security taxes or acknowledge the two painters as his employees to satisfy the dictates of any other state or federal social legislation did not alter the fundamental fact that he was hiring the labor for a fixed fee.

The standard setting process

One of the biggest complications to managing workplace safety is the issue of which government agencies handle which aspects of regulatory process. The answer isn't simply *OSHA*. There are at least three other government entities that influence the promulgation and enforcement of safety regulations.

The U.S. Department of Labor—OSHA's parent agency—is responsible for:

- developing and promulgating safety and health standards,

- inspecting and investigating work sites,

- enforcing standards and proposing penalties for violators, and

- collecting work injury and illness data.

The U.S. Department of Health and Human Services is responsible for:

- developing criteria for safety and health standards,

- carrying out research and development,

- establishing professional training and education programs, and

- keeping accident records and logs.

The Occupational Safety and Review Commission is responsible for:

- hearing employer cases contesting citations, penalties, and abatement periods,

- hearing employee cases contesting abatement periods, and

- affirming, modifying, or vacating orders.

Before OSHA can begin the rulemaking process it must first demonstrate that:

- the proposed standard will substantially reduce a significant risk of material harm;

- compliance is technologically feasible in the sense that the protective measures being required already exist, can be brought into existence with available technology, or can be created with technology that can reasonably be developed;

- compliance is economically feasible in the sense that industry can absorb or pass on the costs without major dislocation or threat of instability; and

- the standard is cost effective in that it employs the least expensive protective measures capable of reducing or eliminating significant risk.

OSHA can begin standard-setting procedures on its own, or in response to petitions from other parties which include the Secretary of Health and Human Services (HHS); the National Institute for Occupational Safety and Health; state and local governments; and nationally recognized standards producing organizations such as the American National Standards Institute (ANSI). In addition, employers, labor representatives, industry groups or individuals can petition OSHA to set standards.

Proposed safety standards must be compatible with existing OSHA regulations, policies and procedures.

Management, labor and individuals can all petition for standards

OSHA is also required to gather public comment from employers and other interested parties and consider that input when completing the rulemaking process.

If OSHA determines that a specific standard is needed, any of several advisory committees may be called upon to deliver specific recommendations. There are two standing committees to serve these purposes—and ad hoc committees may be appointed to examine special areas of concern to OSHA. These committees include members that represent management, labor and state agencies, the general public and HHS.

The two standing committees are: the National Advisory Committee on Occupational Safety and Health (NACOSH), which advises, consults with, and makes recommendations to the Secretary of HHS and to the Secretary of Labor on issues related to OSHA regulations; and the Advisory Committee on Construction Safety and Health, which advises the Secretary of Labor on regulatory issues pertaining to the construction industry.

Over the past few years, virtually every new OSHA regulation has faced legal challenges in the courts. As a result, OSHA has tried to reduce the number of legal petitions by inviting interested parties— "stakeholders" in bureaucratic jargon—into the rulemaking process from the very beginning. This trend is likely to continue.

As an employer interested in workplace safety, you can use the stakeholder approach to your advantage. As we've seen, OSHA's mission is creeping toward a more consultative relationship with regulated employers. Your input can impact the rulemaking process. Even more importantly, your input can give you contacts at your local OSHA office—contacts who are being encouraged to help you avoid problems.

NIOSH may also recommend that OSHA develop standards. NIOSH, which represents OSHA's science/research arm, conducts research on various safety and health problems and provides techni-

cal assistance to the agency. While conducting its research, NIOSH may make workplace investigations, gather testimony from employers and employees and require that employers measure and report employee exposure to potentially hazardous materials. NIOSH can also require employers to provide medical examinations and test to determine the incidence of occupational illness among employees.

Keep in mind that, when examinations and tests are required by NIOSH, it should foot the bill.

Once OSHA has developed plans to propose, amend or revoke a standard, it publishes these intentions in the Federal Register as a "Notice of Proposed Rulemaking," or often as an earlier "Advance Notice of Proposed Rulemaking."

An "Advanced Notice" is used when OSHA needs to solicit information essential to drafting a proposal. The Notice of Proposed Rulemaking includes the terms of the new rule and provides a specific time (at least 30 days from the date of publication, usually 60 days or more) for the public to respond.

Interested parties who submit written arguments and pertinent evidence may request a public hearing on the proposal when none has been announced in the notice. When such a hearing is requested, OSHA will schedule one, and will publish, in advance, the time and place for it in the Federal Register.

After the comment period and public hearings are concluded, OSHA must publish in the Federal Register the full, final text of any standard amended or adopted and the date it becomes effective, along with an explanation of the standard and the reasons for implementing it. OSHA may also publish a determination that no standard or amendment needs to be issued.

Under certain limited conditions, OSHA can issue emergency temporary standards that take effect immediately and remain in effect until replaced by a permanent standard. Typical scenarios in-

In certain cases, OSHA can issue emergency temporary standards

clude instances where OSHA determines that workers are in grave danger due to exposure to toxic substances or other significant hazards. Like its conventional rulemaking, OSHA must also publish all emergency temporary standards in the Federal Register.

The Federal Register is one of the best sources of information on standards, since all OSHA standards are published there when adopted—as are all amendments, corrections, insertions or deletions. The Federal Register is available in most public libraries, it is also available on the Department of Labor's computerized bulletin board service as well as on the Internet's World Wide Web.[1]

Each year, the Office of the Federal Register publishes all current regulations and standards in the Code of Federal Regulations (CFR). The CFRs are available at most libraries and from the Government Printing Office. OSHA regulations are collected in Title 29 of the CFR, Parts 1900-1999.

Where OSHA turns its attention

OSHA has concentrated its regulatory attention in heavy industries, such as manufacturing, construction, and oil and gas extraction. OSHA Administrator Joseph Dear claims that, between 1975 and 1993, injury and illness rates in these industries have declined significantly. In industries that received less enforced attention, such as wholesale trade, retail trade and the service industry (including health care), the rates went up.

Dear argues that his agency has done well when it identifies specific maladies to combat:

> OSHA's cotton dust standard has virtually eliminated brown lung disease, which used to plague workers in the textile industry. The lead standard has reduced the poisoning of workers in smelting plants and battery plants by two-thirds. In five years the grain dust standard reduced fatalities in grain elevators by 58 percent and reduced related injuries by more than 40 percent. OSHA's trenching standard

[1] See Appendix 4 for a list of electronic media sources for OSHA-related information. Annual subscriptions are also available from the Superintendent of Documents, U.S. Government Printing Office, Washington, DC 20402.

has helped reduce trenching fatalities by 35 percent since 1990.

The General Duty Clause

To assure the broadest application of the OSH Act, Congress relied upon the commerce clause, stating that every employer "affecting commerce" would be subject to the provisions of the law. This means that virtually every employer in industry, business and farming is covered if he employs one or more persons. It is estimated that OSHA covers more than 57 million workers in over 6 million workplaces.

The diversity of those six million workplaces makes it nearly impossible for OSHA to regulate specific industries or applications in such detail that any employer can simply review an OSHA standard and immediately understand what steps must be taken to meet compliance.

Instead, OSHA often issues broad based regulations leaving the employer to grapple with the specifics involved in eliminating hazards and maintaining a safe and healthful workplace. Just because OSHA doesn't recognize or specifically address a workplace hazard in its regulations doesn't mean you can't be cited for it. Welcome to the General Duty Clause.

When enforcing compliance, OSHA inspectors often cite employers under the General Duty Clause because the agency does not have a specific regulation that addresses a particular hazard in the workplace. Employers should note that any recognized hazard in the workplace, whether specifically addressed by OSHA or not, can be cited under the General Duty Clause. It is up to you, not OSHA, to identify and eliminate all existing and potential hazards.

These provisions of the OSH Act of 1970, commonly known as the General Duty Clause, appear as follows:

(a) Each employer

Any hazard— recognized by OSHA or not—can be cited

51

(1) shall furnish to each of his employees employment and a place of employment which are free from recognized hazards that are causing or are likely to cause death or serious physical harm to his employees;

(2) shall comply with occupational safety and health standards promulgated under this Act.

(b) Each employee shall comply with occupational safety and health standards and all rules, regulations, and orders issued pursuant to this Act which are applicable to his own actions and conduct.

As we've noted before, this Clause is important because it gives OSHA its broadest regulatory discretion. A multitude of sins can be dealt with under these words.

OSHA also requires that each employee comply with the Occupational Safety and Health Standards and rules, regulations and orders pursuant to the Act that are applicable to the employee's own actions and conduct.

However, no penalties or enforcement provisions are applied to an employee who does not comply with the law. Penalties only apply to the employer.

It's important to note that OSHA has a harder time enforcing workplace safety and health when, in lieu of a specific regulation, it cites employers under the General Duty Clause.

Although OSHA acknowledges that ergonomic hazards such as carpal tunnel syndrome significantly impact all industries, the agency has been unable to get a final ergonomics standard past the wary eyes of Congress, industry and labor groups who claim that there isn't enough definitive research available to justify a standard. As a result, OSHA continues to enforce ergonomic hazards through the use of the General Duty Clause with limited success.

Case in point: Beverly Enterprises is one of the largest nursing home chains in the U.S. with approximately 820 nursing homes. Employee com-

plaints from five Beverly nursing homes prompted OSHA to conduct inspections in 1990 and 1991.

The inspections revealed that nursing assistants at each of the facilities sustained numerous musculoskeletal injuries. OSHA officials cited each of the five nursing homes. Beverly contested the citations and the five cases were consolidated into one.

Because it lacks an ergonomics standard, OSHA charged Beverly with violating the General Duty Clause, and exposing employees to ergonomic hazards. Specifically, Beverly exposed employees to unsafe lifting hazards and other strenuous operations that caused or aggravated back injuries.

Keep in mind that it is more difficult for OSHA to win a case under the General Duty Clause than under a specific OSHA standard. To promulgate standards the agency must find that significant risks are present in the workplace and that these risks can be abated.

This applies to the General Duty Clause as well and the agency must meet the same minimal criteria as when promulgating a standard. However, the General Duty Clause is more restrictive and requires that the hazards be recognized by the employer.

Administrative Law Judge John Frye determined that OSHA must define the hazard in a way that would also provide instruction to Beverly on how to abate the hazard. Because back pain is a symptom widespread in the general population and it is difficult to trace its origins, Frye found that OSHA did not adequately define the hazard.

OSHA argued that epidemiological studies demonstrate that lower back pain and ergonomics injuries are more common in jobs involving heavy lifting. However, because the relationship between lifting and back pain is not known and existing research is made up of retrospective/cross-sectional studies, Beverly claims that the studies do not prove causation.

Nursing assistants had numerous musculoskeletal injuries

In fact one of OSHA's own experts testified that there are no definitive studies relating back pain among nurses to patient handling activities. Frye concluded that there is not any reliable epidemiological evidence that establishes lifting as the cause.

The court then looked at whether lifting is the cause of the specific injuries sustained by the nursing assistants. A doctor provided expert testimony on this point for OSHA. After looking at videotapes of assistants lifting and transferring residents and reviewing reports of another OSHA expert, the doctor testified that he believed that the lifting or transferring causes, aggravates, or precipitates pain in the back, shoulders, and neck of the nursing assistants.

Frye found that the doctor's opinion stated nothing more than the obvious and did not demonstrate a significant hazard. Beverly then pointed to the fact that none of the medical experts could say with reasonable medical certainty that the injuries claimed were caused by their job tasks.

Frye concluded that the medical testimony only showed that the injuries could have been caused by work related incidents but didn't identify lifting practices that cause injuries.

OSHA did not define the lifting hazard in a way that would instruct Beverly as to its obligations or identify practices that it could reasonably be expected to control. OSHA did not demonstrate that a significant hazard exists, as defined by the General Duty Clause.

Frye emphasized that because the hazard is so subjective in nature, science is unable to describe it objectively or in quantifiable terms. Thus, OSHA did not meet its burden and Frye vacated the five serious violations under the General Duty Clause.

OSHA's authority to use the General Duty Clause to cite employers has also been challenged in two significant cases before the OSHRC. In both cases the citations were vacated because OSHA failed to meet its own criteria for establishing a violation under the OSH Act.

In order to establish a violation under the General Duty Clause, OSHA must prove that:

- a condition or activity in the employer's workplace presented a hazard to workers;

- the cited employer or the employer's industry recognized the hazard;

- the hazard was causing or likely to cause death or serious physical harm; and

- feasible means existed to eliminate or materially reduce the hazard.

In the first case, OSHA cited a company operating nursing homes for failing to offer its employees hepatitis B vaccinations before they were exposed to the virus.

The company, ARA Living Centers, argued that its use of universal precautions and post-exposure vaccination was just as effective as providing the vaccines to workers before exposure to HBV. ARA also argued that the risk of HBV in the nursing home industry was too small to prove that the hazard would lead to death or serious injury.

An administrative law judge vacated the citations on the grounds that OSHA did not establish that the HBV hazard could be materially reduced by requiring the vaccine to be offered to workers before exposure instead of after.

The judge also ruled that HBV was not a recognized hazard in the nursing home industry.

OSHA requested a review of the decision but the OSHRC also vacated the citations. Although the commission disagreed with the judge's opinion that HBV was not a recognized hazard in the nursing home industry, it did agree that OSHA did not establish that pre-exposure vaccinations would significantly reduce the hazards.

When a vaccine is administered before an exposure to HBV, it is 90 to 95 percent effective in preventing the onset of the disease. When administered post-exposure, the vaccine has an effectiveness rate of 95 percent.

A nursing home failed to offer employees vaccinations

A cookie maker is fined $1.4 million for willful violations

ARA estimated that it would have to spend close to $150,000 to vaccinate all eligible workers at both cited nursing homes. The commission held that it was impossible to determine whether the nursing homes could absorb those costs without creating a financial hardship.

It found that:

> ...given that there are no significant benefits to be gained by requiring that the vaccine be given prophylactically, rather than post-exposure, the record fails to demonstrate that the substantial cost of providing the vaccine to all employees who might be exposed to blood was reasonable or practical.

> [OSHA] failed to fulfill the burden of establishing that it was economically feasible for ARA to have made the HBV vaccination available to their employees on a pre-exposure basis.

You can defend yourself against a citation under the General Duty Clause by proving that the abatement methods you use are just as effective as the ones suggested by OSHA.

In the second case, OSHA cited Pepperidge Farm, Inc. under the General Duty Clause for failure to abate repetitive stress hazards.

The agency slapped the cookie maker with almost $1.4 million in proposed penalties for 389 instances of alleged willful violations including ergonomic hazards and record-keeping infractions.

The judge affirmed 176 of the 179 willful record-keeping violations as well as 21 of 27 repetitive lifting violations cited under the General Duty Clause. But he vacated the remaining six repetitive lifting violations and 175 willful violations for cumulative trauma disorders (all cited under the General Duty Clause).

The judge ruled that since OSHA did not have an ergonomics standard it could not require employers to abate repetitive stress hazards without specific regulations to guide them.

Although, OSHA has the right to use the General Duty Clause to control repetitive stress hazards, the judge held that in this case, the agency only met the first three elements necessary to justify its use.

OSHA failed to prove that feasible means existed at the time of the inspection to abate or significantly reduce the hazard.

Current research on the causes and control of ergonomic injuries remains incomplete. It's safe to say that OSHA can't provide a feasible solution for employers to abate all existing ergonomic hazards without first gathering a consensus from the science and medical communities.

Until that time, the review commission decision will severely curtail OSHA's ability to cite ergonomic violations under the General Duty Clause.

Protecting us from the protectors

Certainly, one of the most potent weapons OSHA uses when it goes into combat is its egregious penalty authority. However, the mid-1990s have seen some restraint applied—even from within the regulatory system—to the use of these weapons.

In the 1995 OSHRC case *Secretary of Labor v. Arcadian Corp.*, the commission ruled that the agency's attempt to cite a Louisiana fertilizer manufacturer 87 times for each employee exposed to the same hazard was inconsistent with the intent of the Occupational Safety and Health Act of 1970.

In July 1992, OSHA inspectors launched an investigation of Arcadian, when an after-hours explosion destroyed the facility and injured three employees and four non-employees.

OSHA cited Arcadian for 87 separate willful violations of its General Duty Clause. The fertilizer company was cited for each employee exposed to the conditions that led to the explosion. OSHA proposed penalties of $5,000 for each exposed employee, amounting to $4,350,000 in total.

Ergonomic standards remain incomplete

The Feds use the General Duty Clause as a catch-all rule

Arcadian appealed, arguing that the citations should be vacated because they are identical and constitute only a single violation of an employer's duty under the Clause.

Administrative Law Judge Stanley Schwartz agreed, concluding that citing Arcadian for each employee's exposure was "inappropriate." Schwartz reduced the penalty to $50,000. OSHA appealed to the OSHRC.

Historically, the OSHRC had upheld use of OSHA's egregious penalty authority. The commission had previously held in several cases—including an infamous case involving tractor-maker Caterpillar, Inc.—that OSHA had authority under some standards and regulations to cite separate instances of noncompliance as separate violations of the OSH Act.

However, the *Arcadian* case was the first time the commission had ruled on the legality of citing employers under the GDC for individual employee exposures.

The case was important because OSHA uses the General Duty Clause as a catch-all violation to cite employers in cases where a workplace hazard is not specifically addressed by a particular OSHA standard. The primary issue for the OSHRC in the *Arcadian* decision: Can OSHA cite an employer under the General Duty Clause for the condition that led to the hazard or the number of employees exposed to the hazard?

The commission first looked at Congress' intent in formulating the OSH Act. OSHA argued that in the statute, Congress referred to protecting employees as individuals. The commission refuted this argument by stating that OSHA was taking words out of context.

More importantly, the OSHRC concluded that throughout the OSH Act Congress referred more frequently to employees as a group. The commission then found that the legislative history of the General Duty Clause did not support OSHA's claim.

The Clause required that each employer provide "to each of his employees" employment free from recognized hazards. The OSHRC claimed that Congress did not specifically address whether the phrase allowed citations on an individual basis. The commission reasoned that, if Congress intended to allow citations on a per exposed employee basis, it would have discussed the matter.

OSHA argued that Congress had approved the per exposed employee citation policy in the Omnibus Budget Reconciliation Act of 1990. The Omnibus bill raised the maximum penalty for willful and repeat violations to $70,000 and established a $5,000 minimum penalty for willful violations.

The OSHRC held that this was not evidence of congressional intent, since neither the legislative history nor the Omnibus bill expressly endorses the egregious penalty citation policy in question.

The commission then considered whether the agency's construction of the statute is "reasonable." In determining reasonableness, the commission looked at OSHA's history of interpreting General Duty Clause citations. In its twenty years of existence, OSHA never cited a separate violation of the General Duty Clause for each exposed employee. However, the agency had issued separate GDC citations for separate hazards relating to the same event or area in fines against Caterpillar, Inc., that had been considered in an earlier case.

In that ruling, the commission had stated, "The test of whether the Act and the cited regulation permits multiple or single units of prosecution is whether they prohibit individual acts, or a single course of action."

The commission considered the fact that only one workplace hazard at Arcadian led to the explosion—not 87 different events.

Lastly, the commission noted that it is its role— and not OSHA's—to settle statutory issues. The OSHRC did not need to defer to OSHA's interpretation on this, or any other, statute. Moreover, the commission decided the appropriateness of the

A reform bill raised the maximum penalty for willful violations

penalties involved because this review fell within its statutory authority.

The OSHRC can issue a single, combined penalty even when OSHA cites an employer for more than one violation. Thus, the commission majority agreed that "the 87 citations were duplicative and the conditions causing the explosion constitute a single violation under the General Duty Clause."

Because it represented a novel question of law never before considered, the commission sent the *Arcadian* case back to the administrative law judge. The commission then directed the judge to give OSHA the opportunity to amend the citations.

Chapter 3
How OSHA Selects Companies to Inspect

Introduction

One of the important mysteries of how OSHA operates is the method by which it picks the companies it's going to inspect. Like so much else about the agency, the inspection selection process is one that could only be developed in a bureaucratic culture. It follows a framework that means to be fair and effective. However, it ends up being complicated, arbitrary and of questionable effectiveness.

Traditionally, OSHA targeted employers for inspections using a priority system. The first priority was given to reactive inspections, initiated by reports of imminent danger, reports of fatalities or catastrophes, media referrals and employee complaints. Second priority was given to scheduled inspections—those initiated solely by OSHA. Scheduled inspections were primarily determined by examining high rates of worker injuries, and employer history of noncompliance.

However, in recent years, OSHA has acknowledged the shortcomings of its own methods for targeting inspections and has begun to make changes designed to go after those employers and industries that pose the greatest threat to worker safety. Understanding that its limited resources and manpower make it extremely difficult to inspect most workplaces unless prompted by an employee com-

plaint or a major catastrophe, OSHA has taken several steps in the last few years to assess your safety and health programs—without sending an OSHA inspector.

How do they do it? By compelling you to submit written safety and health programs, workers' compensation data, and injury and illness records.

OSHA inspection strategies for the 90s

In early 1994, the agency decided to forgo Bureau of Labor Statistics annual injury and illness survey to target high hazard industries for inspections—those perceived to pose the greatest threat to worker health and safety. OSHA opted to rely upon its own inspection and citation data gathered on its Computerized Integrated Management Information System (IMIS). The agency also began to examine statistics and data taken from state workers' compensation agencies.

OSHA prioritizes safety and health inspections in high hazard industries by analyzing those industries within Standard Industrial Classification (SIC) codes with a previous history of serious safety and health violations.

Each year, OSHA generates an inspection priority list of the top 200 safety and 200 health industries by ranking the industry's number of serious violations per inspection.

OSHA derives its figures by dividing the number of serious violations for the previous three calendar years in the industry by the overall number of inspections conducted in that industry.

The lists are sent electronically to the agency's regional offices at the beginning of each fiscal year.

OSHA's inspection plan for non-manufacturing businesses entails the generation of a list randomly selected from industries with SIC codes in the ranges 0100 through 0799 and 4000 through 8999.

OSHA will generate an inspection register that will determine which establishments are scheduled for inspection during the current fiscal year.

Keep in mind that under the agency's inspection targeting strategy for high hazard industries, even if your worksite has ten or fewer employees—you could still face an OSHA inspection, if you are part of a larger employer.

Inspectors have also been granted greater decision-making authority when conducting inspections in the field. In the past, inspectors were mandated to review injury and illness records, employer's hazard communication and lockout/tagout programs, make an evaluation of the safety and health management program and perform a brief walkaround inspection to identify hazards. In an effort to streamline its inspection process, OSHA now allows compliance staff to exercise their discretion in choosing which components of an employer's safety program is reviewed.

Also in 1994, OSHA implemented its "Focused Inspections in Construction"—a program designed to encourage construction employers to take the initiative to develop strong safety and health programs on their own. Where OSHA compliance officers found an effective program onsite, the agency conducted an abbreviated inspection. This inspection was limited to the top four hazards that kill workers in the construction industry: falls from heights, electrocution, crushing injuries, and being struck by material or equipment.

In cases where the safety and health program was ineffective or didn't exist, OSHA conducted a complete site inspection—increasing the odds significantly of uncovering some violations. The success of the focused inspection program for construction has prompted OSHA to expand it to other industries—including general industry.

Perhaps the biggest change in OSHA's inspection strategies is the implementation and expansion of its "Maine 200" program.

Focused inspections in the construction industry

OSHA monitors by means of reporting and random inspection

In 1993, OSHA experimented with a new workplace safety and health program in the state of Maine. Using employer-specific data, OSHA found the 200 employers with Maine's highest number of workplace injuries and illnesses. The 200 companies represented only 1 percent of the state's employers and 30 percent of Maine's workers, but accounted for 45 percent of the states workers' compensation injuries and illnesses.

Each employer had a choice: either participate in the program or take your chances with OSHA's traditional enforcement program. OSHA requested that each participant develop a comprehensive safety and health program that addressed the hazards responsible for causing the injuries and illnesses at each workplaces.

Those who complied were given a significantly lower priority for inspection and a high priority for technical assistance. OSHA requested that each program include committment from management, employee involvement, worksite analysis, hazard prevention and control, and worker training.

OSHA monitors the performance of the safety and health programs through regular reporting and random inspections.

Although OSHA received criticism that the Maine 200 program was nothing more than a "paper program"—meaning employers only had to have an effective safety and health program on paper to pass muster with OSHA—the agency expanded the program to Massachusetts, Wisconsin, New Hampshire and Missouri. In fact, Joe Dear plans to expand the program nationally, and will select potential participants by collecting data directly from employers.

OSHA focuses its selection process on either health issues or safety issues. This isn't any surprise. The unexpected complexity arises when you consider the details of these processes.

Scheduled inspections

OSHA's policy on programmed safety and health inspections is that they are based primarily in high hazard industries. In the area of safety, OSHA considers a high hazard industry to be one within a Standard Industrial Classification (SIC) with a national lost workday injury and illness rate among the highest 200 as published by the Bureau of Labor Statistic in 1992.

In the area of health, OSHA considers a high hazard industry to be one with a previous history of OSHA health citations.

Keep in mind that OSHA considers the construction, maritime, logging, gas and oil extraction industries to also be high hazard industries.

Recent changes in the scheduling of programmed inspections will increase the odds of inspection for those businesses operating within the top 100 industries for health and safety hazards.

To target employers for programmed inspections OSHA develops a list of the top 200 high hazard industries and a list of businesses that fall within those classifications.

Under this system, businesses are removed from inspection lists if they underwent a complete health and safety inspection within the last five years.

In comparison with injury incidence rates, illness incidence rates—as derived from the Bureau of Labor Statistics annual survey of occupational injuries and illnesses—do not reflect the health hazards that may exist in the workplace.

The following excerpts from OSHA's Compliance Directive 2.25I—Scheduling System for Programmed Inspections provide additional insight into the methods OSHA uses to target businesses for programmed inspections:

200 industries qualify as "high hazard"

Useful insight into how local OSHA offices work

...Regional Administrators and Area Directors shall ensure that the policies and procedures established in this instruction are transmitted to all Area and District Offices, and to appropriate staff members.

As you'll see throughout OSHA directives and compliance rules, the Regional Administrators and Area Directors have a great deal of discretion in who gets inspected. Depending on the industry and part of the country you're in, you may be able to cultivate what the regulators call a "consultative" relationship with these people. In recent years, these ongoing contacts have been encouraged by OSHA—they can provide useful insight into how the local OSHA operations work.

...For safety, national BLS Lost Workday Injury and Illness data are used to rank industries at the 4 digit SIC Level. The data are for Calendar year 1992, the most recent that BLS has published. National data are used because BLS no longer supplies OSHA with the state data.

...For safety and health, deletion criteria is extended to 5 years for a complete inspection. Previous deletion criteria was 2 years for safety and 3 years for health.

...For both safety and health, establishment lists are in random order and contain all the establishments in the top 200 industries. The establishments in the top 100 industries are given two chances to rank high on the list. That is, for safety, all the establishments within the 200 industries with the highest lost workday injury and illness rates are placed in random order with the top 100 industries twice as likely to rank high. For health, all establishments within the 200 industries ranked by serious health violation per inspection are placed in random order with the top 100 industries twice as likely to rank high. The establishments are selected for inspection in this random order.

SIC codes make up the structure of OSHA's regulatory apparatus. As you can see, within the SIC

codes deemed high-risk, companies—called *estab-lishments* throughout OSHA literature—are more likely to be chosen for surprise inspection.

> ...Small employers that are part of another em-ployer are included on the lists. Some employ-ers with sizable employment appear on the Dun and Bradstreet (D&B) list as having no employ-ment. This is because some corporations re-port corporation employment to Dun and Bradstreet and do not separate the employment by worksite. The small employers will have a small employer deletion code of "TO" which needs to be removed if the employer is to be inspected.

Although all employers are subject to OSHA rules, the agency only spot inspects employers with 11 or more workers in one location. For this reason, the agency uses a special code for removing small employers from the inspection lists.

> ...Scheduling System for Programmed Inspec-tions provides general guidelines to the Regional Administrator and Area Director in planning compliance operations and related activities and instructions for their implementation.

> ...The primary consideration in conducting compliance operations is the attainment of maximum effective inspection coverage.

> ...A programmed inspection generally is a com-prehensive inspection of the worksite but may be limited as necessary in view of resource avail-ability and other enforcement priorities such as focused inspections. (Low hazard areas, such as office space, may be excluded from inspec-tion without affecting the comprehensiveness of the inspection.)

In OSHA jargon, *programmed inspection* means a surprise inspection. The process of selecting com-panies to be inspected is referred to as the agency's *targeting process.*

> It is OSHA policy that inspections conducted as programmed inspections be primarily in the "high hazard" sectors of employment.

OSHA only spot inspects employers with more than 10 workers

Other reasons your industry might count as "high hazard"

In the area of safety, the Agency considers a "high hazard" industry to be one within a Standard Industrial Classification (SIC) code with a national lost workday injury and illness rate among the highest 200 as published for calendar year 1992 by the Bureau of Labor Statistics (BLS) at the 4-digit SIC level. The 1992 data are the most recently published data by BLS.

In the area of health, the agency considers a "high hazard" industry to be one with a previous history of serious OSHA health citations.

There are other ways in which your industry might be considered a high hazard. As discussed earlier, construction and maritime operations are considered to be categories of high hazard. Other specific industries—such as logging, and oil and gas extraction—are also high hazard industries and are frequently scheduled for inspection as special emphasis programs (which we'll see more about later).

Both programmed safety inspections and programmed health inspections are scheduled using a multiple-step process.

The initial selection of a particular category of employment (e.g., Federal Agency, high rate general industry, construction, maritime, or high hazard health) is made with current agency policy and with actual members of planned inspections taken from the annual Field Operations Program Plan projections made at the Area Office level, reviewed at the Regional and National Office levels and approved by the Assistant Secretary.

Within a category, establishments are grouped by some criteria—such as industry—and priority is established by grouping. Within the grouping, establishments are selected for inspection and placed in an inspection cycle.

...For General Industry safety, the priority is based on the Lost Workday Injury and Illness Rate by industry and the list of establishments within these industries will be provided by the National Office.

...For General Industry health, the priority is based on the number of serious health violations per health inspection by industry and the list of establishments within these industries will be provided by the National Office.

...For Construction, the universe of active construction sites is maintained by the Construction Resource Analysis (CRA) group at the University of Tennessee. Each month CRA randomly selects active worksites for inspection. Each area office receives the list from CRA and the OSHA Construction Inspection Reports for each site from F. W. Dodge.

...For Low Rate Manufacturing and Non-manufacturing safety, the National Office supplies a list of establishments randomly selected from those available in each category and the Planning Guide software randomly selects the number needed from this list based on a 90/5/5 split among high rate manufacturing/low rate manufacturing/non-manufacturing.

...Where no establishment list is provided by the National Office (e.g., maritime and logging categories), the Area Director shall compile a complete list of active establishments (worksites) considering all establishments (worksites) within the coverage of the office and using the best available information (commerce directories, commercial telephone listings, local permits, local knowledge, etc.). From this list worksites for inspection will be selected randomly.

This, in relatively few paragraphs, is the heart of how OSHA weights its selection system for surprise inspections. If you're in one of the top SIC codes, you're at least twice as likely as other high hazard companies to be inspected.

Some business people are struck by how out-of-date OSHA information sometimes is. The *best available information* isn't always current. However, don't count on this information lag to protect you. The regulators tend to be inexact—

Questions about the "best available information"

misclassifying an SIC code—more often than they are completely uninformed.

Programmed inspections shall be conducted jointly by both safety and health personnel whenever resources are available and it is likely, based on experience in inspecting similar workplaces, that both safety hazards and health hazards exist to a significant degree. If an inspection is begun as safety only or as health only but the CSHO determines during the course of the inspection that it should be expanded, the CSHO shall make a referral as appropriate.

NOTE: Establishments which appear on both the safety and health registers should be scheduled for a joint safety/health inspection whenever practicable.

As we've seen, OSHA can inspect your worksite for both safety and health issues. As you might guess, the agency tries to combine the inspections whenever it can.

The following procedures are to be adhered to in programming General Industry safety and health inspections.

...The National Office shall provide each Area/District Office with a Statewide Industry Rank Report (SIC List), listing industries by their 4-digit Standard Industrial Classification (SIC) codes where available. These lists are sent electronically at the beginning of each fiscal year. Ranks are assigned based on the priority criteria described above.

The Safety SIC List is a statewide listings of industries with the highest Lost Workday Injury and Illness Rates.

The Health SIC List is a statewide listing of industries with high average numbers of serious (willful and repeat) health violations per inspection. A list is provided with the top 200 health industries ranked by the industry's average number of serious health violations per inspection. The average number of serious health vio-

lations per inspection is calculated by dividing the number of serious health violations for the previous five calendar years in the industry by the number of health inspections conducted in the industry. Two lists are provided, one in SIC order and the other in serious health violations per inspection order from highest to lowest.

OSHA's headquarters in Washington clearly keeps a tight rein on the lists of companies to be inspected. This serves two purposes: First, it allows enforcement priorities to be centralized on a national level; second, it prevents local offices from being influenced excessively by local interests.

...The National Office will also provide a series of establishment lists (in random order)...for use by the Area Office in programming inspections. These lists are provided electronically when needed.

...The establishments are placed in random order...using the following procedure. Each establishment in the top 200 industries is assigned a random decimal number between 0 and 1. Establishments in industries ranked 1 to 100 are given two random numbers with the larger number selected and assigned to the establishment. The list is sorted from largest to smallest random number. The resulting establishment list is in random order with the establishments in industries in the top 100 given two chances to place high on the list.

...Because the existing software...is limited to three-digit rank values, any establishment list with more than 999 establishments is renumbered, with the result that more than one establishment may share the same rank number. For example, on an establishment list of 2400 establishments, the first three establishments will be given rank value "1", the second three establishments given rank value "2", and so on. The rank value...will be used for the random ordering of the establishment list.

A consistent level of randomness is the goal

Bureaucratic random number lists

In the past, the rank value had been used to provide a reference to the Industry rank report. The planning guide software will randomly select when there are firms of the same rank and not all are selected.

Here is a fine example of bureaucracy at work: A wordy policy on the random selection of companies to be inspected. A consistent level of randomness is the goal—and probably a good one, however ironic it might sound.

Elsewhere in its guidelines, OSHA takes the random-selection process to absurd extremes, though.

The three lists of random numbers provided are designed to order randomly a list of firms which contains 1,000 or fewer firms. A larger list of random numbers will be supplied upon request.

The following tables have been produced by ordering the integers from 1 to 1,000 randomly and displaying the results in three lists corresponding to establishment list size.

The procedure to be used is as follows:

1) Make all modifications to the establishment list.

2) Number the establishment list sequentially; i.e., assign "1" to the first firm on the list, "2" to the second, etc.

3) Select the smallest random number table with more numbers than firms on the establishment list; e.g., for 110 firms, select list two.

4) Cross out all numbers on the random number list that have been selected which are greater than the number of firms on the establishment list.

5) Include all firms in the inspection cycle whose sequence number is listed in column I. If the size is larger than the size of column I, start at the top of column II and select enough numbers to fill out the inspection cycle.

6) Draw a line after the last random number

used; this will be the starting point for the next inspection cycle.

Example: Suppose there are 70 firms on the establishment list and an inspection cycle containing 12 firms is needed. Random number list one is selected and all numbers greater than 70 are crossed out. The first inspection cycle would then contain firms with the following sequence numbers: 64, 18, 16, 22, 47, 14, 39 51, 38, 67, 24 and 1. Draw a line under the number 1 and start the next cycle with the numbers 5, 33, 11, on down Column II.

This may sound ridiculous, but that's not the end. Things get even more complicated, as OSHA's headquarters tries to keep control of the random process.

A list of establishments located within the Area/District Office jurisdiction for each SIC code on the High Rate SIC List (the top 200 safety industries) will be provided by the National Office as available to all Area/District Offices. This list will be in random order. The list is divided into four sublists and made available electronically to all Area/District Offices.

...A list of randomly selected establishments in industries not included in the top 200 safety industries located within the Area/District Office jurisdiction will be provided by the National Office to all Area/District Offices. A randomly selected pool of these establishments is included in each sublist of establishments made available electronically to all Area/District Offices.

...A list of establishments located within the Area/District Office jurisdiction for each SIC code on the Health SIC List will be provided by the National Office to all Area/District Offices. This list will be in random order. The list is divided into four sublists and made available electronically to all Area/District Offices.

...The lists are in random order. No additions should be made to the lists. When an estab-

The grounds for not being on a random inspection list

lishment is identified for addition to the list, it should be sent to the National Office for inclusion in next year's list.

OSHA guidelines also include conditions under which an employer can be removed from an inspection list. These conditions can serve as a kind of evasion audit. If any of them are true for you, you shouldn't have any surprise inspections from OSHA. The conditions include:

- Consultation—Establishment has been approved for exemption from inspection through consultation.

- Health inspection—A substantially complete or focused health inspection was conducted within the current or previous five (5) fiscal years with no serious violations cited; or, where serious violations were cited, an acceptable abatement letter or a follow-up inspection has documented 'good faith' efforts to abate all serious hazards.

- Incorrect SIC code—The correct SIC code for the establishment is not on the current Safety High Rate SIC List or the current Health SIC Lists. This deletion also applies when the correct establishment SIC code is not on the Low Hazard SIC List when used for scheduling....

- Safety inspection—Any comprehensive programmed or focused safety inspection or a substantially complete unprogrammed safety inspection conducted within the current or previous five (5) fiscal years.

- Ten or fewer employees—Establishments with no more than 10 employees at any time during the previous 12 months. Establishments with 10 or fewer employees and are part of larger employers will be included in the employer lists supplied by the National Office.

- Voluntary protection program participation approved. Establishment has been approved to participation in the voluntary protection program.[1]

[1] For a more detailed discussion of voluntary protection programs, see Chapter 10.

Once the random lists have been sent to the local offices and all appropriate deletions have been made, OSHA has its *registers*—the actual lists of companies to be inspected. These are the lists that most employers would rather avoid.

After all the appropriate changes are made, the Area Office inspection registers shall be made up by determining which establishments are to be scheduled for inspection during the current fiscal year. The number of projected programmed inspections is taken from the revised OSHA-146 Form (OSHA-146 EZ). This number shall be adjusted to reflect the number of planned inspections in each category that are expected to be done in the next year. The number of carryover establishments shall be subtracted to determine the number of establishments required to meet the projected number.

The General Industry Safety Inspection Register shall consist of the following elements:

a) Up to five percent of the total number of projected programmed high hazard safety inspections to be conducted shall be scheduled from the Low Hazard Establishment List;

b) Up to five percent of the total number of projected programmed high hazard safety inspections to be conducted shall be scheduled from the Non-manufacturing Establishment List (...*up to five percent* should be read to mean up to, but not exceeding five percent. If, for example, the total number is 50, five percent would be 2.5, but only 2, not 3, establishments should be inspected.);

c) Ninety percent of the total number of projected programmed high hazard safety inspections shall be selected in random order from the High Hazard Establishment List, for the purpose of inspection scheduling.

The Health Inspection Register shall consist of the total number of projected programmed health inspections selected in random order from the Health Establishment List.

Registers are maintained for three years after inspections

Inspection cycles usually last 10 to 12 months

The inspection registers, together with adequate documentation on all additions, deletions, or other modifications, shall be maintained in the Area Office for 3 years following their completion.

Next, the inspectors move to an *inspection cycle*—a group of worksites which have been selected for inspection. The cycle has two characteristics: 1) once started all worksites within the cycle must be inspected, and 2) the worksites within the cycle can be inspected in any order.

Ideally, the size of the cycle should be such that all establishments will be inspected during the course of the fiscal year and there would be no carry-over. It is best to estimate a cycle size of sufficient size to last 10 to 12 months. If the cycle is not large enough to cover the entire fiscal year, when it is about to be finished another cycle can be chosen that is of a size to cover the balance of the fiscal year. The next year's cycle will be selected from next year's register which will have refreshed data.

...Within a cycle, establishments may be scheduled and inspected in any order that makes efficient use of available resources.

Each inspection cycle shall be completed before another cycle is begun. The only exceptions are as follows:

a) An establishment may be carried over to another cycle if the establishment is not operating normally because of strikes, seasonal fluctuations, or other factors.

b) An establishment may be carried over to another cycle if necessary equipment or personnel with necessary experience and qualifications to perform the inspection are not presently available.

c) An establishment may be carried over to another cycle if it is the last remaining establishment in a cycle, its inspection would require travel in excess of 50 miles and it cannot be combined with other inspection activity.

d) An establishment may be carried over to another cycle if the employer has not yet completed abatement action required as a result of a previous comprehensive OSHA inspection of the same inspection type (safety or health) because the final abatement date has not yet come.

e) An establishment may be carried over to another cycle if the employer has contested a citation item issued as a result of a previous OSHA inspection and the case is still pending before the Review Commission.

f) An establishment may be carried over to another cycle if the inspection cannot be completed due to the employer's refusal to allow the entry.

g) An establishment may be carried over to another cycle if the inspection must be deferred because of the presence of a consultant at the worksite or because the establishment has applied for participation but has not yet been approved in the Inspection Exemption through Consultation Program or a Voluntary Protection Program which carries a temporary exemption from inspection.

h) Approval for carrying over an establishment for reasons not listed above must be requested from the Regional Administrator and approved by the Director, Office of Field Programs.

The issue of carry-over is an important one—and not just for OSHA managers trying to incentivize the maximum number of inspections. Some companies have tried to argue that being kept on a cycle or register for too long is an unfair practice. These rules are designed to keep the lists moving.

...Once the inspection cycle itself begins, the following policy shall guide deletions:

1) An establishment shall be deleted from an inspection cycle whenever one of the criteria for deletion becomes applicable. For example, an establishment may be out of business or inactive.

A private-sector
contractor
provides a lot of
safety data

2) Where it is learned only after the compliance officer has arrived at the establishment that one of the criteria for deletion applies, the inspection shall not be conducted (or continued if already begun). Citations for the completed portion of the inspection shall still be issued, unless the establishment has fewer than 11 employees and the SIC code is exempted.

3) If the CSHO learns after arrival that the establishment has been classified in the wrong SIC code, but the correct SIC is on the safety or the health SIC list, the CSHO shall conduct the inspection at that time. Otherwise, the inspection shall be deferred.

How construction sites are chosen

Due to the mobility of the construction industry, the transitory nature of construction worksites and the fact that construction worksites frequently involve more than one construction employer, OSHA inspections are scheduled from a list of construction worksites rather than construction employers.

The National Office will provide to each Area/District Office a randomly selected list of construction projects from all covered active projects. This list should contain the projected number of sites the office plans on inspecting in the next month.

...OSHA has contracted with F.W. Dodge and the Construction Resources Analysis (CRA) group of the University of Tennessee. Each month F.W. Dodge will provide to CRA information on construction projects which are expected to start in the next 60 days.

CRA adds to the Dodge data a time period when each project is active and maintains a file containing all active construction projects. From active construction projects, CRA will generate monthly for each Area Office a randomly selected construction inspection list based upon:

1) Counties located within Area Office boundaries;

2) Estimated number of worksites to be inspected during the monthly scheduling period (to be determined by the Area Director);

3) The selection criteria are to be determined by the Area Director based on local conditions, approved by the Regional Administrator, and provided to CRA for entry into the system. These selection criteria may be designed to include any class of worksites within the computerized selection process. Some examples of such criteria are:

a) A minimum dollar value of the construction project.

b) Specific stages of construction project (in percent complete).

c) Specific types of construction projects.

...Normally, no site shall be selected for inspection more frequently than once per trimester. Therefore, CRA will remove from its master files any project selected for an inspection for a period of four months and reenter it in the fifth month if it is still active. Thus, if a list is not used, CRA should be notified so those sites will be returned to available status.

...The scheduling period (cycle) for construction inspections shall be one calendar month. Each month, each Area Office will receive its programmed construction inspection list from CRA. Within the following 10 days it will receive the OSHA Construction Inspection Reports corresponding to the sites on the inspection list.

...All sites on the inspection list shall be inspected, and the sites can be scheduled in any order to make efficient use of resources.

...The Area Office shall make no deletions from the inspection list, except where the Area Director documents that:

Selection criteria are based on local conditions

a) Little or no construction activity at a worksite on the list has begun or construction activity has already been substantially completed before an inspection can be made.

b) A worksite has become ineligible for any reason; e.g., where a substantially complete inspection of the worksite has been conducted as a result of a complaint investigation.

c) A worksite has been approved for exemption from inspection through consultation or for participation in the voluntary protection program.

...By the middle of each cycle, the Area Director shall assess progress in inspecting all sites on the list in order to plan resources for the following cycle.

The Area Director shall be responsible for maintaining documentation of the construction inspection list and for ensuring that selection criteria are current and appropriate.

No separate scheduling method is applied for programmed construction health inspections. Rather, the Area Director shall determine which construction inspections are to be conducted as a joint inspection where serious health hazards are likely to exist at the site. A local emphasis plan may be submitted and approved for scheduling health construction inspections.

Special Emphasis Programs

Special Emphasis Programs provide for programmed inspections of establishments in industries with potentially high injury or illness rates which are not covered by the scheduling systems outlined above or, if covered, are not addressed to the extent considered adequate under the specific circumstances present. Special Emphasis Programs may also be used to set up alternative scheduling procedures or other departures from national procedures. They include National Emphasis Programs and Local Emphasis Programs.

...The description of and the reasons for specific National Emphasis Programs will be set forth in appropriate instructions or notices as the occasion arises. Local Emphasis Programs may be developed by the Area Office or by the Regional Office, depending on the matter addressed.

The description of the particular Special Emphasis Program shall be identified by one or more of the following:

a) Specific industry.

b) Trade/craft.

c) Substance or other hazard.

d) Type of workplace operation.

e) Type/kind of equipment.

f) Other identifying characteristic.

The reasons for and the scope of a Special Emphasis Program shall be described and may be limited by geographic boundaries, size of worksite, or similar considerations.

National or local pilot programs may also be established under Special Emphasis Programs. Such programs may be conducted for the purpose of assessing the actual extent of suspected or potential hazards, determining the feasibility of new or experimental compliance procedures, or for any other legitimate reason.

The following guidelines apply in scheduling Special Emphasis Program inspections:

- Certain Special Emphasis Programs identify the specific worksites and/or industries that will be inspected; therefore, the only action remaining to be taken is the scheduling of inspections.

- Other Special Emphasis Programs identify only the subject matter of the program and contemplate that not all worksites within the program will necessarily be inspected.

- If no special worksites are identified within the program, the Regional Administrator or the Area Director shall use available information

to compile a worksite list.

- Where no procedures for selecting worksites for inspection are specified by the National Office, the Regional Administrator or the Area Director, the selection procedures should be random....Other selection procedures shall be submitted for approval to the Director of Field Operations through the Regional Administrator.

OSHA policy requires the Regional Administrator to evaluate any Special Emphasis Program approved for inspection within the Region. This evaluation consists of a report of the program's successes and difficulties in accomplishing its identified goals. Every program submitted for approval must contain a program evaluation element.

The Agency may develop programs to cover special categories of inspections which are not covered under the planning guide or under Special Emphasis Programs. An example: In the early 1990s, migrant farm worker camp inspections were designated as such a program.

Congress may place exemptions and limitations on OSHA activities through the annual Appropriations Act. Refer to current OSHA Instructions for guidelines on how to apply current exemptions and limitations to compliance programming.

Health inspection plan

OSHA establishes priority for industries in scheduling programmed General Industry health inspections on the basis of the previous inspection experience of the industry. The agency assumes that industries for which OSHA has found a high number of serious, willful and repeat health violations in the establishments that were inspected have the greatest potential for health problems in those establishments not inspected.

The agency uses violation data from all inspection types except follow-up inspections. Since the majority of OSHA's inspections are not programmed, the system is not inbred and most of

the data used are the results of unprogrammed inspections.

The basis for the health inspection plan is from OSHA's previous inspection experience as recorded in the Integrated Management Information System (IMIS).

Industries are selected by 4-digit Standard Industrial Classification (SIC) code on the basis of the average number of serious health violations found during the previous 5 years of OSHA health inspections of that industry. A ratio is calculated for all industries of the number of serious, repeat and willful health violations found to the number of inspections conducted within that industry from January 1989 through December 1993. Industries are then ranked in accordance with the ratios calculated, beginning with the highest ratio. The ranking is a national ranking; and, consequently, each State will receive a list of all industries operating within that State in the same rank order as on the national list. Data from over 30,000 inspections produce data on all of the 1,000 4-digit SICs that are used to classify industry in the private sector.

Once the industry priorities are established, an Industry Rank Report for health (Health SIC list) is generated, and a commercially available employer mailing list obtained from Dun & Bradstreet is used to identify all the establishments (with more than 10 employees) belonging to these industries (Health Establishment List).

Establishments are listed separately by Area/District Office jurisdiction. For each office all the establishments within the top 200 industries are randomly ordered and placed into four sublists....

The establishments are placed in random order using the following procedure.

Each establishment in the top 200 industries is assigned a random decimal number between 0 and 1. Establishments in industries ranked

1 to 100 are given two random numbers with the larger number selected and assigned to the establishment. The list is sorted from largest to smallest random number. The resulting establishment list is in random order with the establishments in industries in the top 100 given two chances to place high on the list. To provide compatibility with the planning guide software, the rank value will be use at the micro for the random ordering of the establishment list. In the past the rank value has been used to provide a reference to the Industry Rank Report. The software uses the rank value to provide the order in which establishments are selected. Since rank is allowed only three digits on the micro computers, those area offices with more than 999 firms on their establishment lists will have up to three firms showing with the same rank. The planning guide software will randomly select when there are firms of the same rank and not all are selected.

Industry sector samples

OSHA uses several reports to determine high hazard industries. Samples of two of these reports appear here as Figures 1 and 2.

Report A-1 is the health industry list and lists the top 200 industries by 4-digit SIC codes by state (including all top 200 SIC codes, even those without establishments within the Area/District Office boundaries).

For each state, the rank of the highest 200 industries is based on the number of serious health violations per inspection. Report A-1 contains all industries with or without identified establishments employing more than 10 employees within the State. The list is presented in two ways: in rank order and in SIC code order. Industries with the same average number of serious violations per inspection are assigned the same rank.

Figure 1 is a sample report with fictitious data as it would appear for the state of Texabama (the rank order has also been modified so as to protect the true ranking).

Figure 1

INDUSTRIES RANKED BY SERIOUS HEALTH VIOLATIONS (SHV) PER INSPECTION

SIC CODE	INDUSTRY DESCRIPTION	RANK	SHV PER INSP	WORKERS	FIRMS	CUMULATIVE TOTALS WORKERS	FIRMS
2011	MEAT PACKING	123	2.89	4,200	42	4,200	42
2013	SAUSAGES AND OTHER PREPARED MEATS	19	2.66	1,375	13	5,575	55
2015	POULTRY SLAUGHTERING AND PROCESSING	23	4.05	3,372	30	8,947	85
2021	CREAMERY BUTTER	107	2.94	25	1	8,972	86
2022	CHEESE, NATURAL AND PROCESSED	144	2.81	65	4	9,03	90
2023	DRY, CONDENSED, EVAPORATED PRODUCTS	18	4.28	5,861	16	4,898	106
2024	ICE CREAM AND FROZEN DESERTS	7	6.27	2,003	13	16,901	119
2026	FLUID MILK	29	3.75	40	1	16,941	120
2032	CANNED SPECIALTIES	173	2.73			16,941	120
2033	CANNED FRUITS AND VEGETABLES	144	2.81	125	2	17,066	122
2034	DEHYDRATED FRUITS, VEGETABLES, SOUPS	122	2.90	185	3	17,251	125
2035	PICKLES, SAUCES, AND SALAD DRESSINGS	80	3.07	7	3	17,322	128
2037	FROZEN FRUITS AND VEGETABLES	74	3.11			17,322	128
2038	FROZEN SPECIALTIES, NEC	122	2.90			7,322	128
2041	FLOUR AND OTHER GRAIN MILL PRODUCTS	107	2.94	880	8	18,202	136
2043	CEREAL BREAKFAST FOODS	90	3.00			18,202	136
2044	RICE MILLING	20	4.08	409	6	18,611	142
2045	PREPARED FLOUR MIXES AND DOUGHS	135	2.87			18,611	142
2046	WET CORN MILLING	47	3.47	110	1	18,721	143
2047	DOG AND CAT FOOD	150	2.80	3,154	17	21,875	160
2048	PREPARED FEEDS, NEC	133	2.88	140	3	22,015	163
2051	BREAD, CAKE, AND RELATED PRODUCTS	154	2.78	134	4	22,149	167
2052	COOKIES AND CRACKERS	150	2.80	4,359	14	26,508	181
2061	RAW CANE SUGAR	144	2.81	377	19	26,885	200
2062	CANE SUGAR REFINING	157	2.77	1,829	48	28,714	248
2063	BEET SUGAR	199	2.66	1,748	34	30,462	282
2064	CANDY & OTHER CONFECTIONERY PRODUCTS	74	3.11	343	4	30,805	286
2066	CHOCOLATE AND COCOA PRODUCTS	68	3.20	288	9	31,093	295
2067	CHEWING GUM	173	2.73	8,345	20	39,438	15
2074	COTTONSEED OIL MILLS	53	3.39	1,533	39	40,971	354
2075	SOYBEAN OIL MILLS	140	2.84	2,504	28	43,475	382
2076	VEGETABLE OIL MILLS, NEC	153	2.79	1,233	10	44,708	392
2077	ANIMAL AND MARINE FATS AND OILS	150	2.80	859	7	45,567	399
2079	EDIBLE FATS AND OILS, NEC	173	2.73	495	2	46,062	401
2082	MALT BEVERAGES	99	2.97	1,937	8	47,999	409
2083	MALT	36	3.58	457	12	48,456	421
2084	WINES, BRANDY, AND BRANDY SPIRITS	17	3.77	731	9	49,187	430
2085	DISTILLED AND BLENDED LIQUORS	103	2.96	1,093	10	50,280	440
2086	BOTTLED AND CANNED SOFT DRINKS	57	3.30	1,697	41	51,977	481
2087	FLAVORING EXTRACTS AND SYRUPS, NEC	178	2.72	4,342	32	56,319	513

The key safety threshold—3.9 lost days per 100 workers

Report A-2 lists the violations most frequently cited for each of the top 200 ranked industries. This report is available on request from the Office of Statistics.

For each industry listed in Report A-1, Report A-2 lists the health standards cited during inspections.

Safety inspection planning

The planning of General Industry safety inspections is based on Lost Workday Injury and Illness (LWDC) rates for calendar year 1992 as provide for the nation by the Bureau of Labor Statistics. LWDC stands for Lost Work Day cases, either injury or illness. The information presented in report form lists industries in rank order beginning with the industry with the highest LWDC rate. Only the Top 200 industries are included in the reports.

All industries with an LWDC rate of 3.9 or greater per 100 full-time employees are considered high rate industries. However, the top 200 industries are used because in these 200 industries there are more establishments than can be used by most Area Offices. The rate of 3.9 is the national average LWDC rate for the private sector as published by the Bureau of Labor Statistics (BLS) for calendar year 1992.

In this way, OSHA is able to maximize the utilization of available resources by targeting establishments in the Top 200 industries for programmed (planned) inspections. Report B-1 consists of a list of the top 200 high rate industries with or without establishments located in the state.

OSHA guidelines explain:

> The establishments are placed in random order at the host using the following procedure. Each establishment in the top 200 industries is assigned a random decimal number between 0 and 1. Establishments in industries ranked 1 to 100 are given two random numbers with the larger number selected and assigned to the establishment. The list is sorted from largest to smallest random number.

The resulting establishment list is in random order with the establishments in industries in the top 100 given two chances to place high on the list. For the purpose of downloading the appropriate number of establishments for each office, the list for each office is divided into four sublists each containing about one quarter of the firms on the list.

The industry LWDC rates are based on the latest available national BLS injury and illness rates obtained from the annual survey for 1992. Statewide High Rate SIC List (Report B-1) is generated using national BLS data and statewide establishment and worker data. Establishments within each industry are obtained from a commercially available establishment mailing list. OSHA obtains the establishment list from Dun & Bradstreet to identify all the establishments belonging to these industries. These establishments are supplied electronically to the Area Office with jurisdiction.

For each state, the rank of all high rate industries is given in descending order beginning with the industry with the highest Lost Workday Injury and Illness (LWDC) rate. REPORT B-1 contains all industries with or without identified establishments employing more than 10 employees within the state. The list is presented in two ways: in rank order and in SIC code order. Industries with the same lost workday injury and illness rate are assigned the same rank. Only manufacturing industries are used in the selection process.

Figure 2 is a sample with fictitious data as it would appear in the report for the state of Texabama.

For each industry in the report, the following data are furnished:

- SIC CODE—Based on the 1987 SIC code manual and presented at the 4-digit SIC level.

- INDUSTRY DESCRIPTION—Short SIC code industry titles.

LWDC rates are based on other government labor data

- RANK—Sequential numbers assigned in the report, beginning with "1" for the industry with the highest LWDC rate.

- LOST WORKDAY INJ/ILL—National LWDC rate as determined by the latest available BLS Survey, 1992.

- WORKERS—Total number of employees in the industry for firms with 11 or more employees and smaller worksites related to larger firms.

- FIRMS—Total number of establishments in the industry with 11 or more employees and smaller locations related to larger firms.

- CUMULATIVE TOTALS—Cumulative totals are provided for each industry in a state for the number of employees and number of establishments. The last ranked industry in the state contains the respective totals for the state.

Figure 2

STATEWIDE INDUSTRY RANK REPORT

INDUSTRIES RANKED BY LOST WORK DAY INJURY AND ILLNESS RATE

SIC CODE	INDUSTRY DESCRIPTION	RANK	LOST WORK DAY	WORKERS	FIRMS	CUMULATIVE TOTALS WORKERS	FIRMS
2011	MEAT PACKING PLANTS	131	6.0	4,200	42	4,200	42
2015	POULTRY SLAUGHTERING AND PROCESSING	124	6.1	2,931	28	7,131	70
2026	FLUID MILK	24	10.6	1,375	13	8,506	83
2034	DEHY DRATED FRUITS, VEGETABLES, SOUPS	26	10.4	16	1	8,522	84
2037	FROZEN FRUITS AND VEGETABLES	147	5.7	759	14	9,281	98
2038	FROZEN SPECIALTIES, NEC	44	8.8	2,461	7	11,742	105
2052	COOKIES AND CRACKERS	170	5.2	858	15	12,600	120
2061	RAW CANE SUGAR	194	4.9	3,372	30	15,972	150
2062	CANE SUGAR REFINING	202	4.8	2,024	3	17,996	153
2063	BEET SUGAR	66	7.7	1,745	20	19,741	173
2077	ANIMAL AND MARINE FATS AND OILS	178	5.1	25	1	19,766	174
2084	WINES, BRANDY, AND BRANDY SPIRITS	124	6.1	298	7	20,064	181
2092	FRESH OR FROZEN PREPARED FISH	56	7.9	65	4	20,129	185
2231	BROADWOVEN FABRIC MILLS, WOOL	246	4.2	5,861	16	25,990	201
2253	KNIT OUTERWEAR MILLS	212	4.7	575	14	26,565	215
2258	LACE AND WARP KNIT FABRIC MILLS	5	13.3	1,025	3	27,590	218
2261	FINISHING PLANTS, COTTON	54	8.0			27,590	218
2281	YARN SPINNING MILLS	131	6.0	506	4	28,096	222
2282	THROWING AND WINDING MILLS	39	9.2			28,096	222
2295	COATED FABRICS, NOT RUBBERIZED	283	3.8	964	6	29,060	228
2298	CORDAGE AND TWINE	66	7.7	807	17	29,867	245
2299	TEXTILE GOODS, NEC	92	6.8	6,933	64	36,800	309
2311	MEN'S AND BOYS' SUITS AND COATS	131	6.0	2,003	13	38,803	322
2394	CANVAS AND RELATED PRODUCTS	30	10.0	40	1	38,843	323
2421	SAWMILLS AND PLANING MILLS, GENERAL	19	11.2			38,843	323
2434	WOOD KITCHEN CABINETS	164	5.3	125	2	38,968	325
2435	HARDWOOD VENEER AND PLY-WOOD	138	5.8	1,512	23	40,480	348
2441	NAILED WOOD BOXES AND SHOOK	246	4.2	51	2	40,531	350
2452	PREFABRICATED WOOD BUILDINGS	252	4.1			40,531	350
2499	WOOD PRODUCTS, NEC	147	5.7			40,531	350
2511	WOOD HOUSEHOLD FURNITURE	48	8.3	284	4	40,815	354
2512	UPHOLSTERED HOUSEHOLD FURNITURE	239	4.3			40,815	354
2514	METAL HOUSEHOLD FURNITURE	97	6.7	185	3	41,000	357
2517	WOOD TV AND RADIO CABINETS	48	8.3	146	1	41,146	358
2519	HOUSEHOLD FURNITURE, NEC	309	3.5	1,200	3	42,346	361
2521	WOOD OFFICE FURNITURE	43	9.0			42,346	361
2522	OFFICE FURNITURE, EXC. WOOD	28	10.3	71	3	42,417	364
2531	PUBLIC BUILDING & RELATED FURNITURE	22	10.7	750	2	43,167	366
2541	WOOD PARTITIONS AND FIXTURES	212	4.7	4,446	44	47,613	410
2542	PARTITIONS AND FIXTURES, EXC WOOD	92	6.8	688	10	48,301	420

CHAPTER 4

JOB ANALYSIS AND IDENTIFYING HAZARDS

Introduction

Safety on the job is a personal matter. It involves each worker, machines, tools, materials, processes and procedures. Only when an individual worker has a thorough understanding of all the elements that make up his or her job—including all potential hazards—will he or she have appreciation for exercising a safety minded attitude.

How do you instill this kind of knowledge in your workers?

Safety has to be made an integral part of job procedure. Experienced safety directors, plant managers and personnel directors, know the importance of training workers so they thoroughly know every step involved in each job—every step in a construction or manufacturing process. Workers should be made familiar with ALL known and recognizable hazards that may be present in the equipment used, the materials handled, and the conditions they may encounter.

A carefully documented Job Safety Analysis Sheet, prepared on the job—while observing how each stage and each step of the job or process is actually performed—becomes the basic text model and guide for job-process training.

The Job Safety Analysis form is best completed by first line supervisors working with employees on-

the-job in your own plant. This assures that your special procedures and job methods are understood and followed. Try to appoint individuals capable of assessing your workplace with a fresh, objective outlook—assemble a team that will seek to identify all hazards—especially those which could be considered outside the mainstream of your operations.

Depending upon the size and complexity of your operation, you may also want to consider developing a team that includes a safety professional, an industrial hygienist and an occupational health professional. If your operation is small, safety and industrial hygiene consultants can be found through OSHA's state-run consultation services.[1]

The tools of job analysis

According to Milton J. Terrell, author of *Safety and Health Management in the Nineties*, there are several signs to assure that an outside safety professional, industrial hygienist, or occupational health professional has conducted a thorough job analysis survey:

- Safety professionals, supervisors or industrial hygienists should start with your injury and illness logs, looking for patterns that expose unabated hazards, the need for additional training, etc.

- Your hazard communication program should be reviewed, and if applicable, your hearing conservation and respirator programs.

- The occupational health professional should review your records of employees who have received medical treatment for work-related injuries or illnesses. He or she should also review records that document employee training for first aid, CPR, and EMT.

One of the best methods of conducting a job analysis/hazard assessment survey is to start at the beginning of the production cycle—at the place where raw materials are taken in—and end at the

[1] For more on these services and others like them see Appendix 2.

place where finished product is taken out of the facility. Terrel offers the following suggestions:

- Watch how materials are handled and stored, checking the stability of storage racks and the appropriateness of storage for flammables and explosives.

- Check the openings that expose moving parts for pinch points and other hazards.

- Check hand tools and equipment and wiring in the maintenace shop.

- Arrange to see operations on every shift and to observe any after hours operations such as cleanup or fork lift battery recharging.

- Open every door and look in every corner of your facility.

- Walk around the outside of buildings to check on such things as:

 Chocks for trucks at the loading/unloading docks

 Fork lift ramps

 Outdoor storage of flammables and explosives

 Any fueling areas

- Suggest jobs for job safety analysis — especially jobs that might expose workers to ergonomic hazards.

- Check your inventory of chemicals against what can be found in the worksite.

- Know what metals are used in any welding operations.

- Check any production areas where eating and smoking is allowed.

- Check for the possible presence of asbestos, lead, carcinogens, or other toxic substances.

- If respirators are used, check if you are using more than one brand, how you fit test each employee, whether pulmonary function testing is done, how the respirators are cleaned, maintained, and stored.

Reviewing the entire production cycle

- Do full shift sampling of contaminants to establish overall exposure to workers.

- Watch the movements of workers performing their jobs to determine if there are actual or potential cumulative trauma disorder, or other ergonomic hazards.

After identifying the specific job, its location, and the responsible supervisor in the space provided, start preparation—in draft form first. Avoid "stage setting" the observations. It is important that the employee goes through the job procedures in the usual manner and not in a deliberate or in a self-conscious way.

Avoiding this kind of analysis can result in even more difficult methods of discovery.

Ohio-based Tube Products, Inc., manufactured auto exhaust pipes and exhaust systems. A call from a local hospital alerted OSHA that a noticeable number of Tube employees were coming in with injuries. In the summer of 1995, OSHA began inspecting the facility.

According to the Cincinnati OSHA office, Tube used a large amount of temporary personnel. At the time of the inspections, the company employed 365 temps and 126 permanent workers. Conditions in the plant were so crowded that employees could hardly move without exposure or potential exposure to welding arcs or other dangerous tools.

When OSHA reviewed the workplace injury records for the company, the records revealed nine instances of amputated fingers, 54 cases of smashed fingers and hands, 56 instances of flash burns from welding, 16 cases of broken bones, and 37 back injuries between January 1993 and December 1994.

Tube was cited 11 times under OSHA's egregious-case policy for allegedly failing to adequately guard points of operation. Those citations carried a proposed penalty of $770,000. The cited instances "related to smashed fingers and lacerations," according to an agency spokesman.

The company was also cited for alleged willful violations of eight OSHA standards. Among these: lack of safe means of egress, carrying a $70,000 proposed penalty; failure to provide a continuing effective hearing conservation program, a $55,000 proposed penalty; lack of arm and hand protection, a $55,000 proposed penalty; lack of personal protective equipment, a $55,000 proposed penalty; failure to train employees on the safe operation of equipment, a $70,000 proposed penalty; failure to provide fall protection, a $60,000 proposed penalty; and failure to adequately guard point of operation on spot welder, a $70,000 proposed penalty.

The company was also cited for failing to train employees on safe operation of equipment and failing to provide a continuing effective hearing conservation program. OSHA also proposed $52,500 in penalties for 11 other alleged serious violations.

These proposed fines totaled some $1.3 million.

Tube initially said it would contest the citation to the OSHRC—but decided to settle. In February 1996, it announced a deal in which it paid $750,000 and agreed to develop and implement an ongoing training program for its machine operators of pipe-fabrication equipment.

The company also agreed to implement routine inspections of operations involving pipe-fabrication equipment and hire a consultant to verify the company's machine guarding improvements.

OSHA was very happy with settlement. The agency claimed that, in the six months after the initial inspection, the employee turnover rate at Tube had gone down drastically.

You'll be amazed to discover hazards in what you consider normal job routines, which were previously missed or overlooked. Prepare a separate Job Safety Analysis for each specific job and make it part of the company safety procedure manual. Copies should be provided for use by affected departments or supervisors.

Six months after an inspection, turnover had dropped significantly

A general outline for job analysis surveys

The following items may serve as the basis for a general outline when putting together your job analysis survey:

- job title and description;
- name of supervisor or department head;
- job location;
- machines, tools, equipment to be used;
- materials or compounds to be used;
- job procedure;
- potential health/injury hazards;
- protective equipment or clothing required;
- precautionary or safety practices to be followed;
- how, when, and to whom problems are to be reported.

When you've completed your analysis, and have identified hazards, processes, personal protective equipment and chemicals used on the premises, etc., refer to Appendix 1 which provides a brief synopsis of each OSHA 1910 and 1926 regulation. This appendix will help you to establish which OSHA regulations apply to your operations based on the results of your analysis.

An example of the kind of hazard you should be able to discover in this process: In the 1995 decision *Secretary of Labor v. Delta Drilling Co.*, OSHRC considered a situation in which an employer hadn't adequately secured an on-site staircase.

Delta's drill rig worksite outside of Corpus Christi, Texas, was inspected by OSHA in early 1993. A 28-foot high stairway bolted to the drill rig platform on the east side of the rig was one of two used by employees to access the rig platform. OSHA inspectors found a gap approximately 12 inches wide at the top of the stairway between the end of one of the stairway's railings and the rig platform's guardrail.

Employees regularly walked by the gap exposing them to fall hazard that could result in serious

injury. Delta was cited for violating 1910.24(h)—failure to provide railing that covered gap. This section of the law states:

> Fixed industrial stairs...
>
> ...railings and handrails.
>
> Standard railings required on the open sides of all exposed stairways and stair platforms.

The agency concluded that Delta didn't comply with this standard.

An administrative law judge vacated the citation, finding that—although there had been a 12-inch gap—the stairway's railings complied with the OSHA standard. The railings went to the top of the stairway. The agency appealed the reversal to OSHRC. In July 1995, the commission—led by Chairman Stuart E. Weisberg—reversed the ALJ's reversal. The citation went back into effect.

OSHRC looked at testimony by the company's compliance officer that stated that stairway railing went to the top of the stairs. It also looked at exhibits offered by OSHA that suggested otherwise. The commission found that the evidence "clearly shows that the stairway railing does not extend over the topmost tread of the stairway, creating the gap," in violation of the standard. As there was no railing over the gap, the commission ruled that Delta violated the standard.

Delta appealed the OSHRC decision to the federal appeals court in Texas. As of March 1996—three years after the citation had intially been written—no decision had yet been reached.

The following pages provide both a blank and a sample copy of a Job Safety Analysis form, and an office area inspection checklist and accident reporting and analysis forms. These forms can be adapted to most any job situation. If your operations and procedures are more complex (or simpler) you may want to alter the form to suit your needs or design a totally different form.

An oil rig company cited for a 12-inch gap in a staircase railing

JOB SAFETY ANALYSIS

JOB TITLE / DESCRIPTION DRILLING MACHINE OPERATIONS		LOCATION / DEPARTMENT Machine Shop "B" Building #4	PREPARED BY: SUPERVISOR
KEY JOB PROCESS STEPS	**TOOLS/MATERIAL USED**	**POTENTIAL HAZARDS:** CONDITIONS OR ACTIONS WHICH COULD CAUSE AN INJURY / AFFECT HEALTH	**RECOMMENDED SAFE PRACTICES** PERSONAL PROTECTIVE DEVICES, SPECIAL CLOTHING PROCEDURES
1. OBTAIN MATERIAL	Tote boxes or containers	Strains from lifting or handling parts;	Exercise correct lifting practices;
		Injuries to fingers or hands caught in pinch points, or cuts caused by sharp edges.	Wear hand protection and/or use mechanical lifting aids.
2. MOVING MATERIALS TO THE JOB	Cart, truck or mechanical lift	Strains from pushing or pulling, falling, slipping, tripping; hand or body caught between objects.	Get help to move heavy or bulky parts. Keep work area clear and work surfaces smooth. Keep aisles free of obstructions.
3. SET-UP	Drill press, drills, related equipment	Unguarded belt or pulleys;	Provide guards for belts, pulleys, exposed moving parts;
		Unsecured machines or parts;	Secure machine to floor or base;
		Lighting poor, area around machine cluttered; machine close to traffic;	Provide adequate lighting. Clear area near machine. Set up barrier if needed;
		Controls awkward to reach.	Move controls for easy reach.
4. DRILLING OPERATIONS		Loose fittings, flying chips, oil spray, falling parts;	Be sure chuck key is removed and all parts and fitting are secure. Eye and face protection to be worn;
		Clothing/hair caught in drill;	Keep hair in place with cap or snood; ties or loose clothing should not be worn—shop coat or apron to fit;
		Spinning parts caught in drill;	Back-up bars or hold-down devices to be used to secure material;
		Fumes generated by drilling action on certain types of material or cutting compounds.	Make sure there is adequate ventilation and/or devices to remove fumes from worker area.
5. FINISHED WORK REMOVAL	See steps 1 and 2.	See steps 1 and 2.	See steps 1 and 2.

JOB SAFETY ANALYSIS

JOB TITLE / DESCRIPTION		LOCATION / DEPARTMENT	PREPARED BY: SUPERVISOR
KEY JOB PROCESS STEPS	**TOOLS/MATERIAL USED**	**POTENTIAL HAZARDS:** CONDITIONS OR ACTIONS WHICH COULD CAUSE AN INJURY / AFFECT HEALTH	**RECOMMENDED SAFE PRACTICES** PERSONAL PROTECTIVE DEVICES, SPECIAL CLOTHING PROCEDURES

OFFICE AREA SAFETY INSPECTION CHECKLIST

LOCATION:	INSPECTION DATE:
SUPERVISOR:	FOLLOW-UP DATE:
INSPECTED BY:	INSPECTION PERIODS: Weekly ☐ Monthly ☐ Quarterly ☐

O.K. ✓	Description	x	Corrective Action Needed (Comments)	Date Corrected	By
	WALKING SURFACES				
	Aisles correctly established and clear				
	No tripping hazards in evidence				
	Floors(s) even (no holes or cracks)				
	Wires not stretched across aisles				
	Entrance mats available, used for wet weather				
	Floors dry - not slippery				
	Carpets and rugs secure				
	Outside walkways, parking areas in good repair				
	STAIRWAYS, HALLS, RAMPS, STORAGE AREAS				
	Adequate lighting suitable for work to be done				
	Ramps have non-slip surface				
	Stairways clear - not cluttered				
	Stair treads in good condition				
	Guardrails in good condition				
	Halls kept clear of equipment and supplies				
	BOOKCASES, SHELVES, CABINETS				
	Shelves not overloaded				
	Heavy storage shelves secured to wall				
	Heavy storage files secured from tipping				
	Bookcases secured from tipping				
	OFFICE EQUIPMENT, DUPLICATING MACHINES, TOOLS				
	File cabinets secure				
	File drawers closed when not in use				
	File drawers not overstuffed				
	Chairs (springs, casters) in good mechanical condition				
	Fans guarded, secure from falling or tipping				
	Paper cutter equipped with guard; blade spring functioning				
	Paper shredder guarded				
	Safe step stools used when needed (non-rolling type)				
	Step stools kept clear of aisleways when not in use				
	Sufficient ventilation where required				
	Spirit duplicating liquid properly stored				
	"No smoking" sign near spirit duplicating machines and no-smoking rule enforced				

(Continued other side)

OFFICE AREA SAFETY INSPECTION CHECKLIST (Continued)

O.K. √	Description	x	Corrective Action Needed (Comments)	Date Corrected	By
	OFFICE EQUIPMENT, DUPLICATING MACHINES,TOOLS (Continued)				
	Paper, supplies, material safety stacked				
	Knives, scissors, other sharp tools used/ stored correctly				
	Emptied containers of solvents, duplicating machine liquids properly disposed of				
	ELECTRIC HAZARDS				
	Machines and equipment grounded				
	Extensions cords - 3-wire type				
	Extension cords - maximum length 10 feet				
	Condition of power cords (not patched or spliced)				
	Condition of plugs and wall outlets				
	Electric switch panels clear (at least 30" open area)				
	Circuits not overloaded				
	Management-approved use of coffee pots- (used in controlled locations only)				
	No wires under carpets				
	Electric heaters grounded				
	Management-approved use of electric heaters				
	Portable power tools equipped with guards				
	FIRE PREVENTION				
	Fire extinguisher properly marked and installed				
	Fire extinguisher has current inspection tag				
	Fire extinguisher not blocked or obstructed				
	Fire escapes clear				
	Fire doors not blocked open				
	Approved ashtrays in use				
	No-smoking areas established as needed				
	Exits properly marked				
	Sprinkler heads not blocked				
	Excess paper and trash removed				
	SANITATION, WATER SUPPLY, PERSONAL PROTECTION				
	Drinking water available				
	Condition of toilet facilities				
	Personal protective devices available if needed				
	Condition of approved eating areas				
	Food scraps, peels, wrappings disposed of daily				
	First-aid supplies available				
	All required notices posted				

REPORT OF ACCIDENT
To be completed for all accidents, even if no injury was sustained.

1. Date and time of accident _____ _____ AM _____ PM

2. Location of accident (Area/Dept) _____

3. Equipment involved _____

4. Employee(s) involved: _____

Name	AGE	JOB Classification	IF INJURED	
			First Aid given	Med Att'n Needed

5. First aid administered by:

6. Medical attention authorized by:

7. Who witnessed accident?

8. Describe accident and nature of injury, if any:

9. What happened?

10. How did it happen?

11. What unsafe act was committed?

12. List any unsafe conditions which contributed to accident/injury:
 ☐ Complete checklist of possible causes on the other side

13. Could this accident have been prevented? Explain: _____

14. What should be done to prevent similar accidents?

WRITTEN RECORDS
ANALYSIS OF FACTORS CONTRIBUTING TO CAUSE OF ACCIDENT

WORKING CONDITIONS

- ☐ Poor housekeeping
- ☐ Poor ventilation
- ☐ Poor lighting
- Temperature (_____Hot _____Cold)
- ☐ _____
- ☐ _____

BUILDING/PLANT CONDITION
- ☐ Fire protection inadequate
- ☐ Exits unmarked
- ☐ Exits blocked
- ☐ Unguarded floor opening
- ☐ _____
- ☐ _____

EQUIPMENT/MACHINERY
- ☐ Faulty tools
- ☐ Faulty machinery
- ☐ Lack of maintenance
- ☐ Improper guarding
- ☐ Guards removed
- ☐ Guards missing

☐ Guards tampered with:
- ☐ _____
- ☐ _____
- _____

EMPLOYEE(S) CONDITION/ATTITUDE
- ☐ Inexperienced
- ☐ Insufficient training/instructions
- ☐ Instructions disregarded
- ☐ Instructions not enforced
- ☐ Unskilled
- ☐ Ignorant
- ☐ Used poor judgment
- ☐ _____

ATTITUDE/DISCLIPLINE
- ☐ Disobeyed rules
- ☐ Attention distracted
- ☐ Inattentive
- ☐ Fooling, horseplay
- ☐ Attempted shortcuts
- ☐ Was hasty
- ☐ Did not follow safe practice procedure

PHYSICAL/MEDICAL CONDITION
- ☐ Fatigued
- ☐ Sluggish
- ☐ Weak
- ☐ Sick
- ☐ Disturbed

- ☐ Personal problems
- ☐ Drunk, drug abuse
- ☐ _____
- ☐ _____

DRESS/SAFETY EQUIPMENT
- ☐ Protective wear not used
- ☐ Protective wear not available
- ☐ Safety equipment not used
- ☐ Safety equipment not readily available
- ☐ _____
- ☐ _____
- ☐ Clothing loose or too long
- ☐ Failure to wear safety shoes
- ☐ Faulty shoes, high heels
- _____

Employee's Statement: _____

Employee's Signature _____

Witness' Statement: _____

Witness' Signature _____

Supervisor's or investigator's remarks: _____

Chapter 5

Safety Programs and Hazard Abatement

Introduction

Safety experts use heavy jargon like "hazard abatement" to convey the relatively simple concept of preventative safety programs. These programs aren't as difficult to put in place as you might think—they're mostly common sense subject matter combined with a few consistent forms to establish the paper trail that proves you've made a consistent effort to enact a program.

Although OSHA does not require an employer to establish a general safety program, voluntary establishment of a program demonstrates evidence of good faith. OSHA continues to encourage employers to develop such programs—and has recently taken steps to provide incentives to those who do. This could prove helpful to you during a scheduled or programmed inspection—in fact, it could help you to avoid such an inspection altogether.

Through an effective safety program, management may assign responsibility for safety and be sure performance meets that responsibility. To achieve these results, you should develop as complete a safety program as possible. Such a program should include the following:

- a safety coordinator;
- a safety committee (or committees);

The safety coordinator is the key to a complete safety program

- regularly scheduled safety meetings;
- a written Management Safety Policy; and
- general safety rules designed to meet all OSHA guidelines.

In this chapter, you will find some detailed instructions on how such an ongoing safety program can be established.

The safety coordinator

Appoint a key person to assume the responsibility for developing and implementing your complete safety program. A safety representative—that is a lieutenant to the coordinator, often drawn from non-management employees—should also be named. The safety coordinator should:

- coordinate safety activities throughout the company;
- keep and analyze all accident reports;
- conduct educational activities for all supervisors and employees;
- conduct activities to maintain interest of employees using safety bulletins, posters, and contests;
- investigate accidents and near accidents;
- plan and direct internal safety inspections;
- check for compliance for federal, state, and city safety regulations;
- issue regular reports showing accident trends and safety performance;
- serve on the safety committee; and
- serve in a staff capacity, without line authority.

Safety committees

The purpose of the safety committee is to maintain/improve workplace safety and to create and maintain employee interest in safety. To accom-

plish these objectives, management must form committees to establish safety policies, perform inspections, see that the necessary corrections are made, and conduct safety training of all employees.

Through such committee action, improvements in the work environment and in work practices can be facilitated. Even if you resist committee decisions in other areas, safety is one that really begs this kind of involvement. "Employee buy-in" is a phrase that some business people find overused—this is one context in which it's important.

Ideally, the safety committee should have a minimum of two to three members; represent management, supervisors, and employees; and meet at least every 30 days. The committee should have the following duties:

- development of safety rules and programs for all employees;

- review of any accidents that occur;

- appoint inspection and accident investigation committees;

- review and plan action on safety suggestions from employees;

- check any operational changes or new construction to be sure that all safety regulations are met;

- delegate employees to investigate accidents, make hazard inspections, and report the results to the safety committee;

- plan future activities to generate interest in safety; and

- plan general safety meetings.

Safety meetings

General safety meetings should be planned regularly (at least once a month), so that all employees will be trained and educated in safe working procedures. A chairman for the general meetings should be appointed by the safety commit-

The duties of a safety committee

Inspection committees should survey the premises for hazards

tee. The duties of the chairman should include the following:

- arranging a suitable place for the meeting,

- notifying all employees as to the time and place of the meeting,

- making sure the program has been completed for the meeting, and

- making sure that the inspection committees have completed their reports.

A secretary should be appointed to keep minutes for the record. An employee from the office might be considered. The secretary's duties should include:

- reading the minutes from the last meeting;

- calling the roll;

- taking notes during the meeting;

- preparing minutes and furnishing the safety committee with a copy; and

- preparing a status report on old and new recommendations.

Two or more employees from the general meeting should be delegated to act as an inspection committee, and membership should be rotated regularly. The duties of the inspection committee should include the following:

- before each meeting, a survey should be made of the entire premises to determine physical and fire hazards, as well as unsafe practices; and

- a written report of these findings should be prepared for the safety committee, as well as a personal oral report to the general safety meeting.

An investigative committee should also be appointed from the employee group, with rotating membership. Its duties should include:

- handling investigations of any accident or of any unsafe condition or act that has caused injury;

- issuing a report of findings to the safety committee; and

- issuing a report to the general safety meeting about the action taken to prevent recurrence of the same kind of accident.

A written safety policy

The management of every business should prepare and publish a Management Policy on Safety. This should be printed on company stationery and posted or distributed so all employees are aware of management's attitude toward safety. It is also advisable to prepare the safety policy in the form of a leaflet or incorporate it in an employee manual to be distributed to each employee.

Some companies require new employees to sign a statement indicating that they have read and understand the company safety policy and safety rules. The signed statement is then kept in the employee's personnel file.

In the event of an OSHA inspection, you will need to produce more than just the generic sample Written Safety Policy which follows. One of the first things an OSHA inspector will do is establish whether or not your employees—at all levels—can articulate what the workplace policy on safety and health is, where it is located, and how it applies to other organizational values, such as production. Be sure to include goals in your policy that are updated at least annually. Clearly state all plans and objectives needed to achieve those goals. And above all, make certain that your employees—all of them—understand the objectives stated in your written safety policy.

Use the sample Written Policy as a guideline for the development of one in your own words, and post it on your bulletin board along with General Safety Rules you should establish for your company. For guidance, we provide sample written policy ideas, an example of a typical company safety policy, plus a series of recommended

General Safety Rules. Select the rules that apply to your type of operation, and add any other that may be needed by your company.

A note: Some states require posting of English and Spanish versions of safety rules and related information.

Management's Policy on Safety

As corporate officials, we consider accident prevention to be of prime importance. Accident control involves the safety and well-being of our employees and the public, in addition to affecting costs and profits.

Management has every desire to provide a safe working environment for its employees. To accomplish this, management feels there is nothing more important than making certain that:

1. You are provided with all reasonable safeguards to ensure safe working conditions.

2. You are provided with neat, clean, safe, attractive, and healthful working conditions.

3. We maintain all equipment, tools, and machines in good repair.

4. We study and develop safe work methods, and train employees in these methods.

5. We comply with federal, state and local laws regarding accident prevention and working conditions.

Management recognizes that more than safety is involved, because the existence of accident hazards is proof of a wasteful, inefficient operation. Accidents lead to complaints, dissatisfaction, interference with work plans, and loss of good will.

The success of our Accident Prevention Program depends on the sincere, constant, and cooperative effort of all employees and their active participation and support. If you see a hazard, report if immediately; the life you save may be your own.

Signature

Sample Written Safety Policy

(Company Letterhead)

From: _____

President

Subject: COMPANY SAFETY AND HEALTH POLICY

The personal safety and health of each employee of this company is of primary importance. The prevention of occupationally-induced injuries and illnesses is of such consequence that it will be given precedence over operating productivity whenever necessary. To the greatest degree possible, management will provide all mechanical and physical facilities required for personal safety and health, in keeping with the highest standards.

We will maintain a safety and health program conforming to the best practices of organizations of this type. To be successful, such a program must embody the proper attitudes toward injury and illness prevention on the part of both supervisors and employees. It also requires cooperation in all safety and health matters, not only between supervisor and employee, but also between each employee and his fellow workers. Only through such a cooperative effort can a safety record in the best interest of all be established and maintained.

Our objective is a safety and health program that will reduce the number of disabling injuries and illnesses to a minimum, not merely in keeping with, but surpassing, the best experience of other operations similar to ours. Our goal is ZERO accidents and injuries. Our safety and health program will include:

1. Providing mechanical and physical safeguards to the maximum extent that is possible.

2. Conducting a program of safety and health inspections to find and get rid of unsafe working conditions or practices; to control health hazards; and to comply fully with the safety and health standards for every job.

3. Training all employees in good safety and health practices.

4. Providing necessary personal protective equipment and instructions for its use and care.

5. Developing and enforcing safety and health rules; requiring that employees cooperate with these rules as a condition of employment.

6. Investigating, promptly and thoroughly, every accident to find out what caused it and to correct the problem so that it won't happen again.

7. Setting up a system of recognition and awards for outstanding safety performance.

We recognize that the responsibilities for safety and health are shared:

a. As your employer we accept the responsibility for leadership of the safety and health program, and for its effectiveness and improvement, and for providing the safeguards required to ensure safe conditions.

b. Our supervisors are responsible for developing the proper attitudes toward safety and health in themselves and in those they supervise; and for ensuring that all operations are performed with the utmost regard for the safety and health of all personnel involved, including themselves.

c. As employees, you are responsible for wholehearted, genuine cooperation with all aspects of the safety and health program including compliance with all rules and regulations, and for continuously practicing safety while performing your duties.

Signature

General Safety Rules

1. In case of sickness or injury, no matter how slight, report at once to your supervisor for First Aid. Never attempt to treat your own or another worker's injury or try to remove foreign particles from the eye.

2. Safety devices are for your protection. Never operate your machine unless all guards provided are in place.

3. Guards must never be removed except when necessary to make adjustments or repairs, and they should be replaced immediately upon completion of work. If a guard is not in its proper position, report this at once to your supervisor.

4. Employees must remain in their own departments unless called away on business or in the regular course of their employment.

5. RUNNING on the premises is NOT PERMITTED.

6. Horseplay, throwing objects, scuffling, and fooling around are very dangerous and will not be tolerated.

7. Never distract the attention of another employee, as you might cause injury.

8. Illegal drugs and liquor will not be permitted on the premises at any time.

9. Jewelry, rings, bracelets, watch chains, key chains, etc., shall not be worn, for these objects might catch in machines, causing serious accidents such as the loss of fingers or hands.

10. Gloves must not be worn when operating machinery unless their use has been approved by your supervisor.

11. Loose ties or torn clothing must not be worn around machinery. It is suggested that sleeves be cut off at the elbow.

12. Before using any ladder, make sure it has good safety feet, and is free from cracks, broken rungs, or other defects. When there is any danger of slipping, have another worker hold the ladder.

13. Never use makeshift or defective scaffolding, rigging, or stages.

14. Never climb through, over, under, or between railroad cars. Wait until the train passes or walk around the end of the train, giving yourself plenty of room for safety.

15. Do not attempt to lift or push objects that may be too heavy for you. ASK FOR HELP when you need it. Learn to lift the right way to avoid strains: bend your knees; keep your body erect; then push up with your legs. This is the easiest and the safest way.

16. Shut down your machine before cleaning, adjusting, or repairing. Lock and tag the machine.

17. Never oil machines while they are in motion except where points of oiling are so located or guarded that you are not subject to contact with moving parts.

18. Never use your finger for removing chips from machines. Use a brush or a hook.

19. Never use defective chisels, sledge hammers, punches, wrenches, or other tools. Flying chips from tools with mushroomed or split heads cause many injuries. Exchange or see that the defective tools are repaired.

20. If you are provided with eye protection, you are expected to wear it.

21. Never operate any machine, crane, tractor, elevator, or other piece of moving equipment unless you have permission from your supervisor.

22. Caps should be worn around moving machinery by any employee with long hair.

23. If you are working where there are heavy fumes or dust, you are expected to wear the respirators provided for your protection. In some cases, a lifeline and an observer may be required.

24. Keep the area around you clean. Put all oily water, rubbish, and papers in the containers provided for those purposes.

25. Learn the location of all the fire exits and alarm boxes in your department.

26. Pile material, trucks, skids, racks, crates, boxes, ladders, and other equipment so that they do not block aisles, exits, fire fighting equipment, alarm boxes, electric lighting, power panels, etc. FIRE DOORS MUST BE KEPT CLEAR.

27. Learn the location and proper use of firefighting equipment in your department. Under no circumstances use a pail of water where extinguishers are provided.

28. Slippery floors cause falls. Always keep the floor clean.

29. If you see someone working carelessly and liable to be hurt, warn and advise them to work carefully.

30. Protect your feet and head by keeping your shoes and hard hat (especially the soles of the shoes and the liner of the hard hat) in good shape. Wear safety-toe-capped shoes to prevent serious toe injuries.

31. Unless you are an electrician, never tamper with electrical circuits or switches.

32. Always obey all warning signs.

33. Read the Safety Bulletins that are posted, for they will help you do your part in the accident prevention drive.

34. Never take short cuts through dangerous places.

35. If you don't know the safe way, stop and find out.

Education and training

Some employees work safely in dangerous and hazardous conditions, while other employees have accidents performing jobs that are quite safe. Training employees is therefore necessary for a safety program to be effective.

Simply ordering employees to work safely doesn't necessarily mean that they will. In order for management to achieve stated objectives, namely to provide for the safety of employees, it is necessary to educate both the supervisors and the employees to do their jobs properly. The supervisor must be able to train the employee on how to work safely, and management must educate the supervisor in the proper safety training techniques. Therefore, the following kinds of education programs should be conducted:

- job safety analysis;
- training of supervisors;
- training of employees; and
- regularly scheduled classes in safety, first aid, and fire control.

Training of supervisors

A formal safety course of instructions is required to establish desired attitudes in supervisors and to impart the necessary information about safety. All supervisors should complete a Supervisor's Basic Course in Safety. This training will increase the ability of a supervisor to perform a job from the standpoint of handling employees, efficiency or operation, and safety performance.

The following course form will provide the training required to accomplish these objectives. Assign the topics on this list to individual supervisors. Then enter the supervisors' names in the appropriate columns, with the dates, times, and places for them to conduct the lectures.

Teach employees how to do their jobs properly

117

OCCUPATIONAL SAFETY AND HEALTH PROGRAM
MANAGEMENT TRAINING SCHEDULE

Topic	Lecturer	Date and Time	Place of Meeting
Introduction			
Industrial Loss Prevention			
Organization and Committees			
Supervisor's Responsibility in Loss Prevention			
Inspection and Control Procedures			
Removing the Hazard from the Job			
Human Factors Engineering			
Human Behavior and Industrial Loss Prevention			
Loss Prevention Training for Employee for Safe Performance			
Maintaining Interest in Loss			
Prevention and Motivating Employees to Work Safely Publicizing Loss Prevention			

MANAGEMENT TRAINING SCHEDULE (continued)

Topic	Lecturer	Date and Time	Place of Meeting
Accident Record & Injury Rate			
Accident Investigation, Analysis and Costs			
Results of Accidents (The Nature and Causes) and How to Prevent Basic Types			
Workers' Compensation Insurance			
Sources of Help (How to Find Answers to Your Loss Prevention Problems)			
Psychological Factors in Loss Prevention			
Layout of Buildings			
Building Construction & Maintenance			
Boilers & Unfired Pressure Vessels			
Principles of Materials Handling & Storage			
Hoisting Apparatus and Conveyors			
Elevators and Plant Railways			
Powered Industry Trucks			

MANAGEMENT TRAINING SCHEDULE (continued)

Topic	Lecturer	Date and Time	Place of Meeting
Ropes, Chains and Slings			
Principles of Guarding and Transmission Guards			
Cold Forming & Repairing of Metals			
Machine Tools			
Woodworking Machinery			
Hot Working of Metals			
Local Exhaust Systems			
General and Comfort Ventilation			
Welding and Cutting			
Hand & Portable Power Tools			
Preventing Falls, Overexertion, and Exposure Accidents			
Electrical Hazards			
Scaffolding, Ladders & Platforms			

MANAGEMENT TRAINING SCHEDULE (Continued)

Topic	Lecturer	Date and Time	Place of Meeting
Place of Meeting			
Flammable & Combustible Liquids			
Fire Loss Control			
Fire Extinguishment & Control (Proper Use of Fire Extinguishers, etc.)			
Planning for Emergencies			
Personal Protective Equipment (Eye Protection, etc.)			
Industrial Sanitation and Personnel Facilities			
Industrial Hygiene			
Elements of Toxicology			
Industrial Noise			
Motorized Equipment			
Job Loss Prevention Analysis			
Job Loss Prevention Observations			
Handling the Loss Prevention			
Problem Employee			

The individual's role in safety maintenance is essential

Training of employees

The promotion and maintenance of safe practices and safe conditions depends largely upon employees. Theirs is a vital role because they are closest to the actual working conditions and are, therefore, in a position to exercise a great deal of influence over their work environment and fellow employees.

The program outlined below should be regarded as a core around which you may build a thorough training program adapted to your local needs. The basic program consists of five sessions, each one and a half hours in length. These sessions have a logical sequence and are designed to lay the groundwork for more specialized sessions that you may arrange.

The subjects of the basic training sessions are:

Session I—Introduction

Session II—Accident Causes and Control

Session III—Working with People in Accident Prevention

Session IV—Accident Prevention Workshop

Session V—Personal Protective Equipment

The first session should introduce employees to the functions of the safety organization and show them how they fit into the total safety program. An effort should be made to generate enthusiasm and safety consciousness among employees, encouraging them to carry out their jobs effectively without incurring accidents.

The second session is designed to familiarize employees with the causes of accidents and the control measures that should be applied to prevent them.

The third session raises the question of how to handle employees who work unsafely. The point should be made that because people are different, each employee who is seen acting unsafely must be handled as an individual.

During the fourth session, the principles of the third session are applied to actual situations. Each employee is presented with an actual situation that involves an unsafe condition. He is then asked to demonstrate how he would handle the situation. Afterwards, the group should discuss his performance and offer constructive criticism and comments.

The fifth session introduces employees to the reasons for personal protective equipment. The various types of equipment should be shown and explained.

As previously mentioned, these five sessions lay the groundwork for other, more specialized topics with which you may want to deal in additional sessions.

Job training

No specific training will stop resentment of authority, distraction, anger, impatience, indifference, or boredom. Therefore control barriers must be established to prevent accidents due to these emotional states. One such control barrier is continuous job training. An employee properly and continually trained is less likely to break the pattern of safe work performance even when in a seriously disturbed or emotional state.

Formal training and retraining courses should be established for all types of jobs. Training and safety meetings should be conducted on topics such as the following:

- new employee indoctrination,
- lifting and material handling methods,
- first aid training,
- training in use of fire protection equipment,
- emergency procedures,
- driver training,
- power equipment operation,
- storage limitation of hazardous materials,

Continuous job training prevents accidents

- lock and tag procedures,

- hazardous materials handling,

- fire safety, and

- personal protective equipment.

Fire control procedures and training

Employees must be trained in how to evacuate the building and must know how to call the fire department when a fire occurs. Employees should also be trained to apply the proper control measures when a fire is small. Therefore, employee training in an efficient alarm system and effective firefighting is essential.

Establish the following training programs:

- fire evacuation plan,

- fire department call procedure, and

- Fire Brigade training.

First aid training

First Aid Training Courses can be arranged with your local Red Cross service representative. Courses are offered at the Red Cross facilities or at your establishment. A minimum of six people are required for in-plant courses. Red Cross offers a variety of courses from basic first aid to more advanced training. Included in the training is a valuable first aid text book.

The following guideposts are suggested to help you establish First Aid Procedures:

1. The First Aid supplies must be approved by your company doctor.

2. A qualified person must be in charge of the First Aid supplies. The person designated must have First Aid training.

3. The First Aid station must be available to all employees.

4. A notice of emergency numbers should be

posted throughout the premises, especially at the First Aid stations.

5. A check of First Aid supplies must be made every sixty (60) days by the consulting physician. Kits can be taken to the doctor's office for inspection. Keep a written record of the physician's check.

Medical programs

The OSH Act makes it necessary for every establishment to have a medical facility and a company doctor or doctors who will agree to handle your medical needs.

Be sure that you have a physician ready and available for advice and consultation on matters of employee health.

The objectives of the medical requirements of OSHA (Form lB) are to ensure that:

- the employee's physical capabilities make him suitable for his job;

- the job does not endanger the employee's health; and

- proper medical services are provided in the event of an injury. The program described on the following pages has been developed to help fulfill these objectives.

An accurate system of medical records will facilitate achievement of these goals. Records for each employee should include the date of job placement and a complete history of his or her health maintenance and rehabilitation.[1]

Motor vehicle safety programs

Safe operation of motor vehicles is the result of safety planning and actions. The principal factors of motor vehicle accidents are driver failure and vehicle failure. OSHA will be concerned with both of these factors.

Transportation safety is an issue that interests

Some kind of medical facility must be available

[1] A "Guide to Development of an Occupational Medical Record System" is available from The American Medical Association, 535 North Dearborn Street, Chicago, Illinois 60610.

**Vehicle
accidents are
a leading
cause of
work-related
death**

agencies other than OSHA, though. In this section, we'll consider guidelines set up by the National Highway Traffic Safety Administration, the Department of Transportation and other government agencies. The purpose of flooding all these regulatory agencies into such a short space is to provide you the broadest perspective on setting up a transportation safety program.

Motor vehicle accidents continue to be the leading cause of work-related deaths. According to 1992 figures from the National Highway Traffic Safety Administration, on-the-job motor vehicle accidents cost employers more than $40 billion a year.

Therefore, you should establish a motor vehicle safety program as well as a shop safe practices program. Be sure to include specific information on driver selection, training, and supervision; (b) safety meetings; (c) preventative maintenance; (d) fleet accident data; and (e) department of transportation requirements.

The following criteria are useful for selecting drivers. The employee:

- should be at least twenty-one (21) years old,

- should be checked out and must be qualified to operate the type of equipment assigned,

- must undergo physical examinations to meet DOT regulations,

- must hold a current and valid operator's license, and

- must have an acceptable past driving record. Past violations if any should be investigated.

For the safe operation of a fleet of road vehicles, regardless of how small, a training program is needed. The following procedures can serve as the core of any good safety program:

- maintain written records of all employee training,

- arrange to have several of your drivers attend a Driver's Training School (for details,

contact your local Trucking Association),

- the trained drivers should then be used to train the balance of the present drivers,

- all new drivers should be trained by your training officers,

- the standard driver's test used by the DOT should be incorporated in your program. This can be used by the training officers.

One person in the organization should be assigned the responsibility to supervise the operations of all commercial equipment. His or her duties should be to:

- assign loads,

- route drivers,

- plan loads and delivery,

- keep written daily records of the operations of all trucks,

- see that drivers maintain logs when required, and

- maintain a complete accident record file.

Safety meetings should be held for truck drivers at least quarterly. Drivers should be required to attend all safety meetings. Programs for the meetings should include outside traffic authority. Vehicle accidents for the past quarter should be reviewed, and hazards of the season should be stressed.

A complete preventative maintenance program should be installed. This should cover all equipment.

The fleet supervisor should implement the program and keep records for daily checks. The details for this type of program are available from: truck dealers, trucking associations, and insurance companies. A qualified mechanic should make these checks.

Fleet accident data should be maintained with records as complete as those for personal in-

Preventive maintenance programs should be in effect

jury. Accidents must be analyzed as to cause and steps must be taken to eliminate the cause, thereby preventing future accidents with similar causes.

The fleet safety record should be included in the Safety Committee agenda. All drivers should be aware of the company fleet safety record.

Refer to the DOT Manual for all applicable requirements. The trucks that come under these rules should conform to DOT Regulations for safety equipment and logging.[2]

Assessing your safety and health program

The following checklist will help you to establish the effectiveness of your jobsite safety and health program. It will also help you to establish a paper trail in the event of an OSHA inspection.

[2] Copies of the DOT Safety Regulations, as well as the necessary forms, should be obtained by the Safety Coordinator. Forms are available from the American Trucking Association, Safety Dept. 2200 Mill Road, Alexandria, VA 22314. (703) 838-1700. The record-keeping requirements will justify appointing a fleet supervisor.

✔ Job safety and health program assessment checklist

Overall workplace policy reflecting safe and healthful working conditions

	Yes	No

Do you have a written policy in place?

Does it rank worker safety and health as a priority in relations to other company values?

When asked, can all employees tell you what the safety and health policy is, and how it fits in with the company's core values or mission?

Can employees tell you where it's posted in the workplace?

Have injuries occurred because employees have emphasized other company organizational values, such as production, over workplace safety and health?

Goals and objectives for protecting workers

Is there a written goal for your safety and health program?

Are these goals updated annually?

Are written objectives clearly stated?

Do managers and supervisors understand their objectives in meeting safety and health goals?

Do employees understand the objectives?

The role of top management

Are there written programs that involve top management in safety and health activities, e.g. inspection sign offs?

Can employees describe how management is involved in the overall safety and health program?

Do all employees perceive that managers and supervisors follow the same safety and health rules, as they are expected to?

When employees have violated onsite safety or health requirements, have they stated that management also violate similar rules?

The role of employees

Are there one or more written programs that allow employees to provide input on work-related safety and health decisions?

	Yes	No

Is documentation provided for those activities, such as employee inspection reports, minutes of joint employee-management, or employee committee meetings?

Is there written documentation of any management response to employee safety and health program activities?

Are there written guarantees of protection for employees from possible harrassment resulting from safety and health program activities?

Are employees aware of the ways they can be involved in decisions affecting workplace safety and health?

Are employees comfortable answering questions pertaining to the site safety and health program?

Do employees feel they have the support of management?

Assigment of responsibilities

Are responsibilities written out so they can be clearly understood?

Do employees understand their own responsibilities and the responsibilities of others?

Was an overlooked hazard due in part to the fact that no employee was assigned responsibility to control or prevent it?

Establishment of authority

Do safety staff members or any other workers have responsibilities to ensure the safe operation of equipment—but not the authority to shut the equipment down, or provide maintenance?

Do employees discuss costs as being the reason safety and health improvements are not made?

Do employees mention the need for additional, or more experienced safety and health personnel?

Do recognized hazards remain unabated because of a lack of authority to correct them?

Are there unrecognized hazards due to a lack of expertise necessary to identify such hazards?

Accountability

	Yes	No

Do all line manager and supervisor performance evaluations include specific safety and health protection criteria?

Is there documentation to support instances where employees at all levels have been held accountable for safety and health responsibilities?

How has this been documented (pay cuts, performance evaluation, disciplinary action, etc.)?

When asked, do employees indicate that they are held accountable, in a clear and consistent manner for breaking health and safety rules?

Do employees complain that managers and supervisors are not held to the same standards, or level of accountability, as they are with regard to following health and safety rules?

Are hazards in existence due to employees, managers or supervisors not being held accountable for their responsibilities?

Evaluating program operations

Is there a written evaluation of each major part of the program that lists what is being done, evaluates how effective it is against the goal and objectives, and recommends changes where necessary to make the program more effective?

Can all employees state how the program is evaluated and revised each year?

Assessing workplace hazard analysis

Are there documents that establish completed analysis of potential safety and health hazards?

Are there documents that provide updated hazard information for new sites, equipment, and processes—and the means implemented to abate those hazards?

Is the step-by-step analysis of the hazards in each part of each job documented?

If there are complicated processes with the potential for serious accidents or catastrophes, are there documents analyzing potential hazards in each part of the processes, and the means to abate them?

	Yes	No

Are "fault tree" or "what if" scenarios documented to provide backup systems in the event that one or more hazard controls fail?

Do employees complain of hazards related to new facilities, equipment, or processes?

Do any employees say that they have been involved in job safety analysis or process review and are satisfied with the results?

Does the safety and health staff indicate ignorance of existing or potential hazards?

Does the occupational health professional (doctor, nurse, health care provider) understand the potential work-related diseases or health risk presented in the workplace?

Have hazards appeared where no one in management realized there was a potential for their development?

Where workers have followed job procedures faithfully, have accidents or near misses occurred because of hidden hazards?

Have hazards been discovered in the design of new facilities, equipment, materials, or processes after use was begun?

Site safety and health inspections

If inspection reports are written, do they show that inspections are done on a regular basis?

Are hazards uncovered during inspections tracked to complete abatement?

Are there instances where a relationship or link can be established between hazards found in an inspection and responsible employees?

Do employees indicate that the inspections thay have witnessed are thorough?

Are the hazards discovered during an accident investigation or near miss ones that should have been identified and corrected during the inspection process?

Employee reports of hazards

Is there a system in place for providing written hazard reports?

	Yes	No

Are valid hazards identified by employees abated in an expedient manner?

Do employees know whom to contact and what to do if they see something they believe to be hazardous?

Do employees feel that responses to their hazard reports are timely and adequate?

Do employees state that sometimes reported hazards are ignored?

Do employees mention that they or other employees have been harrassed for reporting hazards?

When hazards are found, are there instances when employees state that they have been complaining about them for a long time but no one has done anything about them?

Are hazards ever uncovered that should have been recognized by employees but were never reported?

Accident and near-miss investigations

Do accident investigation reports show a thorough analysis of the cause of accidents?

Are near-misses investigated using the same techniques as accident investigations?

Are hazards identified as contributing to accidents or near-misses tracked to abatement?

Do employees understand and accept the results of accident and near-miss investigations?

Do employees mention a tendency on management's part to blame the injured employee?

Injury and illness pattern analysis

In addition to required OSHA log injury illness record-keeping requirements, are careful records kept of first aid injuries and illnesses that might not immediately appear to be work-related?

Is there any periodic, written analysis of the patterns of near-misses, injuries, and/or illness over time to determine whether there are previously unrecognized connections between them and unrecognized hazards?

	Yes	No

If there is an occupational nurse or doctor on site or if employees are encouraged to take ordinary illness to a nearby health care provider, are the lists of those visits analyzed to see if there are any clusters of illness that might be work related?

✗ Hazard prevention and control

If there are documented surveys to assess engineering controls, work practices, personal protective equipment, and administrative controls, are they accompanied by a plan for systematic prevention or control?

If there is a written plan, does it show the best method of hazard protection was chosen?

Are there written safe work procedures?

If respirators are used, is there a written respirator program?

Do employees say they have been trained in and have ready access to reliable safety work procedures?

Do employees complain of difficulties completing work due to unwieldy controls meant to protect them?

Do employees complain of difficulties completing work due to interference from personal protective equipment, work practices, or engineering controls?

Do employees who use personal protective equipment understand why they use it and how to maintain it?

Do employees who use personal protective equipment indicate that the rules for PPE are evenly enforced?

Do employees indicate that safe work procedures are evenly enforced?

Do you ever find that controls meant to protect workers actually put them at risk, or don't provide enough protection?

Are employees involved in unsafe practices or creating unsafe conditions because rules are not enforced?

Are employees wearing PPE properly and without exception?

✳ Facility and equipment preventive maintenance

	Yes	No

Is there a preventive maintenance schedule that provides timely maintenace of the facilities and equipment?

Is there a documented record of when maintenance was performed that shows the schedule was adhered to?

Do maintenance request records show a pattern of certain facilities or equipment needing repair or breaking down before maintenance was scheduled or completed?

Do any accident/incident investigations list facility or equipment breakdown as a major cause?

Do employees mention difficulty with improperly functioning equipment or facilities in poor repair?

Do maintenance employees feel that the preventative maintenance system is working well?

Do employees feel that hazard controls needing maintenance are properly cared for?

Is poor maintenance a frequent source of hazards?

Are hazard controls in good working order?

Does equipment appear to be in good working order?

Planning and preparing for emergencies

Are there written procedures that clearly cover every likely emergency with clear evacuation routes, assembly points, and emergency telephone numbers?

Can employees tell you exactly what they are supposed to do in case of any type of emergency?

Have hazards occurred in actual or simulated emergencies due to employee confusion on what to do?

In larger workplaces, are emergency evacuation routes clearly marked?

Are emergency telephone numbers and fire alarms easy to find?

Establishing a medical program

Are good, clear records kept of medical testing and assistance?

	Yes	No

Do employees say that test results have been explained to them?

Do employees feel that more first aid or CPR-trained personnel should be available?

Are employees satisfied with the medical arrangements at or for the site?

Does the occupational health care provider understand the potential hazards of the workplace so that illness symptoms can be recognized?

Have further injuries or worsening of injuries occurred because proper medical assistance—including trained first aid and CPR was not readily available?

Have occupational illnesses gone undetected due to no one with occupational health training reviewing employee symptoms as part of the medical program?

Safety and health training

In order to establish that all employees understand hazards, does the written training program include complete training for every employee in every potential hazard to which each employee may be exposed in emergency procedures?

Do training records show that every employee received the planned training?

Do the written evaluations of training indicate that the training was successful and the employee learned what was intended?

Can employees tell you what hazards they are exposed to, why those hazards are a threat, and how they can help protect themselves and other from those hazards?

If PPE is used, can employees explain why they use it and how to use and maintain it?

Do employees feel that health and safety training is adequate?

Have employees been hurt or made ill by hazards they were unaware of, did not understand the danger, or did not know how to protect themselves?

	Yes	No

Have employees or rescue workers ever been endangered by an employee's lack of knowledge about what to do or where to go in any type of emergency situation?

Are there instances where employees have not worn PPE because they were not properly trained?

Supervisor responsibilities

Do training records indicate that all supervisors have been trained in their responsibilities to analyze work under their supervision for unrecognized hazards, to maintain physical protection, and to reinforce employee training through performance feedback?

Are supervisors aware of their responsibilities?

Do employees say that supervisors are carrying out their duties?

Has supervisor lack of understanding of health and safety responsibilities played a part in creating a hazardous condition?

Manager responsibilities

Do training plans and training records indicate that training for safety and health responsibilities is part of the training that managers receive and that all line managers receive it?

Do employees indicate that managers know and carry out their safety and health responsibilities?

Has managerial lack of understanding of safety and health responsibilities played a part in creating hazardous activities and conditions?

CHAPTER 6

THE MOST FREQUENTLY VIOLATED OSHA STANDARDS

Introduction

Employers usually ask for a list of those standards most often cited. OSHA's hazard communication standard heads the June 1995 list which reflects OSHA inspection data from 1994. The lockout/tagout standard—which applies to machines being serviced or repaired—is also a common problem.

Most of the violations on this list share one common—and hopeful—theme: They don't require a lot of money to rectify. In fact, seven of these ten items really require time and attention more than cash as a solution.

In this chapter, we'll look at OSHA's hit list from the summer of 1995. We'll explain why each of these items is a problem. Finally, we'll look at a couple of examples of how employers get into each kind of trouble—and how the smart ones got out.

The list

1. Hazard communication—failure to develop an adequate written plan (1910.1200 (e)(1)).

2. Hazard communication—failure to provide employee information and training (1910.1200 (h)).

3. Lockout/tagout—failure to establish an energy control program (procedures and employee training) to prevent injuries from unexpected energization of equipment (1910.147 (c)(1)).

4. Machine guarding—failure to guard employees from point of operation hazards (1910.212 (a)(1)).

5. Abrasive wheel machinery—failure to guard abrasive wheels (1910.215 (b)(9)).

6. Hazard communication—failure to label containers of hazardous chemicals with the identity of the chemicals (1910.1200 (f)(5)(i)).

7. Hazard communication—failure to obtain a material safety data sheet for hazardous chemicals (1910.1200 (g)(1)).

8. Medical services/first aid—failure to provide eye/body wash equipment where employees are exposed to corrosives (1910.151 (c)).

9. Hazard communication—failure to label containers of hazardous chemicals with appropriate warnings (1910.1200 (f)(5)(ii)).

10. Mechanical power transmission—failure to guard pulleys (1910.219 (d)(1)).

Other common violations

Also frequently cited are requirements to maintain a log and summary of occupational injuries and illnesses (1904.2 (a)), to post the OSHA poster (1903.2 (a)(1)) and the employer's general obligation to provide a workplace free of recognized hazards (Section 5(a)(1)) of the Occupational Safety and Health Act of 1970).

Hazard communication

As you can see, provisions from OSHA's hazard communication standard represent the lion's share of the agency's top ten citations. There are two reasons why. The first is that OSHA takes a broad brush approach to the classification of hazardous materials. Virtually any employer who stores household cleaning products falls under the aus-

pices of the hazcom standard. Secondly, OSHA considers <u>chemical exposure to be a serious threat to workers and has always placed particular emphasis on this standard when conducting inspections</u>. Since violations of the hazcom standard make up numbers 1,2,6,7 and 9 of OSHA's top ten list—they will be consolidated and discussed together.

Communication standards are intended to keep employees informed

The intent of the hazard communication standard is to ensure that employers and employees know about chemical hazards and how to protect themselves. By assigning employees the "right to know" about the potential dangers of chemical exposure, OSHA hopes to reduce the incidence of chemical source illnesses and injuries.

The 1995 OSHRC decision *Secretary of Labor v. Well Solutions Inc.* considered an example of an employer's failure to provide employee information and training.

In 1990, four employees of Well Solutions were changing the pump on a relatively new oil well that was being drilled in the South Texas town of Dilley. The crew was drilling horizontally in Austin Chalk, a geological formation in that area. A rig supervisor was making the rounds on that particular day but was not assigned to a particular rig.

The crew was in the process of changing the pump when a rig blowout occurred. Oil started flowing into the rig. The crew tried to stop it, but the oil very quickly rose to a height of 20 or 30 feet. The crew tried to shut the well off by bolting down a flange—but this effort was stopped by an ensuing fire.

Two employees died in the fire and two others suffered third-degree burns over much of their bodies.

A blowout prevention (BOP) device that takes 45 minutes to install had been brought to the site that morning by Well Solution—but it hadn't been installed. (The burn victims later testified that the customer told them not to use the BOP because he did not want to pay for the $200 required to install it.)

141

Drilling company is fined for failure to train first aid

Well Solutions was cited for violating the General Duty Clause. An adminstrative law judge ruled that the hazard of a blowout was recognized in the well-servicing industry and that Well Solutions could have materially reduced this hazard through the use of a BOP device.

The ALJ also cited Well Solutions for violating the first aid requirements of the OSH Act because no one at the remote oil well site throughout the time the crew was working there had been trained in first aid. This was required because there was no medical facility nearby. The ALJ quoted the Act:

> In absence of infirmary, clinic, or hospital in near proximity to the workplace which is used for the treatment of all injured employees a person or persons shall be adequately trained to render first aid....

Well Solutions didn't try to rebut OSHA's claim—instead, it argued that OSHA didn't make sufficient effort to determine whether two deceased workers had been trained in first aid. The ALJ ruled that, "while testimony of deceased workers would have been the best evidence," OSHA had offered sufficient evidence to establish a prima facie showing of violation. OSHA's evidence was not overwhelming but was "sufficient in absence of rebuttal."

OSHA had also cited Well Solutions for violating the hazard communication elements of the OSH Act because it did not train its employees in measures they should have taken to protect themselves from chemical hazards they faced while performing well servicing—such as the expulsion of crude oil and methane gas during a blowout. Again, the ALJ cited the Act:

> ...employers shall provide employees with ...training on hazardous chemicals in their work area at the time of their initial assignment, and whenever a new hazard is introduced....

> ...Employee training must include...measures employees can take to protect themselves from those hazards, including specific procedures

the employer has implemented to protect employees from exposure to hazardous chemicals, such as appropriate work practices, emergency procedures, and personal protective equipment to be used.

Well Solutions appealed the decision, but OSHRC upheld the ALJ's findings. It ruled that OSHA only needs to prove that one employee was not properly trained. The rig supervisor had testified that he had never received any training relating to the hazardous chemicals with which he worked. Though the rig supervisor had not been assigned to the particular crew at the well, he did count as an employee at the site. Even more: Because he was a supervisor, the fact he was untrained indicated a lax safety program.

OSHRC upheld a $9,000 penalty for the general duty clause violation and $700 for each of the two other hazard communication violations.

The following guidelines and samples will help you to comply with the standard. In addition, a plain English, question and answer checklist of OSHA's hazard communication standard will follow.

1. Read the standard to understand the requirements and to know your responsibility as an employer.

2. List the hazardous chemicals in your workplace.

✳Walk around the workplace, read all container labels, and list the identity of all materials that may be hazardous; the manufacturer's product name, location, and telephone number; and the work area where the product is used. Be sure to include hazardous chemicals that are generated in the work operation but are not in a container (e.g., welding fumes).

✓ Check with your purchasing department to ensure that all hazardous chemicals purchased are on your list.

✓ Review your list and determine whether any substances are exempt (see paragraph (b) of the rule for exemptions).

An MSDS is a crucial part of a safety program

Establish a file on hazardous chemicals used in your workplace, and include a copy of the latest Material Safety Data Sheet (MSDS), and any other pertinent information.

Develop procedures to keep your list current. When new substances are used, add them to your list.

3. Obtain material safety data sheets for all chemical substances.

If you do not have an MSDS for a hazardous substance in your workplace, request a copy from the chemical manufacturer, distributer or importer as soon as possible. An MSDS must accompany or precede the shipment and must be used to obtain identifying information such as the chemical name and the hazards of a particular substance.

Review each MSDS to be sure that it is complete and clearly written. The MSDS must contain the physical and chemical properties of a substance, as well as the physical and health hazards, routes of exposure, precautions for safe handling and use, emergency and first aid procedures, and control measures.

If the MSDS is incomplete or unclear, contact the manufacturer or importer to get clarification on the missing information.

Make sure the MSDS is available to employees, designated representatives, and to OSHA.

4. Make sure that all containers are labeled.

The manufacturer, importer or distributor is responsible for labeling containers, but the employer must adhere to the following: Ensure that all containers of hazardous substances in the workplace are labeled, tagged or marked and include the identity of the hazardous chemical, and the appropriate hazard warnings. Container labels for purchased chemicals must also include the name and address of the chemical manufacturer, importer, or other responsible party.

Check all incoming shipments of hazardous chemicals to be sure that they are labeled.

If a container is not labeled, obtain a label or the label information from the manufacturer, importer, or other responsible party or prepare a label using information obtained from these sources. Employers are responsible for ensuring that containers in the workplace are labeled, tagged, or marked.

Do not remove or deface existing labels on containers unless the container is immediately marked with the required information.

Instruct employees on the importance of labeling portable receptacles into which they have poured hazardous substances. If the portable container is for their immediate use, then the container does not have to be labeled.

5. Develop and implement a written hazard communication program.

This progam must include:

- container labeling and other forms of warnings;

- material safety data sheets;

- employee training based on the list of chemicals, MSDS's, and labeling information; and

- methods for communicating hazards and protective measures to employees and others.

The following is a sample MSDS sheet, sample letter requesting an MSDS, sample Sign-off Statement, and a Hazard Communication Employee Information and Training Schedule/Log.

Label, tag and mark container with relevant hazard information

MATERIAL SAFETY DATA SHEET

Required under USDL Safety and Health Regulations for Ship Repairing,
Shipbuilding, and Shipbreaking (29 CFR 1915, 1916, 1917)

SECTION I

MANUFACTURER'S NAME	EMERGENCY TELEPHONE NO.
ADDRESS (Number, Street, City, State, and Zip Code)	

CHEMICAL NAME AND SYNONYMS	TRADE NAME AND SYNONYMS
CHEMICAL FAMILY	FORMULA

SECTION II — HAZARDOUS INGREDIENTS

PAINTS, PRESERVATIVES, & SOLVENTS	%	TLV (Units)	ALLOYS AND METALLIC COATINGS	%	TLV (Units)
PIGMENTS			BASE METAL		
CATALYST			ALLOYS		
VEHICLE			METALLIC COATINGS		
SOLVENTS			FILLER METAL PLUS COATING OR CORE FLUX		
ADDITIVES			OTHERS		
OTHERS					

HAZARDOUS MIXTURES OF OTHER LIQUORS, SOLIDS, OR CASES	%	TLV (Units)

SECTION III — PHYSICAL DATA

BOILING POINT (°F)		SPECIFIC GRAVITY (H_2O = 1)	
VAPOR PRESSURE (mm Hg.)		PERCENT, VOLATILE BY VOLUME (%)	
VAPOR DENSITY (AIR = 1)		EVAPORATION RATE (_____ = 1)	
SOLUBILITY IN WATER			
APPEARANCE AND ODOR			

SECTION IV — FIRE AND EXPLOSION HAZARD DATA

FLASH POINT (Method Used)	FLAMMABLE LIMITS	Lel	Uel
EXTINGUISHING MEDIA			
SPECIAL FIRE FIGHTING PROCEDURES			
UNUSUAL FIRE AND EXPLOSION HAZARDS			

SECTION V — HEALTH HAZARD DATA

THRESHOLD LIMIT VALUE

EFFECTS OF OVEREXPOSURE

EMERGENCY AND FIRST AID PROCEDURES

SECTION VI — REACTIVITY DATA

STABILITY	UNSTABLE		CONDITION TO AVOID	
	STABLE			

INCOMPATABILITY *(Materials to avoid)*

HAZARDOUS DECOMPOSITION PRODUCTS

HAZARDOUS POLYMERIZATION	MAY OCCUR		CONDITIONS TO AVOID
	WILL NOT OCCUR		

SECTION VII — SPILL OR LEAK PROCEDURES

STEPS TO BE TAKEN IN CASE MATERIAL IS RELEASED OR SPILLED

WASTE DISPOSAL METHOD

SECTION VIII — SPECIAL PROTECTION INFORMATION

RESPIRATORY PROTECTION *(Specify type)*

VENTILATION	LOCAL EXHAUST	SPECIAL
	MECHANICAL *(General)*	OTHER

PROTECTIVE GLOVES	EYE PROTECTION

OTHER PROTECTIVE EQUIPMENT

SECTION IX — SPECIAL PRECAUTIONS

PRECAUTIONS TO BE TAKEN IN HANDLING AND STORING

OTHER PRECAUTIONS

SAMPLE LETTER REQUESTING AN MSDS

Acme Manufacuring Company
P.O. Box 9955
Santa Monica, CA 90406

Dear Sir:

The Occupational Safety and Health Administration (OSHA) Hazard Communication Standard requires employers be provided Material Safety Data Sheets (MSDSs) for all hazardous substances used in their facility, and to make these MSDSs available to employees potentially exposed to these hazardous substances.

We, therefore, request a copy of the MSDS for your product listed as Stock Number _____.

We did not receive an MSDS with the initial shipment of the_____ _____ we received from you on June 30. We also request any additional information, supplemental MSDS's, or any other relevant data that your company or supplier has concerning the safety and health aspects of this product.

Please consider this letter a standing request to your company for any information concerning the safety and health aspects of using this product that may become known in the future.

The MSDS and any other relevant information should be sent to use within 10, 20, 30 days (select appropriate time). Delays in receiving the MSDS information may prevent use of your product. Please send the requested information to Mr. Eddie Jondo, Safety and Health Manager, XYZ Corporation, Boston, MA 02109.

Please be advised that if we do not receive the MSDS on the above chemical by (date), we may have to notify OSHA of our inability to obtain this information. It is our intent to comply with all provisions of the Hazard Communication Standard and the MSDSs are integral to this effort.

Your cooperation is greatly appreciated. Thank you for your timely response to this request. If you have any questions concerning this matter, please contact Mr. Jondo on (phone number).

<div align="right">

Sincerely,

Joseph Smith
XYZ Company

</div>

SAMPLE SIGN-OFF STATEMENT

I have received information on the Hazard Communication Standard 29 CFR 1910.1200, and understand how to interpret and to use the labeling systems and Material Safety Data Sheets (MSDSs) that are in use and accessible to me in my work area. I agree to observe and follow safe work practices as presented to me in the training sessions I attended on _____

_____ at _____

_____ .

_____ _____

Employee Signature Date

The above named employee has been informed and instructed by _____

_____ on safe work practices, chemical hazard recognition, interpretation and use of chemical labels, MSDSs, the CFR 29 1910.1200(e) Standard, and the location at which these items are accessible to the employee.

_____ _____

Supervisor or Foreman Date

SAMPLE SIGN-OFF STATEMENT (SPANISH)

Yo he recebido informacion sobre Comunication de Peligros Estandarte 29 CFR 1910.1200, y comprendo como usar y interpretar los systemas de marqueo junto con las Hojas de Datos sobre Seguridad (MSDS), que se encuentran en uso y accessible en me area de trabajo. Yo estoy de acuerdo a observar y seguir las practicas seguras presentadas a mi en la sesion de entrenamieno attendida este dia, _____

en _____ .

_____ _____

Firma de Empleado Fecha

El empleado nombrado anterior, a sido informado y instruido por_____

en las practicas seguras, a reconozer peligros de quimicas, la interpretacion y uso de las etiquetas quemica, MSDS, la CFR 29 1910.1200 (e) Estandarte, y la locacion en donde estos articulos son accessible a los empleados.

_____ _____

Supervisor o Mayordormo Fecha

HAZARD COMMUNICATION EMPLOYEE INFORMATION AND TRAINING SCHEDULE/LOG

Department _____ Manager/Supervisor _____

(Enter date(s) education/training sessions are scheduled for or attended)

EMPLOYEE NUMBER	EMPLOYEE NAME	GENERAL INFO. HAZARD COMM. STANDARD	HAZARD RECOGNITION	LABELING AND MSDS	PERSONAL PROTECTION PROCEDURES	SAFE OPERATIONS	EMERGENCY PROCEDURES

(Other topics or comments —divide as needed)

1910.1200 — HAZARD COMMUNICATION

(a) Purpose

NOTE: The purpose of this section is to make certain that the hazards of all chemicals produced or imported are evaluated, and that information concerning their hazards is passed on to employers and employees. The passing on information is to be accomplished by means establishing comprehensive hazard communication programs, which are to include container labeling and other forms of warning, material safety data sheets and employee training. **(a)(1)**

NOTE: This standard is intended to address the issue of evaluating the potential hazards of chemicals, and communicating information concerning hazards and appropriate protective measures to employees, and to preempt any legal requirements of a state, or political subdivision of a state, pertaining to this subject. Evaluating the potential hazards of chemicals, and communicating information concerning hazards and appropriate protective measure to employees, may include, for example, but is not limited to, provisions for:

- Developing and maintaining a written hazard communication program for the workplace, including lists of hazardous chemicals present;

- Labeling of containers of chemicals in the workplace, as well as of containers of chemicals being shipped to other workplaces;

- Preparation and distribution of material safety data sheets to employees and downstream employers; and

- Development and implementation of employee training programs regarding hazards of chemicals and protective measures. **(a)(2)**

Under section 18 of the Act, no state or political subdivision of a state may adopt or enforce, through any court or agency, any requirement relating to the issue addressed by this Federal standard, except pursuant to a Federally-approved state plan. **(a)(2)**

(b) Scope and Application

NOTE: This section requires chemical manufacturers or importers to examine and identify the hazards of chemicals which they produce or import. This section also requires all employers to provide information to their employees about the hazardous chemicals to which they are exposed, by means of a hazard communication program, labels and other forms of warning, material safety data sheets, and information and training. In addition, this section requires distributors to transmit the required information to employers. **(b)(1)**

NOTE: Employers who do not produce or import chemicals need only focus on those parts of this rule that deal with establishing a workplace program and communicating information to their workers. Appendix E of this section is a general guide for such employers to help them determine their compliance obligations under the rule. **(b)(1)**

1910.1200 — HAZARD COMMUNICATION

NOTE: This section applies to any chemical which is known to be present in the workplace in such a manner that employees may be exposed under normal conditions of use or in a foreseeable emergency. **(b)(2)**

NOTE: This section applies to laboratories only as follows: **(b)(3)**

Do employers ensure that labels on incoming containers of hazardous chemicals are not removed or defaced? **(b)(3)(i)**

Do employers maintain any material safety data sheets that are received with incoming shipments of hazardous chemicals, and make certain that they are readily accessible to laboratory employees when they are in their work areas? **(b)(3)(ii)**

Do employers make certain that laboratory employees are informed of the hazards of the chemicals in their workplaces in accordance with paragraph (h) of this section, except for the location and availability of the written hazard communication program under paragraph (h)(2)(iii) of this section? **(b)(3)(iii)**

Do laboratory employers that ship hazardous chemicals and are considered to be either a chemical manufacturer or a distributor under this rule, guarantee that any containers of hazardous chemicals leaving the laboratory are labeled in accordance with paragraph (f)(1) of this section, and that a material safety data sheet is provided to distributors and other employers in accordance with paragraphs (g)(6) and (g)(7) of this section? **(b)(3)(iv)**

NOTE: In work operations where employees only handle chemicals in sealed containers which are not opened under normal conditions of use (such as are found in marine cargo handling, warehousing, or retail sales), this section applies to these operations only as follows: **(b)(4)**

Do employers ensure that labels on incoming containers of hazardous chemicals are not removed or defaced? **(b)(4)(i)**

Do employers maintain copies of any material safety data sheets that are received with incoming shipments of the sealed containers of hazardous chemicals? **(b)(4)(ii)**

Do employers obtain a material safety data sheet for sealed containers of hazardous chemicals received without this data sheet if an employee requests such a sheet? **(b)(4)(ii)**

Do employers make certain that the material safety data sheets are readily accessible during each work shift to employees when they are in their work area(s)? **(b)(4)(ii)**

Do employers make certain that employees are provided with information and training in accordance with paragraph (h) of this section (except for the location and availability of the written hazard communication pro-

OSHA COMPLIANCE MANANUAL FOR GENERAL INDUSTRY

1910.1200 — HAZARD COMMUNICATION

gram under paragraph (h)(2)(iii), to the extent necessary to protect them in the event of a spill or leak of a hazardous chemical from a sealed container? **(b)(4)(iii)**

NOTE: This section does not require labeling of the following chemicals: **(b)(5)**

Any pesticide as defined in the Federal Insecticide, Fungicide, and Rodenticide Act (7 U.S.C. 136 et seq.), when subject to the labeling requirements of that Act and labeling regulations issued under that Act by the Environmental Protection Agency; **(b)(5)(i)**

Any chemical substance or mixture as defined in the Toxic Substances Control Act (15 U.S.C. 2601 et seq.), when subject to the labeling requirements of that Act and labeling regulations issued under that Act by the Environmental Protection Agency; **(b)(5)(ii)**

Any food, food additive, color additive, drug, cosmetic, or medical or veterinary device or product, including materials intended for use as ingredients in such products (e.g. flavors and fragrances), as such terms are defined in the Federal Food, Drug, and Cosmetic Act (21 U.S.C. 301 et seq.) or the Virus-Serum-Toxin Act of 1913 (21 U.S.C. 151 et seq.), and regulations issued under those Acts, when they are subject to the labeling requirements under those Acts by either the Food and Drug Administration or the Department of Agriculture; **(b)(5)(iii)**

Any distilled spirits (beverage alcohols), wine, or malt beverage intended for nonindustrial use, as such terms are defined in the Federal Alcohol Administration Act (27 U.S.C. 201 et seq.) and regulations issued under that Act when subject to the labeling requirements of that Act and labeling regulations issued under that Act by the Bureau of Alcohol, Tobacco, and Firearms; **(b)(5)(iv)**

Any consumer product or hazardous substance as those terms are defined in the Consumer Product Safety Act (15 U.S.C. 2051 et seq.) and Federal Hazardous Substances Act (15 U.S.C. 1261 et seq.) respectively, when subject to a consumer product safety standard or labeling requirement of those Acts, or regulations issued under those Acts by the Consumer Product Safety Commission; and **(b)(5)(v)**

Agricultural or vegetable seed treated with pesticides and labeled in accordance with the Federal Seed Act (7 U.S.C. 1551 et seq.) and the labeling regulations issued under that Act by the Department of Agriculture. **(b)(5)(vi)**

NOTE: This section does not apply to: **(b)(6)**

Any hazardous waste as defined by the Solid Waste Disposal Act, as amended by the Resource Conservation and Recovery Act of 1976, as amended (42 U.S.C. 6901 et seq.), when subject to regulations issued under that Act by the Environmental Protection Agency; **(b)(6)(i)**

1910.1200 — HAZARD COMMUNICATION

Any hazardous substance as such term is defined by the Comprehensive Environmental Response, Compensation, and Liability Act (CERCLA)(42 U.S.C. 9601 et seq.), when the hazardous substance is the focus of remedial or removal action being conducted under CERCLA in accordance with the Environmental Protection Agency regulations; **(b)(6)(ii)**

Tobacco or tobacco products; **(b)(6)(iii)**

Wood or wood products, including lumber which will not be processed, where the chemical manufacturer or importer can establish that the only hazard they pose to employees is the potential for flammability or combustibility (wood or wood products which have been treated with a hazardous chemical covered by this standard, and wood which may be subsequently sawed or cut, generating dust, are not exempted); **(b)(6)(iv)**

Articles (as that term is defined in paragraph (c) of this section); **(b)(6)(v)**

Food or alcoholic beverages which are sold, used, or prepared in a retail establishment (such as a grocery store, restaurant, or drinking place), and foods intended for personal consumption by employees while in the workplace; **(b)(6)(vi)**

Any drug, as that term is defined in the Federal Food, Drug, and Cosmetic Act (21 U.S.C. 301 et seq.), when it is in solid, final form for direct administration to the patient (e.g., tablets or pills); drugs which are packaged by the chemical manufacturer for sale to consumers in a retail establishment (e.g., over-the-counter drugs); and drugs intended for personal consumption by employees while in the workplace (e.g., first aid supplies); **(b)(6)(vii)**

Cosmetics which are packaged for sale to consumers in a retail establishment, and cosmetics intended for personal consumption by employees while in the workplace; **(b)(6)(viii)**

Any consumer product or hazardous substance, as those terms are defined in the Consumer Product Safety Act (15 U.S.C. 2051 et seq.) and Federal Hazardous Substances Act (15 U.S.C. 1261 et seq.) respectively, where the employer can show that it is used in the workplace for the purpose intended by the chemical manufacturer or importer of the product, and the use results in a duration and frequency of exposure which is not greater than the range of exposures that could reasonably be experienced by consumers when used for the purpose intended; **(b)(6)(ix)**

Nuisance particulates where the chemical manufacturer or importer can establish that they do not pose any physical or health hazard covered under this section; **(b)(6)(x)**

Ionizing and nonionizing radiation; and, **(b)(6)(xi)**

Biological hazards. **(b)(6)(xii)**

	Y E S	N O	N / A

1910.1200 — HAZARD COMMUNICATION

(c) Definitions

Definitions applicable to 1910.1200, Hazard communication:

Article. A manufactured item: (i) Which is formed to a specific shape or design during manufacture; (ii) which has end use function(s) dependent in whole or in part upon its shape or design during end use; and (iii) which under normal conditions of use does not release more than very small quantities, e.g., minute or trace amounts of a hazardous chemical (as determined under paragraph (d) of this section), and does not pose a physical hazard or health risk to employees.

Assistant Secretary. The Assistant Secretary of Labor for Occupational Safety and Health, U.S. Department of Labor, or designee.

Chemical. Any element, chemical compound or mixture of elements and/or compounds.

Chemical manufacturer. An employer with a workplace where chemical(s) are produced for use or distribution.

Chemical name. The scientific designation of a chemical in accordance with the nomenclature system developed by the International Union of Pure and Applied Chemistry (IUPAC) or the Chemical Abstracts Service (CAS) rules of nomenclature, or a name which will clearly identify the chemical for the purpose of conducting a hazard evaluation.

Combustible liquid. Any liquid having a flashpoint at or above 100 degrees F (37.8 degrees C), but below 200 degrees F (93.3 degrees C), except any mixture having components with flashpoints of 200 degrees F (93.3 degrees C), or higher, the total volume of which make up 99 percent or more of the total volume of the mixture.

Common name. Any designation or identification such as code name, code number, trade name, brand name or generic name used to identify a chemical other than by its chemical name.

Compressed gas.

- A gas or mixture of gases having, in a container, an absolute pressure exceeding 40 psi at 70 degrees F (21.1 degrees C); or **(i)**

- A gas or mixture of gases having in a container, an absolute pressure exceeding 104 psi at 130 degrees F (54.4 degrees C) regardless of the pressure at 70 degrees F (21.1 degrees C); **(ii)**

OR

- A liquid having a vapor pressure exceeding 40 psi at 100 degrees F (37.8 degrees C) as determined by ASTM D-323-72. **(iii)**

Container. Any bag, barrel, bottle, box, can, cylinder, drum, reaction vessel, storage tank, or the like that contains a hazardous chemical. For purposes of this section, pipes of piping systems, and engines, fuel tanks, or other operating systems in a vehicle, are not considered to be containers.

Designated representative. Any individual or organization to whom an employee gives written authorization to exercise such employee's rights under this section. A recognized or

1910.1200 — HAZARD COMMUNICATION

	Y E S	N O	N / A

certified collective bargaining agent shall be treated automatically as a designated representative without regard to written employee authorization.

Director. The Director, National Institute for Occupational Safety and Health, U.S. Department of Health and Human Services, or designee.

Distributor. A business, other than a chemical manufacturer or importer, which supplies hazardous chemicals to other distributors or to employers.

Employee. A worker who may be exposed to hazardous chemicals under normal operating conditions or in foreseeable emergencies. Workers such as office workers or bank tellers who encounter hazardous chemicals only in non-routine, isolated instances are not covered.

Employer. A person engaged in a business where chemicals are either used, distributed, or are produced for use or distribution, including a contractor or subcontractor.

Explosive. A chemical that causes a sudden, almost instantaneous release of pressure, gas, and heat when subjected to sudden shock, pressure, or high temperature.

Exposure or Exposed. When an employee is subjected in the course of employment (inhalation, ingestion, skin contact or absorption, etc.), and includes potential (e.g. accidental or possible) exposure. "Subjected" in terms of health hazards includes any route of entry (e.g. inhalation, ingestion, skin contact or absorption.)

Flammable. A chemical that falls into one of the following categories:

- *Aerosol, flammable.* An aerosol that, when tested by the method described in 16 CFR 1500.45, yields a flame projection exceeding 18 inches at full valve opening, or a flashback (a flame extending back to the valve) at any degree of valve opening:

- *Gas, flammable.*

 A gas that, at ambient temperature and pressure, forms a flammable mixture with air at a concentration of thirteen (13) percent by volume or less; or **(ii)(A)**

 A gas that, at ambient temperature and pressure, forms a range of flammable mixtures with air wider than twelve (12) percent by volume, regardless of the lower limit. **(ii)(B)**

- *Liquid, flammable.* Any liquid having a flashpoint below 100 degrees F (37.8 degrees C), except any mixture having components with flashpoints of 100 degrees F (37.8 degrees C) or higher, the total of which make up 99 percent or more of the total volume of the mixture.

- *Solid, flammable.* A solid, other than a blasting agent or explosive as defined in 1901.109(a), that is liable to cause fire through friction, absorption of moisture, spontaneous chemical change, or retained heat from manufacturing or processing, or which can be ignited readily and when ignited burns so vigorously and persistently as to create a serious hazard. A chemical shall be considered to be a flam-

	Y E S	N O	N / A

	Y E S	N O	N / A

1910.1200 — HAZARD COMMUNICATION

mable solid if, when tested by the method described in 16 CFR 1500.44, it ignites and burns with a self-sustained flame at a rate greater than one-tenth of an inch per second along its major axis.

Flashpoint. The minimum temperature at which a liquid gives off a vapor in sufficient concentration to ignite when tested as follows:

- Tagliabue Closed Tester (See American National Standard Method of Test for Flash Point by Tag Closed Tester, Z11.24-1979 [ASTM D 56-79]) for liquids with a viscosity of less than 45 Saybolt Universal Seconds (SUS) at 100 degrees F (37.8 degrees C), that do not contain suspended solids and do not have a tendency to form a surface film under test; or (i)

- Pensky-Martens Closed Tester (See American National Standard Method of Test for Flash Point by Pensky-Martens Closed Tester, Z11.7-1979 [ASTM D 93-79]) for liquids with a viscosity equal to or greater than 45 SUS at 100 degrees F (37.8 degrees C), or that contain suspended solids, or that have a tendency to form a surface film under test; or (ii)

- Setaflash Closed Tester (see American National Standard Method of Test for Flash Point by Setaflash Closed Tester [ASTMD 3278-78]). (iii)

NOTE: Organic peroxides, which undergo autoaccelerating thermal decomposition, are excluded from any of the flashpoint determination methods specified above.

Foreseeable emergency. Any potential occurrence such as, but not limited to, equipment failure, rupture of containers, or failure of control equipment which could result in an uncontrolled release of a hazardous chemical into the workplace.

Hazardous chemical. Any chemical which is a physical hazard or a health hazard.

Hazard warning. Any words, pictures, symbols, or combination thereof appearing on a label or other appropriate form of warning which convey the specific physical and health hazard(s), including target organ effects, of the chemical(s) in the container(s). (See the definitions for "physical hazard" and "health hazard" to determine the hazards which must be covered.)

Health hazard. A chemical for which there is statistically significant evidence based on at least one study conducted in accordance with established scientific principles that acute or chronic health effects may occur in exposed employees. The term "health hazard" includes chemicals which are carcinogens, toxic, or highly toxic agents, reproductive toxins, irritants, corrosives, sensitizers, hepatotoxins, nephrotoxins, neurotoxins, agents which act on the hematopoietic system, and agents which damage the lungs, skin, eyes, or mucous membranes. Appendix A provides further definitions and explanations of the scope of health hazards covered by this section, and Appendix B describes the criteria to be used to determine whether or not a chemical is to be considered hazardous for purposes of this standard.

1910.1200 — HAZARD COMMUNICATION

	Y E S	N O	N / A

Identity. Any chemical or common name which is indicated on the material safety data sheet (MSDS) for the chemical. The identity used shall permit cross-references to be made among the required list of hazardous chemicals, the label and the MSDS.

Immediate use. The hazardous chemical will be under the control of and used only by the person who transfers it from a labeled container and only within the work shift in which it is transferred.

Importer. The first business with employees within the Customs Territory of the United States which receives hazardous chemicals produced in other countries for the purpose of supplying them to distributors or employers within the United States.

Label. Any written, printed, or graphic material, displayed on or affixed to containers of hazardous chemicals.

Material safety data sheet (MSDS). <FS>Written or printed material concerning a hazardous chemical which is prepared in accordance with paragraph (g) of this section.

Mixture. Any combination of two or more chemicals if the combination is not, in whole or in part, the result of a chemical reaction.

Organic peroxide. An organic compound that contains the bivalent -O-O-structure and which may be considered to be a structural derivative of hydrogen peroxide where one or both of the hydrogen atoms has been replaced by an organic radical.

Oxidizer. A chemical other than a blasting agent or explosive as defined in 1910.109(a), that initiates or promotes combustion in other materials, thereby causing fire either of itself or through the release of oxygen or other gases.

Physical hazard. A chemical for which there is scientifically valid evidence that it is a combustible liquid, a compressed gas, explosive, flammable, an organic peroxide, an oxidizer, pyrophoric, unstable (reactive) or water-reactive.

Produce. To manufacture, process, formulate, blend, extract, generate, emit, or repackage.

Pyrophoric. A chemical that will ignite spontaneously in air at a temperature of 130 degrees F (54.4 degrees C) or below.

Responsible party. Someone who can provide additional information on the hazardous chemical and appropriate emergency procedures, if necessary.

Specific chemical identity. The chemical name, Chemical Abstracts Service (CAS) Registry Number, or any other information that reveals the precise chemical designation of the substance.

Trade secret. Any confidential formula, pattern, process, device, information or compilation of information that is used in an employer's business, and that gives the employer an opportunity to obtain an advantage over competitors who do not know or use it. Appendix D sets out the criteria to be used in evaluating trade secrets.

	Y E S	N O	N / A

	Y E S	N O	N / A

1910.1200 — HAZARD COMMUNICATION

Unstable (reactive). A chemical which in the pure state, or as produced or transported, will vigorously polymerize, decompose, condense, or will become self-reactive under conditions of shocks, pressure or temperature.

Use. To package, handle, react, emit, extract, generate as a byproduct or transfer.

Water-reactive. A chemical that reacts with water to release a gas that is either flammable or presents a health hazard.

Work area. A room or defined space in a workplace where hazardous chemicals are produced or used, and where employees are present.

Workplace. An establishment, job site, or project, at one geographical location containing one or more work areas.

(d) Hazard Determination

Do chemical manufacturers and importers evaluate chemicals produced in their workplaces or imported by them to determine if they are hazardous? **(d)(1)**

NOTE: Employers are not required to evaluate chemicals unless they choose not to rely on the evaluation performed by the chemical manufacturer or importer for the chemical to satisfy this requirement. **(d)(1)**

Do chemical manufacturers, importers or employers evaluating chemicals identify and consider the available scientific evidence concerning such hazards? **(d)(2)**

NOTE: For health hazards, evidence which is statistically significant and which is based on at least one positive study conducted in accordance with established scientific principles is considered to be sufficient to establish a hazardous effect if the results of the study meet the definitions of health hazards in this section. Appendix A shall be consulted for the scope of health hazards covered, and Appendix B shall be consulted for the criteria to be followed with respect to the completeness of the evaluation, and the data to be reported. **(d)(2)**

Does the chemical manufacturer, importer or employer evaluating chemicals treat the following sources as establishing that the chemicals listed in them are hazardous: **(d)(3)**

- 29 CFR part 1910, Subpart Z, Toxic and Hazardous Substances, Occupational Safety and Health Administration (OSHA); **(d)(3)(i)**

OR

- Threshold Limit Values for Chemical Substances and Physical Agents in the Work Environment, American Conference of Governmental Industrial Hygienists (ACGIH) (latest edition)? **(d)(3)(ii)**

NOTE: The chemical manufacturer, importer, or employer is still responsible for evaluating the hazards associated with the chemicals in these source lists in accordance with the requirements of this standard. **(d)(3)(ii)**

Do chemical manufacturers, importers and employers evaluating chemicals treat the following sources as establishing

1910.1200 — HAZARD COMMUNICATION

	Y E S	N O	N / A

that a chemical is a carcinogen or potential carcinogen for hazard communication purposes: **(d)(4)**

- National Toxicology Program (NTP), Annual Report on Carcinogens (latest editions); **(d)(4)(i)**
- nternational Agency for Research on Cancer (IARC) Monographs (latest editions); **(d)(4)(ii)**

OR

- 29 CFR part 1910, Subpart Z, Toxic and Hazardous Substances, Occupational Safety and Health Administration? **(d)(4)(iii)**

NOTE: The Registry of Toxic Effects of Chemical Substances published by the National Institute for Occupational Safety and Health indicates whether a chemical has been found by NTP or IARC to be a potential carcinogen.

Does the chemical manufacturer, importer or employer determine the hazards of mixtures of chemicals as follows: **(d)(5)**

- If a mixture has been tested as a whole to determine its hazards, are the results of such testing used to determine whether the mixture is hazardous? **(d)(5)(i)**
- If a mixture has not been tested as a whole to determine whether the mixture is a health hazard, is the mixture assumed to present the same health hazards as do the components which comprise one percent (by weight or volume) or greater of the mixture; **(d)(5)(ii)**

EXCEPTION: The mixture shall be assumed to present a carcinogenic hazard if it contains a component in concentrations of 0.1 percent or greater which is considered to be a carcinogen under paragraph (d)(4) of this section. **(d)(5)(ii)**

- If the mixture contains a component in concentrations of 0.1 percent or greater which is considered to be a carcinogen under paragraph (d)(4) of this section, is such a mixture assumed to present a carcinogenic hazard; **(d)(5)(iii)**
- If a mixture has not been tested as a whole to determine whether the mixture is a physical hazard, does the chemical manufacturer, importer, or employer use whatever scientifically valid data is available to evaluate the physical hazard potential of the mixture; **(d)(5)(iii)**

AND

- Is the mixture assumed to present the same hazard if the chemical manufacturer, importer, or employer has evidence to indicate that a component present in the mixture in concentrations of less than one percent (or in the case of carcinogens, less that 0.1 percent) could be released in concentrations which would exceed an established OSHA permissible exposure limit or ACGIH Threshold Limit Value, or could present a health hazard to employees in those concentrations? **(d)(5)(iv)**

Do chemical manufacturers, importers, or employers evaluating chemicals describe in writing the procedures they use to determine the hazards of the chemical they evaluate? **(d)(6)**

	Y E S	N O	N / A

1910.1200 — HAZARD COMMUNICATION

Are the written procedures made available, upon request, to employees, their designated representatives, the Assistant Secretary and the Director? **(d)(6)**

NOTE: The written description may be incorporated into the written hazard communication program required under paragraph (e) of this section. **(d)(6)**

(e) Written Hazard Communication Program

Do employers develop, implement, and maintain at each workplace, a written hazard communication program for their workplaces which at least describes how the criteria specified in paragraphs (f), (g), and (h) of this section for labels and other forms of warning, material safety data sheets, and employee information and training will be met? **(e)(1)**

Does this program also include the following:

- A list of the hazardous chemicals known to be present using an identity that is referenced on the appropriate material safety data sheet (the list may be compiled for the workplace as a whole or for individual work areas); **(e)(1)(i)**

AND

- The methods the employer will use to inform employees of the hazards of non-routine tasks (for example, the cleaning of reactor vessels), and the hazards associated with chemicals contained in unlabeled pipes in their work areas? **(e)(1)(ii)**

Multi-employer Workplaces

Do employers who produce, use, or store hazardous chemicals at a workplace additionally ensure that the hazard communication programs developed and implemented under this paragraph (e) include the following: **(e)(2)**

- The methods the employer will use to provide the other employer(s) with on-site access to material safety data sheets for each hazardous chemical the other employer(s)' employees may be exposed to while working; **(e)(2)(i)**

- The methods the employer will use to inform the other employer(s) of any precautionary measures that need to be taken to protect employees during the workplace's normal operating conditions and in foreseeable emergencies; **(e)(2)(ii)**

AND

- The methods the employer will use to inform the other employer(s) of the labeling system used in the workplace? **(e)(2)(iii)**

If an employer relies on an existing hazard communication program to comply with these requirements, does it meet the criteria established in this paragraph (e)? **(e)(3)**

Does the employer make the written hazard communication program available, upon request, to employees, their designated representatives, the Assistant Secretary and the Director, in accordance with the requirements of 29 CFR 1910.20(e)? **(e)(4)**

1910.1200 — HAZARD COMMUNICATION

Is the written hazard communication program kept at the primary workplace facility where employees must travel between workplaces during a workshift, i.e., their work is carried out at more than one geographical location? **(e)(5)**

(f) Labels and Other Forms of Warning

Does the chemical manufacturer, importer, or distributor ensure that each container of hazardous chemicals leaving the workplace is labeled, tagged or marked with the following information: **(f)(1)**

- Identity of the hazardous chemical(s); **(f)(1)(i)**

- Appropriate hazard warnings; **(f)(1)(ii)**

AND

- Name and address of the chemical manufacturer, importer, or other responsible party? **(f)(1)(iii)**

NOTE: For solid metal (such as a steel beam or metal casting), solid wood, or plastic items that are not exempted as articles due to their downstream use, the required label may be transmitted to the customer at the time of the initial shipment, and need not be included with subsequent shipments to the same employer unless the information on the label changes. **(f)(2)(i)**

NOTE: The label may be transmitted with the initial shipment itself, or with the material safety data sheet that is to be provided prior to or at the time of the first shipment. **(f)(2)(ii)**

EXCEPTION: This exception to requiring labels on every container of hazardous chemicals is only for the solid material itself and does not apply to hazardous chemicals used in conjunction with, or known to be present with, the material and to which employees handling the items in transit may be exposed (for example, cutting fluids or pesticides in grains). **(f)(2)(iii)**

Do chemical manufacturers, importers, or distributors make certain that each container of hazardous chemicals leaving the workplace is labeled, tagged, or marked in accordance with this section in a manner which does not conflict with the requirements of the Hazardous Materials Transportation Act (49 U.S.C. 1801 et seq.) and regulations issued under that Act by the Department of Transportation? **(f)(3)**

If the hazardous chemical is regulated by OSHA in a substance-specific health standard, does the chemical manufacturer, importer, distributor or employer make certain that the labels or other forms of warning used are in accordance with the requirements of that standard? **(f)(4)**

Except as provided in the following paragraphs (f)(6) and (f)(7), does the employer ensure that each container of hazardous chemicals in the workplace is labeled, tagged or marked with the following information: **(f)(5)**

- Identity of the hazardous chemical(s) contained therein; **(f)(5)(i)**

AND

	Y E S	N O	N / A

1910.1200 — HAZARD COMMUNICATION

- Appropriate hazard warnings, or words, pictures, symbols, or combinations which provide at least general information regarding the hazards of the chemicals, and which, in conjunction with the other information immediately available to employees under the hazard communication program, will provide employees with the specific information regarding the physical and health hazards of the hazardous chemical? **(f)(5)(ii)**

NOTE: The employer may use signs, placards, process sheets, batch tickets, operating procedures, or other such written material in lieu of affixing labels to individual stationary process containers, as long as the alternative method identifies the containers to which it is applicable and conveys the information required by paragraph (f)(5) of this section to be on a label. **(f)(6)**

Are the written materials readily accessible to the employees in their work area throughout each work shift? **(f)(6)**

NOTE: The employer is not required to label portable containers into which hazardous chemicals are transferred from labeled containers, and which are intended only for the immediate use of the employee who performs the transfer. **(f)(7)**

Does the employer make certain not to remove or deface existing labels on incoming containers of hazardous chemicals, unless the container is immediately marked with the required information? **(f)(8)**

Labeling and Other Warnings in Languages Other than English

Does the employer make sure that labels or other forms of warning are legible, in English, and prominently displayed on the container, or readily available in the work area throughout each work shift? **(f)(9)**

NOTE: Employers having employees who speak other languages may add the information in their language to the material presented, as long as the information is presented in English as well. **(f)(9)**

NOTE: The chemical manufacturer, importer, distributor or employer need not affix new labels to comply with this section if existing labels already convey the required information. **(f)(10)**

Do chemical manufacturers, importers, distributors, or employers who become newly aware of any significant information regarding the hazards of a chemical, revise the labels for the chemical within three months of becoming aware of the new information? **(f)(11)**

Do labels on containers of hazardous chemicals shipped after that time contain the new information? **(f)(11)**

If the chemical is not currently produced or imported, does the chemical manufacturer, importer, distributor, or employer add the information to the label before the chemical is shipped or introduced into the workplace again? **(f)(11)**

(g) Material Safety Data Sheets

Do chemical manufacturers and importers obtain or develop a material safety data sheet for each hazardous chemical they produce or import? **(g)(1)**

1910.1200 — HAZARD COMMUNICATION

Do employers have a material safety data sheet for each hazardous chemical which they use? **(g)(1)**

Is each material safety data sheet in English? **(g)(2)**

Does each sheet contain at least the following information:

- The identity used on the label, and, except as provided for in paragraph (i) of this section on trade secrets: **(g)(2)(i)**

 If the hazardous chemical is a single substance, its chemical and common name(s); **(g)(2)(i)(A)**

 If the hazardous chemical is a mixture which has been tested as a whole to determine its hazards, the chemical and common name(s) of the ingredients which contribute to these known hazards, and the common name(s) of the mixture itself; or **(g)(2)(i)(B)**

 If the hazardous chemical is a mixture which has not been tested as a whole: **(g)(2)(i)(C)**

 The chemical and common name(s) of all ingredients which have been determined to be health hazards, and which comprise 1% or greater of the composition, except that chemicals identified as carcinogens under paragraph (d) of this section shall be listed if the concentrations are 0.1% or greater; **(g)(2)(i)(C)(1)**

 The chemical and common name(s) of all ingredients which have been determined to be health hazards, and which comprise less than 1% (0.1% for carcinogens) of the mixture, if there is evidence that the ingredient(s) could be released from the mixture in concentrations which would exceed an established OSHA permissible exposure limit or ACGIH Threshold Limit Value, or could present a health risk to employees; and **(g)(2)(i)(C)(2)**

 The chemical and common name(s) of all ingredients which have been determined to present a physical hazard when present in the mixture; **(g)(2)(i)(C)(3)**

- Physical and chemical characteristics of the hazardous chemical (such as vapor pressure, flash point); **(g)(2)(ii)**

- The physical hazards of the hazardous chemical, including the potential for fire, explosion, and reactivity; **(g)(2)(iii)**

- The health hazards of the hazardous chemical, including signs and symptoms of exposure, and any medical conditions which are generally recognized as being aggravated by exposure to the chemical; **(g)(2)(iv)**

- The primary route(s) of entry; **(g)(2)(v)**

- The OSHA permissible exposure limit, ACGIH Threshold Limit Value, and any other exposure limit used or recommended by the chemical manufacturer, importer, or employer preparing the material safety data sheet, where available; **(g)(2)(vi)**

- Whether the hazardous chemical is listed in the National Toxicology Program (NTP) Annual Report on Carcinogens (latest edition) or has been found to be a potential carcino-

	Y E S	N O	N / A

	Y E S	N O	N / A			Y E S	N O	N / A

1910.1200 — HAZARD COMMUNICATION

gen in the International Agency for Research on Cancer (IARC) Monographs (latest editions), or by OSHA; **(g)(2)(vii)**

- Any generally applicable precautions for safe handling and use which are known to the chemical manufacturer, importer or employer preparing the material safety data sheet, including appropriate hygienic practices, protective measures during repair and maintenance of contaminated equipment, and procedures for clean-up of spills and leaks; **(g)(2)(viii)**

- Any generally applicable control measures which are known to the chemical manufacturer, importer or employer preparing the material safety data sheet, such as appropriate engineering controls, work practices, or personal protective equipment; **(g)(2)(ix)**

- Emergency and first aid procedures; **(g)(2)(x)**

- The date of preparation of the material safety data sheet or the last change to it; **(g)(2)(xi)**

AND

- The name, address and telephone number of the chemical manufacturer, importer, employer or other responsible party preparing or distributing the material safety data sheet, who can provide additional information on the hazardous chemical and appropriate emergency procedures, if necessary? **(g)(2)(xii)**

If no relevant information is found for any given category on the material safety data sheet, does the chemical manufacturer, importer or employer preparing the material safety data sheet mark it to indicate that no applicable information was found? **(g)(3)**

NOTE: Where complex mixtures have similar hazards and contents (i.e. the chemical ingredients are essentially the same, but the specific composition varies from mixture to mixture), the chemical manufacturer, importer or employer may prepare one material safety data sheet to apply to all of these similar mixtures. **(g)(4)**

Does the chemical manufacturer, importer or employer preparing the material safety data sheet make sure that the information recorded accurately reflects the scientific evidence used in making the hazard determination? **(g)(5)**

If the chemical manufacturer, importer or employer preparing the material safety data sheet becomes newly aware of any significant information regarding the hazards of a chemical, or ways to protect against the hazards, is this new information added to the material safety data sheet within three months? **(g)(5)**

If the chemical is not currently being produced or imported does the chemical manufacturer or importer add the information to the material safety data sheet before the chemical is introduced into the workplace again? **(g)(5)**

Do chemical manufacturers or importers ensure that distributors and employers are provided an appropriate material safety data sheet with their initial shipment, and with the first shipment after a material safety data sheet is updated? **(g)(6)(i)**

1910.1200 — HAZARD COMMUNICATION

Does the chemical manufacturer or importer either provide material safety data sheets with the shipped containers or send them to the employer prior to or at the time of shipment? **(g)(6)(ii)**

If the material safety data sheet is not provided with a shipment that has been labeled as a hazardous chemical, does the employer obtain one from the chemical manufacturer, importer, or distributor as soon as possible? **(g)(6)(iii)**

Does the chemical manufacturer or importer also provide distributors or employers with a material safety data sheet upon request? **(g)(6)(iv)**

Do distributors make certain that material safety data sheets, and updated information, are provided to other distributors and employers with their initial shipment and with the first shipment after a MSDS has been updated? **(g)(7)(i)**

Does the distributor either provide material safety data sheets with the shipped containers, or send them to the other distributor or employer prior to or at the time of the shipment? **(g)(7)(ii)**

Do retail distributors selling hazardous chemicals to employers having a commercial account provide a material safety data sheet to such employers upon request? **(g)(7)(iii)**

Do they also post a sign or otherwise inform them that a material safety data sheet is available? **(g)(7)(iii)**

NOTE: Wholesale distributors selling hazardous chemicals to employers over-the-counter may also provide material safety data sheets for all hazardous chemicals they sell, provide material safety data sheets upon the request of the employer at the time of the over-the-counter purchase, and shall post a sign or otherwise inform such employers that a material safety data sheet is available. **(g)(7)(iv)**

If an employer without a commercial account purchases a hazardous chemical from a retail distributor not required to have MSDS on file (i.e., the retail distributor does not have commercial accounts and does not use the materials), does the retail distributor provide the employer, upon request, with the name, address, and telephone number of the chemical manufacturer, importer, or distributor from which a material safety data sheet can be obtained? **(g)(7)(v)**

Do wholesale distributors also provide material safety data sheets to employers or other distributors upon request? **(g)(7)(vi)**

NOTE: Chemical manufacturers, importers, and distributors need not provide material safety data sheets to retail distributors that have informed them that the retail distributor does not sell the product to commercial accounts or open the sealed container to use it in their own workplaces. **(g)(7)**

Does the employer maintain copies of the required material safety data sheets for each hazardous chemical? **(g)(8)**

Does the employer make certain that they are readily accessible during each work shift to employees when they are in their work area(s)? **(g)(8)**

1910.1200 — HAZARD COMMUNICATION

	YES	NO	N/A

NOTE: Electronic access, microfiche, and other alternatives to maintaining paper copies of the material safety data sheets are permitted as long as no barriers to immediate employee access in each workplace are created by such options. **(g)(8)**

NOTE: Where employees must travel between workplaces during a workshift, i.e., their work is carried out at more that one geographical location, the material safety data sheets may be kept at the primary workplace facility. **(g)(9)**

If this is the situation, does the employer make sure that employees can immediately obtain the required information in an emergency? **(g)(9)**

NOTE: Material safety data sheets may be kept in any form, including operating procedures, and may be designed to cover groups of hazardous chemicals in a work area where it may be more appropriate to address the hazards of a process rather than individual hazardous chemicals. **(g)(10)**

Nevertheless, does the employer ensure that in all cases the required information is provided for each hazardous chemical, and is readily accessible during each work shift to employees when they are in their work area(s)? **(g)(10)**

Are material safety data sheets also made readily available, upon request, to designated representatives and to the Assistant Secretary, in accordance with the requirements of 29 CFR 1910.20 (e)? **(g)(11)**

Is the Director also given access to material safety data sheets in the same manner? **(g)(11)**

(h) Employee Information and Training

Do employers provide employees with information and training on hazardous chemicals in their work area at the time of their initial assignment, and whenever a new hazard is introduced into their work area? **(h)(1)**

Information

Have employees been informed of: **(h)(2)**

- The requirements of this section; **(h)(2)(i)**

- Any operations in their work area where hazardous chemicals are present; **(h)(2)(ii)**

AND

- The location and availability of the written hazard communication program, including the required list(s) of hazardous chemicals, and material safety data sheets required by this section? **(h)(2)(iii)**

Training

Does employee training include at least: **(h)(2)**

- Methods and observations that may be used to detect the presence or release of a hazardous chemical in the work area (such as monitoring conducted by the employer, continuous monitoring devices, visual appearance or odor of hazardous chemicals when being released, etc.); **(h)(3)(i)**

1910.1200 — HAZARD COMMUNICATION

	YES	NO	N/A

- The physical and health hazards of the chemicals in the work area; **(h)(3)(ii)**

- The measures employees can take to protect themselves from these hazards, including specific procedures the employer has implemented to protect employees from exposure to hazardous chemicals, such as appropriate work practices, emergency procedures, and personal protective equipment to be used; **(h)(3)(iii)**

AND

- The details of the hazard communication program developed by the employer, including an explanation of the labeling system and the material safety data sheet, and how employees can obtain and use the appropriate hazard information? **(h)(3)(iv)**

(i) Trade Secrets

If the chemical manufacturer, importer or employer withholds the specific chemical identity, including the chemical name and other specific identification of a hazardous chemical, from the material safety data sheet, is it provided that: **(i)(1)**

- The claim that the information withheld is a trade secret can be supported; **(i)(1)(i)**

- Information contained in the material safety data sheet concerning the properties and effects of the hazardous chemical is disclosed; **(i)(1)(ii)**

- The material safety data sheet indicates that the specific chemical identity is being withheld as a trade secret; **(i)(1)(iii)**

AND

- The specific chemical identity is made available to health professionals, employees, and designated representatives in accordance with the applicable provisions of this paragraph? **(i)(1)(iv)**

Where a treating physician or nurse determines that a medical emergency exists and the specific chemical identity of a hazardous chemical is necessary for emergency or first-aid treatment, does the chemical manufacturer, importer or employer immediately reveal the specific chemical identity of a trade secret chemical to that physician or nurse, regardless of the existence of a written statement of need or a confidentiality agreement? **(i)(2)**

NOTE: The chemical manufacturer, importer or employer may require a written statement of need and confidentiality agreement, in accordance with the provisions of paragraphs (i)(3) and (4) of this section, as soon as circumstances permit. **(i)(2)**

In non-emergency situations, does a chemical manufacturer, importer or employer, upon request, reveal a specific chemical identity, otherwise permitted to be withheld under paragraph (i)(1) of this section, to a health professional (i.e. physician, industrial hygienist, toxicologist, epidemiologist, or occupational health nurse) providing medical or other occupational health services to exposed employee(s), and to employees or designated representatives, if: **(i)(3)**

OSHA COMPLIANCE MANANUAL FOR GENERAL INDUSTRY

1910.1200 — HAZARD COMMUNICATION

	Y E S	N O	N / A

- The request is in writing; **(i)(3)(i)**
- The request describes with reasonable detail one or more of the following occupational health needs for the information:

 To assess the hazards of the chemicals to which employees will be exposed: **(i)(3)(ii)(A)**

 To conduct or assess sampling of the workplace atmosphere to determine employee exposure levels; **(i)(3)(ii)(B)**

 To conduct pre-assignment or periodic medical surveillance of exposed employees; **(i)(3)(ii)(C)**

 To provide medical treatment to exposed employees; **(i)(3)(ii)(D)**

 To select or assess appropriate personal protective equipment for exposed employees; **(i)(3)(ii)(E)**

 To design or assess engineering controls or other protective measures for exposed employees; and **(i)(3)(ii)(F)**

 To conduct studies to determine the health effects of exposure? **(i)(3)(ii)(G)**

- The request explains in detail why the disclosure of the specific chemical identity is essential and that in lieu thereof, the disclosure of the following information to the health professional, employee, or designated representative, would not satisfy the purposes described in paragraph (i)(3)(ii) of this section: **(i)(3)(iii)**

 The properties and effects of the chemical; **(i)(3)(iii)(A)**

 Measures for controlling workers' exposure to the chemical; **(i)(3)(iii)(B)**

 Methods of monitoring and analyzing worker exposure to the chemical; and **(i)(3)(iii)(C)**

 Methods of diagnosing and treating harmful exposures to the chemical; **(i)(3)(iii)(D)**

- The request includes a description of the procedures to be used to maintain the confidentiality of the disclosed information; **(i)(3)(iv)**

AND

- The health professional, and the employer or contractor of the services of the health professional (i.e. downstream employer, labor organization, or individual employee), employee, or designated representative, agree in a written confidentiality agreement that the health professional, employee, or designated representative, will not use the trade secret information for any purpose other than the health need(s) asserted and agree not to release the information under any circumstances other that to OSHA, as provided in paragraph (i)(6) of this section, except as authorized by the terms of the agreement or by the chemical manufacturer, importer or employer? **(i)(3)(v)**

NOTE: The confidentiality agreement authorized by paragraph (i)(3)(iv) of this section: **(i)(4)**

1910.1200 — HAZARD COMMUNICATION

	Y E S	N O	N / A

May restrict the use of the information to the health purposes indicated in the written statement of need; **(i)(4)(i)**

May provide for appropriate legal remedies in the event of a breach of the agreement, including stipulation of a reasonable pre-estimate of likely damages; and **(i)(4)(ii)**

May not include requirements for the posting of a penalty bond. **(i)(4)(iii)**

Does the employer understand that nothing in this standard is meant to preclude the parties from pursuing non-contractual remedies to the extent permitted by law? **(i)(5)**

If the health professional, employee, or designated representative receiving the trade secret information decides that there is a need to disclose it to OSHA, is the chemical manufacturer, importer or employer who provided the information informed by the health professional, employee, or designated representative prior to, or at the same time as, such disclosure? **(i)(6)**

If the chemical manufacturer, importer or employer denies a written request for disclosure of a specific chemical identity, is the denial: **(i)(7)**

- Provided to the health professional, employee, or designated representative, within thirty days of the request; **(i)(7)(i)**
- In writing; **(i)(7)(ii)**

AND

Does the denial also:

- Include evidence to support the claim that the specific chemical identity is a trade secret; **(i)(7)(iii)**
- State the specific reasons why the request is being denied; **(i)(7)(iv)**

AND

- Explain in detail how alternative information may satisfy the specific medical or occupational health need without revealing the specific chemical identity? **(i)(7)(v)**

NOTE: The health professional, employee, or designated representative whose request for information is denied under paragraph (i)(3) of this section may refer the request and the written denial of the request to OSHA for consideration. **(i)(8)**

NOTE: When a health professional, employee, or designated representative refers the denial to OSHA under paragraph (i)(8) of this section, OSHA shall consider the evidence to determine if: **(i)(9)**

The chemical manufacturer, importer or employer has supported the claim that the specific chemical identity is a trade secret; **(i)(9)(i)**

The health professional, employee, or designated representative has supported the claim that there is a medical or occupational health need for the information; and **(i)(9)(ii)**

	Y E S	N O	N / A

1910.1200 — HAZARD COMMUNICATION

The health professional, employee or designated representative has demonstrated adequate means to protect the confidentiality. **(i)(9)(iii)**

NOTE: If OSHA determines that the specific chemical identity requested under paragraph (i)(3) of this section is not a bona fide trade secret, or that it is a trade secret, but the requesting health professional, employee, or designated representative has a legitimate medical or occupational health need for the information, has executed a written confidentiality agreement, and has shown adequate means to protect the confidentiality of the information, the chemical manufacturer, importer or employer will be subject to citation by OSHA. **(i)(10)(i)**

NOTE: If a chemical manufacturer, importer or employer demonstrates to OSHA that the execution of a confidentiality agreement would not provide sufficient protection against the potential harm from the unauthorized disclosure of a trade secret specific chemical identity, the Assistant Secretary may issue such orders or impose such additional limitations or conditions upon the disclosure of the requested chemical information as may be appropriate to assure that the occupational health services are provided without an undue risk of harm to the chemical manufacturer, importer or employer. **(i)(10)(ii)**

NOTE: If a citation for a failure to release specific chemical identity information is contested by the chemical manufacturer, importer, or employer, the matter will be adjudicated before the Occupational Safety and Health Review Commission in accordance with the Act's enforcement scheme and the applicable Commission rules of procedure. In accordance with the Commission rules, when a chemi-

1910.1200 — HAZARD COMMUNICATION

cal manufacturer, importer or employer continues to withhold the information during the contest, the Administrative Law Judge may review the citation and supporting documentation in camera or issue appropriate orders to protect the confidentiality of such matters. **(i)(11)**

Notwithstanding the existence of a trade secret claim, does a chemical manufacturer, importer or employer, upon request, disclose to the Assistant Secretary any information which this section requires the chemical manufacturer, importer, or employer to make available? **(i)(12)**

Where there is a trade secret claim, is such claim made no later than at the time the information is provided to the Assistant Secretary so that suitable determinations of trade secret status can be made and the necessary protections can be implemented? **(i)(12)**

NOTE: Nothing in this paragraph shall be construed as requiring the disclosure under any circumstances of process or percentage of mixture information which is a trade secret. **(i)(13)**

(j) Effective Dates

Chemical manufacturers, importers, distributors, and employers shall be in compliance with all provisions of this section by March 11, 1994.

Editor's Note:

To allow more time to prepare labels and MSDS's, OSHA is staying until August 11, 1994, the coverage of the Hazcom Standard to wood and wood products which are processed in a manner which creates wood dust or are treated with hazardous chemicals.

	Y E S	N O	N / A

Lockout/Tagout

The standard for the control of hazardous energy sources (lockout-tagout) covers servicing and maintenance of machines and equipment in which the unexpected energization or start up of the machines or equipment or release of stored energy could cause injury to employees.

Most employers find themselves face to face with an OSHA inspector for failing to adopt a written program that identifies and describes the means and methods you will use to meet the standard's requirements.

The rule generally requires that energy sources for equipment be turned off or disconnected and that the switch either be locked or labeled with a warning tag.

OSHA estimates that about three million workers actually servicing equipment face the greatest risk. These include craft workers, machine operators, and laborers. OSHA data show that packaging and wrapping equipment, printing presses, and conveyors account for a high proportion of the accidents associated with lockout/tagout failures. Typical injuries include fractures, lacerations, contusions, amputations, and puncture wounds with the average lost time for injuries running 24 days.

The generation, transmission, and distribution of electric power by utilities and work on electric conductors and equipment are excluded because lockout/tagout procedures for these specific industries are included in separate standards.

Under the lockout/tagout standard employers must:

- Develop an energy control program.

- Use locks when equipment can be locked out.

- Ensure that new equipment or overhauled equipment can accommodate locks.

- Employ additional means to ensure safety when tags rather than locks are used by using an effective tagout program.

Energy sources must be turned off and locked or tagged

163

Things that are included—and excluded—from lockout/tagout rules

- Identify and implement specific procedures (generally in writing) for the control of hazardous energy including preparation for shutdown, shutdown, equipment isolation, lockout/tagout application, release of stored energy, and verification of isolation.

- Institute procedures for release of lockout/tagout including machine inspection, notification and safe positioning of employees, and removal of the lockout/tagout device.

- Obtain standardized locks and tags which indicate the identity of the employee using them and which are of sufficient quality and durability to ensure their effectiveness.

- Require that each lockout/tagout device be removed by the employee who applied the device.

- Conduct inspections of energy control procedures at least annually.

- Train employees in the specific energy control procedures with training reminders as part of the annual inspections of the control procedures.

- Adopt procedures to ensure safety when equipment must be tested during servicing, when outside contractors are working at the site, when a multiple lockout is needed for a crew servicing equipment, and when shifts or personnel change.

Operations excluded from coverage are:

- Normal production operations including repetitive, routine minor adjustment which would be covered under OSHA's machine guarding standards.

- Work on cord and plug connected electric equipment when it is unplugged, and the employee working on the equipment has complete control over the plug.

- Hot tap operations involving gas, steam, water, or petroleum products when the employer shows that continuity of service is essential,

shutdown is impractical, and documented procedures are followed to provide proven effective protection for employees.

✱ The most cited provision in OSHA's lockout/tagout standard (1910.147 (c)(1)) requires employers to implement a program that includes written documentation of energy control procedures, employee training, and periodic inspections of the use of the procedures—before beginning service or maintenance work on machinery or equipment where the accidental start-up or accidental release of energy could cause injury.

OSHA states that you have the flexibility to develop a program and procedures that meet the needs of your particular workplace and the particular types of machines and equipment being maintained or serviced.

The written procedures must identify the information that employees must know in order to control hazardous energy during servicing or maintenance. If this information is the same for various machines or equipment or if other means of logical grouping exists, then a single energy control procedure may be sufficient. If there are other conditions—such as multiple energy sources, different connecting means, or a particular sequence that must be followed to shut down the machine or equipment—then the employer must develop separate energy control procedures to protect employees.

The energy control procedure must outline the scope, purpose, authorization, rules, and techniques that will be used to control hazardous energy sources as well as the means that will be used to enforce compliance. At minimum, you should include the following elements:

- A statement on how the procedure will be used

- The procedural steps needed to shut down, isolate, block, and secure machines or equipment

- The steps designating the safe placement, removal, and transfer of lockout/tagout devices and who has the responsibility for them

Lack of written documentation is a major lockout/tagout issue

- The specific requirements for testing machines or equipment to determine or verify the effectiveness of locks, tags, and other energy control measures

The employer or an authorized employee must notify affected employees before lockout or tagout devices are applied and after they are removed from the machine or equipment

The following is a plain English, question and answer checklist of OSHA's Lockout/Tagout standard.

1910.147 — THE CONTROL OF HAZARDOUS ENERGY (LOCKOUT/TAGOUT)

	Y E S	N O	N / A

(a) Scope, Application and Purpose

NOTE: This standard covers the servicing and maintenance of machines and equipment where the unexpected energization, start-up, or release of energy could cause injury to employees. The standard establishes minimum performance requirements for the control of such hazardous energy, and applies to the control of energy during normal servicing and/or maintenance of machines and equipment. Normal production operations are covered in Subpart O. **(a)(1)(i)**

NOTE: This standard does not apply to: **(a)(1)(ii)**

- Construction, agriculture, and maritime employment; **(a)(1)(ii)(A)**

- Installations under the exclusive control of electric utilities for the purpose of power generation, transmission and distribution, including related equipment for communication or metering; **(a)(1)(ii)(B)**

- Exposure to electrical hazards from work on or near, or with conductors or equipment in electric utilization installations, which is covered by subpart S of this part; **(a)(1)(ii)(C)**

AND

- Oil and gas well drilling and servicing. **(a)(1)(ii)(D)**

Application

NOTE: Normal production operations are not covered by this standard. See subpart O of this part. **(a)(2)(ii)**

NOTE: Servicing and/or maintenance that take place during normal product operations are covered by this standard, if: **(a)(2)(ii)**

- An employee is required to remove or bypass a guard or other safety device; **(a)(2)(ii)(A)**

OR

- An employee is required to place any part of his or her body into an area on a machine or piece of equipment where work is being performed on the material being processed (point of operation), or when an associated danger zone exists during a machine operating cycle. **(a)(2)(ii)(B)**

EXCEPTION: Minor tool changes and adjustments which take place during normal production operations are not covered by this standard if they are routine, repetitive, and integral to the use of the equipment for production, provided that the work is performed using alternative measures which provide effective protection. (See Subpart O).

NOTE: This standard does not apply to: **(a)(2)(iii)**

- Work on cord and plug connected electrical equipment, for which exposure to the hazards of unexpected energization or start up of the equipment is controlled by the unplugging of the equipment from the energy source, and by the plug being under the exclusive control of the employee performing the servicing or maintenance; **(a)(2)(iii)(A)**

1910.147 — THE CONTROL OF HAZARDOUS ENERGY (LOCKOUT/TAGOUT)

	Y E S	N O	N / A

- Hot tap operations involving transmission and distribution systems for substances such as gas, steam, water or petroleum product, when they are performed on pressurized pipelines, provided the employer demonstrates that: **(a)(2)(iii)(B)**

Continuity of service is essential; **(a)(2)(iii)(B)(1)**

Shutdown of the system is impractical; **(a)(2)(iii)(B)(2)**

AND

Documented procedures are followed, and special equipment is used that will provide proven, effective protection for employees. **(a)(2)(iii)(B)(3)**

Purpose

Has a program been established which outlines procedures for fastening appropriate lockout or tagout devices to energy isolating devices? **(a)(3)(i)**

Do the procedures in this program prevent the unexpected energization of machines or equipment or the release of stored energy, that could cause injury to employees? **(a)(3)(i)**

When other standards in this part require the use of lockout or tagout devices, are they supplemented by procedural and training requirements of this section? **(a)(3)(ii)**

(b) Definitions

Affected employee. An employee whose job requires him or her to operate or use a machine or equipment on which servicing or maintenance is being performed under lockout or tagout; or whose job requires him or her to work in an area where such servicing or maintenance is being performed.

Authorized employee. A person who locks or implements a lockout system procedure on machine or equipment to perform the service or maintenance on that machine or equipment. An authorized employee and an affected employee may be the same person when the affected employee's duties also include performing maintenance or service on a machine or equipment which must be locked or tagged out.

Capable of being locked out. An energy isolating device is considered capable of being locked if it is designed with a hasp or other attachment that a lock can be fastened on or through, or if the device has a locking mechanism built into it. Other energy isolating devices are considered capable of being locked out if lockout can be achieved without the need to dismantle, rebuild, or replace the energy isolating device or permanently alter its energy control capability.

Energized. Connected to an energy source or Containing residual or stored energy

Energy isolating device. A mechanical device that Physically prevents the transmission or release of energy. Examples include: a manually operated electrical circuit breaker, a disconnect switch, a manually operated switch by which the conductors of a circuit can be disconnected from all ungrounded supply connectors and no pole can be operated independently; a slide gate; a slip blind; a line valve; a block; and any similar device used to block or isolate energy. The term does not in-

	Y E S	N O	N / A

1910.147 — THE CONTROL OF HAZARDOUS ENERGY (LOCKOUT/TAGOUT)

clude a push button, selector switch, and other control circuit type devices.

Energy source. Any source of electrical, mechanical, hydraulic, pneumatic, chemical, thermal, or other energy.

Hot tap. A procedure used in maintenance and service activities that involves welding on a piece of equipment under pressure in order to install connections or appurtenances. It is commonly used to replace or add sections of pipeline without the interruption of service for air, gas, water, steam, and petrochemical distribution systems.

Lockout. The placement of a lockout device on an energy isolating device, in accordance with an established procedure, ensuring that the energy isolating device and the equipment being controlled cannot be operated until the lockout device is removed.

Lockout device. A device that utilizes a positive means, such as a lock (key or combination type), to hold an energy isolating device in the safe position and prevent the energizing of a machine or equipment.

Normal production operations. The utilization of a machine or equipment to perform its intended production function.

Service and/or maintenance. Workplace activities such as constructing, installing, setting up, adjusting, inspecting, modifying, and maintaining or servicing machines or equipment. These activities include lubrication, cleaning, or unjamming of machines or equipment and making adjustments where the employee may be exposed to the unexpected energization or start-up of the equipment or release of hazardous energy.

Setting up. Any work performed to prepare a machine or equipment to perform its normal production operation

Tagout. The placement of a tagout device on an energy isolating device, in accordance with an established procedure, to indicate that the energy isolating device and the equipment being controlled may not be operated until the tagout device is removed.

Tagout device. A prominent warning device, such as a tag and a means of attachment, which can be securely fastened to an energy isolating device in accordance with an established procedure, to indicate that the energy isolating device and the equipment being controlled may not be operated until the tagout device is removed.

(c) General

Energy Control Program

Before any employee begins service or maintenance work on machinery or equipment where the accidental start-up or release of stored energy could cause injury, has a program consisting of energy control procedures and employee training been established in accordance with paragraph (c)(4) of this section? (c)(1)

Lockout/Tagout

If an energy isolating device cannot be locked out, does the energy control program under paragraph (c)(1) of this section utilize a tagout system? (c)(2)(i)

1910.147 — THE CONTROL OF HAZARDOUS ENERGY (LOCKOUT/TAGOUT)

	Y E S	N O	N / A

If an energy isolating device can be locked out, does the energy control program use a lockout system, unless it can be demonstrated that tagout will provide full protection as provided in paragraph (c)(3) of this section? (c)(2)(ii)

Whenever major replacement, repair, renovation, or modification of machines or equipment is performed, or new machinery or equipment is installed, is such machinery or equipment designed to accept a lockout device? (c)(2)(iii)

Full Employee Protection

When a tagout device is used on an energy isolating device that capable of being locked out, is the tagout device attached at the same location the lockout device would have been attached? (c)(3)(i)

Does the employer demonstrate that the tagout program provides a level of safety equal to that of a lockout program? (c)(3)(i)

In demonstrating that the tagout program achieves the same level of safety as a lockout program, have all tagout-related provisions of this standard been applied? (c)(3)(ii)

Does the employer demonstrate full compliance with all tagout-related provisions of this standard together with additional elements, to provide the equivalent safety available from the use of a lockout device? (c)(3)(ii)

When using a tagout program, are additional safety measures, such as removing an isolating circuit element, blocking a controlling switch, opening an extra disconnecting device, or removing a valve handle, applied? (c)(3)(ii)

Energy Control Procedure

Have procedures been developed, documented, and utilized for the control of potentially hazardous energy when employees are engaged in activities covered by this section? (c)(4)(i)

> **EXCEPTION:** The employer does not need to document required procedures for machines or equipment when all the following provisions exist:
>
> 1) There is no potential for stored energy or reaccumulation of stored energy after shutdown;
>
> 2) There is a single energy source which can be readily identified and isolated;
>
> 3) The isolation and locking out of that energy source will completely de-energize and deactivate the machine or equipment;
>
> 4) The machine or equipment is isolated from that energy source and locked out during service or maintenance;
>
> 5) A single lockout device will achieve a locked-out condition;
>
> 6) The lockout device is under the exclusive control of the authorized employee performing the service or maintenance;
>
> 7) The service or maintenance does not create hazards for other employees;
>
> **AND**

1910.147 — THE CONTROL OF HAZARDOUS ENERGY (LOCKOUT/TAGOUT)

	Y E S	N O	N / A

8) The employer, in utilizing this exception, has had no accidents involving the unexpected activation or re-energization of the machine or equipment during service or maintenance.

Do the energy control procedures clearly and specifically outline the scope, purpose, authorization, rule, and techniques to be used for the control of hazardous energization? **(c)(4)(ii)**

Do the energy control procedures include the following:

A specified statement of the intended use; **(c)(4)(ii)(A)**

- Steps for shutting down, isolating, blocking, and securing machines or equipment; **(c)(4)(ii)(B)**

- Steps for the placement, removal, and transfer of lockout or tagout devices and the responsibility for them; **(c)(4)(ii)(C)**

- Requirements for testing machines or equipment to verify the effectiveness of a lockout, tagout, or other energy control procedure? **(c)(4)(ii)(D)**

Protective Material and Hardware

Are locks, tags, chains, wedges, key blocks, adapter pins, self locking fasteners, or other hardware provided for isolating, securing, or blocking machines or equipment from energy sources? **(c)(5)(i)**

Are the lockout and tagout devices singularly identified? **(c)(5)(ii)**

Are the lockout and tagout devices the only devices used for controlling energy? **(c)(5)(ii)**

Do the lockout and tagout devices meet the requirements below? **(c)(5)(ii)**

Durable

Are lockout and tagout devices capable of withstanding the environment to which they are exposed for the maximum period of time? **(c)(5)(ii)(A)(1)**

Are tagout devices constructed and printed so that exposure to weather conditions or wet and damp locations will not cause the tag to deteriorate or the message on the tag to become illegible? **(c)(5)(ii)(A)(2)**

Are the tags able to withstand deterioration when used in corrosive environments, such as areas where acid and alkali chemicals are handled? **(c)(5)(ii)(A)(3)**

Standardized

Are lockout and tagout devices standardized within the facility, based on at least one of the following ways: color, shape, or size? **(c)(5)(ii)(B)**

Are tagout devices standardized in print and in format? **(c)(5)(ii)(B)**

Lockout Devices

Are lockout devices strong enough to prevent removal except in cases of excessive force, such as the use of bolt cutters? **(c)(5)(ii)(C)(1)**

1910.147 — THE CONTROL OF HAZARDOUS ENERGY (LOCKOUT/TAGOUT)

	Y E S	N O	N / A

Tagout Devices

Are tagout devices and their means of attachment strong enough to prevent accidental removal? **(c)(5)(ii)(C)(2)**

Are tagout devices a non-reusable type, attachable by hand, self-locking, and non-releasable with a minimum unlocking strength of no less than 50 pounds? **(c)(5)(ii)(C)(2)**

Do tagout devices attachments have equivalent strength of one-piece, all environment-tolerant nylon cable ties? **(c)(5)(ii)(C)(2)**

Identifiable

Do all lockout and tagout devices indicate the identity of the employee applying the device(s)? **(c)(5)(ii)(D)**

Do tagout devices warn against hazardous conditions if the machine or equipment is energized? **(c)(5)(iii)**

Does the warning include a legend such as the following:

DO NOT START, DO NOT OPEN, DO NOT CLOSE, DO NOT ENERGIZE, DO NOT OPERATE? **(c)(5)(iii)**

Periodic Inspection

Is a periodic inspection of energy control procedures conducted at least annually, to ensure that the procedures and requirements of this standard are being followed? **(c)(6)(i)**

Are periodic inspections conducted by an authorized employee other than the one(s) utilizing the energy control procedure being inspected? **(c)(6)(i)(A)**

Is the periodic inspection designed to correct any deviations or inadequacies observed? **(c)(6)(i)(B)**

When lockout is used for energy control, does the inspection include a review between the inspector and each affected employee of that employee's responsibility under the energy control procedure being inspected? **(c)(6)(i)(C)**

When tagout is used for energy control, does the inspection include a review between the inspector and each affected employee, of that employee's responsibility under the energy control program and the elements set forth in paragraph (c)(7)(ii) of this section? **(c)(6)(i)(D)**

Has the inspection been certified by an authorized employee, and does the certification contain the identity of the machines or equipment for which the energy control procedures are being used, the date of the inspection, the employees included in the inspection, and the person performing the inspection? **(c)(6)(ii)**

Training and Communication

Has training been provided to ensure that the purpose and function of the energy control program are understood by employees? **(c)(7)(i)**

Has each affected employee received training to provide the knowledge and skills required for the safe application, usage and removal of energy controls? **(c)(7)(i)**

Does the training include the following: **(c)(7)(i)**

1910.147 — THE CONTROL OF HAZARDOUS ENERGY (LOCKOUT/TAGOUT)

	Y E S	N O	N / A

- Employee recognition of applicable hazardous energy sources, the type and magnitude of energy sources in the workplace, and the methods and means necessary for energy isolation and control; **(c)(7)(i)(A)**
- Employee instruction in the purpose and use of the energy control procedure; **(c)(7)(i)(B)**

AND

- Instruction (for all other employees whose work operations may be in an area where energy control procedures may be utilized) about the procedure and the prohibition of restarting or re-energizing machines that are locked out or tagged out? **(c)(7)(i)(C)**

When tagout systems are used, are employees informed of the following: **(c)(7)(ii)**

- That tags are warning devices fastened to energy isolating devices, and do not provide the physical restraint that is provided by a lock; **(c)(7)(ii)(A)**
- That when a tag is attached, it's not to be removed, bypassed or ignored, except by authorized employees; **(c)(7)(ii)(B)**
- That tags are legible and understandable by all affected employees and all other employees whose work operations are or in the areas; **(c)(7)(ii)(C)**
- That tags and their means of attachment are made of material to withstand environmental conditions encountered in the workplace; **(c)(7)(ii)(D)**
- That tags may evoke a false sense of security, so their meaning as it applies to the overal energy control program, must be understood by all employees; **(c)(7)(ii)(E)**

AND

- Are tags securely attached to energy isolating devices, and cannot be inadvertently or accidentally detached? **(c)(7)(ii)(F)**

Employee Retraining

Is retraining provided for all affected employees whenever: **(c)(7)(iii)(A)**

- There is a change in their job assignments; **(c)(7)(iii)(A)**
- A change in machines, equipment, or processes; **(c)(7)(iii)(A)**
- A change in the energy control procedures; **(c)(7)(iii)(A)**

OR

- When inspection reveals that there are deviations from or inadequacies in the employee's knowledge or use of the energy control procedures? **(c)(7)(iii)(A)**

Is additional retraining conducted whenever a periodic inspection as stated in (c)(6) of this section, reveals or the employer believes, that the employee's knowledge or use of the energy controls procedures is inadequate? **(c)(7)(iii)(B)**

Does the retraining reestablish employee proficiency and introduce new or revised control methods and procedures, as necessary? **(c)(7)(iii)(C)**

1910.147 — THE CONTROL OF HAZARDOUS ENERGY (LOCKOUT/TAGOUT)

	Y E S	N O	N / A

Is retraining certified, kept up to date, and does certification contain each employee's name and date of training? **(c)(7)(iv)**

Energy Isolation

Is the implementation of a lockout or tagout system performed only by authorized employees who perform the servicing or maintenance? **(c)(8)**

Notification of Employees

Are affected employees notified of the application and removal of lockout or tagout devices before the controls are applied and after they are removed from the machine or equipment? **(c)(9)**

(d) Application of Control

Do the established energy control procedures contain the following provisions in sequence: **(d)**

Preparation for Shutdown

Before an authorized employee turns off a machine or equipment, does he or she know the type and magnitude of the energy, the hazards of the energy to be controlled, and the methods or means to control the energy? **(d)(1)**

Machine or Equipment Shutdown

Are machines or equipment turned off or shut down using the procedures required by this standard. **(d)(2)**

Is an orderly shutdown of the machines and equipment utilized, to avoid additional or increased hazard(s) to employees, as a result of the equipment stoppage? **(d)(2)**

Machine or Equipment Isolation

Are all energy isolating devices needed to control the energy to the machine or equipment physically located and operated in such a manner that isolates the machine or equipment from the energy source(s)? **(d)(3)**

Lockout or Tagout Device Application

Are lockout or tagout devices fastened on each energy device by an authorized employee? **(d)(4)(i)**

When lockout devices are used, are they fastened on in a way that will hold the energy isolating device in a safe or "off" position? **(d)(4)(ii)**

Do tagout devices when affixed, clearly indicate that the operation or movement of the energy isolating device from the "safe" or off position, is prohibited? **(d)(4)(iii)**

Where tagout devices are used with energy isolating devices that are capable of being locked out, is the tag attachment fastened on at the same point the lock would have been attached? **(d)(4)(iii)(A)**

When a tag cannot be fastened on directly to the energy isolating device, is the tag located as close as safely as possible to the device, in a position that is immediately obvious to anyone attempting to operate the device? **(d)(4)(iii)(B)**

1910.147 — THE CONTROL OF HAZARDOUS ENERGY (LOCKOUT/TAGOUT)

	Y E S	N O	N / A

Stored Energy

After the application of lockout or tagout device to energy isolating devices, is all potentially hazardous stored or residual energy relieved, disconnected, restrained, and otherwise rendered safe? **(d)(5)(i)**

If there is a possibility of re-accumulation of stored energy to a hazardous level, is verification of isolation continued until servicing or maintenance is completed, or until the possibility of such accumulation no longer exists? **(d)(5)(ii)**

Verification of Isolation

Before working on machines or equipment that have been locked or tagged out, does the authorized employee verify that isolation and de-energization has been accomplished? **(d)(6)**

(e) Release from Lockout or Tagout

Before lockout or tagout devices are removed and energy is restored to the machine or equipment, have the following been adhered to? **(e)**

The Machine or Equipment

Has the work area been inspected to ensure that nonessential items have been removed and that machine or equipment components are operationally intact? **(e)(1)**

Employees

Is the work area checked to ensure that all employees have been safely positioned or removed? **(e)(2)(i)**

Are affected employees notified that the lockout or tagout device(s) have been removed and before a machine or equipment is started? **(e)(2)(ii)**

Lockout or Tagout Device(s) Removal

Is each lockout or tagout device removed from each energy isolating device by the employee who applied the device? **(e)(3)**

> **EXCEPTION:** When the authorized employee who applied the lockout or tagout device is not available to remove it, that device may be removed under the direction of the employer, provided that specific procedures and training for such removal have been developed, documented, and incorporated into the employer's energy control program. The employer shall demonstrate that the specific procedures provide equivalent safety to the removal of the device by the authorized employee who applied it. The specific procedures must include at least the following elements: **(e)(3)**

- Verification that the authorized employee who applied the device is not at the facility; **(e)(3)(i)**

- Making all reasonable efforts to contact that employee to inform him or her that the lockout or tagout device has been removed; **(e)(3)(i)**

AND

1910.147 — THE CONTROL OF HAZARDOUS ENERGY (LOCKOUT/TAGOUT)

	Y E S	N O	N / A

- Ensuring that the authorized employee has this knowledge before he or she resumes work at that facility. **(e)(3)(iii)**

(f) Additional Requirements

Testing or Positioning of Machines, Equipment or Their Components Thereof

When lockout or tagout devices have to be removed temporarily from the energy isolating device and the machine or equipment energized to test or position of the machine, equipment, or component thereof, are the following sequence of actions followed: **(f)(1)**

- Clear the machine or equipment of tools and material in accordance with paragraph (e)(1) of this section; **(f)(1)(i)**

- Remove employees from the machine or equipment area in accordance with paragraph (e)(2) of this section; **(f)(1)(ii)**

- Remove all lockout and tagout devices as specified in paragraph (e)(3) of this section; **(f)(1)(iii)**

- Energize and proceed with testing or positioning; **(f)(1)(iv)**

AND

- De-energize all systems and re-apply energy control measures in accordance with paragraph (d) of this section to continue the servicing and or maintenance? **(f)(1)(v)**

Outside Personnel (Contractors, etc.)

Whenever outside servicing personnel are engaged in activities covered by this standard, have the on-site employer and the outside employer informed each other of the respective lockout/tagout procedures? **(f)(2)(i)**

Has the on-site employer ensured that his or her personnel understand and comply with restrictions and prohibitions of the outside employer's energy control procedures? **(f)(2)(ii)**

Group Lockout or Tagout

When servicing or maintenance is performed by a crew, craft, department, or other group, do they use procedures that afford them a level of protection equal to that provided by the implementation of a personal lockout or tagout device? **(f)(3)(i)**

Are group lockout or tagout devices used in accordance with the procedures required by paragraph (c)(4) of this section, including, but not limited to, the following specified requirements: **(f)(3)(ii)**

- Is primary responsibility vested in an authorized employee for a set number of employees working under the protection of a group lockout or tagout device; **(f)(3)(ii)(A)**

- Are provisions made for the authorized employee to ascertain the exposure status of individual group members with regard to the lockout or tagout of the machines or equipment; **(f)(3)(ii)(B)**

1910.147 — THE CONTROL OF HAZARDOUS ENERGY (LOCKOUT/TAGOUT)

	YES	NO	N/A

- When more than one crew, craft, or department is involved, is assignment of overall job-associated lockout or tagout control responsibility given to an authorized employee designated to coordinate affected work forces, and to ensure continuity of protection; **(f)(3)(ii)(C)**

AND

- Has each authorized employee fastened a personal lockout or tagout device to the group lockout device, group lock box, or comparable mechanism when he or she begins work and removes those devices when he or she stops working on the machine or equipment being serviced or maintenanced? **(f)(3)(ii)(D)**

1910.147 — THE CONTROL OF HAZARDOUS ENERGY (LOCKOUT/TAGOUT)

	YES	NO	N/A

Shift or Personnel Changes

Are specific procedures used during shift or personnel changes to ensure the continuity of lockout or tagout protection, including provision for the orderly transfer of lockout or tagout devices between off-going and oncoming employees, to minimize exposure to hazards from the unexpected energization of machines or equipment or release of stored energy? **(f)(4)**

[Standard 1910.147 is effective January 2, 1990.]

The fourth most cited OSHA standard is 1910.212(a)(1)—General Requirements for All Machines. This provision requires you to provide one or more methods of machine guarding designed to protect operators and other workers from hazards created by point of operation, ingoing nip points, rotating parts, flying chips and sparks.

If you have already completed a job hazard analysis survey, as discussed in the previous chapter, you probably have a good idea of which machines pose which hazards—and which ones require guarding. Keep in mind that all hazardous moving parts of machines, power tools and other equipment need to be safeguarded. Be sure to check all belts, gears, shafts, pulleys, sprockets, spindles, drums, fly wheels, chains, or other reciprocating, rotating, or moving parts of equipment. If employees can come into contact with any of them—they must be guarded. Manufacturers of your equipment can generally provide or clarify information pertaining to machine guarding.

The 1995 OSHRC decision *Secretary of Labor v. Eyelematic Manufacturing Co.* is considered an illustrative case involving machine guarding. The employer ended up prevailing because OSHA didn't make a strong enough connection between a potential guard problem and injuries.

Eyelematic manufactured small metal parts used for various commercial products such as cosmetics and battery cans. OSHA cited the company for failure to protect employees from hazards associated with ingoing nip points, rotating parts, and reciprocating parts of machine tools.

OSHA standard 1910.212 (a) (1) requires machine guarding to be provided to protect the operator and other employees in the machine area from hazards as those created by point of operation, ingoing nip points, rotating parts, flying chips and sparks. Guarding method examples include: barrier devices, two hand tripping devices, electronic safety devices, etc.

The review commission reasoned that, in order to prove a violation, OSHA must show that employ-

A manufacturer is cited for failure to protect workers from machine tools

**Vague
references
lacked
context for
OSHA
charges**

ees were exposed to a hazard as a result of the manner in which the cited machine functioned and is operated. This would emerge as an important distinction.

The commission found that the OSHA inspector did not provide information as to how Eyelematic's machines functioned or how its employees operated the machines. One inspector admitted he did not know how an eyelet machine—one of the items central to the citations—operated.

The OSHRC found that without detailed information about the actual operation of these machines, the inspector's vague references to *points of operation, nip points,* and *rotating parts*—as well as the numerous photographs he took of the cited machines—lacked context. They provided "little support for OSHA's allegations."

The commission then considered credible testimony from Eyelematic's safety director, which indicated that—in the course of their normal work duties—Eyelematic's employees did not come "in proximity to any of these allegedly hazardous areas during the machine's operation."

The commission then considered a second allegation—an alleged violation for lack of guarding of a trash compactor. Once again, the OSHA inspectors didn't explain how the compactor functioned or how Eyelematic's employees operated it. "Pictures taken by [the inspector] don't even shed any light on this critical issue."

It again turned to the testimony of Eyelematic's safety director, who stated that anyone operating the compactor must remain stationed at the controls located several feet away. There was no reason for any employee to go into the compactor while it was operating. The safety director also indicated that it was an outside contractor, not Eyelematic, that handled the trash compactor's repair and maintenance.

Because the record didn't show that the compactor, as operated, posed a hazard to Eyelematic employees, a violation of the machine guarding standard could not be established.

OSHA's fifth most cited citation also addresses guarding—in this case—failing to guard abrasive wheels. OSHA's Abrasive Wheel Machinery standard—1910.215 (b) provides very specific requirements for guarding abrasive wheels. Powered abrasive grinding, cutting, polishing, and wire buffing wheels create special safety problems because they throw off flying fragments.

Before an abrasive wheel is mounted, it should be inspected closely and should be sound—or ring-tested to ensure that it is free from cracks or defects. To test, wheels should be tapped gently with a light non-metallic instrument. If they sound cracked or dead, they must not be damaged because they could fly apart in operation. A sound and undamaged wheel will give a clear metallic tone or "ring."

To prevent the wheel from cracking, the user should be sure it fits freely on the spindle. The spindle nut must be tightened enough to hold the wheel in place, without distorting the flange. Follow the manufacturer's recommendations. Care must be taken to ensure that the spindle wheel will not exceed the abrasive wheel specifications.

The wheel may disintegrate or explode during start-up. Make sure your employees never stand directly in front of the wheel as it accelerates to full operating speed.

OSHA's eighth most cited standard (passing over two provisions of the hazcom standard) is the failure to provide eye/body wash equipment where employees are exposed to corrosives. 1910.151(c)—Medical Services and First Aid requires suitable facilities to provide quick drenching or flushing of the eyes and body.

OSHA inspectors often infer that the term "suitable facilities" means a specific type of eyewash station. Not so. In the OSHA Review Commission Case—*Secretary of Labor v. Trinity Industries, Inc.*, BNA OSHC 1985 (1992)—Trinity contested an OSHA violation of its eyewash standard.

The company acknowledged that paint shop work-

Guarding against abrasive wheel machinery

Lack of water source suitable for quick drenching or flushing

ers were exposed to corrosive materials in the paints as they mixed, sprayed, and otherwise handled the paints. An industrial hygienist testified that he understood the closest source of water to be 40 to 50 yards away—a pedal-operated water fountain supplying a "trickle" suitable only for washing hands. The IH did not make an inventory of water sources and was under the mistaken impression that this was the only source of water available for the "quick drenching or flushing" contemplated by the standard. The Secretary issued Trinity a citation for failure to provide appropriate eyewash facilities for workers in the paint area, and proposed a penalty of $630.

At the hearing, a Trinity superintendent listed a number of sources of running water in the vicinity, including lavatories, drinking fountains, and water hoses, and testified that based on testing he had done, a worker in the paint area could walk at a normal pace to one of these sources of fresh running water within 15 to 30 seconds. The judge accepted the evidence on the number and location of sources, but still affirmed the violation because the sources were not suitable under the standard.

Trinity appealed the decision, arguing that its facilities were the same as those found "suitable" under Commission precedent and that nothing in the record supported a finding of unsuitability.

The judge maintained that prior decisions had eroded the intent of the standard to the point that it was almost unenforceable.

OSHA argued that the plain meaning of the standard requires access to water sources "specifically suited to delivering water to the eyes," and stated that lavatories, ordinary sinks, drinking fountains and garden hoses did not fit that description, and that nothing in the supervisor's list of water sources even remotely approximated an appropriate eye-drenching facility, such as an eyewash fountain.

The commission vacated the violation, citing the fact that in affirming the violation, the judge

shifted the burden of proof from the Secretary to the employer. According to the judge "[w]here the Secretary establishes a need for quick drenching or flushing, as in this case, the burden is on the employer to prove that he has suitable facilities." Trinity argued that the burden was on the Secretary to show that the facilities were unsuitable, not on Trinity to show that they were suitable.

The commission agreed. If an employer has a source of running water within close proximity to employees, it's up to OSHA to prove that the water source fails to meet the requirements of 1910.151(c).

Number ten on OSHA's list of violations is the failure to guard pulleys as required in 1910.219(d)(1) — Mechanical Power Transmission Apparatus.

1910.219 requires employers to safeguard components of the mechanical power transmission system which transmits energy from the power source to the part of the machine performing the work. Typical components include pulleys, flywheels, shafting, coupling, belts, cams, spindles, chains, gears and cranks.

Paragraph (d) of the standard is intended to protect workers from being caught by rotating members, in-running nip points, sprockets or pulleys, etc. Pulleys that have any part that is 7 feet or less from the floor or working platform must be guarded in accordance with the requirements of paragraphs (m) Standard Guards—General Requirements; and (o) Approved Material of 1910.219.

Once again, the best way to assess whether you are in compliance is to complete a job analysis survey to determine which machines pose which hazards—and which ones require guarding. Manufacturers of your equipment can generally provide or clarify information pertaining to machine guarding.

In addition to OSHA's top ten list of violations, failing to maintain or accurately maintain a log and summary of occupational injuries and ill-

Guarding pulleys of mechanical power transmissions

A job analysis survey is the best way to determine hazards

nesses is also a high priority for OSHA inspectors and has ranked in the top ten in prior years. This paperwork intensive requirement will be addressed in greater detail in the next chapter.

Failing to have an OSHA poster has also been a hot violation—but you won't have to worry anymore about paying hefty fines for not having the OSHA poster hanging in the workplace. OSHA has decided that it has more serious hazards to concern itself with and now classifies not having an OSHA poster as a de minimis violation.

One final, often cited violation does deserve notice—OSHA's catch all citation—the General Duty Clause.[1] Remember that any recognized hazard in the workplace, whether specifically addressed by OSHA or not, can be cited under the General Duty Clause. It is up to you, not OSHA, to identify and eliminate all existing and potential hazards.

[1] For more detail on the General Duty Clause, see Chapter 2.

CHAPTER 7

RECORDKEEPING

Introduction

We've seen already that a big part of creating a safe workplace—and complying with OSHA guidelines—involves paying attention to the details of information gathering and communication.

In this chapter, we'll consider information about the written records that must be maintained to comply with OSHA.

Within the agency, the trend in recent years has been toward lightening the paperwork burden for companies—in fact, the agency has been required to do so under the Paperwork Reduction Act.

However, it is important to keep those records for which you are responsible, since OSHA reviews records first during any inspection and uses its findings to decide whether further inspections are necessary. Although OSHA's main interest lies in the abatement of workplace hazards, if an employer knowingly falsifies records and OSHA can prove it, the employer can face a fine of up to $10,000 and a six-month jail term.

A caveat: OSHA recordkeeping requirements are independent of any workers' compensation laws or rulings of any state. Also, OSHA requires federal reporting that is different from any state law or regulation.

Employee injuries and illnesses are the most important records

Types and forms of records

In the case of occupational injury and illness records, certain prescribed formats should be used. Where no specific form is required, the record can be of your own design as long as it contains all pertinent data as required by the standard.

The following pages outline a number of these required records along with some illustrations and sample forms. These samples can be used to develop your own records forms.

Anyone who wishes to maintain records by a different procedure outlined in the OSHA regulations must petition OSHA for an exception ruling. For more information on petitioning for a recordkeeping variance, contact the nearest OSHA area office.

By far the most important records are those kept of employee injuries and illnesses in the workplace. These records are designed to help compliance officers when they visit a work site for an inspection, but can be of even greater help to the employer in identifying "trouble spots" and hazards in the workplace.

Who must keep injury/illness records

OSHA injury and illness records are required of employers in the following industries who have 11 or more employees:

- agriculture, forestry, and fishing (SICs 01-02 and 07-09),
- oil and gas extraction (SICs 13 and 1477),
- construction (SICs 15-17),
- manufacturing (SICs 20-39),
- transportation and public utilities (SICs 41-42 and 44-49),
- wholesale trade (SICs 50-51),
- building materials and garden supplies (SIC 52),
- general merchandise and food stores (SICs 53-54),

- hotels and other lodging places (SIC 70),

- repairs services (SICs 75-76),

- amusement and recreation services (SIC 79),

- health services (SIC 80).

The following retail, trade, finance, insurance, real estate, and services industries do not normally have to keep OSHA injury and illness records:

- automotive dealers and gasoline service stations (SIC 55),

- apparel and accessory stores (SIC 56),

- furniture, home furnishings, and equipment stores (SIC 57),

- eating and drinking places (SIC 58),

- miscellaneous retail (SIC 59),

- banking (SIC 60),

- credit agencies other than banks (SIC 61),

- securities and commodity brokers, and services (SIC 62),

- insurance (SIC 63),

- real estate (SIC 65),

- combined real estate, insurance, etc. (SIC 66),

- holding and other investment offices (SIC 67),

- personal services (SIC 72),

- business services (SIC 73),

- motion pictures (SIC 78),

- legal services (SIC 81),

- educational services (SIC 82),

- social services (SIC 83),

- museums, botanical, zoological gardens (SIC 84),

- membership organizations (SIC 86),

- private households (SIC 88),

- miscellaneous services (SIC 89).

Your state may also require recordkeeping

Each year, a small sample of these industries is required to keep records to participate in the Bureau of Labor Statistics' annual survey of occupational injuries and illnesses. Also, these employers must comply with OSHA standards, display the OSHA poster, and report to OSHA within 48 hours any accident which results in a fatality or in the hospitalization of five or more employees. Lastly some state programs may require these employers to keep injury and illness records even though the federal government does not.

Excluded entirely from OSHA recordkeeping requirements are:

- small employers who at no time during the year had more than 10 employees;
- self-employed individuals;
- partners with no employees;
- employers of household domestics;
- employers whose employees are engaged in the performance of religious services, such as clergy, choir members, organists, ushers, etc.

Employers with 10 or fewer employees must keep records if asked to participate in the Bureau of Labor Statistics' annual survey of occupational illnesses and injuries. Small employers must still report fatalities and accidents resulting in the hospitalization of five or more employees. States may also extend recordkeeping requirements to all employers regardless of size.

Log and summary of occupational injuries and illnesses

The OSHA Form number 200 is the combination log and summary form which all employers subject to recordkeeping requirements should use. If an alternative form is used, it must be readable and comprehensible to a person not familiar with the OSHA Form 200.

Computerized recordkeeping is allowed; however, two requirements must be met: sufficient infor-

mation must be available at the computer location to complete the log within six work days after the receipt of information that a recordable case has occurred, and a copy of the log updated to within 45 calendar days must be present at all times at the establishment.

The log and summary form is presented in reproducible form for printing or photocopying on pages 170 and 171. The required data can be recorded with "log" entries in the left hand pages, and can be found below.

Since not every injury or illness occurring in the workplace is recordable, charts to help determine the recordability of occupational illnesses and injuries can be found on page 183.

The summary portion of the form (the right hand side) is the cumulative record to be posted in the workplace at the end of the calendar year (no later than February 1 of the year immediately following) and remain posted until March 1.

The forms for recording injuries as OSHA requires

U.S. Department of Labor

Injury/Illness Summary

For Calendar Year 19—— Page —— (b) of ——

Form Approved

Company Name

O.M.B. No. 44R 2453

Establishment Name

Establishment Address

	EXTENT OF AND OUTCOME OF INJURY						TYPE, EXTENT OF, AND OUTCOME OF ILLNESS												
	FATA-LITIES	NONFATAL INJURIES					TYPE OF ILLNESS							FATA-LITIES	NONFATAL ILLNESS				
	INJURY RELATED	INJURIES WITH LOST WORKDAYS				INJURIES WITHOUT LOST WORK DAYS	7	CHECK Only one column for each illness (See instructions for terminations or permanent transfers)						ILLNESS RELATED	INJURIES WITH LOST WORKDAYS				ILLNESSESS WITHOUT LOST WORK DAYS
	1	2	3	4	5	6	a	b	c	d	e	f		8	9	10	11	12	13
	Enter DATE of Death Mo/day/yr	Enter a CHECK if injury involves days away from work or days of restricted work activity or both.	Enter a CHECK if injury involves days away from work.	Enter number of DAYS away from work	Enter number of DAYS of restricted work activity	Enter a CHECK if no entry was made in columns 1 or 2 but the injury is recordable as defined above.	Occupational skin diseases or disorders	Dust diseases of the lungs	Respiratory conditions due to toxic agents	Poisoning (systemic effects of toxic materials)	Disorders due to physical agents	Disorders associated with repeat trauma	All other occupational illnessess	Enter DATE of Death Mo/day/yr	Enter a CHECK if injury involves days away from work or days of restricted work activity or both.	Enter a CHECK if injury involves days away from work.	Enter number of DAYS away from work	Enter number of DAYS of restricted work activity	Enter a CHECK if no entry was made in columns 8 or 9 but the injury is recordable as defined above.
1.																			
2.																			
3.																			
4.																			
5.																			
6.																			
7.																			
8.																			
9.																			
10.																			
11.																			
12.																			
13.																			
14.																			
15.																			
16.																			
17.																			
18.																			
19.																			
20.																			

Certification of Annual Summary Totals By _____ Title _____ Date _____

OSHA No. 200 POST ONLY THIS PORTION OF THE LAST PAGE NO LATER THAN FEBRUARY 1

Bureau of Labor Statistics
Log and Summary of Occupational
Injuries and Illnesses

Page _____ (a) of _____

NOTE: **This form is required by Public Law 91-596 and must be kept in the establishment for 5 years. Failure to maintain and post can result in the issuance of citations and assessment of penalties. (See posting requirements)**

RECORDABLE CASES: **You are required to record** information about every occupational death; every nonfatal occupational illness; and those nonfatal occupational injuries which involve one or more of the following: loss of consciousness, restriction of work or motion, transfer to another job, or medical treatment (other than first aid). (See definitions.)

CASE OR FILE NUMBER **Enter a nondupli-catingnumber which will facilitate comparisons with supplementary records.**	DATE OF INJURY OR ONSET OF ILLNESS **Enter Mo./day**	EMPLOYEE'S NAME **Enter first name or initial, middle initial, last name.**	OCCUPATION **Enter regular job title, not activity employee was performing when injured or at onset of illness. In the absence of a formal title, enter a brief description of the employee's duties.**	DEPARTMENT Enter department in which the employee is regularly employed or a description of normal workplace to which employee is assigned, even though temporarily working in another department at the time of injury or illness.	DESCRIPTION OF INJURY OR ILLNESS **Enter a brief description of the injury or illness and indicate the part or parts of body affected.** **Typical entries for this column might be: Amputation of 1st joint right forefinger; Strain of lower back; Contact dermatitis on both hands; Electrocution - body.**
A	B	C	D	E	F
1.					Previous Page Totals ⇒
2.					
3.					
4.					
5.					
6.					
7.					
8.					
9.					
10.					
11.					
12.					
13.					
14.					
15.					
16.					
17.					
18.					
19.					
20.					Totals (see instructions) ⇒

OSHA No. 200

185

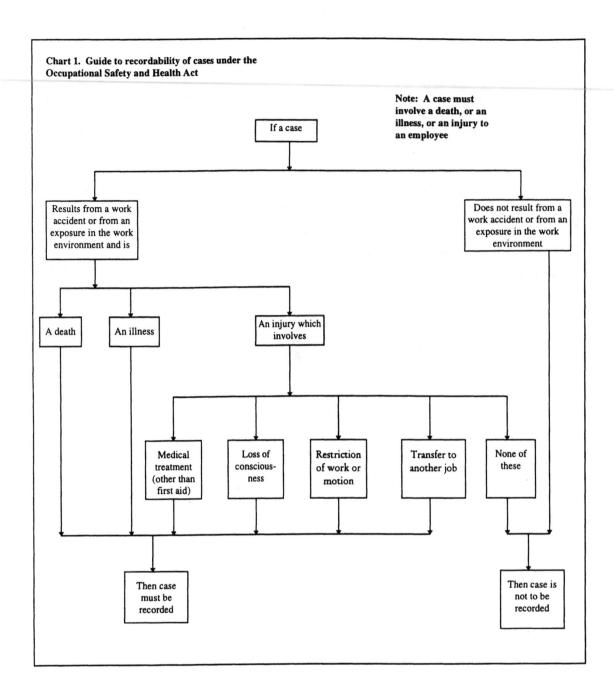

Chart 1. Guide to recordability of cases under the
Occupational Safety and Health Act

Note: A case must
involve a death, or an
illness, or an injury to
an employee

If a case

Results from a work
accident or from an
exposure in the work
environment and is

Does not result from a
work accident or from an
exposure in the work
environment

A death

An illness

An injury which
involves

Medical
treatment
(other than
first aid)

Loss of
conscious-
ness

Restriction
of work or
motion

Transfer to
another job

None of
these

Then case
must be
recorded

Then case is
not to be
recorded

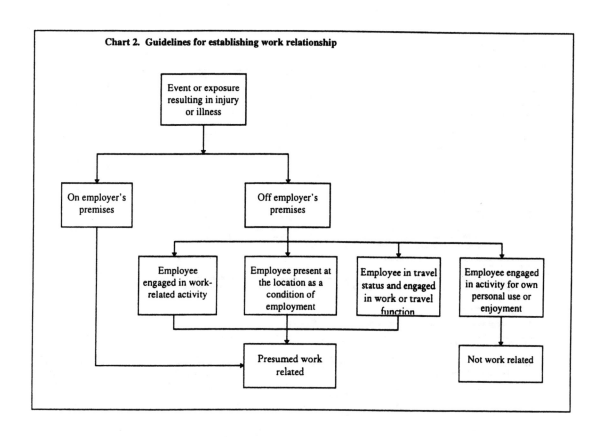

Chart 2. Guidelines for establishing work relationship

Event or exposure resulting in injury or illness

On employer's premises

Off employer's premises

Employee engaged in work-related activity

Employee present at the location as a condition of employment

Employee in travel status and engaged in work or travel function

Employee engaged in activity for own personal use or enjoyment

Presumed work related

Not work related

187

Bureau of Labor Statistics
Supplementary Record of
Occupational Injuries and Illnesses

U.S. Department of Labor

This form is required by Public Law 91-598 and must be kept in the establishment for *5 years.* Failure to maintain can result in this issuance of citations and assessment of penalties.	Case or File No.	Form Approved O.M.B. No. 1220-0029

Employer

1. **Name**
2. **Mail address** *(No. and street, city or town, State, and zip code)*
3. **Location, if different from mail address**

Injured or Ill Employee

4. **Name** *(First, middle, and last)* Social Security No.

5. **Home Address** *(No. and street, city or town, State, and zip code)*

6. **Age** 7. **Sex:** *(Check one)* Male ☐ Female ☐

8. **Occupation** *(Enter regular job title, not the specific activity he was performing at time of injury.)*

9. **Department** *(Enter name of department or division in which the injured person is regularly employed, even though he may have been temporarily working in another department at the time of injury.)*

The Accident or Exposure to Occupational Illness

If accident or exposure occurred on employer's premises, give address of plant or establishment in which it occurred. Do not indicate department or division within the plant or establishment. If accident occurred outside employer's premises at an identifiable address, give that address. If it occurred on a public highway or at any other place which cannot be identified by number and street, please provide place references locating the place of injury as accurately as possible.

10. **Place of accident or exposure** *(No. and street, city or town, State, and zip code)*

11. **Was place of accident or exposure on employer's premises?** Yes ☐ No ☐

12. **What was the employee doing when injured?** *(Be specific. If he was using tools or equipment or handling material, name them and tell what he was doing with them.)*

13. **How did the accident occur?** *(Describe fully the events which resulted in the injury or occupational illness. Tell what happened and how it happened. Name any objects or substances involved and tell how they were involved. Give full details on all factors which led or contributed to the accident. Use a separate sheet for additional space.)*

Occupational Injury or Occupational Illness

14. **Describe the injury or illness in detail and indicate the part of body affected.** *(E.g., amputation of right index finger at second joint; fracture of ribs; lead poisoning; dermatitis of left hand, etc.)*

15. **Name the object or substance which directly injured the employee.** *(For example, the machine or thing he struck against or which struck him; the vapor or poison he inhaled or swallowed; the chemical or radiation which irritated his skin; or in cases of strains, hernias, etc., the thing he was lifting, pulling, etc.)*

16. **Date of injury or initial diagnosis of occupational illness** 17. **Did employee die?** *(Check one)* Yes ☐ No ☐

Other

18. **Name and address of physician**
19. **If hospitalized, name and address of hospital**

Date of report	Prepared by	Official position

OSHA No. 101 (Feb. 1981)

Instructions for Completing the Log and Summary (OSHA Form 200)

Columns A through F (Left Page)

Column A
Enter case or file number.

Column B
Enter date of injury or onset of illness:

for injuries enter date of work accident resulting in injury.

for occupational illness enter date of initial diagnosis, or if absence from work occurred before diagnosis, enter first day of absence attributable to the illness.

Column C
Enter employee's name (first name or initial, middle initial, last name).

Column D
Enter occupation job title or duties of employee.

Column E
Enter department or workplace in which the employee is regularly employed or assigned.

Column F
Enter description of injury or illness briefly stated.

Indicate part or parts of body affected.

Columns 1 through 13 (Right Page)

Injury-Related Entries: Columns 1 through 6

Column 1
Enter date(s) of any injury-related fatalities.

Column 2
Enter a check if injury resulted in lost workdays or days of restricted activity.

Column 3

Enter a check if injury resulted in days away from work.

Column 4
Enter the number of workdays (consecutive or not) on which the employee would have worked but could not because of the injury. Do not include the day of the injury or days on which the employee would not have worked even if able.

In instances where the employee does not have a regularly scheduled shift (is a part-time employee, casual laborer, etc.) it may be necessary to estimate the number of lost workdays based on prior work history of the employee AND comparison with days worked by other employees in the same department and/or occupation as the ill or injured employee.

Column 5
Enter number of workdays (consecutive or not) on which because of the injury the employee was:

1) assigned to another job on a temporary basis;

2) working at a permanent job less than full time; or

3) worked at a permanently assigned job but could not perform all duties normally connected with it.

NOTE: The number of lost workdays should not include the day of injury or any days on which the employee would not have worked even if able to work.

Column 6
Enter a check if recordable injury not involve lost workdays.

Illness-Related Entries: Columns 9 through 13

Column 7 (a through g)
Enter a check in only one column for each illness.

If the illness resulted in termination of employment or permanent transfer, place an asterisk to the right of the check mark entry.

Column 8
Enter the date of any illness-related fatality.

Column 9
Enter check if illness resulted in lost workdays or days of restricted activity.

Column 10
Enter check if illness resulted in days away from work.

Column 11
Enter the number of days away from work (consecutive or not) due to illness. Do not include the day of the illness or days on which the employee would not have worked even if able.

In instances where the employee does not have a regularly scheduled shift (is a part-time employee, casual laborer, etc.) it may be necessary to estimate the number of lost workdays based on prior work history of the employee in comparison with days worked by other employees in the same department and/or occupation as the ill or injured employee.

Column 12
Enter number of workdays (consecutive or not) on which because of the illness the employee was:

1) assigned to another job on a temporary basis;

2) working at a permanent job less than full time; or

3) works a permanently assigned job but could not perform all duties normally connected with it.

NOTE: The number of lost workdays should not include the day of the onset of illness or any days on which the employee would not have worked even if able to work.

Column 13
Enter check if recordable illness did not involve lost workdays.

Totals

Enter totals at the bottom of each column and then in the upper section of columns on the next page (previous page totals).

Columns 1 and 8: Add total number of fatalities.

Columns 2, 3, 6, 7, 9, 10 and 13: Add total number of checks in each column.

Columns 4, 5, 11 and 12: Add the number of days entered in each column.

Totals should be generated for each column at the end of each page and at the end of each year. Only the yearly totals are required for posting.

If an employee's loss of workdays is continuing at the time the totals are summarized, estimate the number of future workdays the employee will lose and add that estimate to the workdays already entered as lost workdays and include this figure in the annual totals. No further entries should be made with respect to such cases in the next year's log and summary.

Changes in extent or outcome of injury or illness

If, during the five-year period the log must be retained, there is a change in the outcome of an injury or illness for which an entry was made in columns 1, 2, 6, 8, 9 or 12, the first entry should be lined out and a new entry made.

If an employee who had been injured required only medical treatment, it would be recorded in column 6. If the injury later resulted in lost workdays away from work, the check mark in column 6 should be lined out and checks entered in columns 2 and 3, and the number of lost workdays entered in column 4.

If an employee with an occupational illness lost workdays, returned to work, and then died of the illness, entries in columns 9 and 10 should be lined out and the date of death entered in column 8.

Entries for injuries or illness which are later determined to be nonrecordable should be lined out.

An injury or illness is determined to be not work-related: An injury initially thought to involve medical treatment is later determined to have only involved first aid.

Supplementary record (OSHA Form 101)

In addition to the OSHA Form 200, each employer must have available for inspection at each establishment a supplementary record for each recordable occupational injury or illness. The record must be completed in detail and be available within six working days after receiving information that a recordable case has occurred.

Workers compensation, insurance, or other reports are acceptable if they contain the required information, which appears below. Any missing items may be added somewhere on the other form or on an attachment.

The supplementary record must contain the following:

- The employer's name, mail address and location if different than mailing address.

- The injured or ill employee's name, social security number, home address, age, sex, occupation, and department.

- Accident or exposure details or exposure whether it was on the employer's premises, what the employee was doing when injured and how the accident occurred.

- Occupational injury or illness details—description of the injury or illness, part or parts of body affected, name of the object or substance which directly injured the employee, and date of injury or diagnosis of illness.

- Name and address of physician, if hospitalized name and address of hospital.

- Date of report, and name and position of person preparing the report.

The summary of injuries is posted with zeros if none occur

Posting the annual summary

✳ An annual summary of occupational injuries and illnesses must be posted for each establishment no later than February 1 of the year immediately following, and remain posted until at least March 1. The summary must include the year's totals from the OSHA Form 200 and the calendar year covered, company name, establishment name and address certification signature, title, and date.

✳ If no injuries or illnesses occurred, the form must still be posted with zeros filled in for the totals. Whoever supervises the preparation of the log and summary must certify (by signature) that the annual summary is true and complete. Employers must present or mail a copy of the summary to those employees who do not regularly report to a single establishment.

Retention of records

✓ All records must remain in the establishment for five years after the year to which they relate. If an establishment changes ownership, the new employer must preserve the records for the remainder of the five-year period.

Records must be maintained at each establishment (workplace). If an employer has more than one establishment, a different set of records must be maintained at each one.

Firms engaged in activities which are physically dispersed, such as agriculture construction, and transportation, are to maintain records of injuries and illnesses at the place where employees report each day. Records for employees such as traveling salespeople and technicians must be maintained either at the base from which they operate or at the place from which they are paid.

Required records must be kept current and be available for inspection and copying at any reasonable time by authorized federal or state government representatives (this includes representatives of the Department of Labor, the Depart-

ment of Health and Human Services, and states with jurisdiction). The log and summary must also be made available to any employee, former employee, and employee representatives (union officials) for examination and copying.

✳ Whenever an occupational accident results in a fatality or the hospitalization of three or more employees, the employer must notify the nearest OSHA area office (either by telephone or in person) within eight hours. The report must relate the accident circumstances, number of fatalities and the extent of injuries. More detailed reports also may be required.

When a business or establishment has changed ownership, the employer is responsible for maintaining records and filing reports only for that portion of the year during which he or she owned the establishment. However, in the event of any change of ownership, the new employer must retain the previous employer's records for a period of five years after the year in which they relate.

Two charts—the *Guide to recordability of cases under the OSH Act* and the *Guidelines for establishing work relationship*—can help you determine which safety records you need to keep and how to keep them.[1]

Emergency reports

A written or oral report must be filed within 8 hours of any accident which occurs at any place of employment and:

a. is fatal to one or more employees, or

b. requires hospitalization of three or more employees.

The report shall relate the circumstances of the accident, the number of fatalities, if any, and the extent of the injuries. The Area Director may request a further report, in writing, concerning details of the accident.

You may report by telephone or telegraph to the

[1] You'll find these charts on pages 186 and 187.

A review of the important workplace safety definitions

nearest Area Director of the U.S. Department of Labor, Occupational Safety and Health Administration.

If your state has its own plan in effect, you should check for additional reporting requirements you may have to comply with.

If your state has a plan in effect, we recommend that you check with the appropriate state agency for details on its reporting requirements and add notes on such requirements on this page for your future reference.

Definitions

The following key terms have been identified and defined in OSHA's Regulations for Recording and Reporting Occupational Injuries and Illnesses. They serve as a primer for the things you need to know and have available when you're inspected.

Act. The Williams-Steiger Occupational Safety and Health Act of 1970 (84 Stat. 1590 et seq., 29 U.S.C. 651 et seq.).

Establishment. A single physical location where business is conducted or where services or industrial operations are performed. (For example: A factory, mill, store, hotel, restaurant, movie theater, farm, ranch, bank, sales office, warehouse, or central administrative office.) Where distinctly separate activities are performed at a single physical location (such as contract construction activities operated from the same physical location as a lumber yard), each activity shall be treated as a separate establishment.

For firms engaged in activities such as agriculture, construction, transportation, communications, and electric, gas and sanitary services, which may be physically dispersed, records may be maintained at a place to which employees report each day.

Records for personnel who do not primarily report or work at a single establishment, and who

are generally not supervised in their daily work, such as traveling salesmen, technicians, engineers, etc., shall be maintained at the location from which they are paid or the base from which personnel operate to carry out their activities.

First Aid. Any one-time treatment, and any follow up visit for the purpose of observation, of minor scratches, cuts, burns, splinters, and so forth, which do not ordinarily require medical care. Such one-time treatment, and follow up visit for the purpose of observation, is considered first aid even though provided by a physician or registered professional personnel.

Lost workdays. The number of days (consecutive or not) after, but not including, the day of injury or illness during which the employee would have worked but could not do so; that is, could not perform all or any part of his normal assignment during all or any part of the workday or shift, because of the occupational injury or illness.

Medical treatment. Treatment administered by a physician or by registered professional personnel under the standing orders of a physician. Medical treatment does not include first aid treatment even though provided by a physician or registered professional personnel.

Recordable occupational injuries or illnesses are any occupational injuries or illnesses which result in:

1. Fatalities, regardless of the time between the injury and death, or the length of the illness; or

2. Lost workday cases, other than fatalities, that result in lost workdays; or

3. Nonfatal cases without lost workdays which result in transfer to another job or termination of employment, or require medical treatment (other than first aid) or involve loss of consciousness or restriction of work or motion. This category also includes any diagnosed occupational illnesses which are reported to the employer but are not classified as fatalities or lost workday cases.

Some records have to be kept for 30 years

OSHA requires certain employers to keep other records besides injury and illness records. These other written requirements include:

- emergency plans, maintenance manuals,
- environmental and personal monitoring records,
- exposure records or reports,
- job analysis,
- material safety data sheets,
- medical surveillance records,
- periodic medical exams,
- pre-assigned or initial medical exam records,
- maintenance, inspections, tests, records or certification,
- operations/incidence reports,
- respirator programs,
- training programs, instructions, documentation,
- written compliance programs,
- employee exposure and medical records.

Employee exposure and medical records must be kept mainly for employees who are exposed to harmful substances or noise in the workplace. OSHA may at times require access to these records, but is careful to ensure the privacy of the individuals whose records are personally identifiable. Medical exposure records must also be released upon request to the director of the National Institute for Occupational Safety and Health (NIOSH). Employee exposure and medical records must be made available upon request to employees within a reasonable time (no more than 15 days after the request).

Access to employer records must also be provided to employee representatives, except in the case of medical records, where the written consent of the employer is required. Upon initial hiring and at

least annually thereafter, employers must inform employees exposed to toxic substances or harmful physical agents of the existence, location and availability of records; the person responsible for maintaining and providing access to the records; and each employee's rights of access to the records.

✓ Exposure records and data analysis must be maintained for 30 years, and medical records for the duration of employment plus 30 years (except where noted otherwise in a specific standard).

When an employer ceases to do business, the records must be passed on to and maintained by the successor employer. If there is no successor, the employer must notify affected employees three months before the cessation of business. These records must then be transferred to NIOSH or the employer must notify NIOSH three months before disposing of the records.

Exemptions

Whenever a company is exempted from OSHA recordkeeping regulations, it should maintain records including the relevant objective data which justifies the exemption.

For example: A company who can prove that asbestos cannot be released in dangerous concentrations under the expected processing conditions can be exempted from the monitoring and medical surveillance requirements of the asbestos standard if it retains the data that supports the exemption.

Refer to Appendix 2 to determine which OSHA 1910 and 1926 standards contain written requirements.

On the following pages are some forms and additional materials you may use or adapt for your recor keeping process. These include:

- Internal Accident Report
- Analysis Factors Contributing to the Cause of Accident

Even if you're exempt from OSHA, it's important to keep good records

- Authorization for Physician's Services,
- Air Sampling Data,
- Fire Extinguisher Inspections,
- Compliance Directive for Critical Fatality/Catastrophe Investigation Factors.

REPORT OF ACCIDENT
To be completed for all accidents, even if no injury was sustained.

1. Date and time of accident _____ _____ AM _____ PM

2. Location of accident (Area/Dept.) _____

3. Equipment involved _____

4. Employee(s) involved: _____

Name	Age	Job Classification	If Injured	
			First Aid Given	Med Att'n Needed

5. First aid administered by: _____

6. Medical attention authorized by: _____

7. Who witnessed accident? _____

8. Describe accident and nature of injury, if any: _____

9. What happened? _____

10. How did it happen? _____

11. What unsafe act was committed? _____

12. List any unsafe conditions which contributed to accident / injury:
 ☐ Complete check-list of possible causes on other side

13. Could this accident have been prevented? Explain:

14. What should be done to prevent similar accidents?

15. Responsibility for this accident: ☐ Employee _____
 (Explain reason) ☐ Supervision _____
 ☐ _____

16. Additional investigation ☐ needed ☐ not needed

Date of report _____ Prepared by _____

 Supervisor _____

☐ First aid only required, non-recordable injury

☐ Medical treatment required / physician to indicate if injury is recordable

☐ Recordable injury; enter on OSHA Forms 200 and 101. File or Log No. _____

ANALYSIS OF FACTORS CONTRIBUTING TO CAUSE OF ACCIDENT

WORKING CONDITIONS

☐ Poor housekeeping
☐ Poor ventilation
☐ Poor lighting
☐ Temperature (____ Hot / ____ Cold)
☐ _____
☐ _____

BUILDING / PLANT CONDITION

☐ Fire protection inadequate
☐ Exits unmarked
☐ Exits blocked
☐ Unguarded floor opening
☐ _____
☐ _____

EQUIPMENT / MACHINERY

☐ Faulty tools
☐ Faulty machinery
☐ Lack of maintenance
☐ Improper guarding
☐ Guards removed
☐ Guards missing

☐ Guards tampered with:
☐ _____
☐ _____
☐ _____

EMPLOYEE(S) CONDITION / ATTITUDE

☐ Inexperienced
☐ Insufficient training / instructions
☐ Instructions disregarded
☐ Instructions not enforced
☐ Unskilled
☐ Ignorant
☐ Used poor judgment
☐ _____

ATTITUDE / DISCIPLINE

☐ Disobeyed rules
☐ Attention distracted
☐ Inattentive
☐ Fooling, horseplay
☐ Attempted shortcuts
☐ Was hasty
☐ Did not follow safe practice procedure

PHYSICAL / MENTAL CONDITION

☐ Fatigued
☐ Sluggish
☐ Weak
☐ Sick
☐ Disturbed

☐ Personal problems
☐ Drunk, drug abuse
☐ _____
☐ _____

DRESS / SAFETY EQUIPMENT

☐ Protective wear not used
☐ Protective wear not available
☐ Safety equipment not used
☐ Safety equipment not readily available
☐ _____
☐ _____
☐ Clothing loose or too long
☐ Failure to wear safety shoes
☐ Faulty shoes, (high heels)
☐ _____

Employee's Statement: _____

Employee's Signature _____

Witness' Statement: _____

Witness' Signature: _____

Supervisor's or investigator's remarks: _____

Use additional sheets, if needed, for statements from involved employees or witnesses.

AUTHORIZATION FOR PHYSICIAN'S SERVICES

Company _____

SUPERVISOR: Complete this section, sign as indicated, and send Original
and two copies to doctor with injured employee.

Injured Employee _____ Job Title _____

Date of Accident _____ Time _____ AM _____ PM _____ Shift

Where did accident happen? _____

How did accident happen? _____

Probably / Suspected injury _____

First aid administered? _____ By whom? _____

Examination and/or treatment authorized by _____

Supervisor signature

EMPLOYEE: It is your responsibility to make certain that the original and one copy of this form is returned to your
supervisor immediately after completion by physician.

PHYSICIAN: Please fill out this section completely. Retain one copy for your records, and return the
original and a copy to us by the patient attendant.

Arrived for Treatment: Date _____ Time _____

Extent of injury _____

Treatment given _____

Your recommendation:

☐ Employee can return to regular work

☐ Employee can return to light duty work (comment) _____

Lost time _____ days

Employee's return to doctor _____ days

Other Comments: _____

☐ Non-recordable injury, first aid treatment only

☐ Recordable injury

RECOMMENDED DISTRIBUTION: Original - Company file; Employee's personnel file; Physician's copy;
Employee's copy; Supervisor's record copy.

AIR SAMPLING DATA

FACILITY / PLANT _____

ADDRESS _____

DATE _____

CALIBRATION / DEVICE / METHOD _____

BY _____

(1) SAMPLE NO	(2) SAMPLE MEDIUM	(3) PUMP NO	(4) FLOW RATE (Lpm)		(5) START TIME	(6) STOP TIME	(7) TOTAL MINUTES	(8) TOTAL VOL (L)	(9) LOCATION - DESCRIPTION - REMARKS
			START	STOP					

(1) Enter above: Field or Lab No.
(2) Enter filter type, tube type, impinger & solution, etc.

(9) Brief notation of: Breathing zone (personal) sample; employee name, etc.
Area sample - Equipment used, work done, conditions observed, etc.

204

MONTHLY FIRE EXTINGUISHER INSPECTION LOG

Month: _____ Complete and Return by: _____

EXTINGUISHER NUMBER	TYPE	LOCATION	LAST DATE SHOWN ON INSPECTION TAG	INSPECTED BY (INITIAL/DATE)	CONDITION/COMMENT (ACTION REQUIRED)

Compliance Directive For Critical Fatality/Catastrophe Investigation Factors

[Note: Although this directive is geared toward OSHA compliance safety and health officers, the majority of the information provided will benefit employers as well.]

CPL 2.77 12/30/86

SUBJECT: Critical Fatality/Catastrophe Investigation Factors

A. Purpose. This instruction makes mandatory the address of critical fatality/catastrophe investigation factors.

B. Scope. This instruction applies OSHA-wide.

C. Action. Regional Administrators and Area Directors shall ensure:

1. The development and implementation of systems and procedures as will ensure that each accident/fatality investigation file generated within his/her Region appropriately addresses each of the critical accident/fatality investigation factors in accordance with Appendixes A and B of this instruction.

√ 2. No company safety and health officer (CSHO) shall be assigned to lead or conduct a fatality/catastrophe investigation without first having completed the OSHA Training Institute course on accident investigations, or upon the showing of equivalent training to the satisfaction of the Area Director with the concurrence of the Regional Administrator.

3. The use of other (untrained) CSHOs to assist in fatality/catastrophe investigations is encouraged in the interest of resource utilization and for the purpose of giving such CSHOs the experience which, until they can complete the OSHA Training Institute course, will enhance the CSHO's capacity to be of assistance in future fatality/catastrophe investigations.

D. Federal Program Change. This instruction describes a Federal program change which affects State programs. Each Regional Administrator shall:

1. Ensure that this instruction is promptly forwarded to each State designee, and the content is explained.

2. Ensure that State designees are asked to acknowledge receipt of this Federal program change in writing to the Regional Administrator, within 30 days of notification. This acknowledgment should include a description either of the State's plan

to implement the change or of the reasons why the change should not apply to that State.

a. If the State plans to follow the procedures for assigning CSHO's to fatality/catastrophe investigations and use the investigatory aids set out in this instruction, it should indicate this in the letter of acknowledgment.

b. If the State does not plan to follow the procedures contained in this instruction, an alternative system must be submitted as a State plan supplement within 6 months.

3. Notify the State designee that the requirements in paragraph E will not be applied to State fatality/catastrophe investigation files.

E. Procedures. The following procedures will be implemented to evaluate compliance with, and effectiveness of, this instruction:

1. In accordance with this instruction, the Regional Offices will incorporate the review and analysis of fatality/catastrophe files into their audit functions and include such review and analysis into their regular audit reports to the National Office, Directorate of Field Operations.

2. The National Office Audit Team, Office of Field Coordination, will incorporate the review and analysis of fatality/catastrophe files into their regular audit functions and incorporate their findings into their normal audit reports.

3. The Office of Field Coordination will periodically call in approximately 50 preidentified files for review and analysis and report the findings with recommendations for programmatic action to the Director, Directorate of Field Operations.

4. The Director of the Office of Field Coordination will, based upon the review of the Regional Offices Audit Reports, the National Office's Audit Team Reports and the Office of Field Coordination's review and analysis of selected fatality/catastrophe files, submit a unified report and analysis of the effectiveness of this instruction, together with recommendations, to the Director, Directorate of Field Operations, within 1 year of the effective date of this instruction.

F. Background. OSHA produces some 1600 fatality investigation files per year. To maximize the utility of these files requires identification, accurate reporting and professional analysis of critical factors related to safety and health conditions

and practices. While the scope and amount of detail in an inspection may vary from case to case, there must be sufficient information in the file to support the enforcement aspects of OSHA as well as an identification, whenever possible, of causal factors so that the causal factors can be dealt with in the interest of preventing recurrences.

1. Appendixes A and B itemize many of the critical investigatory factors covered in the Field Operations Manual (FOM), Chapter III. This instruction places these factors into organized structures for easy reference by the CSHO. Appendix A is a simple enumeration of investigatory factors under major group headings. Appendix A repeats the major group headings, amplifies some factors, refers to appropriate OSHA forms for entries and provides page references to the FOM where that item is discussed.

2. The "address of critical fatality/catastrophe investigation factors" means that where a factor is applicable that factor is discussed and made a part of the file. Where a factor is not applicable, a notation to that effect is inserted into the file.

Internal Accident Report

[Note: This is *not* an OSHA Checklist Form to be inserted into a fatality/catastrophe investigation file. It is strictly intended as an investigatory aid to the CSHO.]

I. Personal Data—Victim.

Name _____

Address _____

Telephone _____

Age _____

Sex _____

Job Title _____

Date of Employment _____

Time in Present Position _____

Training for Present Job _____

Condition of Employee Deceased/Injured _____

Nature of Injury—Fracture, Amputation, etc. _____

II. Accident Data.

Physical Layout: _____

Sketches/Drawings _____

Measurements _____

Photos _____

Equipment Involved or Process:

Machine Type _____

Manufacturer _____

Model _____

Manufacturer's Instructions _____

Kind of Process _____

Condition _____

Misuse _____

Maintenance Program _____

Equipment Inspection (Logs, Reports) _____

Warning Devices (Detectors) _____

Tasks Performed _____

Witness Statements:

Public _____

Fellow Employees _____

Management _____

III. Other.

Employer's safety and health program _____

Employer's training and education program _____

Competent or Designated safety/health person _____

Safety Precautions _____

Signs, Signals, Barricades _____

Special Instructions _____

Emergency/Evacuation Plans_____

Human Factors _____

History (Related to Present Accident) _____

Other Employers Involved _____

Accident Description _____

IV. Accident Reports.

Coroner _____

Fire _____

Police _____

Medical _____

Employer Insurance Investigator _____

V. Test Data of Physical Evidence Obtained.

OSHA Laboratory Tests _____

Contracted for Tests _____

VI. Information for the Case File.

Complete Narrative (WHO, WHERE, WHAT, WHEN and WHY).

Selected annotation of the accident report

I. Personal Data.

Name. Give the full name, e.g., Robert T. Browne—not "Browne." Do not use nicknames except in signed statements where a witness identifies Robert T. Browne as "Buzz" or whatever. In that case, tie the two together, Robert "Buzz" T. Browne.

Address. Give the complete address, e.g., 1234 Maude Place, Apt. #203, Kennott, Wisconsin 53210.

Human factors. Be careful to stick to supportable fact here, especially dealing with approved OSHA classifications like Malfunction of Neuro-muscular system and Malfunction of Perception System with Respect to Task Environment.

II. Accident Data.

Place of accident. In this section the CSHO should move from the general to the specific, e.g., Wet Processing Department, Bay 1, Toros Pulp Press #5, lower roll.

This description can be supported with:

- sketches/drawings (clear drafting, definition and identification are important),
- measurements, and
- photos.

Type of accident. In this category the file should show the nature of the accident, e.g., boom collapse, electrocution, cave-in, toxic exposure, etc.

Description of Equipment or Process on the Worksheet. This should include machine type, manufacturer, model, manufacturer's instructions, kind of process—and other relevant items.

Statements/Interviews. Some things to remember:

Write legibly.

Identify the witness.

Use the words of the witness, as said.

Control the interview to facts as much as possible.

Witness' opinions as to distances, etc., are acceptable.

Do not leave any empty spaces in the body of the statement.

Corrections to the statement should be initialed by the witness.

After the last line of the statement, use a phrase like "I have read this statement (approximately 2 and a half pages), and it is true and correct to the best of my knowledge.

Insert the date.

Have the witness sign.

At the end of the statement, draw a diagonal line across all unused portions of the page, after the signature of the witness.

Weather Conditions. As reported by the U.S. Weather Bureau, media, Sheriff, Fire, etc., Departments, and persons on the scene at the time of the accident. Copies of official weather reports should be obtained, if appropriate. Weather observations of individuals on the scene should take the form of a signed statement.

Deductive Reasoning. Using all the information gathered in an investigation, deductive reasoning is used to determine the cause(s) or, at least, the probable cause(s) of an accident. The complexity and extent of an accident investigation will govern the amount of information that is put into, the summary. However, the five W's (WHO, WHERE, WHAT, WHEN and WHY) shall be addressed.

III. Accident Reports.

This is supplemental information, including:

coroner reports,

Fire Department reports,

Police Department reports,

other medical reports.

IV. Other.

Competent or Designated safety/health person. Did the employer have a person responsible for identifying safety/health hazards and taking or recommending corrective action?

VI. Information for the Case File.

This section should include one or more narrative accounts of the accident. They should be taken from witnesses or key personnel.

VII. Recommendations.

These should relate to the elimination of causal factors connected to the accident.

Standardized information and optional recordkeeping case outline

Case files for recordkeeping citations to be considered for violation-by-violation penalty procedures shall be set up to group violations, using a numerical code as shown below, followed by the case number of the violation as may be recorded in the optional recordkeeping case outline.

A. Case types are as follow:

INJURY:

01—Laceration

02—Puncture wound

03—Fracture

04—Eye injury

05—Burn

06—Contusion

07—Strain/sprain

08—Hernia

09—Other (major category)

10—All other injuries (non-specific)

ILLNESS:

11—Dermatitis

12—Cumulative trauma disorder

13—Hearing loss

14—Poisoning

15—Respiratory disorder

16—Cancer

17—Other (major category)

18—All other illnesses (non-specific)

B. For burns, there shall be some estimate of the size of the burn. This can be given in the "Detailed Description of Event" column on the suggested recordkeeping case outline.

C. Using the suggested recordkeeping case outline or some other appropriate format, include the following types of information for each violation under "Detailed Description of Event":

1. Work relationship.

EXAMPLE: "While working as a welder...."

2. Injury.

EXAMPLE: Employee sprained his left wrist. Employee fractured her right index finger.

3. Basis of recordability: injury or illness.

EXAMPLE: Employee was to take prescription medicine (Naprosyn) for 5 days and received heat therapy on three subsequent visits.

D. Each violation must have:

1. A unique case file number;

2. A way to be identified, either by name or employee clock number;

3. The reason the instance is a violation of the BLS guidelines; and

4. A detailed description of the injury or illness.

E. Five guides are included in this appendix and in Appendix C for use in determining recordability:

1. Chart 1. Guide to Recordability of Cases Under the Occupational Safety and Health Act.

2. Chart 2. Guidelines for establishing Work Relationship.

NOTE: The charts are from the BLS September 1986 Recordkeeping Guidelines for Occupational Injuries and Illnesses.

3. Medical Treatment vs. First Aid Guidelines.

4. A partial list of prescription and nonprescription drugs based on previous recordkeeping investigation history.

5. Physician's Abbreviations Guide. For Pages B-4 and B-5 refer to printed copy of CPL 2.80.

Medical treatment versus first aid treatment

The following procedures are generally considered medical treatment. Workrelated injuries for which these types of treatment were provided or should have been provided are recordable:

Treatment of INFECTION;

Treatment of SECOND OR THIRD DEGREE BURN(S);

Application of SUTURES (stitches);

Application of BUTTERFLY ADHESIVE DRESSING(S) or STERI STRIP(s) in lieu of sutures;

Removal of FOREIGN BODIES EMBEDDED IN EYE;

Removal of FOREIGN BODIES FROM WOUND if procedure is COMPLICATED because of depth of embedment, size, or location;

Use of PRESCRIPTION MEDICATIONS (except a single dose administered on first visit for minor injury or discomfort);

Use of hot or cold SOAKING THERAPY during second or subsequent visit to medical personnel;

Application of hot or cold COMPRESS(ES) during second or subsequent visit to medical personnel;

CUTTING AWAY DEAD SKIN (Surgical debridement);

Application of HEAT THERAPY during second or subsequent visit to medical personnel;

Use of WHIRLPOOL BATH THERAPY during second or subsequent visit to medical personnel;

POSITIVE X-RAY DIAGNOSIS (e.g., fractures, broken bones);

ADMISSION TO A HOSPITAL or equivalent medical facility FOR TREATMENT.

The following procedures are generally considered first aid treatment (e.g., one-time treatment and subsequent observation of minor injuries) and work-related injuries involving procedures that are not recordable unless they involve loss of consciousness, restriction of work or motion, or transfer to another job.

Treatment of FIRST DEGREE BURN(S);

Application of BANDAGE(S) during any visit to medical personnel;

Use of ELASTIC BANDAGE(S) during first visit to medical personnel;

Removal of FOREIGN BODIES NOT EMBEDDED IN EYE if only irrigation is required;

Removal of FOREIGN BODIES FROM WOUND if procedure is UNCOMPLICATED and is, for example, by tweezers or other simple technique;

Use of NONPRESCRIPTION MEDICATION AND administration of single dose of PRESCRIPTION MEDICATION on first visit for minor injury or discomfort;

SOAKING THERAPY on initial visit to medical personnel or removal of bandages by SOAKING;

Application of hot or cold COMPRESS(ES) during first visit to medical personnel;

Application of OINTMENTS to abrasions to prevent drying or cracking;

Application of HEAT THERAPY during first visit to medical personnel;

Use of WHIRLPOOL BATH THERAPY during first visit to medical personnel;

NEGATIVE X-RAY DIAGNOSIS;

OBSERVATION OF injury during visit to medical personnel.

The following procedure, by itself, is not considered medical treatment.

Administration of TETANUS SHOT(S) or BOOSTER(S). However, these shots are often given in conjunction with more serious injuries; consequently, injuries requiring these shots may be recordable for other reasons.

CHAPTER 8

HOW TO SURVIVE AN INSPECTION

Introduction

What can you expect when OSHA compliance officers inspect your work site?

It helps to keep in mind that the compliance officer holds the credentials of a federal law enforcement officer whose duty is to determine whether you comply with the general duty clause of the OSH Act and with those specific regulations that apply to your industry. The officer is a trained professional who has prepared for the inspection of your facility by becoming familiar with:

- the inspection history of your establishment, if any;

- the nature of your business;

- the industrial processes you use and their hazards; and

- the specific OSHA standards that apply to your industry.

Expect the officer to know what to look for during the inspection—what hazards your workers face and what you and your employees must do to comply with the agency's regulations governing such things as protective clothing, equipment, and procedures.

Things will go most smoothly if you don't adopt an adversarial attitude. The OSH Act makes it your

What the OSHA inspector is allowed to do in your shop

duty to provide your employees with "a place of employment which (is) free from recognized hazards...likely to cause death or serious physical harm." You will demonstrate good faith if you show that you take this duty seriously, not just that you follow those regulations which apply to your industry.

The compliance officer has the right to inspect your facilities without delay and at reasonable times. You have the right to demand that the officer obtain a search warrant, but don't expect to gain much by doing so. The courts grant search warrants as a matter of routine, and the OSH Act gives the Labor Department the wherewithal to make things painful for employers who obstruct the inspection process.

There are three scenarios in which a compliance officer can inspect a worksite without a warrant: when you consent to the inspection; when the compliance officer sees violations in plain view, without a search; and when emergency conditions pose an immediate theat of danger or serious injury to employees.

Keep in mind that a compliance officer doesn't have to ask you for consent or inform you of your rights to request a warrant.

Any competent management official can give consent to an inspection—in fact, the OSHRC states that even senior employees may offer consent. You may want to brief any employees who could be approached by an OSHA inspector and give them specific instructions on referring the compliance officer to senior personnel.

In fact, a seventh circuit case held that a striking employee can accompany an OSHA inspector during a workplace inspection.

In June 1994, OSHA received a written complaint from the employees of Caterpillar Inc.'s plant in Mossville, Illinois.

The complaint alleged that Caterpillar was violating OSHA's overhead crane standard. Soon after, the employees at the plant went on strike.

In September 1994, an OSHA inspector and a Caterpillar striking employee tried to conduct an inspection at the plant premises in Mossville.

Caterpillar refused to allow the striking employee to accompany the inspector. A district court issued a limited warrant allowing the employee to accompany the inspector to the inspection specific items. Caterpillar moved to nullify the warrant in district court but was denied. Ultimately, Caterpillar allowed the inspection but appealed it to the Seventh Circuit.

In its appeal, Caterpillar did not challenge OSHA's right to inspect its premises. The company claimed that the district court lacked the authority to force it to allow a private person accompany an OSHA officer during inspection.

The court rejected Caterpillar's argument by pointing to Section 8 of the OSH Act, which allows for right of entry and inspection of work places by both OSHA and private parties.

Further, the Act gives authorized employee representatives the opportunity to accompany an OSHA inspector during a workplace inspection to offer assistance.

Caterpillar then countered that these permissive provisions only apply to persons that are properly on the premises. The company reasoned that since striking employees are not lawfully on the premises, it has a right to exclude them from inspections.

The court rejected that argument as well. Previous case law has stated that striking employees are considered "employees" or "employee representatives" under the Act.

The court then looked at the intent behind the OSH Act and its regulations to find if striking employees should be excluded from inspections. The OSH Act sets out explicit limits on certain employee inspections and walk around rights but does not specifically address striking employees.

However the court did rule that the Act gives OSHA

A court forces an employer to allow a striking worker in on an inspection

Other court rulings give the Feds discretion when inspecting

control over inspections and that the OSHA inspector has the authority to settle disputes regarding who is an authorized employee representative.

Recent court cases have also given OSHA broad authority to inspect workplaces after observing hazards open to "public view." In *Marshall v. Western Waterproofing Co., Inc.,* the Eighth Circuit Court of Appeals ruled that OSHA compliance officers were entitled to examine a scaffold suspended on the eleventh floor of a building, by going to the fifth floor mezzanine with the building manager and by peering through the window of an attorney's office with the attorney's consent.

Another example: In *Secretary of Labor v. LaForge & Budd Construction Co., Inc.,* the City of Shawnee hired a consulting engineering firm to enlarge it's wastewater treatment plant. The firm subcontracted La Forge & Budd Construction Co. to perform the construction work.

One day, a member of the firm saw LaForge employees working in a trench that had recently collapsed. The engineer believed the excavation did not comply with OSHA's trenching standards, so he notified OSHA of the possible violation.

An OSHA compliance officer arrived to inspect the site, but LaForge's vice president demanded a warrant.

A city official intervened, however, asking the compliance officer to remain at the site. Returning with the engineer and the police, the city official and the compliance officer inspected the work area.

OSHA cited the LaForge for failing to adequately protect employees from trench cave-ins. LaForge contested the citation and brought the case before an administrative law judge. The subcontractor claimed that OSHA violated its fourth amendment rights by searching the site without a warrant and filed a motion to suppress evidence found during the inspection.

OSHA argued that the city's consent made the inspection legal.

The Fourth Amendment allows warrantless searches of property, but only if investigators (such as OSHA officials or policemen) gain permission from someone who has mutual use, joint control and access to that property.

LaForge pointed to a section of its contract with the city which stated:

"Access to work: Engineer and engineer's representatives, other representatives of the owner, testing agencies and governmental agencies with jurisdictional interests will have access to the work at reasonable times for their observation, inspecting and testing. Contractor shall provide proper and safe conditions for such access."

LaForge suggested this section gave it control over entries to the site.

Officials also claimed that the contract allowed a "reasonable expectation of privacy" and a right to demand a warrant for an OSHA inspection.

The judge agreed. LaForge "had a reasonable expectation of privacy in its worksite," the judge said. "The compliance officer should not have proceeded without further inquiry."

The judge dismissed the evidence found during the inspection and vacated the citation.

OSHA disputed the judge's decision before the OSHRC.

The commission reviewed the case file and reversed the judge's ruling.

"Consent for the inspection was given by two parties having joint access to or control of the worksite: the city manager and the consulting engineer." the commission said.

The OSHRC disagreed with the judge's interpretation of the contract. "The provision in the contract on which LaForge relies supports a finding that the company had no reasonable expectation of privacy, at least from government inspectors, because LaForge had expressly agreed that inspectors should have safe access to the worksite," the commission concluded.

Privacy issues can't always stop OSHA inspection

The priorities an inspector must consider

The key elements to establish a citation arising out of a compliance officer's observation in plain view are:

- the compliance officer is in a place where he has a right to be, and

- the compliance officer sees what is actually in public view

Remember also that, given its tight budget, OSHA operates under established priorities, and if a compliance officer wants to inspect your workplace, he or she probably has good reason to do so. OSHA puts top priority on those situations which present imminent danger to employees—that is, those conditions which may cause death or serious physical harm. It gives second priority to catastrophes or fatal accidents and third priority to employee complaints. Fourth priority goes to programmed inspections aimed at specific industries presenting high hazards to life and limb.

This last category is important even though it ranks far down on the list of OSHA's priorities. You may expect OSHA to give you special attention if your plant—or for that matter your industry—shows a high incidence of injury or exposure to toxic substances, or a even high number of previous inspections.

Inspections of construction sites

Due to the nature of the construction industry, an inspection of a construction work site may involve several employers (subcontractors). Since the OSH Act places responsibility for safety and health in the workplace on the employer, inspection forms are filled out for each employer covered during the inspection.

A caveat: Although opinions vary among employers—there have been complaints in the past that some OSHA compliance officers arrive on your doorstep wearing labor's heart on their sleeve. Internal labor-managment struggles have often coincided with OSHA inspections—some warrranted—some not. Employers who under-

stand the potential for bias toward employees or formal unions can better prepare and protect themselve during an inspection.

Some food for thought. According to a recent study conducted by a New Jersey based OSHA data collection service, one out of every three OSHA complaint inspections fails to turn up any violations, and over 50 percent find no willful, repeat or serious violations.

Matthew Carmel, president of OSHA Data conducted a study, examined OSHA enforcement data from 1988 to 1993, and found that 141,678 or 19 percent of all inspections performed stemmed from employee complaints.

Out of the 141,678 inspections, 81,505 (58 percent) failed to uncover any willful, repeat or serious violations, and 43,523 (31 percent) didn't turn up any violations at all.

Examining union and non-union establishments, Carmel found that unionized businesses accounted for 21 percent of the complaint-based inspections, 60 percent of which failed to uncover any willful, repeat or serious violations, and 35 percent of which failed to uncover any violations at all.

For non-union businesses, the numbers were 19 percent, 57 percent and 29 percent respectively.

And even Secretary of Labor Robert Reich found himself accused of forsaking managment for labor—after taking a personal role in an OSHA enforcement case against an employer who was in the midst of a labor/management contract dispute.

Under a full media blitz, Reich personally delivered citations, along with a proposed penalty of $7,490,000, to an Oklahoma-based division of Bridgestone/Firestone, Inc. for its role in the death of an employee. On October 19, 1993 an employee at Bridgestone's Dayton Tire plant suffered severe head injuries when a tire assembly machine he was servicing began operating. The worker died a few days later.

Many inspections turn up no violations

The Secretary of Labor plays politics with a safety inspection

Reich asked a federal district court to issue an injunction ordering the tire manufacturer to shut down operations for what Reich described as an "imminent danger" situation.

The judge complied with the request and workers were sent home. However, after meeting with Bridgestone officials who argued that the restraining order was too broad in scope to meet compliance, the judge lifted the order and set a future hearing date.

A subsequent OSHA investigation revealed willful violations of the agency's lockout/tagout standard.

The proposed penalty represented the largest fine to date for violations of OSHA's lockout/tagout standard—and the third largest proposed penalty for any standard.

Congressman Ernest Istook sent a letter to the Labor Secretary raising concerns about Reich's handling of the enforcement action against Bridgestone. "If this matter was important enough for you to spend considerable personal time coming to Oklahoma City to create a media event, then surely you could have devoted some personal time in advance, to visit with company officials and see a less disruptive solution," Istook said.

Istook also took issue with the fact that Reich obtained the court order without letting company officials present their side of the story. He argued that Bridgestone could have clarified the "overly-broad language of the order, and might have prevented the plant's shutdown, which put over 1,000 workers out onto the street."

"The fact that the judge dissolved his order the next day, once Dayton Tire was given a due process hearing, does not excuse the conduct of your Department," Istook said. "...[T]he Court properly questioned how you can claim that circumstances about which you have known for many months should suddenly be reinterpreted as immediate and imminent danger."

In addition, Itsook indicated that Reich's statement praising the involvement of unions to en-

sure worker health and safety "...seemed to reflect an intent of this Administration to work with labor, but not with management."

Reich stated that "The Labor Department intends to continue its efforts to reach out to unions and other organizations across the country that share our commitment to protecting the health and safety of workers."

The United Rubber Workers Union and its Local chapter actively participated in the fatality investigation. At the time of the Reich's press conference, the plant's labor union contract was expiring.

In his letter, Itsook referred to speculation that Reich's decision to personally deliver the citations was an attempt to aid the labor union with its negotiations.

Union involvement becomes a political issue

The inspection process

Four steps make up the inspection:

1) An opening conference. The inspector presents his or her OSHA credentials and gives you copies of the OSH Act, if you don't already have one, and of those regulations which apply to your industry. During this conference the officer informs you what has prompted the inspection and how extensive the inspection will be.

2) A records review. The compliance officer reviews all of your written records, including all injury/illness log and summary records (OSHA Form 200), all Supplementary Records (OSHA Form 100), and all other records required by OSHA.

3) The physical inspection. The compliance officer conducts a detailed physical inspection of your plant.

4) The closing conference. The officer conducts a closing interview in the presence of the employer and the employee representative. During this conference the officer details all unsafe or unhealthful conditions observed during the inspection.

The opening conference

After showing you his or her credentials, the compliance officers will explain the purpose of the visit, the scope of the inspection, and the standards that apply. He or she will ask you to select an employer representative to tag along during the inspection.

An employee representative goes along, too, but you don't get to choose who will serve as employee representative. In union shops, the union agent generally makes the choice. In non-union shops, if your facility has a plant safety committee, the members of the committee make the choice. Otherwise the employees themselves choose, or the compliance officer does. Under no circumstances does the employer choose.

The OSH Act does not require that there be an employee representative for each inspection. Where there is no authorized employee representative, the compliance officer must consult with a reasonable number of employees concerning safety and health issues in the workplace.

The review of records

Whether the compliance officer decides to conduct a comprehensive inspection or not mainly depends on the records review. If your records show a high incidence of occupational illnesses or injuries, you can bet that the inspection will be comprehensive. Ditto if your records look sloppy. OSHA treats record keeping as a very serious matter. Make sure to have your OSHA safety poster posted in a prominent place. Even if not having one is now classified as a minor infraction with no financial penalty —having one lets the compliance officer know that you've at least heard of OSHA.

Specifically, the compliance officer uses your OSHA Form 200, which logs occupational injuries and illnesses, to calculate a lost-workday injury rate for your plant. The compliance officer compares this rate with national averages published by the Bureau of Labor Statistics and, if your rate falls below the average, generally opts

to do a brief tour of your plant—mostly to determine whether you comply with the OSHA Hazard Communication Standard and to see that you have an effective safety and health management program in place.

If your average exceeds the national figures, on the other hand, the compliance officer will conduct a comprehensive inspection.

The inspection

The compliance officer begins the inspection after the opening conference, accompanied by your management representative and the employee representative. The compliance officer may inspect the plant thoroughly or only in part, going wherever he or she sees fit, even when the inspection results from a specific complaint, fatality or catastrophe.

Under no circumstances may the officer order a halt to work, order employees to leave an area, or close your operations down. The officer does have the power to warn employees of imminent danger. The employees themselves have limited rights to refuse to work. Federal law permits them to refuse to work if in good faith they believe a work site unsafe or unhealthful. They may also do so if the work site poses immediate and grave danger to their health.

The officer may use test equipment and a camera to create a permanent record of the inspection. The officer may interview your employees—in private, if necessary—and observe safety procedures in detail. Federal law protects employees who exercise their rights to a safe and healthy workplace. Employees may complain of unsafe or unhealthful conditions confidentially. Employers may not retaliate against workers who alert compliance officers to unsuspected hazards at any time, even while an inspection is underway.

The officer closely observes health and safety conditions, takes instrument readings, collects air samples, measures noise levels, surveys engineer-

Posting notices and keeping records remain key issues

ing controls, and monitors employee exposure to toxic fumes, gases and dusts. The officer will take care to interrupt work as little as possible.

You have the right to protect your trade and manufacturing secrets. Inform the officer of any trade or manufacturing process that you consider secret. You may also request that only those employee representatives who have confidential clearance accompany the compliance officer into sensitive areas. Rest assured that the officer will keep such information in strict confidence.

OSHA stresses the importance of posting notices and keeping accurate and full records, so remember at all times to keep up to speed in these areas. OSHA commonly imposes fines reaching to $10,000 for each misrecorded or unreported injury. The Budget Reconciliation Act of 1990 allows the agency to go even higher—to $70,000 per incident—although it rarely does. This makes it essential that you stick your nose into your plant's record keeping; don't let those who oversee it day to day miss a thing, and if anybody has any doubt about a particular injury, record it.

The officer will also want to examine your records of employee exposure to toxic substances and harmful physical agents. The Hazard Communication Standard requires that you:

1) establish a written, comprehensive hazard communication program;

2) label containers of hazardous substances;

3) keep your Material Safety Data Sheets up to date;

4) have an employee training program up and running for those who come into contact with hazardous substances.

The training program requires that you keep a list of hazardous substances on prominent display in all areas where your employees work with these chemicals and that you train your employees thoroughly in safety practices. You must also inform employees of the dangers of their failure to follow

established routine in working with the substances.

In addition, the inspector may review your company safety and health program, including safety meeting minutes, records of enforcement and training programs, assured equipment grounding programs, etc.

You will do well to treat these requirements seriously. Make every effort to show the compliance officer that you comply not just with the letter of the law, but with its spirit.

With any luck, the officer won't find any unsafe or unhealthful conditions during the inspection, and everybody can go back to work happy and secure. More likely, the officer will find conditions or processes that need your attention. If you can, jump on those violations that can be corrected immediately. The compliance officer will make note of your doing so and will use your willingness to act as evidence of your good faith in complying with OSHA regulations. This is important. Even if you make the correction, however, the officer may use the violation as the basis for a citation and, if appropriate, a proposed penalty.

Employers should also follow these guidelines during an inspection:

- establish a cooperative attitude with OSHA;

- answer OSHA questions with regard to your operation. However, if you do not know the answer, do not guess;

- make certain that OSHA understands the answers;

- do not admit violations. Many OSHA violations are proved by admissions made voluntarily by employer representatives during inspections;

- be familiar enough with OSHA regulations to tactfully represent the company's position if you feel OSHA is making a mistake in citing a violation;

- take notes of each location visited, equipment

You should be cooperative— but don't admit to violations

checked (including serial numbers), personnel talked to, pictures taken, noteworthy comments made by inspectors, etc.;

- always accompany OSHA—never let OSHA inspect alone; and

- do not perform demonstrations.

The closing conference

The compliance officer sits down with you and, usually, your employee representative. The officer will give you a copy of the OSHA publication *Employer Rights and Responsibilities Following an OSHA Inspection* and discuss its details briefly. The publication does not constitute your Miranda rights, but be careful of what you say. The officer expects a frank and open discussion of whatever the inspection has uncovered. You, however, must keep in mind that, if push comes to shove, the officer may use whatever you say against you.

This discussion covers all unsafe or unhealthful conditions observed during the inspection. The officer discusses each in turn and indicates which violations call for a citation and/or a penalty although he or she will not disclose just what the penalty might come to. Remember that citations aren't automatic. Neither are penalties. The officer will tell you what conditions may result in a citation and/or penalty, but the actual decision to issue a citation or propose a penalty lies farther up the chain of command, with the officer's superiors.

Present your case openly during this conference. Produce whatever records you have to substantiate your position, especially those which show your efforts to comply with OSHA regulations. Let the compliance officer know how much time and money you think it will take to correct any problem uncovered during the inspection. If you need it, ask for a second closing conference: You will want one especially when you must evaluate health hazards, possibly using lab reports that take time to get.

In addition, query the compliance officer as to the resources available to employers through OSHA. The agency's offices inform the public as to their health and safety activities and new or revised standards. They also provide technical assistance and materials, including courses offered through the OSHA Training Institute. They promote safety and health through voluntary protection programs and employer abatement assistance efforts. If any of these services apply to your plant, make use of them.

Over the past few years, OSHA has made a number of changes to its inspection policies and procedures in order to make best use of its limited manpower and resources.

Compliance officers may now investigate formal complaints by letter or telephone if the complainant is first contacted and authorizes the procedure.

If the complainant does authorize the phone or mail investigation, the findings can be shared over the phone. OSHA doesn't have to leave the office, leaving more time for high priority inspections of high hazard employers.

Nonformal complaints may now be investigated by telephone and without a letter if they can be satisfactorily resolved in that manner.

The area office may now contact a construction site or contractor in advance of an inspection to determine the stage or activity status of a particular site.

Inspectors do not have to identify the call as an OSHA compliance call, however—so stay alert. If OSHA calls to talk about the weather, maker sure your OSHA Log paperwork is up to date and you OSHA poster is where it should be.

Chapter 9

Responding to OSHA

Introduction

With any luck, the OSHA compliance officer will have inspected your facility and discovered nothing wrong. You and your employees can go about your business without further ado.

But don't count on it. The greater likelihood is that the inspection will result in citations and/or penalties. How does OSHA view violations? What's an "other-than-serious" violation? What's the difference between a "willful" and a "serious" violation? What about repeated violations? What does OSHA do about conditions of imminent danger? How badly may the agency hurt you with penalties? What does it require you to do if it issues citations?

You already know which conditions or procedures worry the compliance officer who inspected your facility; you discussed them with the officer during the closing conference following the inspection. The discussion also covered your options for abating the conditions and the possible dates by which OSHA may require that you act.

In essence, then, the citations put in writing what you already know, so they should come as no surprise. This doesn't make your receipt of the citations any more enjoyable, of course.

In this chapter, we'll consider how you can respond

How OSHA classifies safety violations

to citations an OSHA inspector issues when he or she had looked over your facility. Like so much else about workplace safety, most of these responses require as much concentration and time as they do money. But, if you're going to take control of workplace safety issues, this is a place where you have to invest resources.

Types of violations

The OSH Act does not permit that you go about correcting unsafe or unhealthful conditions lackadaisically. It sorts violations into five main categories, serious, other than serious, repeat, failure to abate and willful.

Serious. A serious violation can be cited if a condition in the workplace could cause an accident or illness that would most likely result in death or serious physical harm.

Other than serious. OSHA cites this type of violation when the accident or illness most likely to result from the hazardous condition is not likely to cause death or serious injury.

Repeat. OSHA had modified its repeat violation classification over the last several years regarding the specificity of the violation, the geographic area to be considered in the case of employers with multiple work sites, and the length of time between the violations.

A violation is considered repeated if the same establishment is cited. In nonfixed establishments, such as construction sites, a violation is considered repeated if the earlier violation occurred anywhere in the same OSHA Area Office jurisdiction. One exception: High gravity serious violations may be considered repeated if the employer had previously cited at any of his establishments nationwide (federal enforcement only) in the same two-digit SIC code.

Repeat violations can be cited within three years of the date of the original citation or the final abatement of the hazard, whichever is later.

Failure to abate. This violation is issued when OSHA determines that an employer has never corrected a cited violation. (A repeat violation would be issued when a violation has been abated and then is found again). In addition to conducting follow-up inspections, OSHA expects employers to fix cited hazards and notify the agency when the corrective actions have been completed.

Willful violation. A willful violation can be issued for serious and other than serious violations. Such a violation can be cited when evidence shows that the employer knew about an unsafe or unhealthful condition and made no reasonable effort to eliminate it.

In order to prove that a violation is willful, OSHA must develop evidence showing that the employer committed an intentional and knowing violation of the OSH Act.

As we've seen, the agency also makes use of the term "egregious" without formally categorizing such violations. Beginning in 1986, OSHA instituted a policy to aggressively pursue those employers who flagrantly violated OSHA regulations. In a limited number of cases, OSHA uses its existing penalty calculation guidelines; but instead of grouping or combining violations to reduce penalties, each instance of noncompliance is considered a separate violation and a penalty is applied separately.

This is one club you don't want to join. Fines in such cases easily hit $1 million or more, and employers who incur them also face the threat of doing jail time.

OSHA requires that you post copies of any citations you receive at or near the location where the violation occurred. Thus a citation covering improper hazardous materials handling must go up at the location in your plant where the compliance officer found the violation—and not in some little-used stairwell, for instance. The point is obvious: OSHA wants your employees, whose safety and health the agency seeks to protect, to know

Egregious penalties— separate fines for each violation

**OSHA needs
an order from
a federal
court to shut
down a
business**

that you have been cited, and why. You must keep the copies of the citations posted until you have corrected the condition, or for at least three days. Weekends and holidays don't count. You must comply with this posting requirement even if you contest the citation.

Imminent danger

The compliance officer has no power to halt work in your plant or to order your employees to leave an area where they face imminent danger—but this doesn't mean that the latter, at any rate, won't happen anyway where imminent danger exists.

OSHA defines imminent danger as "any conditions or practice in any place of employment which are such that a danger exists which could reasonably be expected to cause death or serious physical harm immediately or before the imminence of such danger can be eliminated through the enforcement procedures otherwise provided by (the OSH) Act."

The short way of saying the same thing is that if the compliance officer comes across something that, in his or her opinion, threatens life and limb, you're in trouble. The officer must determine with reasonable certainty that death or serious physical harm will occur within a short period of time—specifically, before OSHA's normal abatement procedures could be brought to bear.

In such circumstances you can expect the officer to warn your employees of the danger right away. You can also expect your workers to abandon their work stations if in good faith they believe themselves in immediate and grave danger. Federal law protects them if they do so, although the sanction does not constitute blanket protection. Under some circumstances your workers will find additional protection under the National Labor Relations Act.

Thus, although the compliance office holds no power to put a stop to your operations, in practice, work will probably come to a halt anyway where conditions of imminent danger exist. And you can expect OSHA to get the blessing of the

federal courts in short order, in the form of a cease and desist order. The compliance officer informs his or her superiors in the agency who, in turn, petition for a restraining order in U.S. District Court. They waste no time doing so, either. OSHA gives first priority to such litigation so as to head off the threat that workers will come to harm.

Penalties

The compliance officer will have already given you some idea what sort of fines to expect from the violations uncovered during the inspection. OSHA gives formal notice of the fines it contemplates in the citations themselves. It never comes as good news.

The Omnibus Budget Reconciliation Act of 1990 gave OSHA authority to increase its fines seven-fold. The agency may fine you up to $7,000 for other-than-serious and serious violations, and up to $70,000 for willful violations. OSHA may also cite you for failing to correct a violation for which you have been previously cited—and fine you up to $7,000 per day for as long as the hazard persists unabated. It may fine you up to $70,000 for repeated violations. It may fine you up to $70,000 for making false statements or for interfering (or even for threatening to interfere) with the inspection. It may fine you $70,000 for falsifying your records, and $7,000 for violating the agency's posting requirements.

Effective July 16, 1994, OSHA increased the minimum penalty for willful serious violations from $5,000 to $25,000.

The citations you receive from OSHA list the fines which the agency proposes to levy against your organization. Since compliance officers rarely uncover only one or two violations, these penalties assume frightening proportions very quickly.

Keep in mind, however, that OSHA levies fines to its greatest authority only rarely. Compliance, after all, is a delicate thing. OSHA's priority is to persuade employers to make the workplace safe

OSHA may fine employers up to $70,000 for each willful violation

237

Demonstrate good faith toward OSHA compliance

and healthful, and as quickly as possible. It doesn't want to force employers up against the wall, or to bludgeon them so violently as to give them no alternative to resisting the agency tooth and nail. The Congressional writers of the 1990 budget act had a massive deficit to paper over. They frankly increased OSHA's authority to levy fines in an attempt to convince people that doing so would actually increase revenue. Nothing of the sort occurred, of course.

Instead, OSHA's leaders take the position that the agency exists to enforce compliance with health and safety regulations, not to produce revenue for the Federal Government. So they use their authority to fine employers with discretion, and although almost any OSHA fine looks imposing to employers—especially to small employers whose resources don't permit them to mount thoroughgoing safety programs—rest assured that OSHA won't try to pay off the national debt by raiding only your bank account.

OSHA sets fines in accordance with four factors:

1) The gravity of the violation;

2) The size of your business;

3) Your good faith;

4) Your history of violations.

Of the four, you have the chance, at this point, to do something only about good faith. OSHA takes your awareness of the OSH Act as evidence of your good faith—and takes items like your safety and health programs as evidence of your awareness of the act. To put it simply, you will demonstrate your good faith if you can show that your health and safety programs work effectively and that you devote serious attention to them. Among small employers who don't maintain formal health and safety programs, OSHA wants to see work site evidence of safety consciousness. In other words, show the compliance officer that you require your workers to observe common safety practices.

Here's a breakdown of how OSHA determines the amount of its penalties.

Adjustment factors

OSHA has decided to "discount" its penalties for cited employers based on the number of employees. The size adjustment factor is as follows: For an employer with only one to 25 workers, the penalty will be reduced 60 percent: 26 to 100 workers, the reduction will be 40 percent; 101 to 250 workers, a 20 percent reduction; and more than 250 workers, there will be no reduction in the penalty.

There may be up to an additional 25 percent reduction for evidence that the employer is making a good faith effort to provide good workplace safety and health, and an additional 10 percent reduction if the employer has not been cited by OSHA for any serious, willful or repeat violations in the past three years.

In order to qualify for the full 25 percent "good faith" reduction, an employer must have a written and implemented safety and health program such as given in OSHA's voluntary "Safety and Health Management Guidelines", including in Appendix and that includes programs required under the OSHA standards, such as Hazard Communication, Lockout/Tagout or safety and health programs for construction required in CFR 29 1926.20.

Serious violations

The typical range of proposed penalties for serious violations, before adjustment factors are applied, will be $1,500 to $5,000, although the Regional Administrator may propose up to $7,000 for a serious violation when warranted.

Serious violations will be categorized in terms of severity— high, medium or low— and the probability of an injury or illness occurring— greater or lesser.

OSHA provides discounted penalties for smaller operations

Base penalties for serious violations will be assessed as follows:

Severity	Probability	Penalty
High	Greater	$5,000
Medium	Greater	$3,500
Low	Greater	$2,500
High	Lesser	$2,500
Medium	Lesser	$2,000
Low	Lesser	$1,500

Penalties for serious violations that are classified as high in both severity and greater in probability will only be adjusted for size and history.

Other-than-serious violations

If an employer is cited for an other-than-serious violation which has a low probability of resulting in an injury or illness, there will be no proposed penalty. However, the violation must still be corrected. If the other-than-serious violation has a greater probability of resulting in an injury or illness, then a base penalty of $1,000 will be used, to which appropriate adjustment factors will be applied.

The OSHA Regional Administrator may use a base penalty of up to $7,000 if circumstances warrant.

Regulatory violations

Regulatory violations involve violations of posting, injury and illness reporting and recordkeeping requirements, and not telling employees about advance notice of an inspection. OSHA will be applying adjustments only for the size and history of the establishments.

Here are the base penalties, before adjustments, to be proposed for posting requirement violations: OSHA notice, $1,000; annual summary, $1,000; and failure to post citations, $3,000.

Base reporting and recordkeeping penalties are as follows: Failure to maintain OSHA 200 and OSHA 101 forms, $1,000; failure to report a fatality or catastrophe within 48 hours, $5,000 (with a provision that the OSHA Regional Administrator could adjust that up to $7,000, in exceptional circumstances); denying access to records, $1,000; and not telling employees about advance notice of an inspection, $2,000.

Fines for willful violations range from $5,000 to $70,000

Willful violations

In the case of willful serious violations, the initial proposed penalty has to be between $5,000 and $70,000. OSHA calculates the penalty for the underlying serious violation, adjusts it for size and history and multiplies it by 7. The multiplier of 7 can be adjusted upward or down at the OSHA Regional Administrator's discretion, if circumstances warrant. The minimum willful serious penalty is $5,000.

Repeat violations

Repeat violations will only be adjusted for size, and the adjusted penalties will then be multiplied by 2, 5, or 10. The multiplier for small employers— 250 employees or fewer— is 2 for the first instance of a repeat violation, and 5 for the second repeat. However, the OSHA Regional Administrator has the authority to use a multiplication factor of up to 10 on a case involving a repeat violation by a small employer to achieve the necessary deterrent effect.

The multiplier for large employers— 250 or more employees— is 5 for the first instance of repeat violation, and 10 for the second repeat.

If the initial violation was other-than-serious, without a penalty being assessed, then the penalty will be $200 for the first repetition of that violation, $500 for the second repeat, and $1,000 for the third repeat.

Failure to abate

Failure to correct a prior violation within the prescribed abatement period could result in a penalty for each day the violation continues beyond the abatement date.

In these failure to abate cases the daily penalty will be equal to the amount of the initial penalty (up to $7,000) with an adjustment for size only.

This failure to abate penalty may be assessed for a maximum of 30 days by the OSHA Area office. In cases of partial abatement of the violation, the OSHA Regional Administrator has authority to reduce the penalty by 25 percent to 75 percent.

If the failure to abate is more than 30 days, it may be referred to the OSHA national office in Washington where a determination may be made to assess a daily penalty beyond the initial 30 days.

As mentioned earlier, OSHA also likes to see an employer jump on health and safety hazards uncovered by the compliance officer. Whenever possible, take corrective action immediately—while the compliance officer is on your premises, if you can.

The informal conference

Whether you comply or contest, you have the right to seek an informal conference with OSHA's area director to discuss any issues related to the citation and the proposed penalties. OSHA sees this informal conference as your opportunity to discuss the problems you foresee in complying with the OSHA citation. You may see in the informal conference a different opportunity—namely the chance to negotiate a settlement.

Come prepared. If you consider it impossible to comply fully with the citation, present your facts and marshal your arguments. Detail what you must do to meet OSHA's demands—dollars, time, effort. Present a realistic schedule for completing the work involved in correcting the violations. Outline the special problems you may have in in-

stituting disciplined employee safety practices. Propose some alternative ways to correct violations.

In all of this, keep uppermost in mind that your objective is to satisfy OSHA that you will properly improve health and safety conditions at your work site on terms with which you, in turn, can live.

If an inspection was initiated because of an employee complaint, the employee or authorized representative may request an informal review of any decision not to issue a citation.

Employees may not contest citations, amendments to citations, proposed penalties, or lack of penalties. They may, however, contest the time allowed for abatement of a hazardous condition. They also may contest an employer's "Petition for Modification of Abatement" which requests an extension of the proposed abatement period. Employees must contest the petition within 10 working days of its posting or within 10 working days after an authorized employee representative has received a copy.

If you choose to comply with the terms of the citation, you must inform the area director in writing exactly what corrective actions you propose to take and when. (You must also pay the penalties, of course.) The law requires that you adequately protect your workers while you correct any unsafe or unhealthful conditions.

This becomes especially important when OSHA has given you an extended period of time to institute the corrective measures. Under such circumstances you must keep the area director informed of your progress; you must also detail, in writing, exactly how you provide your workers with special protection in the interim.

If, for example your plan of corrective action entails substantial re- engineering of your work site— a time-consuming task—you may have to provide your workers with protective clothing or equipment while the new engineering controls go into place. OSHA wants to know about all of this. It

Your employees contest the amount of time you take to abate a hazard

also wants to know how things progress. Keep the agency informed with regular progress reports. When you have completed the entire process, make sure that everybody knows what you have done.

Contesting citations

Once you have been cited, you may either pay the penalty (generally within 15 days) and agree to correct the condition by the date set in the citation, or you can contest the whole thing. The procedures for contesting citations are complex and fraught with dangers to the employer. However, recent reports on OSHA's enforcement data reveal that employers who contest OSHA citations, often pay significantly smaller penalties than those employers who do not contest citations.

To contest an OSHA citation, simply draft a letter and mail it to the area director of the OSHA office where the inspection originated.

On the next page, you'll find a sample letter.

Sample Contest Letter

Touch and Go Chiropractic Clinic
15 Zorro Lane
Macomb, IL 61455

Date:

Area Director
Area Office Address

Dear:

Touch and Go Chiropractic Clinic of Macomb, Illinois, contests all OSHA citations issued to it from your office. The issuance date of the citations is listed thereon as April 1, 1996.

The company also contests the amount of each proposed penalty, on the basis that each amount it too high.

The undersigned represents Touch and Go Chiropractic Clinic in this OSHA proceeding. Please direct all future Department contacts with regard to this matter through me.

Sincerely,

Appealing an OSHA citation before the OSHA Review Commission

Do not offer any other explanations or reasons regarding the notice of contest. Be concise and to the point. Keep in mind that at this point in the process— OSHA's citations are alleged and the penalties are proposed. You can contest either one and since you have not been found guilty of violating any regulations yet your letter of contest is not an appeal.

Contested citations go to hearing before a hearing examiner appointed by the Chairman of the OSHA Review Commission. If an OSHA Hearing Examiner rules in favor of the OSHA Compliance Officer, the employer may appeal to the Review Commission, but only with the Commission's permission. Substantial penalties accrue daily for each individual citation or violation under appeal.

A hearing is scheduled before a Commission Judge after the Area Director receives the notice of contest. Once the employer has filed the notice of contest, any corrective action set forth in the citation is automatically suspended until the Commission Judge's order becomes final.

The Secretary of Labor must file the notice of contest and all citations, penalty notices, and failure to correct violations with the Commission Judge within fifteen working days. The Secretary of Labor must file a complaint against the employer within thirty days. The employer and employee representatives also receive copies of the complaint. For non-union workers, the employer must post the complaint in the same manner as the notice of contest.

An employer who receives a complaint must file an answer within thirty days. This answer should contain statements of fact and must follow form.

New guidelines in 1986 revised OSHA review commision rules to streamline proceedings. The employer may elect to remain silent to an allegation without admitting or denying it, but this only delays settlement. Federal law requires the Secretary of Labor to set forth specific allegations against an employer. Employers must be definite in their answers as well.

The Commissioner appoints a Judge to conduct the hearing. The Judge controls all proceedings, discoveries, depositions, and production of documents in the case. Sometimes the Judge conducts a prehearing conference during which the parties clarify the issues, consider the necessity or desirability of amending the pleadings, stipulate facts and admissions, authenticate documents, request or object to subpoenas, discuss the use of depositions, disclose the names of the witnesses, synopsize expert testimony, etc.

After the prehearing conference, the judge notifies all parties of the time and place of the hearing itself. The employer must post this notice of hearing. Each party has the right to subpoena witnesses and produce relevant books, records and documents.

A new participant in the OSHRC litigation process is the Settlement Judge. The parties in a litigation may request the Commission to appoint a Settlement Judge. The role of the Settlement Judge is to encourage parties to resolve their disputes. This may include private conferences with each side to discuss settlement possibilities. The mediation attempts of the Settlement Judge may not last longer than 45 days without the approval of all parties.

The Secretary of Labor has the burden of proof for the allegations contained in the citation. At the hearing, each party has the right to cross-examine witnesses and present evidence. The proceedings are recorded. and any interested party may acquire a copy of the transcript for a fee.

The Commission Judge certifies the record of the hearing, and all parties have twenty days to contest findings of fact and conclusions of law. Thereafter the Judge prepares a report and files it with the Executive Secretary of the Commission.

Appealing to OSHRC—and beyond

The Judge's report becomes final unless an employer files a petition for discretionary review. The

A judge can mediate a disputed citation before it goes before the OSHRC

A final decision by the OSHRC is enforceable by the Court of Appeals

Occupational Safety and Health Review Commission does not have to review the report, which becomes the final order of OSHRC unless a member grants a discretionary review. The Commission may specify whether it desires oral argument or the filing of supplemental briefs. The parties in the dispute do not have the automatic right to present oral argument.

OSHRC has final decision power over the citation and whether to increase penalties already proposed. The penalty set by the Commissioner is a debt owed to the United States and procedures to recover the debt may include civil action in federal District Court.

The final decision of OSHRC is enforceable by the Court of Appeals. An employer who continues to resist the citation further risks additional daily penalties up to $7,000 per day. A final order can take five months before it is issued, so resistance becomes expensive very quickly. The Area Director can assess additional penalties if he feels the contest was solely for delay or avoidance of the penalties.

The final order of OSHRC directs the employer to take affirmative action to correct the violation. If the employer does not file a petition for review, OSHRC's order and findings of fact become conclusive against the employer. The Court of Appeals has authority to hold the employer in contempt of court for not complying with the order. The court also assesses penalties.

The employer has the right to have OSHRC's order reviewed by the Court of Appeals. This review addresses only questions of law or objections raised before OSHRC. The Court of Appeals does not review questions of fact, but if evidentiary questions come up, the court may direct OSHRC to modify its findings or take new evidence. This does not mean that the court has the authority to grant temporary relief or a restraining order. It can, however, affirm. modify, or set aside the order of the Commission. These proceedings do not stop the

order of OSHRC Judge. Failure to abate or obtain a stay from the Court subjects the employer to additional daily penalties that a follow up inspection might reveal.

The tools of appeal

Appealing an OSHA citation is an exhausting sequence of events which, depending on how long the proceedings last, may be a greater monetary risk for the employer.

The employer must then initiate this procedure with the Area Director within fifteen working days of the citation. The notice of contest can be a letter or legal pleading explaining the reasons. The notice must go certified mail, return receipt requested to the Area Director with a copy to union representatives, if any. In non-union shops, service may consist of posting the notice of contest at the same place where OSHA posted the original citation. Contesting a citation may trigger an increase in penalties.

The employer must post a notice of contest at each site where a citation has been served. If the employer has completed work at a site where the violation occurred, the notice goes to the site where employees report to work each day.

OSHA insists that employers notify employees so as to allow them to identify themselves as parties. Notices should include a warning that any worker who fails to come forward prior to the hearing will not be considered a legitimate participant.

On the following pages are examples of forms for an employer's notice of contest, notice to employees, and certificate of service and posting.

Appealing an OSHA citation poses a significant monetary risk

Notice of contest

OCCUPATIONAL SAFETY AND HEALTH REVIEW COMMISSION

Secretary of Labor, :

Complainant, DOCKET No.

vs. :

Employer, :

Respondent,:

NOTICE OF CONTEST

Comes now _____,
hereinafter referred to "Employer," and files this Notice of Contest to each and every item of the citations and proposed penalties in the citation (DESCRIBE CITATION). The Employer herein contests each and every item of said Citation and each and every proposed penalty proposed therein. The Employer specifically denies that the Employer has violated the Act as alleged, and the Employer intends to raise any and all legal and factual defenses in any ensuing proceedings.

This _____ day of _____ ,19 ____.

(EMPLOYER OR ATTORNEYS)

By _____

(SIGNED)

Notice to employees

The following proceeding is now pending before the Occupational Safety and Health Review Commission, and employees affected and not represented by a certified bargaining representative and who fail to identify themselves as a party by appropriate notice to the Examiner or the Commission prior to the commencement of a hearing shall, except upon order of the Examiner of the Commission, be estopped from asserting his party status.

If you wish to appear or be represented in this proceeding, you will be governed by the rules of the Commission, which are published in 29 Code of Federal Regulations, Part 2200, which was published in the Federal Register August 31, 1971, Volume 36, No. 169, pages 17409, et seq.

Case: _____

OSHRC Docket Number: _____

Certificate of service and posting

The undersigned certifies that a copy of the foregoing Notice or Contest and the foregoing Notice to Employees have been posted in a conspicuous place where employees can see them at (ADDRESS OF ESTABLISHMENTS WHERE POSTED), and that I have served a copy of the foregoing Notice of Contest on the below listed part by Certified Mail, Return Receipt Requested, properly addressed and sufficient postage thereon:

Area Director Occupational Safety and Health Administration United States Department of Labor (ADDRESS)

Occupational Safety and Health Review Commission 1825 K Street, N.W. Washington, D.C. 20006

NOTE: If the affected employees are represented by an authorized representative the authorized representative must be served by Certified Mail, Return Receipt Requested, and his name and address added to the list in this position.

This _____ day of _____ ,19 _____ .

EMPLOYER OR ATTORNEYS: _____

By _____

Signed: _____

Compliance Directive For Violation-By-Violation Penalties

[Note: Although this directive is geared toward OSHA compliance safety and health officers, the information it provides should benefit employers as well.]

CPL 2.80 10/21/90

Standard Number Reference: Violation-by-Violation Penalties

Originator:

Abstract: This instruction establishes procedures for identifying and handling cases proposed for citation using the additional penalty factor, provided for in the Field Operations Manual (FOM), Chapter VI, B.2.i.(4). The procedures set forth in this instruction will be adopted into the FOM.

Subject: Handling of Cases To Be Proposed for Violation-By-Violation Penalties

A. Purpose. This instruction establishes procedures for identifying and handling cases proposed for citation using the additional penalty factor, provided for in the Field Operations Manual (FOM), Chapter VI, B.2.). (4). The procedures set forth in this instruction will be adopted into the FOM.

B. Scope. This instruction applies OSHA-wide.

C. References.

1. OSHA Instruction CPL 2.45B, June 15, 1989, Revised Field Operations Manual (FOM).

2. OSHA Instruction CPL 2-2.38B, August 15, 1988, Inspection Procedures for the Hazard Communication Standard.

3. OSHA Instruction CPL 2-2.46, January 5, 1989, 29 CFR 1913.10(b) (6): Authorization and Procedures for Reviewing Specific Medical Records to Verify Compliance with 29 CFR 1904.

D. Cancellations.

1. Memorandum from John B. Miles, dated November 20, 1986; Subject: Cases proposed for Citation Using Additional Penalty Factor.

2. Memorandum from Leo Carey, dated June 15, 1987; Subject: Procedures for Handling Potentially Extensive Recordkeeping Violations: Additional Guidelines.

E. Action. Regional Administrators and Area Directors shall ensure that the procedures established in this instruction are adhered to in the handling of cases in which the additional penalty factor is proposed.

F. Federal Program Change. This instruction describes a Federal Program Change which affects State programs. Each Regional Administrator shall:

1. Ensure that this change is promptly forwarded to each State designee using a format consistent with the Plan Change Two-way Memorandum in Appendix F, OSHA Instruction STP 2.22A, CH-2.

2. Explain the technical content of this change to the State designee as requested.

3. Advise the State designees that OSHA has determined that the violation-by-violation citation and penalty policy is an integral part of its nation-wide overall compliance strategy and, therefore, States are required to either adopt OSHA's policy or an alternative "at least as effective as" policy for application to the private sector. States may, but are not required to, extend the policy to their public sector programs.

4. Ensure that State designees are asked to acknowledge receipt of this Federal program change in writing to the Regional Administrator as soon as the State's intention is known, but not later than 70 calendar days after the date of issuance (10 days for mailing and 60 days for response). This acknowledgment must include:

a. The State's plan for adopting identical procedures for documenting and reviewing violation-by-violation cases, adapted as appropriate to reference State law, regulations and administrative structure;

b. The State's plan for developing alternative procedures to those in this instruction which are as effective; or

c. The reasons why it is not necessary for the State to adopt the Federal procedures.

5. Ensure that the State designees submit State plan supplements in response to this instruction, which will be incorporated into the OSHA Field Operations Manual with the next FOM change instruction.

While States must adopt this change within six months of issuance, plan change documentation, through State FOM plan

change supplements, is not required to be submitted more than twice a year in response to OSHA's incorporation of Federal program changes in the FOM.

a. If the FOM changes are issued on their next target date (April 1 or October 1), the States shall have 6 months from the change instruction issuance date to submit a plan supplement in response to the FOM change.

b. If an FOM change is not issued within six months of the date of this instruction, the State shall inform the Regional Administrator of its adoption of this change by submitting documentation describing the State's procedures and implementing instructions. This documentation must be submitted by the close of the calendar quarter following the next FOM change target date which affords the State a 6-month period for implementing the change. However, a formal plan supplement will not be required until issuance of the next Federal FOM change.

6. Advise the State designees to notify their Regional Administrators when they plan to issue violation-by-violation citations and penalties. At the State's request, OSHA will provide assistance in reviewing cases involving violation-by-violation citations and penalties. Regional Administrators will coordinate this review. The review of such cases involving recordkeeping violations similarly may be coordinated with the Bureau of Labor Statistics (BLS) through the Regional Administrator.

7. Review policies, instructions and guidelines issued by the State to determine that this change has been communicated to State compliance personnel.

G. Background. Over the past several years, in a limited number of cases OSHA has alleged a separate violation and proposed a separate penalty for each instance of noncompliance with OSHA recordkeeping regulations, with the safety and health standards, and with the General Duty Clause [Section 5(a)(1) of the Occupational Safety and Health Act (the Act)]. The resulting large aggregate penalties are part of a compliance strategy which improves the efficiency and effectiveness of the agency and conserves its limited resources. This instruction is intended to serve as the master document covering the procedures applicable in cases where the violation-by-violation citation and penalty provisions are employed.

1. In the context of the Act, penalties are intended to provide an incentive to employers to prevent safety and health viola-

tions in their workplaces and to correct such violations which do exist voluntarily.

2. The Act intends that this incentive be directed not only to an inspected employer but also to any employer who has hazards and violations of standards or regulations.

a. The large proposed penalties that accompany violation-by-violation citations are not, therefore, primarily punitive nor exclusively directed at individual sites or workplaces; they serve a public policy purpose; namely, to increase the impact of OSHA's limited enforcement resources.

b. The criteria contained in this instruction are intended to ensure that when they are proposed, large penalties serve this public purpose.

3. Large proposed penalties result from application of existing FOM penalty calculation guidelines; but, instead of grouping or combining violations for penalty purposes, each instance of noncompliance is considered a separate violation and a penalty applied separately. This procedure is known as the egregious or violation-by-violation penalty procedure.

a. Application of these procedures is appropriate in situations where the violations in question constitute willful violations of OSHA standards or regulations or of the general duty clause of the Act and meet certain criteria to be discussed later in this instruction at N.2.

b. Since large penalties are likely to result in investigation and widespread public attention, review at the Regional and National Offices of OSHA and the Office of the solicitor of Labor (SOL) is currently mandated.

c. In all other respects, such cases are handled in accordance with the FOM.

4. While this practice of citing each violative instance as a separate violation has been utilized by the agency only since 1986, OSHA is authorized to use this approach by the language of the statute, its legislative history, and the agency's historic role as the sole prosecutor of violations occurring under the Act.

5. In these cases, as in all other cases, violation-by-violation citations and penalties are proposed by the Area Director.

H. Guidance.

1. Early Identification of Cases. It is important that the Area

Director identify cases which may be appropriate for violation-by-violation treatment as early as possible.

a. Meticulous documentation of evidence for each violation and appropriate involvement of such technical specialists as may be required for investigation is essential to the successful pursuit of potential egregious cases.

b. Coordination with the Regional and the National Offices must be scheduled in time for comprehensive review before the expiration of the statutory 6-month citation period.

c. Early involvement of the Regional solicitor's office will ensure adequate legal, evidentiary, and resource coordination.

2. Criteria. In general, this instruction identifies those conditions which normally constitute a flagrant violation of the Act or OSHA standards or regulations such that violation-by-violation handling is appropriate.

a. The criteria given in the following section shall be used by the Area Director to determine whether to recommend the use of violation-by-violation citations and penalties.

b. Cases under consideration for such treatment must be classified as willful (category (1) below) as well as at least one of the categories given in (2) through (7).

(1) The employer is found in violation of an OSHA requirement:

(a) Of which she/he has actual knowledge at the time of the violation. Such knowledge may be demonstrated through previous citation history, accident experience, widely publicized agency enforcement, direct evidence of specific recognized job site hazards or other appropriate factors; and

(b) Intentionally, through conscious, voluntary action or inaction, having made no reasonable effort to eliminate the known violation.

(2) The violations resulted in worker fatalities, a work site catastrophe, or a large number of injuries or illnesses.

(3) The violations resulted in persistently high rates of worker injuries or illnesses.

(4) The employer has an extensive history of prior violations of the Act.

(5) The employer has intentionally disregarded its safety and health responsibilities.

(6) The employer's conduct taken as a whole amounts to clear bad faith in the performance of his/her duties under the Act.

(7) The employer has committed a large number of violations so as to undermine significantly the effectiveness of any safety and health program that might be in place.

3. Penalty Calculation. Penalties for safety and health violations are to be calculated in accordance with the gravity-based penalty procedures in Chapter VI of the FOM. (Since egregious cases involve willful violations, the procedures of B.7.a. generally apply except as noted below.)

a. A separate gravity-based penalty shall be calculated for each violation.

(1) In calculating penalties for each violation, the particular factors associated with that discrete violation shall be used conservatively to calculate a gravity-based penalty; e.g., the number of workers exposed will be low since each violation is to be penalized separately.

(2) The adjustment factor for size shall be applied, if applicable. Factors for good faith and history will normally not be applied.

b. The following additional guidelines are provided to assist in calculating penalties for recordkeeping or similar violations:

NOTE: Only the current and the two previous calendar years are subject to the violation-by-violation penalty procedures in the case of recordkeeping violations (unless the company entered a corporate-wide settlement agreement on recordkeeping) The Regional Administrator may further limit the scope based on resource availability.

(1) How many violations are involved and how extensive is the problem?

(a) Where the total number of violations is less than 20 percent of the total number of OSHA-200 log entries for the year, assign a numerical weight of 1 "for number of employees exposed."

(b) Where the total number of violations exceeds 20 percent but is not more than 50 percent, assign a numerical weight of 2 for "number of employees exposed."

(c) Where the total number of violations exceeds 50 percent, assign a numerical weight of 3 for the "number of employees exposed."

(2) How many of the violations were unreported or misrecorded?

(a) If the violation results because a record required to be kept was not made, assign a numerical weight of 3 under "frequency of exposure."

(b) If the violation resulted because a required record was improperly kept, assign a numerical weight of 1 to 3, under "frequency of exposure," depending on the significance of the violation.

1 For example, if an injury was recorded as an injury without lost workdays when it actually did result in lost workdays, assign a 3.

2 If, on the other hand, an injury was correctly recorded as a lost workday case but the number of days was incorrectly recorded, assign a 1.

(3) Did the recordkeeping violation relate directly to the safety and health conditions in the plant? Assign a numerical weight of between 1 and 3 under "employee proximity", depending on the strength of that relationship.

(4) The following two factors shall be averaged and the result (rounded down to the nearest whole number) entered under "stress."

(a) How much does the lost workday injury (LWDI) rate change if the unrecorded cases are included in a recalculation?

1 If the rate doubles (or more) upon recalculation, assign a weight of 3.

2 If, upon recalculation, the rate does not double, assign a weight of 1.

(b) Were the unrecorded injuries serious, investigated by the company, or the subject of workers' compensation claims?

1 If the majority were of a serious nature, or the subject of workers' compensation claims, and not thoroughly investigated by the company, assign a numerical weight of 3.

2 If a minority of injuries were of a serious nature, the company did investigate, and workers' compensation was not heavily involved, assign a weight of 1.

(5) The following factors shall be averaged and the result (rounded down to nearest whole number) entered under "other factors."

(a) What is the character of the company's safety and health

history? Does the company's program include training, given to employees and supervisors, regarding compliance with the regulations?

1 Assign a rating of 3 if over all history is weak and training is lacking.

2 Assign a rating of 1 if some evidence exists of training; and the company's history does not reveal a pattern of disregard for safety and health.

(b) Any other significant factors relevant to the violation shall be considered and assigned a value of 1 to 3 depending on their impact on the flagrancy of the violation.

NOTE: No severity factor shall be used in recordkeeping violations.

(6) Following evaluation of the above-mentioned items, an average value or weight of all the factors shall be calculated and rounded down to the nearest whole number, thereby providing the gravity-based penalty to be used in the violation-by-violation penalty calculation.

c. Guidance on penalty calculation for violations of the hazard communication standard is provided in the FOM, Chapter IV, and in OSHA Instruction CPL 2-2.38B.

d. What will constitute separate violations for purposes of applying the violation-by-violation penalty procedures will depend on several factors.

(1) In cases involving violations of OSHA standards, the standard language must support citation of separate violations. For example:

(a) 29 CFR 1926.21(b) (2) is a requirement for the employer to train each employee in safety and health. For each employee not so trained there is a separate violation of the standard.

(b) 29 CFR 1910.217(c)(1)(i) is a requirement for a point of operation guard for a mechanical power press. Consequently, each mechanical power press unguarded point of operation found is a separate violation of the standard.

(c) 29 CFR 1910.1000(a)(2) limits the exposure of each employee to air contaminants regulated in Table Z-1-A. Thus each employee exposed above the 8-hour time weighted average for a regulated substance constitutes a separate violation of the standard.

(d) 29 CFR 1910.1000(e) requires the implementation of engineering and work practice controls to reduce employee exposure to air contaminants. With respect to engineering controls, a separate set of controls must be installed at each identifiable source of air contamination. Thus a separate violation exists for each identifiable source of air contamination to which engineering controls have not been applied irrespective of the number of employees overexposed.

NOTE: Since overexposures and engineering controls are two separate violation types, a violation-by-violation citation and penalty may be issued for each.

(2) Substantially similar violative conditions cannot be penalized on a violation-by-violation basis under two different standards. For example:

(a) 29 CFR 1910.1001(c) prohibits exposure of any employee to airborne concentration of asbestos in excess of 0.2 fibers per cubic centimeter of air (8 hr TWA). Hence each employee overexposed constitutes a separate violation.

(b) 29 CFR 1910.1001(g)(1) requires employers to provide respirators to employees overexposed to asbestos and to ensure their use whenever they are required; e.g., in cases where airborne concentrations of asbestos exceed the PEL.

1 Employees without respirator protection have already been cited for overexposure under 29 CFR 1910.1001(c).

2 Respirators are required for that very reason. Thus violation-by-violation penalties for each overexposed employee would be tantamount to a second penalty for substantially the same violative condition and would be inappropriate.

(c) 29 CFR 1910.1001(g)(2) requires that the employer select the appropriate respirator according to Table 1. For the same reason as given in subparagraph (b) 1 above, respirators with the incorrect filters cannot be penalized using violation-by-violation penalty procedures when airborne concentrations exceed the PEL.

(d) When airborne concentrations exceed 50 x PEL and only half-mask respirators are used, the violation is no longer substantially similar and each such respirator may be penalized as a separate violation when provided to an exposed employee for respiratory protection.

(3) Violations of the general duty clause [Section 5(a) (1) of the Act], if egregious, are to be cited in accordance with the FOM, Chapter IV, A.2.

(a) The hazard must be identified with specificity. Multiple citations may not be issued on the basis of missing controls or different sources or causes of the hazard.

(b) Each employee exposed to the recognized hazard at the time of the violation constitutes a separate violation.

e. All violations not recommended for consideration as egregious shall be classified and issued separately in accordance with the FOM, Chapter V. They shall not be grouped with violations recommended as egregious.

4. Case Support Requirements. Because these cases involve administrative and legal issues critical to the effective enforcement of the Act, it is essential to ensure that the highest professional standards are met in the conduct of inspections, the issuance of citations, and the prosecution of litigation in such cases.

a. Documentation. Whenever a case is proposed for violation-by-violation treatment, as fully detailed responses to the questions listed in Appendix A of this instruction as possible must be developed in writing. Supporting documentation shall be provided and cross-referenced whenever possible.

(1) These questions, originally developed for recordkeeping cases, have been adapted as appropriate for safety and health cases.

(2) Mandatory use of these questions is intended to provide a consistent format to aid in review of these cases, as well as to ensure as far as possible uniformity of case development across Regions.

b. Evidence. Documentary support shall ordinarily be planned for and obtained early in the investigation.

(1) The evidence necessary to support citations being considered for violation-by-violation penalty sanctions shall be included in the case file. Such evidence must be present for each separate violation.

(a) Photographs, videotapes, audio tapes, sampling data, and witness statements shall be used whenever possible to provide supporting evidence of violative conditions.

(b) Company documents supporting knowledge of the stan-

dard and the violative conditions as well as willfulness of the violation shall be diligently sought and obtained by subpoena as appropriate.

(c) Examples of such documents are internal audit reports, consultant or insurance company reports, trade association articles, minutes from safety meetings, complaints from employees, memoranda and other correspondence from safety personnel, especially from plant safety to plant management or corporate safety recognizing violations and bringing them to the attention of higher management, and notes relating to OSHA activities and industry practice in other companies or industries.

(2) Employers must be asked explicitly:

(a) If and when they recognized the hazardous nature of each of the violations;

(b) If they knew what OSHA's standards require, and, if so, what steps the company had taken to abate and why the apparent violations had not been corrected;

(c) If they knew of the documents identified under subparagraph (1) above and what those documents contained.

(3) Their responses shall be carefully documented in writing (verbatim if possible). An attempt shall be made to have a second person present as a witness, particularly when dealing with potentially compromising matters.

(4) Signed employee statements shall be obtained routinely to support each of these violations in as much detail as possible.

(5) Employee exposure and the nature and extent of injuries or illnesses related to the violations shall be carefully and adequately described.

(6) The need for subpoenas and medical access orders shall be decided and documents obtained as soon as possible.

(7) The need for experts shall also be decided and necessary arrangements made early. It is anticipated that experts will be needed for cases involving complex violations, such as ergonomics, or abatement methods.

(8) Particular attention shall be paid to anticipating and preparing for possible employer defenses, in accordance with the FOM, Chapter V, E.

c. Early involvement of the Regional Solicitor is essential to

examine and evaluate the documentation and other evidence supporting the violations and to determine whether expert witnesses or depositions will be necessary, as well as to provide sufficient time for the Regional Solicitor to write a legal opinion on the merits of the case.

(1) The Area Director (through the Regional Administrator) shall seek legal guidance (informally) from the Regional Solicitor periodically throughout the case development process.

(2) The Regional Administrator shall ensure that such involvement is accomplished at least 4 full months prior to the 6-month issuance date.

(3) The Regional Administrator shall also ensure that the entire case file, including OSHA-1Bs, documentary evidence, statements, and photographs, is made available to the Regional Solicitor 8 weeks prior to the 6-month date.

5. Citations. The Act authorizes penalties to be proposed for each violation but limits the maximum penalty that can be proposed. In accordance with the FOM, Chapter V, the following procedures shall be adhered to in issuing citations with violation-by-violation penalties:

a. Each separate violation must have its own Standard Alleged Violation Element (SAVE). (The SAVE must be repeated for each violation instance.)

b. Each separate violation must have its own Alleged Violation Description which will describe the particular conditions associated with that violation instance.

c. Each separate violation must have its own penalty calculated in accordance with the procedures given in H.3. of this instruction.

6. Regional and National Office Review. The procedures and timetables given below are to be followed in all cases involving violation-by-violation citations.

a. Documentary Package. It is the responsibility of the Area Director to provide adequate documentation of cases involving violation-by-violation citations.

(1) Two copies of the documentation package for all violation-by-violation citations shall be forwarded to the Regional Administrator for review.

(2) The package submitted for review shall include, at a minimum:

(a) A briefing memorandum summarizing the information obtained under H.4. of this instruction.

(b) Copies of all OSHA 1-Bs related to the violations to be proposed for egregious penalty handling. (See NOTE at the end of subparagraph (4) below.)

(c) Copies of all critical evidence establishing the willfulness of the violations.

(d) Copies of all critical evidence establishing the justification for violation-by-violation citation and penalty.

(e) Copies of samples of each type of violation in the proposed violation-by-violation citations.

(3) If the Regional Administrator, after review of the case file material, believes that the case is appropriate for violation-by-violation citation procedures, a copy of the complete documentation package shall be forwarded to the Regional Solicitor as soon as practicable after completion of the review (but no later than 8 weeks before the citation issuance date) for legal analysis and composition of a legal opinion.

(4) The Regional Administrator shall include a copy of the written legal opinion with the documentation package and submit the complete package to the Directorate of Compliance Programs (DCP) as soon as possible after receipt of the legal opinion.

NOTE: It will not be necessary to include copies of all OSHA-1Bs for recordkeeping cases within the documentation package forwarded to DCP. (See H.6.b.(1) of this instruction.)

(5) If the legal opinion has not been received within 5 weeks of the 6-month date, the documentation package shall nevertheless be submitted to DCP and the legal opinion forwarded as soon as it is received.

(6) The Regional Administrator shall also be responsible for composing a 1- or 2-page summary of the most cogent reasons supporting the egregiousness of the violation and the appropriateness of the application of the additional penalty factor. The summary shall include the following:

(a) Outline of the facts of the inspection, including inspection type, company name and size, operation involved and employee representative, if any.

(b) OSHA inspection history (nationwide and at this plant).

(c) Brief summary of violations found, the number and nature of proposed citations and the amount of the proposed penalty.

(d) Brief justification of willfulness and egregiousness.

(e) Novel issues involved in the case or issues with national implication for program or litigation policy.

(7) The Regional Administrator shall ensure that copies of the summary and the complete documentation package are provided to the Director of Compliance Programs and the National Office of the Solicitor.

b. Recordkeeping Violations. If the case involves recordkeeping violations which are being considered for additional penalties, two further steps are necessary.

(1) The Area Director shall provide an additional (third) copy of the documentary package (See H.6.a.) to the Regional Administrator which will be forwarded to the National Office for review. This extra copy will be used by BLS for its review and must include all OSHA-1Bs related to proposed egregious recordkeeping violations.

(2) Copies of evidence supporting each recordkeeping violation proposed as egregious, as developed from the company's occupational injury and illness logs and supplementary records, workers' compensation records, medical records, first aid logs and other sources, shall be included in the package. (See Appendix B.)

(3) This evidence must support the existence of a violation for both nonrecorded and misrecorded cases. It must include the particular recordability criteria involved: whether the case involved days away from work and/or days of restricted work activity beyond the day of injury or onset of illness as well as evidence that the case was work related.

NOTE: Medical records contained in the case file shall be handled in accordance with OSHA Instruction CPL 2-2.46, K.2.

c. Timetable. It is critical to the development of a uniform national policy that all cases appropriate for violation-by-violation citation be handled as such. Regional Administrators and Area Directors shall adhere as closely as possible to the timetables described below.

(1) Failure to supply the required documentation by the times designated in the following subsections may preclude issuance of violation-by-violation citations in otherwise appropriate cases.

(2) Regional Administrators and Area Directors shall take care not to expand the inspection beyond what they can reasonably expect to accomplish within these time frames.

(3) Within one month after the start of an inspection which appears to be appropriate for consideration for violation-by-violation citation:

(a) The Area Director shall notify the Regional Administrator of a potential egregious case. The Regional Administrator in turn shall notify the Director of Compliance Programs (Attention: Director, Office of General Industry Compliance Assistance, FTS 523-8041) of the following:

1 Establishment name.

2 Area Office of jurisdiction.

3 Six month date.

4 Opening conference date.

5 General type of apparent violations (e.g., safety, health, recordkeeping)

(b) The Regional Administrator shall notify the Regional Solicitor of the impending case and seek advice as to necessary documentation and involvement of outside experts.

(4) The Regional Administrator shall establish an appropriate timetable for periodic submission of the case by the Area Director for Regional Office and Regional Solicitor review.

(a) After 60 days on site, the Area Director shall ensure that the case is submitted to the Regional Office for information.

(b) The Regional Administrator shall submit the case to the Regional Solicitor for an interim legal review, evaluation and guidance.

(c) As the case is being developed and as additional information becomes available, the Regional Administrator shall ensure that this information is submitted to the Regional Solicitor for additional evaluation.

(5) No later than 8 weeks before the 6-month date, the entire case file shall be submitted to the Regional Solicitor for final legal analysis and for a written legal opinion as outlined in H.4.c.(3).

(6) At the same time, a copy of the complete briefing package and relevant portions of the case file as described in K.6.a.

and b. shall be submitted to the Director of Compliance Programs.

(7) No later than 15 days before the 6-month issuance date, at a time to be scheduled by the Director of Compliance Programs, the Regional Administrator shall send appropriate field compliance staff (including the compliance officer(s) conducting the inspection) to the National Office to discuss the proposed citations in detail.

d. National Office Review. Upon receipt of the documentary package, the Director of General Industry Compliance Assistance shall distribute copies to the reviewers.

(1) Copies shall be provided within 2 working days of receipt to the appropriate DCP Compliance Assistance Office, the Office of Field Programs and SOL. The Office of Information and Consumer Affairs shall also be notified.

(2) At the same time a financial profile of the firm shall be requested from the Directorate of Policy, Office of Data Analyses.

(3) Within 10 days of receipt of the documentary package, a National Office technical and legal review shall have been conducted. Following completion of that review, any identified problems or deficiencies shall be conveyed in writing as soon as practicable, but no later than 2 days after the review, to the Regional Administrator for response.

(4) After obtaining any needed additional information, a screening session shall be scheduled with the Deputy Assistant Secretary for presentation of the case. Such screening shall be scheduled no later than 2 weeks before the 6-month issuance date.

(a) Prior to presentation of the case to the Assistant Secretary or the Deputy Assistant Secretary, the case shall be prescreened by the Director of Compliance Programs and the Associate Solicitor of Labor.

(b) If the case is judged egregious as a result of the prescreening, the case shall normally be presented to the Assistant Secretary or the Deputy Assistant Secretary by the Director of Compliance Programs.

(c) The Regional Administrator shall be prepared to present the facts and other evidentiary details of the case.

(d) The Regional Solicitor will be prepared to discuss the potential litigation aspects of the case.

e. The Assistant Secretary or the Deputy will render a decision on the merits of the case and will give appropriate instructions on how the case is to be handled. Such instructions will address the final penalty amount to be proposed, the date of citation issuance, the coordination of any press releases, and the like.

f. Within 48 hours after issuance, the Area Director shall send a copy of the citation to the Director of Compliance Programs; electronic transmission is acceptable.

I. Delegation of Authority. It is agency policy eventually to delegate authority for decisions regarding the use of the violation-by-violation citation and penalty procedures to the Regional Administrator. The actual delegation of this authority will be addressed in future changes to this instruction.

Procedural review of egregious penalty

1. Scope of Inspection.

a. Date initiated.

b. Latest date for issuance of citations (6-month date).

c. Type of inspection (e.g., safety, health, programmed, complaint, referral).

d. Nature of employer's business, corporate-wide and at this facility.

e. Number of employees (overall; in plant).

f. Names of unions representing employees.

2. Inspection History.

a. Numbers and dates of previous inspections.

b. Previous violation history at this establishment and in the corporation, nationwide.

3. Inspection Methodology.

a. Procedures followed in conducting the investigation:

1) Were warrants, medical access orders or administrative subpoenas necessary? Why? Were they obtained and used?

(2) What written records or other documents were examined or obtained?

(3) What are the names of the compliance officers conducting the inspection?

(4) Were experts or other consultants used in the inspection? If so what are their names and qualifications?

(5) Have depositions been taken? Are any planned? Who will be deposed?

b. For recordkeeping violations:

1) Who has the responsibility for maintaining and certifying the OSHA-200, Log and Summary of Occupational Injuries and Illnesses, and related materials?

(2) Were medical or injury and illness records reviewed by OSHA physician(s)?

4. Findings.

a. Summary of violations:

1) Number and classification.

(2) Types of violations:

(a) Standards or regulations violated.

(b) General Duty Clause (Section 5(a) (1) of the Act) violations together with applicable industry standards, NIOSH recommendations, ANSI standards, and other supporting guidelines.

NOTE: In recordkeeping cases violations shall be categorized by year and according to either failure to record or misrecording involvement of days away from work and/or days of restricted work activity, loss of consciousness, job transfer, restriction of work or motion (i.e., restricted work activity on the day of injury/illness only), medical treatment and other.

They shall also be prepared by injury or illness type.

b. Proposed citations:

1) How is the violation-by-violation penalty to be applied?

(2) How many violations?

(3) Are there additional violations, not egregious?

c. For recordkeeping violations:

1) How many cases were not recorded for the previous 2 years? How many were recorded? Of those not recorded, how many were lost workday cases?

(2) What is the LWDI rate according to company records? According to OSHA findings?

(3) What is the LWDI rate among production employees (or among classes of employees affected by the proposed citation) according to company records? According to OSHA findings?

(4) Were any previous inspections terminated because of a low LWDI rate?

5. Documentation Relating to Additional Penalty Factors.

a. Determination of willfulness:

1) What were the firm's guidelines or policies relating to safety and health in general and, in particular, to the subject violation (e.g., recordkeeping, hazard communication, machine guarding, use of respirators, maintenance of pressure vessels)? What was the local facility's safety and health program?

(2) Do corporate or plant policies or guidelines differ from OSHA requirements, or other relevant standards, regulations or guidelines? What is management's explanation for differences between its policies and OSHA's requirements?

(3) Did responsible persons actually know of the requirements of the relevant OSHA standards, guidelines or instructions? Who were they and how did such persons come to know OSHA's requirements?

(4) Did responsible persons actually know of the existing hazardous conditions? Did they recognize the hazardous nature of these conditions? If so, who were these persons and for how long had they recognized the hazard?

(5) How did the employer explain the existence of the violations? Did the employer claim that any steps to abate had already been taken? Was any documentation available to support such previous action?

(6) Had the company done anything toward identifying, evaluating or correcting the hazardous conditions prior to OSHA's visit? Was an abatement program in place or had one been proposed? What progress had been made toward implementing it? Does it seem adequate? What was the company's explanation as to why more progress had not been made?

(7) Are any memoranda, letters, minutes, accident reports or other documents addressing the hazards, violations or corrective measures available? Describe them. Did management admit knowledge of these documents? Had management responded in any to them? How?

b. Penalty factors:

1) How many violations of each standard are involved and how extensive (pervasive) is the problem?

(a) What is the nature of the violation? (How many machines? How many different engineering controls? How many employees exposed?)

(b) What does the Regional Administrator propose as the "multiplier" for penalty calculation purposes? (See H.3.e.) Why that multiplier?

(2) For recordkeeping cases:

(a) Did the unreported or misrecorded cases tend to hide violative safety and health conditions in the establishment?

(b) Were unrecorded incidents investigated by the company?

(c) Were the unrecorded injuries or illnesses serious?

(d) Were the unrecorded injuries or illnesses the subject of workers' compensation claims?

(3) What kind of safety and health program exists in the plant? What is management's attitude toward safety and health? What do management officials actually say?

(4) What training was given to employees and supervisors regarding compliance with the standard or regulation, or abatement of the recognized hazard? If none is given, what did management admit or what explanation did they offer?

(5) Did the company enforce its own policies and guidelines?

(6) What were the most serious reasonably predictable injuries or illnesses that could result from exposure to the hazard? Would these potential injuries or illnesses be classified as serious? Did management admit recognition of the potential for these injuries and illnesses?

(7) What was the company's record (especially relating to workers' compensation claims) for injuries and/or illnesses associated with alleged violations? What kind and how many such injuries or illnesses?

(8) Are the abatement methods used by the company sufficient? Are the hazards well known in the industry? What is industry practice with respect to the hazards? Are appropriate methods to correct the hazards well recognized in the industry? What is industry practice with respect to the hazards? Why had the employer not implemented them? Were any interim protection measures in place? If not, why not?

All of the above questions should be directly asked of management personnel and their responses carefully recorded. A second safety and health officer or other reliable witness should be present if possible. Focus on documentary evidence—that is, your paper trail—throughout the investigation.

Chapter 10

Shaping OSHA Guidelines to Your Needs

Introduction

You may find it impossible to comply with new OSHA health and safety standards for reasons wholly beyond your control. OSHA grants temporary variances from the requirements of its standards under special circumstances. The agency grants permanent variances when you can show that your established practices go beyond what a given health or safety standard requires.

How do you obtain temporary or permanent variances? What do you have to show to persuade OSHA that you can't meet the agency's deadline or that your practices exceed the requirements of a given standard?

As you might expect, OSHA doesn't exactly make it easy to obtain variances. If you need a temporary variance, you must document the circumstances which make it impossible for you to meet the agency's compliance deadline. If you want a permanent variance, you must describe in detail exactly how your own practices go beyond OSHA's requirements in protecting worker health and safety.

In either case, OSHA grants variances only if you present convincing evidence.

OSHA issues all new health and safety standards with effective dates — that is, with deadlines by

275

Applications for a temporary variance

which you must comply. The agency takes these deadlines seriously, but sometimes you can't meet them.

OSHA grants temporary variances when you can show that:

1) You cannot complete the necessary work to install engineering controls on time;

2) You can't get professional help needed to design or complete the necessary construction;

3) You can't get the materials you need.

OSHA issues temporary variances for one year at the most. It renews temporary variances for six months — but only twice. Thus no matter what difficulties you face in meeting the standard, you cannot get a temporary variance from OSHA for more than two years.

The agency stresses the importance of informing employees about your application for a variance. Federal law gives workers the right to request a hearing on your application for a variance; indeed. OSHA encourages workers and their unions, if present, to take part in the process. To this end, the agency goes so far as to publish notices in the Federal Register of all applications for variances, despite the fact that it knows full well that most workers don't spend much of their free time reading that publication.

Your application for a temporary notice must certify that you have informed your workers of your application, that you have given copies of all applications to a union or other employee representative, and that you have posted a summary of your application wherever you customarily post notices in the workplace.

As if that weren't enough, OSHA also requires that you inform your workers of their right to involve themselves in the variance process — specifically of their right to request a hearing on the matter.

The details

Your application for a temporary variance must include the following information:

1) The employer's name and address, and the address of the work site;

2) The specific standards from which you seek the variance, cited by number;

3) A detailed description of how you have informed your employees of your intention to seek a variance — specifically, where you have posted a summary of your application for a variance, where your employees may review a copy of the application itself, and how you have informed them of their worker rights;

4) A request for an interim order or for a hearing, if desired;

5) A full explanation of why you cannot comply by the effective date;

6) A list of the measures you employ in the meantime to protect your employees until you can achieve full compliance;

7) The date by which you expect to achieve full compliance;

8) A description of the process you will undertake to achieve full compliance.

OSHA does not require that you get all this down on a single page.

The agency requires that you submit an original and six copies of your application to the office of the Assistant Secretary for Occupational Safety and Health. If the variance applies to work sites in more than one state, and if one of those states operates an OSHA-approved state plan, then you don't have to file the application with both the federal and state agency. You get to choose to file it with one or the other.

OSHA sends a variance officer on a inspection of the work site for a first-hand look at your practices and at the difficulties you face in meeting

You have to post a summary of the application

the compliance deadline. Normally you will hear of this visit before it takes place.

The agency usually makes a final decision on applications for variances within 120 days. This, of course, allows time for publication in the Federal Register and, if necessary, a public hearing.

Permanent variances

You may obtain a permanent variance if you can demonstrate that your practices exceed the requirements of a given health or safety standard. Once again, the burden of proof lies on your shoulders, and OSHA doesn't make it easy.

Your application must present:

1) The employer's name and address, and the address of the work site;

2) The specific standards from which you seek a variance;

3) A detailed description of how you have informed your employees of your intention to seek a variance — specifically, where you have posted a summary of your application for a variance, where your employees may review a copy of the application itself and how you have informed them of their worker rights;

4) A request for an interim order or for a hearing, if desired;

5) A list of the measures you take to protect your employees and a full explanation of why you believe your practices exceed OSHA's requirements.

File an original and six copies with the Assistant Secretary for Occupational Health and Safety. If your application involves work sites in more than one state, and if one of those states runs an OSHA-approved state plan, you may choose to file with the state only.

In deliberating on your request, OSHA reviews your plant's inspection history and, as it does with temporary variances, sends a variance officer to the work site to gather first-hand evidence.

Once again, the agency encourages input from workers and unions. It publishes a notice of your application in the Federal Register and may schedule a public hearing as well.

The agency's formal approval of your application details the specific responsibilities you undertake to assure worker safety and health. It also explains exactly how your practices differ from the requirements of the standard.

OSHA uses no standard form for applications for either temporary or permanent variances. A model application follows at the end of this section.

Sample variance application

[Post the following notice along with a copy of the variance application in a prominent place frequented by employees.]

TO ALL EMPLOYEES

This is a copy of the variance application submitted by XYZ Company for a variance from OSHA Standard 1910.179 (b) 4, concerning the wind indicator on the outdoor bridge of a Gantry Crane. As an employee of the XYZ Company, you have the right to request a hearing with the Assistant Secretary for Occupational Safety and Health, U.S. Department of Labor, according to Standard 1905.15, Request for Hearing, if you object to the variance requested.

You may also submit comments on the variance application. These requests must be filed in writing, and submitted in quadruplicate to the Assistant Secretary for Occupational Safety and Health, Department of Labor, Washington, DC, 20210.

Company: _____

Manager: _____

Where to apply for variances from OSHA standards

The types of variances and OSHA's criteria for granting them are also discussed in the U.S. Department of Labor technical publication *Variances Under OSHA.*[1]

If the work sites for which variances are sought are under federal OSHA's jurisdiction, applications should be addressed to the Assistant Secretary and sent to OSHA's Office of Variance Determination[2].

The following states are under federal OSHA's jurisdiction:

> Alabama, American Samoa, Arkansas, Colorado, Connecticut, Delaware, District of Columbia, Florida, Georgia, Guam, Idaho, Illinois, Kansas, Louisiana, Maine, Massachusetts, Mississippi, Missouri, Montana, Nebraska, New Hampshire, New Jersey, New York, North Dakota, Ohio, Oklahoma, Pennsylvania, Rhode Island, South Dakota, Texas, Trust Territory of the Pacific Islands, Wake Island, West Virginia and Wisconsin.

If the work sites are in a state or territory with its own approved job safety and health program, variance applications should be made directly to the state OSHA office, usually located in the state department of labor. The following jurisdictions have their own OSHA programs, and are called "state plan states."

> Alaska, Arizona, California, Connecticut, Hawaii, Indiana, Iowa, Kentucky, Maryland, Michigan, Minnesota, Nevada, New Mexico, New York, North Carolina, Oregon, Puerto Rico, South Carolina, Tennessee, Utah, Vermont, Virgin Islands, Virginia, Washington, and Wyoming.

In Connecticut and New York, the state plans cover state and local employees only.

Employers with establishments in more than one state may seek multi-state variances. Even if one

[1] This publication is available from the OSHA Publications Office, Room N-3101, Washington, D.C. 20210 (Phone: 202/219-4667).
[2] The address: Office of Variance Determination, 200 Constitution Ave., N.W., Washington, D.C. 20210 (phone: 202/219-7193).

Multistate employers may follow federal procedures

or more of these states has its own OSHA-approved state safety and health plan, the employer may consolidate the variance applications, address them to the Assistant Secretary and mail them to the Office of Variance Determination.

OSHA's variance procedures permit employers with multi-state establishments to use federal OSHA's variance reciprocity procedures where such requests involve state plan standards (or portions thereof) which are identical in substance and requirements to federal standards. Such applications must include:

(a) a side-by-side comparison of the federal standard and the state standards (or portions thereof) that are identical in substance and requirements;

(b) a certification that the employer has not filed for such variance on the same material facts for the same employment; or place of employment with any state authority having jurisdiction under an approved OSHA plan; and,

(c) a statement, with appropriate identification and current status, of any citations for violations of the state standard that have been issued to the employer by any of the state authorities enforcing the standard under a plan.

Upon receipt of a multi-state variance application meeting all requirements, federal OSHA promptly furnishes copies to appropriate state plan states and provides opportunity for comment, including opportunity to participate as a party to the consideration. As parties to the federal variance proceedings, state plan states review applications and reach judgments on establishments in their states in coordination with federal OSHA.

Federal OSHA will ensure that each state plan state involved in a multi-state variance request has responded in writing, and the response will be made a part of the variance record. If an individual state concurs in the variance, the approval is reflected in the federal decision on all establishments.

If a state objects, it negotiates independently with the employer to resolve any questions. If major differences result, a state may handle that aspect of the variance request under its jurisdiction independent of the multi-state application.

Once a federal OSHA variance has been granted which applies to more than one state (including a state operating under a state plan), the variance becomes the authoritative interpretation of the employer's compliance obligations. This is true for the federal standard as well as any identical state standard, except where objections have been interposed by state authorities.

Utilizing other OSHA resources

OSHA provides free consultation services to employers seeking assistance in implementing effective safety and health programs. There is often a misconception among employers that a call to OSHA means there will be a compliance officer at your door before you've even hung up the phone. It's not true.

OSHA maintains consultation offices in every state that are separate from the field offices. The service is confidential. Your name and firm and any information about your workplace, plus any unsafe or unhealthful working conditions uncovered by the consultant, will not be reported routinely to the OSHA inspection staff. In addition, no citations are issued or penalties proposed as a result of a consultation.

Your only obligations are to allow the consultant to confer with employees in the course of the hazard survey and to correct any imminent dangers and other serious job safety and health hazards in a timely manner. You make these commitments before the consultant's visit.

One of the benefits of using an OSHA consultant: you could be excluded from general OSHA enforcement inspections for one year if you have a complete examination of your workplace, correct all indentified hazards, post a notice of their

OSHA provides consultation and other relevant services

corrrection, and institute the core elements of an effective safety and health program. Inspections prompted by an employee complaint or by a fatality or catastrophe would not be exempted under this program.

Consultation can go beyond the requirements of OSHA regulations. The consultant may point out work practices not yet addressed by standards, and propose measures directed toward reducing workplace injuries and illnesses.

Comprehensive consultation services include the following:

- an appraisal of all mechanical and environmental hazards and physical work practices

- an appraisal of the present job safety and health program or the establishment of one

- a conference with management on its findings

- a written report of recommendations and agreements

- training, and assistance with implementing recommendations, and

- a followup to assure that any required corrections are made

OSHA does tend to limit eligibility for the consultation program to smaller companies, but does provide another option to larger companies.

Voluntary Protection Programs

OSHA offers participation in its Voluntary Protection Program (VPP) to employers who have an effective safety and health program in place and an injury and/or illness rate lower than the industry average.

VPP has three separate levels: Star, Merit or the Demonstration Program. Designed to augment OSHA's enforcement efforts, these programs encourage and recognize excellence in occupational safety and health. Only those companies which demonstrate commitment to workplace safety and

health beyond the requirements of the OSHA standards — especially at senior management levels — are eligible.

One of the benefits: participation exempts a worksite from OSHA's programmed inspections.

General Requirements

An effective, ongoing safety and health program. Companies participating in Merit and Star are expected to have comprehensive programs including elements such as employee participation and annual comprehensive self-evaluation. OSHA assesses the effectiveness of the program through a number of measures including on-site review.

Cooperation. A cooperative atmosphere is essential to make voluntary protection work. Construction companies are required to use a labor-management approach which includes joint labor-management safety and health committees. General industry sites may use some other form of employee participation. Companies must demonstrate that the collective bargaining agent(s) representing their employees, if any, has (have) no objection to the company's participation. It is important under all Voluntary Protection Programs that both employers and employees recognize that they retain their rights and responsibilities under the Occupational Safety and Health Act.

Good performance. Although performance levels required vary with the individual Voluntary Protection Program, the company must demonstrate that its efforts are working to minimize injury and illness in the workplace. Two indicators are the Bureau of Labor Statistics injury incidence and lost workday injury rates. Also, the company must have demonstrated good faith in any previous dealings with OSHA.

Star

Open to any industry, Star is targeted for a company with comprehensive, successful safety and

A cooperative atmosphere is essential—the benefits are valuable

health programs. Companies that are in the forefront of employee protection as indicated by three-year average incidence and lost workday case rates at or below the national average for their industry may participate. They must also meet requirements for extensive management systems. Because of the changing nature of the worksite, construction firms must maintain strong employee participation in their programs. Star participants are evaluated every three years, although their incident rates are reviewed annually.

Merit

Merit is an effective stepping stone to Star. Merit sites may have more general management systems but must set goals for meeting Star requirements. While there are less stringent rate requirements for Merit, applicants must agree to specific goals for reducing rates to below the average for their industry. Merit participants are evaluated onsite annually.

Demonstration

The Demonstration program provides a basis for promising alternative safety and health program approaches that are not currently available under the VPP as well as to allow for special industry operations such as logging, maritime, etc. Alternative approaches that are successful will be considered for inclusion in the Star program.

OSHA Responsibilities

Application review. Each applicant undergoes a review of its safety and health programs including an onsite examination of its records and logs, a review of its inspection history, if any, and an assessment of site conditions. OSHA also conducts interviews of management and employees. The onsite portion of the review requires about four days.

Evaluation. Annual evaluations for Merit and Dem-

onstration participation and three-year evaluations for Star participants compare injury and/or illness rates to industry rates, determine the satisfaction of participants and assure that the companies continue to meet the requirements. In addition, at Merit sites, OSHA measures progress toward Star requirements.

Contact person. For each participant, OSHA provides a contact person to provide assistance.

Inspections. OSHA retains responsibility for inspections in response to formal, valid employee complaints, significant chemical leaks and spills, and workplace fatalities and catastrophes.

As a VPP participant you may also have greater input in OSHA rulemaking.

By gathering input from employers with significant experience in the safety and health arena, OSHA hopes to eliminate controversy and legal roadblocks by developing standards that accurately reflect the industries they address — particularly in the areas concerning technical and economic feasibility.

OSHA officials now seek out those VPP workplaces that have implemented innovative and effective safety and health programs that address upcoming OSHA standards.

OSHA also plans to solicit more comments from VPP members before proposing standards.

For applications or further information, write OSHA Voluntary Protection Programs, Room N3700, Frances Perkins DOL Bldg., 200 Constitution Ave. NW, Washington, D.C. 20210; telephone (202)523-7266.

The document *Safety and Health Program Management Guidelines: Issuance of Voluntary Guidelines*, was published in the Federal Register on January 26, 1989. The guidelines consist of program elements which represent a distillation of applied safety and health management practices that are used by employers who are successful in protecting the safety and health of their employ-

Effective management is a decisive factor

ees. These program elements are advocated by many safety and health professionals and consultants, and were strongly endorsed by individuals, corporations, professional associations, and labor representatives.

Safety and Health Management Guidelines Scope and Application. (1) This guideline applies to all places of employment which are covered by OSHA standards in 29 CFR Parts 1910, 1915, 1917 and 1918.

(2) This guideline does not apply to places of employment which are covered by OSHA standards found in 29 CFR Part 1926. Introduction.

The Occupational Safety and Health Administration (OSHA) has concluded that effective management of worker safety and health protection is a decisive factor in reducing the extent and the severity of work-related injuries and illnesses. Effective management addresses all work-related hazards, including those potential hazards which could result from a change in worksite conditions or practices. It addresses hazards whether or not they are regulated by government standards. OSHA has reached this conclusion in the course of its evaluation of worksites in its enforcement program, its State-operated consultation program, and its Voluntary Protection Programs.

These evaluations have revealed a basic relationship between effective management of worker safety and health protection and a low incidence and severity of employee injuries. Such management also correlates with the elimination or adequate control of employee exposure to toxic substances and other unhealthful conditions.

OSHA's experience in the Voluntary Protection Programs has also indicated that effective management of safety and health protection improves employee moral and productivity, as well as significantly reducing workers' compensation costs and other less obvious costs of work-related injuries and illnesses. Through an analysis of public comment received in response to its request and through an earlier review of literature.

OSHA has found that the conclusions it has reached from its own experience are supported by a substantial body of expert and practitioner opinion. Based on this cumulative evidence that systematic management policies, procedures and practices are fundamental to the reduction of work-related injuries and illnesses and their attendant economic costs. OSHA offers the following guidelines for effective management of worker safety and health protection. OSHA urges all employers to establish and to maintain programs which meet these guidelines in a manner which addresses the specific operations and conditions of their worksites.

The Guidelines

(a) General.

(1) Employers are advised and encouraged to institute and maintain in their establishments a program which provides systematic policies, procedures, and practices that are adequate to recognize and protect their employees from occupational safety and health hazards.

(2) An effective program includes provisions for the systematic identification, evaluation, and prevention or control of general workplace hazards, specific job hazards, and potential hazards which may arise from foreseeable conditions.

(3) Although compliance with the law, including specific OSHA standards, is an important objective, an effective program looks beyond specific requirements of law to address all hazards. It will seek to prevent injuries and illnesses, whether or not compliance is at issue.

(4) The extent to which the program is described in writing is less important then how effective it is in practice. As the size of a worksite or the complexity of a hazardous operation increases, however, the need for written guidance increases to ensure clear communications of policies and priorities and consistent and fair application of rules.

(b) Major Elements.

Commitment and involvement are the motivating force

An effective occupational safety and health program will include the following four elements. To implement these elements, it will include the actions described in paragraph (c).

(1) Management commitment and employee involvement are complementary. Management commitment provides the motivating force and the resources for organizing and controlling activities within an organization. In an effective program, management regards workers safety and health as a fundamental value of the organization and applies its commitment to safety and health protection with as much vigor as to other organizational purposes. Employee involvement provides the means through which workers develop and/or express their own commitment to safety and health protection, for themselves and for their fellow workers.

(2) Worksite analysis involves a variety of worksite examinations, to identify not only existing hazards but also conditions and operations in which changes might occur to create hazards. Unawareness of a hazard which stems from failure to examine the worksite is a sure sign that safety and health policies and/or practices are ineffective. Effective management actively analyzes the work and worksite, to anticipate and prevent harmful occurrences.

(3) Hazard prevention and controls are triggered by a determination that a hazard or potential hazard exists. Where feasible, hazards are prevented by effective design of the jobsite or job. Where it is not feasible to eliminate them, they are controlled to prevent unsafe and unhealthful exposure. Elimination or controls is accomplished in a timely manner, once a hazard or potential hazard is recognized.

(4) Safety and health training addresses the safety and health responsibilities of all personnel concerned with the site, whether salaried or hourly. If is often most effective when incorporated into other training about performance requirements and job

practices. Its complexity depends on the size and complexity of the worksite, and the nature of the hazards and potential hazards at the site.

(c) Recommended Actions

Management Commitment and Employee Involvement.

(i) State clearly a worksite policy on safe and healthful...working conditions, so that all personnel with responsibility at the site and personnel at other locations with responsibility for the site understand the priority of safety and health protection in relation to other organizational values.

(ii) Establish and communicate a clear goal for the safety and health program and objectives for meeting that goal, so that all members of the organization understand the results desired and the measures planned for achieving them.

(iii) Provide visible management involvement in implementing the program, so that all will understand that management's commitment is serious.

(iv) Provide for and encourage employee involvement in the structure and operation of the program and in decisions that affect their safety and health, so that they will commit their insight and energy to achieving the safety and health program's goal and objectives.

(v) Assign and communicate responsibility for all aspects of the program so that manages, supervisors, and employees in all parts of the organization know what performance is expected of them.

(vi) Provide adequate authority and resources to responsible parties, so that assigned responsibilities can be met.

(vii) Hold managers, supervisors, and employees accountable for meeting their responsibilities, so that essential tasks will be performed.

(viii) Review program operations at least annually to evaluate their success in meeting the goal and objectives, so that deficiencies can be identified and the program and/or the objectives can be re-

vised when they do not meet the goal of effective safety and health protection.

(2) Worksite Analysis.

(i) So that all hazards are identified:

(A) Conduct comprehensive baseline worksite surveys for safety and health and periodic comprehensive update surveys:

(B) Analyze planned and new facilities, processes, materials, and equipment; and

(C) Perform routine job hazard analyses.

(ii) Provide for regular site safety and health inspection, so that new or previously missed hazards and failures in hazard controls are identified.

(iii) So that employee insight and experience in safety and health protection may be utilized and employee concerns may be addressed, provide a reliable system for employees, without fear of reprisal, to notify management personnel about conditions that appear hazardous and to receive timely and appropriate responses; and encourage employees to use the system.

(iv) Provide for investigation of accidents and "near miss" incidents, so that their causes and means for their prevention are identified.

(v) Analyze injury and illness trends over time, so that patterns with common causes can be identified and prevented.

(3) Hazard Prevention and Control.

(i) So that all current and potential hazards, however detected, are corrected or controlled in a timely manner, established procedures for that purpose, using the following measures:

(A) Engineering techniques where feasible and appropriate:

(B) Procedures for safe work which are understood and followed by all affected parties, as a result of training, positive reinforcement, correction of unsafe performance, and, if necessary, enforcement

through a clearly communicated disciplinary system:

(C) Provision of personal protective equipment; and

(D) Administrative controls, such as reducing the duration of exposure.

(ii) Provide for facility and equipment maintenance, so that hazardous breakdown is prevented.

(iii) Plan and prepare for emergencies, and conduct training and drills as needed, so that the response of all parties to emergencies will be "second nature."

(iv) Establish a medical program which includes availability of first aid on site and of physician and emergency medical care nearby, so that harm will be minimized if any injury or illness does occur.

(4) Safety and Health Training.

(i) Ensure that all employees understand the hazards to which they may be exposed and how to prevent harm to themselves and others from exposure to these hazards, so that employees accept and follow established safety and health protections.

(ii) So that supervisors will carry out their safety and health responsibilities effectively, ensure that they understand those responsibilities and the reasons for them, including:

(A) Analyzing the work under their supervision to identify unrecognized potential hazards: (B) Maintaining physical protections in their work areas; and

(C) Reinforcing employee training on the nature of potential hazards in their work and on needed protective measures, through continual performance feedback and, if necessary, through enforcement of safe work practices.

(iii) Ensure that managers understand their safety and health responsibilities, as described under (c)(1). "Management Commitment and Employee Involvement," so that the managers will effectively carry out those responsibilities.

Ensure understanding of safety rules

CONCLUSION

NOTES FROM THE FRONT LINES

Although workplace health and safety issues continue to add to the complexity of running a business, common sense is, and will always be the greatest tool you can have to simplify the process of protecting your employees and meeting OSHA compliance.

As you are well aware, OSHA has yet to formally address with final rulemaking such real and significant hazards as cumulative trauma disorders, secondhand smoke and workplace violence. Yet, with or without OSHA regulations as a guideline, you will have to assess and control those hazards on your own. Hopefully, this book has given you the tools to do so.

The objective of OSHA in the Real World was to provide employers the means to make intelligent decisions regarding OSHA compliance, and to take control of their own safety and health programs.

Obviously, some of you will find certain chapters or information of greater value than others. It's a difficult task to decide what information to include or exclude when covering a government agency that enforces thousands of regulations.

Several chapters address in detail OSHA's policies and procedures—particularly with regard to the methods the agency uses to determine what businesses it targets for inspections. Although the methods are complex, perhaps too complex for some—the information was included because it sheds light on how OSHA thinks and operates. That information can be a valuable resource to

The tools and strategy you need

an employer who finds his or her operation under an SIC code considered to be part of a high hazard industry.

An entire chapter was devoted to tracking the evolution of OSHA from its inception to now. Understanding OSHA's history, is to understand its mission, objectives and strategies—and its weaknesses. In doing so, you will realize that you have the power in many cases to meet OSHA on its own terms—and succeed on yours.

Special Note: At the back of this book, you will find a two-disk demonstration of Merritt Publishing's OSHANet 2.0 for Windows on CD-ROM.

OSHANet is a compliance based software program that includes a complete plain English translation of every OSHA 1910 and 1926 regulation. It also allows you to conduct a complete inspection audit of every 1910 and 1926 regulation.

The program is designed to offer safety professionals and employers the flexibility they need to incorporate OSHA requirements into their site specific safety and health programs. It also expands upon many of the recommendations and practices presented in this book.

√ OSHANet also includes complete CFRs 29 (OSHA), 40 (EPA), and 49 (DOT).

With the framework that this book offers—and tools like the ones mentioned here—you have everything you need to take control of workplace safety issues back from federal agencies like OSHA. This is an important thing. No matter how much regulatory agencies try to control the workplace, only employers and employees can actually make substantive changes to the quality over everyone's working life.

As an employer or manager concerned with workplace safety issues, you're the person best positioned to set the policies that make these changes. It's a tough job—but it is a doable one. You know the terms and parameters. Good luck.

APPENDICES

The following appendices offer specific, primary information related to assembling an effective workplace safety program.

Appendix 1, which starts on page 298, provides a quick reference table to help you to determine which OSHA 1910 and 1926 regulations include training, written, inspection/testing, monitoring and medical requirements.

Appendix 2, which starts on page 327, provides a brief synopsis of each OSHA 1910 and 1926 standard. This information is intended to help you determine which OSHA regulations apply or do not apply to your operation.

Appendix 3, which starts on page 377, provides a list of OSHA-related resources: regional offices, state consultation offices, industry associations.

Appendix 4, which starts on page 387, includes a list of OSHA and safety-related resources available on the Internet.

APPENDIX 1

OSHA Number	Standard	Subpart	Training Requirements	Written Requirements	Inspection/ Testing Requirements	Monitoring Requirements	Medical Requirements
1910.1	Purpose and Scope	A					
1910.2	Definitions	A					
1910.3	Petitions for Issuance, Amendment, or Repeal of a Standard	A					
1910.4	Amendments to this Subpart	A					
1910.5	Applicability of Standards	A					
1910.6	Incorporation by Reference	A					
1910.7	Definitions and Requirements for Nationally Recognized Testing Laboratory Definitions	A					
1910.11	Purpose and Scope	B					
1910.12	Construction Work	B					
1910.15	Shipyard Employment	B					
1910.16	Longshoring and Marine Terminals	B					
1910.17	Effective Dates	B					
1910.18	Changes in Established Federal Standard	B					
1910.19	Special Provisions for Air Contaminants	B					
1910.20	Access to Employee Exposure and Medical Records	C	X	X			X

OSHA Number	Standard	Subpart	Training Requirements	Written Requirements	Inspection/ Testing Requirements	Monitoring Requirements	Medical Requirements
1910.21	Definitions	D					
1910.22	General Requirements	D			X		
1910.23	Guarding Floor and Wall Openings and Holes	D					
1910.24	Fixed Industrial Chairs	D					
1910.25	Portable Wood Ladders	D			X		
1910.26	Portable Metal Ladders	D			X		
1910.27	Fixed Ladders	D			X		
1910.28	Safety Requirements for Scaffolding	D	X	X	X		
1910.29	Manually Propelled Mobile Ladders	D			X		
1910.30	Other Working Surfaces	D			X		
1910.31	Sources of Standards	D					
1910.32	Standards Organization	D					
1910.35	Definitions	E					
1910.36	General Requirements	E			X		
1910.37	Means of Egress, General	E			X		
1910.38	Employee Emergency Plans and Fire Prevention Plans	E	X	X			
1910.39	Sources of Standards	E					
1910.40	Standards Organization	E					
1910.66	Powered Platforms for Building Maintenance	F	X	X	X		
1910.67	Vehicle-Mounted Elevating and Rotating Work Platforms	F	X	X	X		

1910.68	Manlifts	F	X	X	X		
1910.69	Sources of Standards	F					
1910.70	Standards Organizations	F					

OSHA Number	Standard	Subpart	Training Requirements	Written Requirements	Inspection/ Testing Requirements	Monitoring Requirements	Medical Requirements
1910.94	Ventilation	G	X		X		X
1910.95	Occupational Noise Exposure	G	X	X	X	X	X
1910.96	Ionizing Radiation	G	X	X	X	X	
1910.97	Non-ionizing Radiation	G					
1910.98	Effective Dates	G					
1910.99	Sources of Standards	G					
1910.100	Standards Organization	G					
1910.101	Compressed Gases-- General Requirements	H			X		
1910.102	Acetylene	H			X		
1910.103	Hydrogen	H	X	X	X		
1910.104	Oxygen	H		X	X		
1910.105	Nitrous Oxide	H			X		
1910.106	Flammable and Combustible Liquids	H	X	X	X		
1910.107	Spray Finishing Using Flammable and Combustible Materials	H		X	X		
1910.108	Dip Tanks Containing Flammable or Combustible Liquids	H		X	X		
1910.109	Explosive and Blasting Agents	H	X	X	X		
1910.110	Storage and Handling Liquefied Petroleum Gases	H	X	X	X		
1910.111	Storage and Handling of an Hydrous Ammonia	H	X	X	X	X	

1910.114	Effective Dates	H					
1910.115	Sources of Standards	H					
1910.116	Standards Organizations	H					
1910.119	Process Safety Management of highly Hazardous Chemicals	H	X	X	X	X	
1910.120	Hazardous Waste Operations and emergency Response	H	X	X	X	X	X
1910.132	General Requirements	I	X	X	X		
1910.133	Eye and Face Protection	I		X			
1910.134	Respiratory Protection	I	X	X	X		X
1910.135	Occupational Head Protection	I					
1910.136	Occupational Foot Protection	I					
1910.137	Electrical Protective Devices	I		X	X		
1910.138	Hand Protection	I					
1910.139	Sources of Standards	I					
1910.140	Standards Organization	I					

OSHA Number	Standard	Subpart	Training Requirements	Written Requirements	Inspection/ Testing Requirements	Monitoring Requirements	Medical Requirements
1910.141	Sanitation	J		X	X		
1910.142	Temporary Labor Camps	J	X	X			X
1910.144	Safety Color Code for Marking Physical Hazards	J		X			
1910.145	Specifications for Accident Prevention Signs and Tags	J		X			
1910.146	Confined Space	J	X	X	X	X	X
1910.147	Control of Hazardous Energy	J	X	X	X		
1910.148	Standards Organization	J					
1910.149	Effective Dates	J					
1910.150	Sources of Standards	J					
1910.151	Medical Services and First Aid	K	X				X

OSHA Number	Standard	Subpart	Training Requirements	Written Requirements	Inspection/ Testing Requirements	Monitoring Requirements	Medical Requirements
1910.155	Scope, Application and Definitions Applicable to this Subpart	L					
1910.156	Fire Brigades	L	X	X	X	X	
1910.157	Portable Fire Extinguishers	L	X	X	X		
1910.158	Stand Pipe and Hose Systems	L	X		X		
1910.159	Automatic Sprinkler Systems	L		X	X		
1910.160	Fixed Extinguishing Systems, General	L	X	X	X		
1910.161	Fixed Extinguishing Systems, Dry Chemical	L					
1910.162	Fixed Extinguishing Systems, Gaseous Agent	L					
1910.163	Fixed Extinguishing Systems, Water Spray and Foam	L					
1910.164	Fire Detection Systems	L	X		X		
1910.165	Employee Alarm Systems	L	X		X		
1910.169	Air Receivers	M			X		
1910.170	Sources of Standards	M					
1910.171	Standards Organization	M					
1910.176	Handling Materials, General	N					
1910.177	Servicing Multi-Piece and Single Piece Rim Wheels	N	X	X	X		

1910.178	Powered Industrial Trucks	N	X	X	X	X	
1910.179	Overhead and Gantry Cranes	N	X	X	X		
1910.180	Crawler Locomotive and Truck Cranes	N	X	X	X		
1910.181	Derricks	N	X	X	X		
1910.182	Effective Dates	N					
1910.183	Helicopters	N	X		X		
1910.184	Slings	N		X	X		
1910.189	Sources of Standards	N					

OSHA Number	Standard	Subpart	Training Requirements	Written Requirements	Inspection/ Testing Requirements	Monitoring Requirements	Medical Requirements
1910.212	General Requirements For All Machines	O					
1910.213	Woodworking Machinery Requirements	O					
1910.215	Abrasive Wheel Machinery	O					
1910.216	Mills and Calenders in the Rubber and Plastics Industries	O					
1910.217	Mechanical Power Presses	O					
1910.218	Forging Machines	O					
1910.219	Mechanical Power Transmission Apparatus	O					
1910.242	Hand and Portable Powered Tools and Equipment, General	P					
1910.243	Guarding of Portable Powered Tools	P					
1910.244	Other Portable Tools and Equipment	P					
1910.251	Definitions	Q					
1910.252	General Requirements	Q					
1910.253	Oxygen-Fuel Gas Welding and Cutting	Q					
1910.254	Arc Welding and Cutting	Q					
1910.255	Resistance Welding	Q					
1910.256	Sources of Standards	Q					
1910.257	Standards Organizations	Q					

OSHA Number	Standard	Subpart	Training Requirements	Written Requirements	Inspection/ Testing Requirements	Monitoring Requirements	Medical Requirements
1910.261	Pulp, Paper, and Paper Board Mills	R					
1910.262	Textiles	R					
1910.263	Bakery Equipment	R					
1910.264	Laundry Machinery and Operations	R					
1910.265	Sawmills	R					
1910.266	Logging Operations	R	X	X	X		X
1910.268	Telecom-munications	R					
1910.269	Electric Power Generation, Transmission, and Distribution	R	X	X	X	X	X
1910.272	Grain Handling Facilities	R					

OSHA Number	Standard	Subpart	Training Requirements	Written Requirements	Inspection/ Testing Requirements	Monitoring Requirements	Medical Requirements
1910.401	General	T					
1910.410	Qualifications of Dive Teams	T					
1910.420	Safe Practices Manual	T					
1910.421	Pre-Dive Procedures	T					
1910.422	Procedures During Dive	T					
1910.423	Post-Dive Procedures	T					
1910.424	SCUBA Diving	T					
1910.425	Surface-Supplied Air Diving	T					
1910.426	Mixed-Gas Diving	T					
1910.427	Liveboating	T					
1910.430	Equipment	T					
1910.440	Record Keeping Requirements	T					

OSHA Number	Standard	Subpart	Training Requirements	Written Requirements	Inspection/ Testing Requirements	Monitoring Requirements	Medical Requirements
1910.1000	Air Contaminants	Z					
1910.1001	Asbestos	Z	X	X	X	X	X
1910.1002	Coal Tar Pitch Volatiles	Z					
1910.1003	4-Nitrobiphenyl	Z					
1910.1004	Alpha-Naphthylamine	Z					
1910.1005	4,4'-Methylene bis (2-chloraniline) (advisory only)	Z					
1910.1006	Methyl Chloromethyl Ether	Z					
1910.1007	3,3'-Dichlorobenzidine (and its salts)	Z					
1910.1008	Bis-Chloromethyl Ether	Z					
1910.1009	Beta-Naphthylamine	Z					
1910.1010	Benzidine	Z					
1910.1011	4- Aminodiphenyl	Z					
1910.1012	Ethyleneimine	Z					
1910.1013	Beta-Propiolactone	Z					
1910.1014	2- Acetyla-minofluorene	Z					
1910.1015	4-Dimethyla-minoazobenzene	Z					
1910.1016	N- Nitroso-dimethylamine	Z					
1910.1017	Vinyl Chloride	Z					
1910.1018	Inorganic Arsenic	Z					
1910.1025	Lead	Z					
1910.1027	Cadmium	Z					
1910.1028	Benzene	Z					
1910.1029	Coke Oven Emissions	Z					
1910.1030	Bloodborne Pathogens	Z					
1910.1043	Cotton Dust	Z					
1910.1044	1, 2-dibromo- 3- chloropropane	Z					
1910.1045	Acrylonitrile	Z					
1910.1047	Ethylene Oxide	Z					
1910.1048	Formaldehyde	Z					
1910.1050	Methylene-dianiline	Z					

1910.1200	Hazard Communication	Z	X	X	X	X	X
1910.1201	Retention of DOT Markings, Placards and Labels	Z					
1910.1450	Occupational Exposure to Hazardous Chemicals in Laboratories	Z	X	X	X	X	X

OSHA Number	Standard	Subpart	Training Requirements	Written Requirements	Inspection/ Testing Requirements	Monitoring Requirements	Medical Requirements
1926.1	Purpose and Scope	A					
1926.2	Variances From Safety and Health Standards	A					
1926.3	Inspections- Right of Entry	A					
1926.4	Rules of Practice for Administrative Adjudications for Enforcement of Safety and Health Standards	A					
1926.10	Scope of Subpart	B					
1926.11	Coverage Under Section 103 of the Act Distinguished	B					
1926.12	Reorganization Plan No. 14 of 1950	B					
1926.13	Interpretation of Statutory Terms	B					
1926.14	Federal Contracts for "Mixed" Types of Performance	B					
1926.15	Relationship to the Service Contract Act; Walsh-Healey Public Contracts Act	B					
1926.16	Rules for Construction	B					
1926.20	General Safety and Health Provisions	C	X		X		
1926.21	Safety Training and Education	C	X				
1926.22	Recording and Reporting of Injuries	C					
1926.23	First Aid and Medical Attention	C					X
1926.24	Fire Protection and Prevention	C					
1926.25	Housekeeping	C					
1926.26	Illumination	C					
1926.27	Sanitation	C					
1926.28	Personal Protective Equipment	C					

1926.29	Acceptable Certifications	C			X		
1926.30	Shipbuilding and Ship Repairing	C					
1926.31	Incorporation by Reference	C					
1926.32	Definitions	C					
1926.33	Access to Employee Exposure and Medical Records	C	X	X			X
1926.34	Means of Egress	C					
1926.35	Employee Emergency Action Plans	C	X	X			X

OSHA Number	Standard	Subpart	Training Requirements	Written Requirements	Inspection/ Testing Requirements	Monitoring Requirements	Medical Requirements
1926.50	Medical Services and First Aid	D	X	X	X		X
1926.51	Sanitation	D					
1926.52	Occupational Noise Exposure	D					
1926.53	Ionizing Radiation	D	X	X	X	X	
1926.54	Non-ionizing Radiation	D	X				
1926.55	Gases, Vapors, Fumes, Dusts, and Mists	D	X				
1926.56	Illumination	D					
1926.57	Ventilation	D	X		X		X
1926.59	Hazard Communication	D	X	X	X	X	X
1926.60	Methylen-ediamiline	D	X	X	X	X	X
1926.61	Retention of DOT Markings, Placards and Labels	D		X	X		
1926.62	Lead	D	X	X	X	X	X
1926.64	Process Safety Management of Highly Hazardous Chemicals	D	X	X	X	X	
1926.65	Hazardous Waste Operations and Emergency Response	D	X	X	X	X	X
1926.66	Criteria for Design and Construction of Spray Booths	D			X		
1926.95	Criteria for Personal Protective Equipment	E					
1926.96	Occupational Foot Protection	E					
1926.97	Protective Clothing for Fire Brigades	E		X	X		
1926.98	Respiratory Protection for Fire Brigades	E			X		
1926.100	Head Protection	E					

1926.101	Hearing Protection	E	X				
1926.102	Eye and Face Protection	E					
1926.103	Respiratory Protection	E	X	X	X		X
1926.104	Safety Belts, Lifelines, and Lanyards	E					
1926.105	Safety Nets	E					
1926.106	Working Over or Near Water	E			X		
1926.107	Definitions Applicable to This Subpart	E					

OSHA Number	Standard	Subpart	Training Requirements	Written Requirements	Inspection/ Testing Requirements	Monitoring Requirements	Medical Requirements
1926.150	Fire Protection	F	X		X		
1926.151	Fire Prevention	F					
1926.152	Flammable and Combustible Liquids	F	X		X		
1926.153	Liquified Petroleum Gas (LP-Gas)	F		X	X		
1926.154	Temporary Heating Devices	F					
1926.155	Definitions Applicable to This Subpart	F					
1926.156	Fixed Extinguishing Systems, General	F	X	X	X		
1926.157	Fixed Extinguishing Systems, Gaseous Agent	F					
1926.158	Fire Detection Systems	F	X		X		
1926.159	Employee Alarm Systems	F	X	X			
1926.200	Accident Prevention Signs and Tags	G					
1926.201	Signaling	G	X				
1926.202	Barricades	G					
1926.203	Definitions Applicable to This Subpart	G					
1926.250	General Requirements for Storage	H					
1926.251	Rigging Equipment for Material Handling	H		X	X		
1926.252	Disposal of Waste Materials	H					

OSHA Number	Standard	Subpart	Training Requirements	Written Requirements	Inspection/ Testing Requirements	Monitoring Requirements	Medical Requirements
1926.300	General Requirements	I			X		
1926.301	Hand Tools	I					
1926.302	Power Operated Hand Tools	I	X		X		
1926.303	Abrasive Wheels and Tools	I			X		
1926.304	Woodworking Tools	I					
1926.305	Jacks-Lever and Ratchet, Screw and Hydraulic	I		X	X		
1926.306	Air Receivers	I			X		
1926.307	Mechanical Power-Transmission Apparatus	I			X		
1926.350	Gas Welding and Cutting	J	X		X		
1926.351	Arc Welding and Cutting	J	X		X		
1926.352	Fire Prevention	J	X		X		
1926.353	Ventilation and Protection in Welding, Cutting, and Heating	J	X				
1926.354	Welding, Cutting and Heating in Way of Preservative Coatings	J			X		
1926.400	Introduction	K					
1926.402	Applicability	K					
1926.403	General Requirements	K		X	X		
1926.404	Wiring Design and Protection	K	X	X	X	X	
1926.405	Wiring Methods, Components, and Equipment for General Use	K					

1926.406	Specific Purpose Equipment and Installations	K					
1926.407	Hazardous (Classified) Locations	K					
1926.408	Special Systems	K			X		
1926.416	General Requirements	K	X		X		
1926.417	Lockout and Tagging of Circuits	K	X	X	X		
1926.431	Maintenance of Equipment	K			X		
1926.432	Environmental Deterioration of Equipment	K					
1926.441	Battery Locations and Battery Charging	K					
1926.449	Definitions Applicable to This Subpart	K					

OSHA Number	Standard	Subpart	Training Requirements	Written Requirements	Inspection/ Testing Requirements	Monitoring Requirements	Medical Requirements
1926.451	Scaffolding	L	X		X		
1926.452	Definitions Applicable to This Subpart	L					
1926.453	Manually Propelled Mobile Ladder Stands and Scaffolds (towers)	L		X	X		
1926.500	Scope, Application, and Definitions Applicable to This Subpart	M			X		
1926.501	Duty to Have Fall Protection	M		X	X		
1926.502	Fall Protection Systems Criteria and Practices	M	X	X	X	X	
1926.503	Training Requirements	M	X	X		X	
1926.550	Cranes and Derricks	N		X	X		
1926.551	Helicopters	N	X		X		
1926.552	Material Hoists, Personnel Hoists and Elevators	N		X	X		
1926.553	Base-Mounted Drum Hoists	N			X		
1926.554	Overhead Hoists	N			X		
1926.555	Conveyors	N			X		
1926.556	Aerial Lifts	N		X	X		

OSHA Number	Standard	Subpart	Training Requirements	Written Requirements	Inspection/ Testing Requirements	Monitoring Requirements	Medical Requirements
1926.600	Equipment	O					
1926.601	Motor Vehicles	O			X		
1926.602	Material Handling Equipment	O		X	X		
1926.603	Pile Driving Equipment	O	X				
1926.604	Site Clearing	O	X				
1926.605	Marine Operations and Equipment	O	X				X
1926.606	Definitions Applicable to This Subpart	O					
1926.650	Scope, Application, and Definitions Applicable to This Subpart	P					
1926.651	General Requirements	P			X	X	
1926.652	Requirements for Protective Systems	P	X	X	X		
1926.700	Scope, Application and Definitions Applicable to This Subpart	Q					
1926.701	General Requirements	Q					
1926.702	Requirements for Equipment and Tools	Q					
1926.703	Requirements for Cast-In-Place Concrete	Q	X		X		
1926.704	Requirements for Precast Concrete	Q					
1926.705	Requirements for Lift-Slab Operation	Q					
1926.706	Requirement of Masonry Construction	Q					

OSHA Number	Standard	Subpart	Training Requirements	Written Requirements	Inspection/ Testing Requirements	Monitoring Requirements	Medical Requirements
1926.750	Flooring Requirements	R					
1926.751	Structural Steel Assembly	R					
1926.752	Bolting, Riviting, Fitting-up, and Plumbing-up	R					
1926.753	Safety Nets	R					
1926.800	Underground Construction	S	X	X	X	X	
1926.801	Caissons	S			X		
1926.802	Cofferdams	S					
1926.803	Compressed Air	S	X	X	X		X
1926.804	Definitions Applicable to This Subpart	S					
1926.850	Preparatory Operations	T			X		
1926.851	Stairs, Passageways, and Ladders	T			X		
1926.852	Chutes	T					
1926.853	Removal of Materials Through Floor Openings	T					
1926.854	Removal of Walls, Masonry Sections, and Chimneys	T					
1926.855	Manual Removal of Floors	T					
1926.856	Removal of Walls, Floors, and Material with Equipment	T					
1926.857	Storage	T					
1926.858	Removal of Steel Construction	T					
1926.859	Mechanical Demolition	T			X		
1926.860	Selective Demolition by Explosives	T					

OSHA Number	Standard	Subpart	Training Requirements	Written Requirements	Inspection/ Testing Requirements	Monitoring Requirements	Medical Requirements
1926.900	General Provisions	U	X	X			
1926.901	Blaster Qualifications	U	X	X			
1926.902	Surface Transportation of Explosives	U	X				
1926.903	Underground Transportation of Explosives	U		X	X		
1926.904	Storage of Explosives and Blasting Agents	U					
1926.905	Loading of Explosives or Blasting Agents	U		X	X		
1926.906	Initiation of Explosive Charges- Electric Blasting	U	X		X		
1926.907	Use of Safety Fuse	U	X				
1926.908	Use of Detonating Cord	U			X		
1926.909	Firing the Blast	U	X				
1926.910	Inspection After Blasting	U			X		
1926.911	Misfires	U	X				
1926.912	Underwater Blasting	U	X				
1926.913	Blasting in Excavation Work Under Compressed Air	U	X				
1926.914	Definitions Applicable to This Subpart	U					
1926.950	General Requirements	V	X		X		
1926.951	Tools and Protective Equipment	V			X		
1926.952	Mechanical Equipment	V					
1926.953	Material Handling	V					
1926.954	Grounded for Protection of Employees	V			X		
1926.955	Overhead Lines	V	X		X		
1926.956	Underground Lines	V	X		X		
1926.957	Construction in Energized Substations	V	X				

1926.958	External Load Helicopters	V					
1926.959	Lineman's Body Belts, Safety Straps, and Lanyards	V			X		
1926.960	Definitions Applicable to This Subpart	V					
1926.1000	Rollover Protective Structures (ROPS) for Material Handling Equipment	W					
1926.1001	Minimum Performance Criteria for Rollover Protective Structures for Designated Scrapers, Loaders, Dozers, Graders, and Crawler Tractors	W			X		
1926.1002	Protective Frame (ROPS) Test Procedures and Performance Requirements for Wheel-Type Agricultural and Industrial Tractors Used in Construction	W		X	X		
1926.1003	Overhead Protection for Operators of Agricultural and Industrial Tractors	W			X		

OSHA Number	Standard	Subpart	Training Requirements	Written Requirements	Inspection/ Testing Requirements	Monitoring Requirements	Medical Requirements
1926.1050	Scope, Application, and Definitions Applicable to This Subpart	X					
1926.1051	General Requirements	X					
1926.1052	Stairways	X					
1926.1053	Ladders	X		X	X		
1926.1060	Training Requirements	X	X				
1926.1071	Scope and Application	Y					
1926.1072	Definitions	Y					
1926.1076	Qualifications of Dive Team	Y	X				X
1926.1080	Safe Practices Manual	Y		X			X
1926.1081	Pre-Dive Procedures	Y	X	X		X	
1926.1082	Procedures During Dive	Y					
1926.1083	Post-Dive Procedures	Y	X	X			
1926.1084	SCUBA Diving	Y			X		
1926.1085	Surface-Supplied Air Diving	Y					
1926.1086	Mixed-Gas Diving	Y					
1926.1087	Liveboating	Y					
1926.1090	Equipment	Y		X	X	X	
1926.1091	Recordkeeping Requirements	Y		X			
1926.1092	Effective Date	Y					

OSHA Number	Standard	Subpart	Training Requirements	Written Requirements	Inspection/ Testing Requirements	Monitoring Requirements	Medical Requirements
1926.1101	Asbestos	Z	X	X	X	X	X
1926.1102	Coal Tar Pitch Volatiles	Z					
1926.1103	4-Nitrobiphenyl	Z	X	X			X
1926.1104	Alpha-Naphthylamine	Z	X	X			X
1926.1106	Methyl Chloromethyl Ether	Z	X	X			X
1926.1107	3,3'-Dichlorobenzidine (and its salts)	Z	X	X			X
1926.1108	Bis-Chloromethyl Ether	Z	X	X			X
1926.1109	Beta-Naphthylamine	Z	X	X			X
1926.1110	Benzidine	Z	X	X			X
1926.1111	4-Aminodiphenyl	Z	X	X			X
1926.1112	Ethyleneimine	Z	X	X			X
1926.1113	Beta-Propiolactone	Z	X	X			X
1926.1114	2- Acetyla-minofluorene	Z	X	X			X
1926.1115	4-Dimethyla-minoazobenzene	Z	X	X			X
1926.1116	N- Nitroso-dimethylamine	Z	X	X			X
1926.1117	Vinyl Chloride	Z	X	X		X	X
1926.1118	Inorganic Arsenic	Z	X	X	X	X	X
1926.1127	Cadmium	Z	X	X	X	X	X
1926.1128	Benzene	Z	X	X	X	X	X
1926.1129	Coke Oven Emissions	Z	X	X	X	X	X
1926.1144	1, 2-dibromo- 3-chloropropane	Z	X	X		X	X
1926.1145	Acrylonitrile	Z	X	X	X	X	X
1926.1147	Ethylene Oxide	Z	X	X	X	X	X
1926.1148	Formaldehyde	Z	X	X	X	X	X

Appendix 2

Explanation of OSHA's General Industry (1910) Regulations

1910.1—Purpose and Scope, establishes OSHA's authority to develop occupational safety and health standards through the incorporation of national consensus standards, (American National Standards Institute, National Fire Protection Association, etc.) and federal standards already established by federal law.

1910.2—Definitions, provides definitions for the following terms used throughout OSHA's regulations: Act, Assistant Secretary of Labor, Employer, Employee, Commerce, Standard, National Consensus Standard, Established Federal Standard.

1910.3—Petitions for Issuance, Amendment, or Repeal of a Standard, establishes the right of any interested person to petition OSHA to initiate, modify or revoke a standard.

1910.4—Amendments to This Part, establishes the authority of the Assistant Secretary of Labor to initiate, modify or revoke OSHA rule making.

1910.5—Applicability of Standards, identifies the extent of OSHA's jurisdiction with respect to states, the District of Columbia, U.S. Commonwealths, federal employees, etc.

1910.6—Incorporation by Reference, establishes that (consensus) standards developed by agencies outside of OSHA, which are incorporated into OSHA standards, have the same force and effect as other OSHA standards. Keep in mind that OSHA does not always include the text of incorporated standards in its rule making, but often just references them. Copies of incorporated standards can

be examined at OSHA's National Office in Washington, or they can be obtained by the issuing organizations.

1910.7—Definition and Requirements for a Nationally Recognized Testing Laboratory, provides definitions of the following terms: Application, Laboratory Requirements, Test Standards, Alternative Test Standards, and Implementation.

✓ **1910.11**—Purpose and Scope, establishes OSHA's authority to regulate specific places of employment, employers, types of work conditions and activities.

1910.12—Construction Work, establishes that all employers engaged in construction work must comply with OSHA standards. For the purposes of this section, construction work means work for construction, alteration, and/or repair, including painting and decorating.

1910.15—Shipyard Employment, establishes that all employers engaged in shipbuilding operations must comply with OSHA standards. This standard also defines the terms: Ship Repair, Ship breaking, Shipbuilding, Related employment, and Vessel

1910.16—Longshoring Terminals, establishes that all employers engaged in longshoring operations must comply with OSHA standards.

1910.17—Effective Dates, establishes that the standards prescribed in subpart B became effective for general industry in 1971.

1910.18—Changes in Established Federal Standards, establishes that any change, amendment, addition or repeal of any OSHA standard will still apply to employers under this subpart.

1910.19—Special Provisions for Air Contaminants, sets forth that the standards for the following air contaminants supersede other applicable standards which also address those contaminants: Asbestos, Tremolite, Anthophyllite, and Actinolite Dust, Vinyl Chloride, Acrylonitrile, Inorganic Arsenic, Lead, Ethylene Oxide, "4,4"—

Methylenedianiline, Formaldehyde, and Cadmium.

1910.20—Access to Employee Exposure and ✓ Medical Records, establishes the right for employees and their representatives to review exposure and medical records.

1910.21—Definitions, defines terms associated with walking and working surfaces including floor openings, handrails, platforms, toe boards, ladders, railings, etc.

1910.22—General Requirements, addresses housekeeping, aisles and passageways, covers and guardrails and floor loading protection as they pertain to walking and working surfaces.

1910.23—Guarding Floor and Wall Openings and Holes, establishes that employers must provide protection for floor openings, wall openings and holes, stairway railings and guards. **1910.23** also addresses specifications for railings, toe boards and covers.

1910.24—Fixed Industrial Stairs, addresses the design, and construction of industrial stairs, including where fixed stairs are required, stair strength, width, angle of rise, stair treads, stairway platforms, railings and handrails, and vertical clearances.

1910.25—Portable Wood Ladders, addresses rules and minimum requirements for the construction, care and use of wooden ladders. Special ladders, including fruit picker's ladders, aisle-way step ladders, shelf ladders and library ladders are not specifically covered by this section.

1910.26—Portable Metal Ladders addresses general specifications regarding the care of ladders. Keep in mind that specific designs and requirements are not part of this section because of the wide variety of metals and design possibilities.

1910.27—Fixed Ladders establishes design requirements for fixed ladders and addresses special features, ladder clearance, special requirements, pitch, and maintenance.

1910.28—Scaffolding Safety Requirements, covers general requirements for the following types of scaffolds: wood pole scaffolds, tube and couple scaffolds, tubular welding frame scaffolds, outrigger scaffolds, mason's adjustable multiple-point suspension scaffolds, two-point suspension scaffolds, stone setter's adjustable multiple point suspension scaffolds, single-point adjustable suspension scaffolds, boatswain's chairs, carpenters' bracket scaffolds, bricklayers' square scaffolds, horse scaffolds, needle beam scaffold, plasterers,' decorators, and large area scaffolds, interior hung scaffolds, ladder-jack scaffolds, window-jack scaffolds, roofing brackets, crawling boards or chicken ladders and float or ship scaffolds.

1910.29—Manually Propelled Mobile Ladder Stands and Scaffolds (Towers), sets rules and requirements for the design and construction and use of mobile work platforms. 1910.29 specifically addresses mobile tubular welded sectional folding scaffolds, mobile tune and coupler scaffolds, and mobile ladder stands.

1910.30—Other Working Surfaces, addresses dockboards (bridge plates), forging machine areas, and veneer machinery.

1910.35—Definitions as Used in Subpart E (Means of Egress), defines the following terms: Means of egress, exit access, exit, low hazard contents, high-hazard contents, ordinary hazard contents, approved, emergency action plan, and emergency escape route.

1910.36—General Requirements (**Subpart E—** Means of Egress), contains general fundamental requirements for providing safe means of egress from fire and similar emergencies. Addresses protection of employees exposed by construction and repair operations, and maintenance.

1910.37—Means of Egress, General applies to all employers and addresses the following: permissible exit components, protective enclosure of exits, width and capacity of means of egress, egress capacity and occupied load, arrangement of exits,

access to exits, exterior ways of exit access, discharge from exits, headroom, changes in elevation, maintenance and workmanship, furnishings and decorations, automatic sprinkler systems, fire alarm signaling systems, fire retardant paints, and exit marking.

1910.38—Employee Emergency Plans and Fire Prevention Plans, requires employers with 11 or more employees to develop and implement a written emergency action plan and fire prevention plan.

1910.66—Powered Platforms for Building Maintenance, covers powered platform installations permanently dedicated to interior or exterior building maintenance of a specific structure or group of structures. Keep in mind that this section does not apply to suspended scaffolds (swinging scaffolds) used in construction or to service buildings on a temporary basis.

1910.67—Vehicle Mounted Elevating and Rotating Work Platforms, provides specific requirements for ladder trucks and tower trucks, extensible and articulating boom platforms, electrical tests, bursting safety factors, and welding standards.

1910.68—Manlifts, applies to the construction, maintenance, inspection, and operation of manlifts in relation to accident hazards. Manlifts covered by 1910.68 consist of platforms or brackets and accompanying handholds mounted or attached to an endless belt that operate vertically in one direction only and are supported and driven through pulleys, at the top and bottom.

1910.94—Ventilation, applies to the following operations: abrasive blasting, grinding, polishing and buffing, spray-finishing, and the immersion of materials in open surface tanks.

1910.95—Occupational Noise Exposure, addresses hearing conservation programs, monitoring, employee notification if exposed at or above the 8-hour time-weighted average, audiometric testing program, audiometric test requirements, hearing protectors, hearing protector attenuation,

training program, access to information and training materials, record keeping, and exemptions.

1910.96—Ionizing Radiation, covers operations in which employees are exposed to alpha, beta, gamma rays, x-rays, neutrons, high speed electrons, high-speed protons and other atomic particles. Addresses definitions, exposure of individuals to radiation in restricted areas, precautionary procedures and personal monitoring, caution signs, labels and signals, instruction of personnel, storage of radioactive materials, waste disposal, notification of incidents, reports of overexposure, records, and disclosure of records.

1910.97—Non-ionizing Radiation covers all radiation originating from radio stations, radar equipment, and other possible sources of electromagnetic radiation such as used for communication, radio navigation, and industrial and science purposes. Keep in mind that 1910.96 does not apply to the deliberate exposure of patients by, or under the direction of, practitioners of the healing arts.

1910.98—Effective Dates, establishes that the provisions of subpart G became effective on August 27, 1971 or on February 15, 1972.

1910.101—Compressed Gases—General Requirements, requires employers to inspect compressed gas cylinders. References Compressed Gas Association Pamphlet P-1-1965.

1910.102—Acetylene incorporates Compressed Gas Association Pamphlets G-1-1966, G-1.3-1959, G-1.4-1966.

1910.103—Hydrogen, applies to the installation of gaseous hydrogen star systems on consumer premises, where the hydrogen supply to the consumer premises originates outside the consumer premises and is delivered by mobile equipment. This section does not apply to gaseous hydrogen systems that have a total hydrogen content of less than 400 cubic feet. It also does not apply to hydrogen manufacturing plants.

1910.104—Oxygen, applies to the installation of bulk oxygen systems on industrial and institutional consumer premises. Keep in mind that 1910.104 does not apply to oxygen manufacturing plants or other establishments operated by the oxygen supplier for the purpose of storing oxygen and refilling portable containers, trailers, mobile supply tanks, or tank cars.

1910.105—Nitrous Oxide, incorporates Compressed Gas Association Pamphlet G-8.1 -1964.

1910.106—Flammable and Combustible Liquids, applies to the handling, storage and use of flammable combustible liquids with a flash point below 200 degrees F. 1910.106 does not apply to bulk transportation and combustible liquids; storage and handling and use of fuel oil tanks and containers connected with oil burning equipment; storage of flammable and combustible liquids on farms; liquids without flash points under some conditions, such as certain halogenated hydrocarbons and mixtures containing halogenated hydrocarbons; mists, sprays or foams, except aerosol covered in paragraph (d) of this section; or installations made in accordance with NFPA standards 32-1970, 35-1970, 36-1967, 37-1970.

1910.107—Spray Finishing Using Flammable and Combustible Materials, applies to flammable and combustible finishing materials when applied as a spray by compressed air, "airless" or "hydraulic atomization", steam, electrostatic methods, or by any other means in continuous or intermittent processes. 1910.107 does not apply to outdoor spray application of buildings, tanks, or other similar structures, nor to small portable spraying apparatus not used repeatedly in the same location.

1910.108—Dip Tanks Containing Flammable or Combustible Liquids, applies to tanks, vats, or containers in which articles or materials are immersed for the purpose of coating, finishing, treating or similar processes. 1910.108 specifically addresses ventilation, construction of dip tanks,

liquids used in dip tanks, electrical and other sources of ignition, operations and maintenance, extinguishment, and special dip tank applications.

1910.109—Explosives and Blasting Agents, applies to the manufacturer, keeping, having, storage, sale, transportation and use, of explosives and blasting agents and pyrotechnics. 1910.109 doesn't apply to the sale and public use (public display) of pyrotechnics, commonly known as fireworks.

1910.110—Storage and Handling of Liquefied Petroleum Gases, describes basic rules, and requirements pertaining to cylinder systems, systems utilizing containers other than DOT containers, liquefied petroleum gas as a motor fuel, storage of containers awaiting use or resale, LP-gas system installations on commercial vehicles, and liquefied petroleum gas service stations.

1910.111—Storage and Handling of Anhydrous Ammonia, applies to the design, construction, location, installation, and operation of anhydrous ammonia systems, including refrigerated ammonia storage systems. 1910.111 does not apply to ammonia manufacturing plants, or refrigeration plants where ammonia is used solely as a refrigerant. 1910.111 covers basic rules, systems utilizing stationary, non-refrigerated storage containers, refrigerated storage systems, systems utilizing portable DOT containers, tank motor vehicles for the transportation of ammonia, and systems mounted on farm vehicles for the application of ammonia.

1910.119—Process Safety Management of Highly Hazardous Chemicals, contains requirements for preventing or minimizing the consequences of catastrophic releases of toxic, reactive, flammable, or explosive chemicals. These releases may result in toxic, fire or explosion hazards. 1910.119 covers employee participation, process safety information, process hazard analysis, operating procedures, training, contractors, pre-startup safety review, mechanical integrity, hot work permit,

management of change, emergency planning and response, compliance audits, and trade secrets.

1910.120—Hazardous Waster Operations and Emergency Response, applies to clean-up operations required by a governmental body involving hazardous substances, and operations conducted at uncontrolled hazardous waste sites; corrective actions involving clean-up operations at sites covered by the Resource Conservation and Recovery Act; Voluntary clean-up operations at sites recognized by federal, state, local governments as uncontrolled hazardous waste sites; operations involving hazardous wastes that are conducted at treatment, storage, and disposal facilities regulated by 40 CFR Parts 264 and 265, in accordance with RCRA; and emergency response operations for releases of, or potential releases of, hazardous substances without regard to the location of the hazard.

1910.132—General Requirements for Personal Protective Equipment, applies to those operations which expose employees to hazards requiring the use of PPE. Employers must furnish when applicable, PPE for the eyes, face, head, extremities, and provide protective clothing, respiratory devices and protective shields and barriers.

1910.133—Eye and Face Protection, requires employers to provide appropriate eye or face protection if employees are exposed to hazards associated with flying particles, molten metal, liquid chemicals, acids or caustic liquids, chemical gases or vapors, or potentially injurious light radiation.

1910.134—Respiratory Protection requires employers to provide respiratory protection when engineering controls are not feasible to control occupational diseases caused by breathing air contaminated with harmful dusts, fogs, fumes, mists, gases, smokes, sprays, or vapors. 1910.134 addresses requirements for a minimal acceptable respirator program; respirator selection; air quality, use of respirators; maintenance and care of respirators; and identification of gas mask canister.

1910.135—Occupational Head Protection, requires employees to wear protective helmets when working in areas where there is a potential for injury to the head from falling objects. 1910.135 incorporates ANSI standards.

1910.136—Occupational Foot Protection, requires employees to wear protective footwear when working in areas where there is a danger of foot injuries due to falling or rolling objects, or objects piercing the sole, and places where employee's feet are exposed to electrical hazards.

1910.137—Electrical Protective Devices, require employers to furnish PPE for electrical hazards. 1910.137 addresses design requirements of PPE; and in-service care and use.

1910.138—Hand Protection, requires employers to provide hand protection when employees' hands are exposed to hazards such as those from skin absorption of harmful substances; severe cuts or lacerations; severe abrasions; punctures; chemical burns; thermal burns; and harmful chemical extremes.

1910.141—Sanitation, requires employers to keep the workplace clean, to dispose of waste appropriately, control vermin, and provide potable water, toilet and washing facilities.

1910.142—Temporary Labor Camps, addresses temporary work sites; shelters; water supplies; toilet facilities; the disposal of sewage; laundry, hand washing, and bathing facilities; lighting, refuse disposal, construction and operation of kitchens, dining hall and feeding facilities; first aid, and reporting communicable diseases.

1910.143—Non-Water Carriage Disposal Systems, Reserved.

1910.144—Safety Color Code for Marking Physical Hazards, requires employers to use specific colors to identify hazards such as flammable liquids, barricades, etc.

1910.145—Specifications for Accident Prevention Signs and Tags, apply to the design, application

and use of signs and symbols intended to identify specific hazards.

1910.146—Confined Spaces, contains requirements for practices and procedures to protect employees in general industry from the hazards of entry into permit-required confined spaces. Keep in mind that 1910.146 does not apply to agriculture, to construction, or to shipyard employment.

1910.147—The Control of Hazardous Energy (Lockout/Tagout), covers the servicing and maintenance of machines and equipment where the unexpected energization, start-up, or release of energy could cause injury to employees. 1910.147 establishes minimum performance requirements for the control of such hazardous energy, and applies to the control of energy during normal servicing and/or maintenance of machines and equipment.

1910.151—Medical Services and First Aid, requires employers to provide medical services or access to medical services, and eye wash facilities.

1910.155—Scope, Application and Definitions Applicable to this Subpart, contains requirements for fire brigades, and all portable and fixed fire suppression equipment, fire detection systems, and fire or employee alarm systems installed to meet the fire protection requirements of this subpart.

1910.156—Fire Brigades, contains requirements for the organization, training, and personal protective equipment of fire brigades whenever they are established by an employer.

1910.157—Portable Fire Extinguishers, apply to the placement, use and maintenance, and testing of portable fire extinguishers provided for the use of employees. Keep in mind that where extinguishers are provided but are not intended for employee use, then only the requirements of paragraphs (e) and (f) of 1910.157 apply. However, the employer must also have an emergency action and fire protection plan which meets the requirements of 1910.38.

1910.158—Standpipe and Hose Systems, applies to all small hose Class III, and Class III standpipe systems installed to meet the requirements of a particular OSHA standard.

1910.159—Automatic Sprinkler Systems, apply to all automatic sprinkler systems installed to meet a particular OSHA standard.

1910.160—Fixed Extinguishing Systems, General, applies to all fixed extinguishing systems installed to meet a particular OSHA standard except for automatic sprinkler systems which are covered by 1910.159.

1910.161—Fixed Extinguishing Systems, Dry Chemical, applies to all fixed extinguisher systems, using dry chemical as the extinguishing agent. These systems must also comply with 1910.160.

1910.162—Fixed Extinguishing Systems, Gaseous Agent, applies to all fixed extinguishing systems, using a gas as the extinguishing agent. These systems must also comply with 1910.160.

1910.163—Fixed Extinguishing Systems, Water Spray and Foam, applies to all fixed extinguishing systems using water or foam solution as the extinguishing agent. These systems must also comply with 1910.160. Keep in mind that 1910.163 does not apply to automatic sprinkler systems which are covered under 1910.159.

1910.164—Fire Detection Systems, applies to all automatic fire detection systems installed to meet the requirements of a particular OSHA standard.

1910.165— Employee Alarm System, applies to all emergency employee alarms installed to meet a particular OSHA standard. This standard does not apply to those discharge or supervisory alarms required on various fixed extinguishing systems or to supervisory alarms on fire suppression, alarm or detection systems unless they are intended to be employee alarm systems.

1910.169—Air Receivers, applies to compressed air receivers, and other equipment used in providing and utilizing compressed air for perform-

ing operations such as cleaning, drilling, hoisting, and chipping. This section does not apply to compressed air machinery and equipment used on transportation vehicles such as steam railroad cars, electric railway cars, and automotive equipment.

1910.176—Handling Materials—General, addresses the use of mechanical equipment; the storage of materials; housekeeping; clearance limits; rolling railroad cars and guarding.

1910.176—Handling Materials—General, addresses the use of mechanical equipment; the storage of materials; housekeeping; clearance limits; rolling railroad cars and guarding.

1910.177—Servicing Multi-Piece and Single Piece Rim Wheels, applies to the servicing of multi-piece and single piece wheels used on large vehicles such as trucks, tractors, trailers, buses and off-road machines. 1910.177 does not apply to the servicing of rim wheels used on automobiles, or on pickup trucks and vans utilizing auto tires or truck tires designated "LT".

1910.178—Powered Industrial Trucks, contains safety requirements relating to fire protection, design, maintenance, and use of forklifts, tractors, platform lift trucks, motorized hand trucks, and other industrial trucks powered by electric motors or internal combustion engines. Keep in mind that this standard does not apply to compressed air or nonflammable compressed gas-operated industrial trucks, or farm vehicles, or vehicles intended primarily for earth moving or over-the-road hauling.

1910.179—Overhead and Gantry Cranes, applies to overhead and gantry cranes, including semigantry, cantilever gantry, wall cranes, storage bridge cranes, and others having the same fundamental characteristics. These cranes are grouped because they all have trolleys and similar travel characteristics.

1910.180—Crawler Locomotive and Truck Cranes, applies to crawler cranes, locomotive

cranes, wheel mounted cranes of both truck and self propelled wheel type, and any variations thereof which retain the same fundamental characteristics. The requirements of 1910.180 are applicable only to machines when used as lifting cranes.

1910.181—Derricks, applies to guy, stiff leg, basket, breast, gin pole, Chicago boom and A-frame derricks of the stationary type, capable of handling loads at variable reaches and powered by hoists through systems of rope reeving, used to perform lifting hook work, single or multiple line bucket work, grab, grapple, and magnet work.

1910.183—Helicopters, addresses pilot/ground briefing; slings and tag lines; cargo hooks; personal protective equipment; loose gear and objects; housekeeping; load safety; hooking and unhooking loads; static charge; weight limitation; ground lines; visibility; signal systems; approach distance; approaching helicopter; personnel; communications; and fires.

1910.184—Slings, applies to slings used in conjunction with other material handling equipment for the movement of material by hoisting. The types of slings covered are those made from alloy steel chain, wire rope, metal mesh, natural or synthetic fiber rope (conventional three strand construction), and synthetic web (nylon, polyester, and polypropylene).

1910.211—Definitions, defines terms used in machinery and machine guarding.

1910.212—General Requirements for All Machines, requires employers to provide one or more methods of machine guarding too protect workers. Addresses types of guarding; general requirements for machine guards; point of operation guarding; barrels, containers, and drums; exposure of blades; and anchoring fixed machinery.

1910.213—Woodworking Machinery Requirements, addresses machine construction; controls and equipment, and specifically addresses hand-fed ripsaws, hand-fed crosscut saws; circular

resaws; self-feed circular; swing cutoff saws; radial saws; band saws and band resaws; jointers; tenoning machines; wood shapers; planing, molding, sticking, and matching machines; sanding machines; veneer cutters and wringers; and miscellaneous woodworking machines.

1910.215—Abrasive Wheel Machinery, mandates that abrasive wheels can be used only on machines provided with safety guards. 1910.215 addresses guard design specifications; flanges; work rests; cup wheels; guard exposure angles; bench and floor stands; cylindrical grinders; surface grinders and cutting-off machines; swing frame grinders; automatic snagging machines; top grinding; exposure adjustment; etc.

1910.216—Mills and Calenders in the Rubber and Plastic Industries, addresses mill roll heights; mill safety controls; calender safety controls; protection by location; trip and emergency switches; and stopping limits.

1910.217—Mechanical Power Presses, addresses press guarding and construction; safeguarding the point of operation; design, construction, setting and feeding of dies; inspection, maintenance, and modification of presses; operation of power presses; reports of injuries to employees operating mechanical power presses; and presence sensing device initiation (PSDI).

1910.218—Forging Machines, applies to lead casts or other use of lead in the forge shop or die shop. 1910.218 addresses inspection and maintenance; hammers and presses; foot operated devices; power-driven hammers; gravity hammers; forging presses; trimming presses; upsetters; and other forging equipment.

1910.219—Mechanical Power-Transmission Apparatus, covers all types and shapes of power-transmission belts, except the following when operating at two hundred and fifty (250) feet per minute or less: (i) Flat belts one (1) inch or less in width, (ii) flat belts two (2) inches or less in width which are free from metal lacings or fasteners, (iii)

round belts one-half (1/2) inch or less in diameter; and (iv) single strand V-belts, the width of which is thirteen thirty-seconds (13/32) inch or less.

1910.241—Definitions, defines terms pertaining to hand and portable powered tools and other hand-held equipment.

1910.242—Hand and Portable Powered Tools and Equipment, General, states that employers are responsible for the safe condition of tools and equipment used by employees.

1910.243—Guarding of Portable Powered Tools, addresses portable circular saws; switches and controls; portable belt sanding machines; pneumatic powered tools and hose; portable abrasive wheels; explosive actuated fastening tools; power lawnmowers; and riding rotary mowers.

1910.244—Other Portable Tools and Equipment, addresses jacks and abrasive blast cleaning nozzles.

1910.251—Definitions, defines the terms "welder and welding operator", and "approved".

1910.252—General Requirements, addresses the following components of welding, cutting and brazing operations: Fire prevention and protection; protection of personnel; health protection and ventilation; and industrial applications.

1910.253—Oxygen-fuel Gas Welding and Cutting, addresses general requirements pertaining to flammable mixtures, maximum pressure, apparatus and personnel; cylinders and containers—approval and marking, storage; manifolding of cylinders—fuel gas manifolds, high pressure oxygen manifolds; service pricing systems; protective equipment, hose and regulators; acetylene generators; and calcium carbide storage.

1910.254—Arc Welding and Cutting, addresses the selection of equipment; the application of arc welding equipment; installation of arc welding equipment; and operation and maintenance.

1910.255—Resistance Welding, addresses installation; spot and seam welding machines; portable welding machines; flash welding equipment; and maintenance.

1910.261—Pulp, Paper, and Paperboard Mills, applies to establishments where pulp, paper, and paperboard are manufactured and converted. Keep in mind that this section does not apply to logging and the transportation of logs to pulp, paper, and paperboard mills.

1910.262—Textiles, apply to the design, installation, processes, operation, and maintenance of textile machinery, equipment, and other plant facilities in all plants engaged in the manufacture and processing of textiles, except those processes used exclusively in the manufacture of synthetic fibers.

1910.263—Bakery Equipment, applies to the design, installation, operation and maintenance of machinery and equipment used within a bakery.

1910.264—Laundry Machinery and Operations, applies to laundries and to conditions unique to this industry, with special reference to the point of operation of laundry machines. 1910.264 does not apply to dry-cleaning operations.

1910.265—Sawmills, applies to safety requirements for sawmill operations including, but not limited to, log and lumber handling, sawing, trimming, and planing; waste disposal; operation of dry kilns; finishing; shipping; storage; yard and yard equipment; and for power tools and affiliated equipment used in connection with such operations, but excluding the manufacture of plywood, cooperage, and veneer.

1910.266—Logging, establishes safety practices, means, methods and operations for all types of logging, regardless of the end use of the wood. These types of logging include, but are not limited to, pulpwood and timber harvesting and the logging of sawlogs, veneer bolts, poles, pilings and other forest products.

1910.267—Agricultural Operations, have been transferred to 1928.21.

1910.268—Telecommunications, establishes safety and health standards that apply to the work conditions, practices, means, methods, operations, installations and processes performed at telecommunications centers and at telecommunications field installations, which are located outdoors or in building spaces used for such field installations.

1910.269—Electric Power Generation, Transmission, and Distribution, covers the operation and maintenance of electric power generation, control, transformation, transmission, and distribution lines and equipment. These provisions apply to power generation, transmission, and distribution installations, including related equipment for the purpose of communication or metering, which are accessible only to qualified employees.

1910.301—Introduction to Subpart S—Electrical, addresses electrical safety requirements that are necessary for the practical safeguarding of employees in their workplaces and is divided into four major divisions as follows: Design safety standards for electrical system; safety-related work practices; safety-related maintenance requirements; and safety requirements for special equipment.

1910.302—Electric Utilization Systems. The provisions of 1910.302 through 1910.308 cover electrical installations and utilization equipment installed or used within or on buildings, structures, and other premises including yards; carnivals; parking and other lots; mobile homes; recreational vehicles; industrial substations; conductors that connect the installations to a supply of electricity, and other outside conductors on the premises. page

1910.303—General Requirements, addresses the examination, installation and use of electrical equipment; installation and use; splices; arcing parts; marking; identification of disconnecting means; 600 volts nominal or less; and over 600 volts, nominal.

1910.304—Wiring Design and Protection, addresses the use and identification of grounded and grounding conductors; outside conductors, 600 volts, nominal or less; disconnecting services; overcurrent protection; and grounding.

1910.305—Wiring Methods, Components, and Equipment for General Use, addresses wiring methods; cabinets, boxes, and fittings; switches; switchboards and panel boards; enclosures for damp or wet locations; conductors for general wiring; flexible cords and cables; portable cables over 600 volts, nominal; and fixture wires; equipment for general use: lighting fixtures, lamp holders, lamps and receptacles.

1910.306—Specific Purpose Equipment and Installations, addresses electric signs and outline lighting; cranes and hoists; elevators, dumbwaiters, escalators, and moving walks; electric welders; data processing systems; X-ray equipment; induction and dielectric heating equipment, electrolytic cells; electrically driven or controlled irrigation machines; and swimming pools, fountains, and similar installations.

1910.307—Hazardous (classified) Locations, covers the requirements for electric equipment and wiring in locations which are classified depending on the properties of the flammable vapors, liquids or gases, or combustible dusts or fibers which may be present.

1910.308—Special Systems, covers systems over 600 volts, nominal; emergency power systems; class 1, 2, 3 remote control, signaling, and power-limited circuits; fire protective signaling systems; and communications systems.

1910.331—Scope, covers electrical safety-related work practices for both qualified persons (those who have training in avoidance of electrical hazards of working on or near exposed energized parts), and unqualified persons, who work on or near premises wiring, wiring for connection to supply, other wiring or optical fiber cable.

1910.332—Training, applies to employees who

face a risk of electric shock that is not reduced to a safe level by the electrical installation requirements of 1910.303 through 1910.308.

1910.333—Selection and Use of Work Practices, requires employers to employ safety-related work practices to prevent electric shock or other injuries resulting from either direct or indirect electrical contacts.

1910.334—Use of Equipment, addresses portable electric equipment; electric power and lighting circuits; test instruments and equipment; and occasional use of flammable or ignitable materials.

1910.335— Safeguards for Personnel Protection, addresses the use of PPE for employees working in areas where there are potential electrical hazards.

1910.399—Definitions Applicable to Subpart S, defines terms pertaining to electrical operations.

1910.401— Scope and Applications of Commercial Diving Operations, applies to diving and related support operations conducted in connection with all types of work and employment, including general industry, construction, ship repairing, shipbuilding, ship breaking and longshoring.

1910.402—Definitions, defines terms pertaining to commercial diving operations.

1910.410—Qualifications of Dive Team, spells out the duties of each dive team member with regard to training; assignments; and designation of person in charge.

1910.420—Safe Practices Manual, requires employers to develop and maintain a safe practices manual that is made available to each dive team member.

1910.421—Pre-dive Procedures, addresses emergency aid; first-aid supplies; planning and assessment; hazardous activities; employee briefing; equipment inspection; and warning signals.

1910.422—Procedures During Dive, requires employers to address the following: water entry and

exit; communications; decompression tables; dive profiles; hand-held power tools and equipment; welding and burning; and explosives.

1910.423—Post-dive Procedures, requires employers to address the following: precautions; recompression capability; record of dive; and decompression procedure assessment.

1910.424—SCUBA Diving, addresses limits and procedures pertaining to SCUBA diving operations.

1910.425—Surface-supplied Air Diving, addresses limits and procedures pertaining to such operations.

1910.146—Mixed-gas Diving, addresses limits and procedures pertaining to such operations.

1910.427—Liveboating, addresses limits and procedures pertaining to such operations.

1910.430—Equipment, requires employers to record and document equipment modifications, tests, repairs, etc., with regard to air compressor systems; breathing gas supply hoses; buoyancy controls; compressed gas cylinders; decompression chambers; gauges and time keeping devices; masks and helmets; oxygen safety; and weights and harnesses.

1910.440—Record keeping Requirements, requires employers to record the occurrence of any diving-related injury or illness which requires any dive team member to be hospitalized for 24 hours or more.

1910.441—Effective Date, establishes the effective date of Subpart T as 1977.

1910.1000—Air Contaminants, defines the exposure limits used in Tables Z-1, Z-2, Z-3.

1910.1001—Asbestos, applies to all occupational exposures to asbestos in all industries covered by OSHA.

1910.1002—Coal Tar Pitch Volatiles, include the fused polycyclic hydrocarbons which volatilize from the distillation residues of coal, petroleum (excluding asphalt), wood, and other organic matter.

1910.1003—13 Carcinogens, applies to any area in which 4-Nitrobiphenyl, alpha-Napthylamine, Methyl Chloromethyl Ether, 3,3'-Dichlorobenzidine (and its salts), bis-Chloromethyl Ether, beta-Napthylamine, Benzidine, 4-Aminodiphenyl, Ethyleneimine, beta-Propiolactone, 2-Acetylaminoflourene, 4-Dimethylaminoazobenzene, N-Nitrosodimethylamine is manufactured, processed, repackaged, released, handled, or stored.

1910.1017—Vinyl Chloride, applies to the manufacture, reaction, packaging, repackaging, storage, handling of use of vinyl chloride or polyvinyl chloride, but does not apply to the handling or use of fabricated products made of polyvinyl chloride.

1910.1018—Inorganic Arsenic, applies to all occupational exposures to inorganic arsenic. However, it does not apply to employee exposures in agriculture or resulting from pesticide application, or the treatment of wood with preservatives, or the utilization of wood preserved with arsenic.

1910.1027—Cadmium, applies to all occupational exposures to cadmium and cadmium compounds in all forms.

1910.1028—Benzene, applies to all occupational exposures to benzene. 1910.1028 addresses permissible exposure limits; regulated areas; exposure monitoring; methods of compliance; respiratory protection; medical surveillance; and record keeping.

1910.1029—Coke Oven Emissions, applies to the control of employee exposure to coke oven emissions. 1910.1029 addresses permissible exposure limits; regulated areas; exposure monitoring and measurement; methods of compliance; respiratory protection; protective clothing and equipment; hygiene facilities and practices; employee information and training; precautionary signs and labels; record keeping; and observation of monitoring.

1910.1030—Bloodborne Pathogens, applies to

all occupational exposure to blood or other potentially infectious materials. 1910.1030 addresses exposure control; methods of compliance; HIV and HBV research laboratories and production facilities; hepatitis B vaccination; communication of hazards; and record keeping.

1910.1043—Cotton Dust, applies to the control of employee exposure to cotton dust in all workplaces where employees engage in yarn manufacturing, engage in slashing and weaving operations, or work in waste houses for textile operations.

1910.1044—1,2-dibromo-3-chloro-propane, applies to occupational exposure to 1,2-dibromo-3-chloro-propane (DBCP). 1910.1043 addresses permissible exposure limits; notification of use; regulated areas; exposure monitoring; methods of compliance; respirators; emergency situations; protective clothing and equipment; housekeeping; hygiene facilities and practices; medical surveillance; employee information and training; and signs and labels.

1910.1045—Acrylonitrile, applies to all occupational exposures to acrylonitrile. 1910.1045 addresses permissible exposure limits; notification of regulated areas and emergencies; exposure monitoring; regulated areas; methods of compliance; respiratory protection; emergency situations; protective clothing and equipment; housekeeping; waste disposal; hygiene facilities and practices; medical surveillance; employee information and training; signs and labels; record keeping; and observation of monitoring.

1910.1047—Ethylene Oxide, applies to all occupational exposures to ethylene oxide. 1910.1047 addresses permissible exposure limits; exposure monitoring; regulated areas; methods of compliance; respiratory protection and personal protective equipment; emergency situations; medical surveillance; communication of hazards to employees; record keeping; and observation of monitoring.

1910.1048—Formaldehyde, applies to all occupational exposures to formaldehyde. 1910,1048

addresses permissible exposure limits; exposure monitoring; regulated areas; methods of compliance; respiratory protection; hygiene protection; housekeeping; emergencies; medical surveillance; hazard communication; employee information and training; and record keeping.

1910.1050—Methylenedianiline, applies to all occupational exposures to MDA. 1910.1050 addresses permissible exposure limits; emergency situations; exposure monitoring; regulated areas; methods of compliance; respiratory protection; protective work clothing and equipment; hygiene facilities and practices; communication of hazards to employees; housekeeping; medical surveillance; and observation of monitoring.

1910.1200—Hazard Communication, requires employers, manufacturers, etc. to evaluate the chemicals they produce, store and use, and provide information concerning those hazards to employers and employees. 1910.1200 addresses hazard determination; written hazard communications program; labels and other forms of warning; material safety data sheets; employee information and training; and trade secrets.

1910.1450—Occupational Exposure to Hazardous Chemical in Laboratories, applies to all employers engaged in the laboratory use of hazardous chemicals. 1910.1450 addresses permissible exposure limits; employee exposure determinations; chemical hygiene plan; employee information; medical consultation and medical examinations; hazard identification; use of respirators; and record keeping.

Explanation of OSHA's Construction Industry (1926) Regulations

1926.1—Purpose and Scope, establishes OSHA's authority to set and enforce standards under section 107 of the Contract Work Hours and Safety Standards Act.

1926.2—Variances from Safety and Health Stan-

dards, establishes OSHA's authority to issue variances to employers subject to the requirements of OSHA safety and health standards.

1926.3—Inspections—Rights of Entry, establishes OSHA's authority to conduct inspections and to gain right of entry to carry out duties described in the Occupational Safety and Health Act.

1926.4—Rules of Practice for Administrative Adjudications for Enforcement of Safety and Health Standards, establishes that the rules of practice in this subpart are the same as those published in part 6 of this title.

1926.10—Scope of Subpart, defines the scope of subpart B, which interprets and applies construction safety and health provisions contained in section 107 of the Contract Work Hours and Safety Standards Act.

1926.11—Coverage Under Section 103 of the Act Distinguished, details the differences between section 107 of the Contract Work Hours and Safety Standards Act and sec 103 of the same act which details overtime requirements.

1926.12—Reorganization Plan No. 14 of 1950, outlines OSHA's enforcement of labor standards under federal and federally assisted contracts that are subject to various statutes. Those are listed in the standard.

1926.13—Interpretation of Statuatory Terms, interprets the meaning of such statutory terms as "construction", "alteration", "repair", "contractor", and "sub- contractor" as they apply to other legislative acts including the Davis-Bacon Act, the Copeland Act and the Miller Act.

1926.14—Federal Contract for "Mixed" Types of Performance, establishes that when federal contracts call for mixed types of performance—both manufacturing and construction, section 107 of the Contract Work Hours and Safety Standards Act applies to construction, alteration and repair operations.

1926.15—Relationship to the Service Contract

Act; Walsh-Healey Public Contracts Act, requires employers fulfilling contracts for any federal agency to make certain that working conditions are sanitary, free of hazards, and do not endanger workers.

1926.16—Rules of Construction, covers the responsibilities of contractors and subcontractors with regard to complying with OSHA regulations.

1926.20—General Safety and Health Provisions, establishes that all employers engaged in construction, alteration, repair, painting, etc., must make sure that employee working conditions are free of hazards, that tools are safe or removed, and that only trained workers operate equipment.

1926.21—Safety Training and Education, establishes that all construction employers must instruct employees on workplace hazards including: the handling and use of caustic or flammable materials, confined space entry and all other hazards associated with the particular work area.

1926.23—First Aid and Medical Attention, requires all employers to provide first aid and medical care for every employee covered under 1926.

1926.24—Fire Protection and Prevention, establishes that employers are responsible for the development and maintenance of fire protection and prevention programs during all phases of construction.

1926.25—Housekeeping, requires employers to keep the construction site free of debris; and to provide containers for the collection of scrap and waste.

1926.26—Illumination, requires all construction work areas to be well lighted.

1926.27—Sanitation, stipulates that health and sanitation requirements for drinking water are covered in Subpart D.

1926.28—Personal Protective Equipment, requires all construction employers to provide personal protective equipment to employees working

in hazardous conditions. See all of Subpart E for specific requirements.

1926.29—Acceptable Certifications, requires construction employers operating or installing pressure vessels and boilers to maintain current and valid certification from an insurance company or other regulatory authority. See subparts F and O for additional requirements.

1926.30—Shipbuilding and Ship Repairing, applies to construction employers engaged in ship building, repairing, and maintenance are subject to OSHA requirements under 1915 and 1916—Safety and health regulations for ship repairing, and building, respectively.

1926.31—Incorporation by Reference, explains that, in its rulemaking, OSHA often incorporates standards from industry associations such as ANSI and NFPA. This standard establishes OSHA's authority to enforce incorporated standards developed by parties outside the scope of the Labor Department.

1926.32—Definitions, provides general definitions for the construction industry to delineate OSHA authority, and safety-related terminology.

1926.33—Access to Employee Exposure and Medical Records, requires all construction employers to provide employees access to their medical and exposure records. OSHA also has the right to view these records. 1926.33 addresses employer and physician responsibilities, trade secrets, and confidentiality.

1926.34—Means of Egress, requires all construction employers to make certain that employees can easily identify exits, and that walkways and exits are unobstructed. Doors which could prevent escape in the event of an emergency should never be locked.

1926.35—Employee Emergency Action Plans, requires all construction employers to prepare an emergency and fire prevention plan. The plan must be in writing and must also be communicated to

employees. An alarm system is also required (see 1926.159 for specifications).

1926.50—Medical Services and First Aid, requires all construction employers to maintain access to medical personnel and to provide first-aid supplies, quick drenching facilities for the eyes and body, and to post emergency telephone numbers.

1926.51—Sanitation, requires all construction employers to provide suitable drinking water, washing facilities and toilet facilities in the workplace. All food handling facilities must meet local codes. Each workplace must be set up to prevent the entrance of vermin.

1926.52—Occupational Noise Exposure, requires construction employers to implement administrative and engineering controls when sound levels exceed those listed in Table D-2 in the standard.

1926.53—Ionizing Radiation, requires construction employers using sources of ionizing radiation to comply with provisions set by the Nuclear Regulatory Commission as well as OSHA requirements including training, the use of signs, labels and signals, recordkeeping and reporting.

1926.54—Nonionizing Radiation, requires employers using laser equipment to train and protect employees from the effects of nonionizing radiation.

1926.55—Gases, Vapors, Fumes, Dusts and Mists, requires employers using materials or substances listed in Appendix A of the standard—Threshold Limit Values of Air Contaminants for 1970, to provide engineering controls or personal protective equipment to protect workers.

1926.56—Illumination, requires all construction employers to provide adequate lighting during work operations. Table D-3 in the standard provides minimum lighting requirements for specific areas of operation.

1926.57—Ventilation, requires construction employers to provide ventilation to protect workers from hazards associated with dusts, fumes, mists,

vapors, or gases produced in the course of construction work. The standard covers specific ventilation systems and operations.

1926.59—Hazard Communication, requires chemical producers and importers to evaluate the potential hazards of chemicals passed on to construction employers and their employees. Chemical producers and employers must establish a comprehensive hazard communication program.

1926.60—Methylenedianiline, applies to all construction employers whose employees are exposed to MDA during construction operations; when installing or finishing surfaces containing MDA; during spills or emergency cleanup of MDA; or transporting, storing, or containment of MDA.

1926.62—Lead, applies to all construction employers whose operations expose employees to lead. Such operations include: demolition of structures containing lead, removal of materials containing lead, and transportation and storage of products containing lead.

1926.64—Process Safety Management of Highly Hazardous Chemicals, is a performance based standard that requires construction employers to prevent catastrophic releases of toxic, reactive, flammable, or explosive chemicals that meet the threshold quantities outlined in Appendix A of 1926.64.

1926.65—Hazardous Waste Operations and Emergency Response, applies to employers involved in: Clean-up operations involving hazardous substances (required by a government body); corrective actions required by the Resource Conservation Act, voluntary clean-up operations, and emergency response operations.

1926.66—Criteria for Design and Construction of Spray Booths, applies to construction employers involved in the design and construction of spray booths. Key provisions: Electrical sources of ignition; ventilation; fixed electrostatic apparatus, Info hand spraying equipment; and drying, curing or fusion apparatus.

1926.95—Criteria for Personal Protective Equipment, requires all construction employers to provide, use and maintain personal protective equipment for eyes, face, head, and extremities, as well as protective clothing, respiratory devices, protective shields and barriers.

1926.96—Occupational Foot Protection, requires construction employers who provide foot protection to employees to meet the requirements set in ANSI standard Z41.1 - 1967.

1926.97—Protective Clothing for Fire Brigades, applies to employees who perform interior structural fire fighting. Employers must provide protective clothing to prevent injuries from fire-related hazards. Exception: Workers who use fire extinguishers to control fires in the earliest stages.

1926.98—Respiratory Protection for Fire Brigades, applies to construction employers who employ fire brigades. Those employers must provide certified respiratory equipment to employees, at no charge to the employee. The rule addresses self-contained breathing apparatus.

1926.100—Head Protection, requires construction employers to provide head protection to employees whenever there is a danger of head injury from impact, falling objects, electrical shocks and burns. References ANSI standards Z89.1-1969, Z89.2-1971.

1926.101—Hearing Protection, requires employers to provide ear protective devices to employees if they cannot reduce noise levels to the levels specified in Table D-2 in 1926.52. The use of plain cotton is prohibited.

1926.102—Eye and Face Protection, requires employers to provide eye and face protective equipment when machines or operations pose a potential eye or face injury from physical, chemical or radiation agents.

1926.103—Respiratory Protection, requires construction employers to provide respiratory protection to workers in cases of emergency or when

engineering controls either fail or are inadequate to prevent harmful exposure to those employees.

1926.104—Safety Belts, Lifelines, and Lanyards, (Removed: 8/9/94), (Administrative stay of enforcement on revised fall protection standards:)

1926.105—Safety Nets, (Removed: 8/9/94), (Administrative stay of enforcement on revised fall protection standards:)

1926.106—Working Over or Near Water, requires employers to provide life jackets, life vests, and ring buoys to employees working over or near water. Employers must also provide a lifesaving skiff if employees are working over or adjacent to water.

1926.107—Definitions Applicable to Subpart E, contains definitions applicable to personal protective and lifesaving equipment.

1926.150—Fire Protection, applies to all construction employers. OSHA requires employers to develop a fire protection program, provide firefighting equipment and inspect and maintain that equipment.

1926.151—Fire Prevention, requires employers to address the following items in their fire prevention programs: Ignition hazards; temporary buildings; and open yard and indoor storage of combustible materials.

1926.152—Flammable and Combustible Liquids, sets requirements for employers who store and dispense flammable and combustible liquids.

1926.153 Liquefied Petroleum Gas (LP-Gas), applies to construction employers who dispense, or store liquefied petroleum gas.

1926.154—Temporary Heating Devices, applies to construction employers who utilize temporary heating devices during work operations. Such heating devices include solid fuel salamanders and oil-fired heaters.

1926.155—Definitions Applicable to this Subpart, provides definitions applicable to subpart F—fire protection and prevention.

1926.156—Fixed Extinguishing Systems, General, applies to construction employers who use fixed fire extinguishing systems but not automatic sprinkler systems. Employers using automatic sprinkler systems must comply with the requirements of 1926.159.

1926.157—Fixed Extinguishing Systems, Gaseous Agent, applies to construction employers who use fixed extinguishing systems that rely on gas to extinguish fires. Such gas-based systems must also meet the requirements of 1926.156.

1926.158—Fire Detection Systems, applies to construction employers who use automatic fire detection systems.

1926.159—Employee Alarm Systems, applies to employers who utilize emergency employee alarm systems. Unless used as an employee alarm system, 1926.159 doesn't apply to discharge or supervisory alarms on various fixed extinguishing, fire suppression, alarm or detection systems.

1926.200 outlines accident prevention signs and tags to be used to protect workers from immediate or potential hazards. Signs addressed: Danger, caution, exit, safety instruction, directional, and traffic. Also covers accident prevention tags.

1926.201—Signaling, applies to operations in which signs, signals, and barricades don't provide enough protection for employees working on or adjacent to highways or streets. In such cases, OSHA requires the use of flagmen. References ANSI standard D6.1-1971.

1926.202—Barricades, requires construction employers who use barricades to protect workers to conform to ANSI standard D6.1-1971, Manual on Uniform Traffic Control Devices for Streets and Highways.

1926.203—Definitions Applicable to Subpart G, provides definitions applicable to Subpart G—signs, signals and barricades.

1926.250—General Requirements for Storage, applies to construction employers who store quan-

tities of materials. OSHA requires that stored materials are secured, storage areas are kept clean and free from fire, tripping or pest hazards. 1926.250 also addresses the use of dockboards.

1926.251—Rigging Equipment for Material Handling, applies to construction employers who use rigging equipment for material handling.

1926.251 addresses: Alloy steel chains; natural, synthetic and wire rope; synthetic webbing; and shackles and hooks.

1926.252—Disposal of Waste Materials, applies to construction employers who dispose of waste materials. 1926.253 addresses the use of chutes, barricades, and signs; and compliance with local fire regulations when waste materials present a fire hazard.

1926.300—General Requirements for Tools—Hand and Power, applies to all construction employers using hand, power tools and similar equipment, whether supplied by the employer or workers. Key provisions: Maintenance; guarding; personal protective equipment; and switches.

1926.301—Hand Tools, requires employers to make certain that all hand tools are in good condition, and do not present safety hazards. 1926.301 specifically addresses: Wrenches, (adjustable, pipe, end, and socket); impact tools; and tools with wooden handles.

1926.302—Power-operated Hand Tools, spells out operating procedures for all construction employers who use electric power-operated tools; pneumatic power tools; fuel powered tools; hydraulic power tools; and power -actuated tools.

1926.303—Abrasive Wheels and Tools, applies to construction employers who utilize grinding machines or other abrasive wheels and tools. 1926.303 addresses: Power; guarding, use of abrasive wheels; and work rests. References ANSI standard B7.1-1970.

1926.304—Woodworking Tools, applies to construction employers who use powered wood work-

ing tools. 1926.304 addresses: Radial & hand-fed crosscut table saws, hand-fed rip saws; disconnect switches; speeds; self -feeding tools; guarding; and PPE. Reference ANSI standard 01.1-1961.

1926.305—Jacks-lever, and Ratchet, Screw, and Hydraulic, applies to construction employers who use lever and ratchet, screw, and hydraulic jacks. 1926.305 addresses: Blocking; and operation and maintenance.

1926.306—Air Receivers, applies to construction employers who use compressed air receivers and other equipment for cleaning, drilling, hoisting and chipping operations.

1926.307—Mechanical Power-Transmission Apparatus, applies to construction employers using power transmission belts. 1926.307 addresses: Prime-mover guards; shafting; pulleys; belt, rope and chain drives; gears, sprockets and chains; guarding; and more.

1926.350—Gas Welding and Cutting, applies to construction employers who transport, move and store compressed gas cylinders. 1926.350 addresses: Placing cylinders; treatment of cylinders; use of fuel gas; fuel gas and oxygen manifolds; hose; torches; etc. ANSI standard Z49.1-1967.

1926.351—Arc Welding and Cutting, applies to construction employers who engage in arc welding and cutting operations. 1926.351 addresses: Manual electrode holders; welding cables and connectors; ground returns and machine grounding; operating instructions; and shielding.

1926.352—Fire Prevention, requires construction employers engaged in welding, cutting, or heating to remove or take positive measures to eliminate fire hazards.

1926.353—Ventilation, and Protection in Welding, Cutting and Heating, requires construction employers engaged in welding, cutting, and heating operations to provide adequate ventilation. 1926.353 addresses: Mechanical ventilation; welding in confined spaces; toxic metals; inert-gas metal arc welding; PPE.

1926.354—Welding, Cutting, and Heating in Way of Preservative Coatings, requires construction employers engaged in welding, cutting, and heating operations to test preservative coatings for flammability. Employees must also be protected from hazards associated with surfaces covered with toxic preservatives.

1926.400—Introduction to Subpart K—Electrical, details electrical safety requirements in subpart K, including: Installation safety requirements; safety-related work practices; safety-related maintenance and environmental considerations; and safety requirements for special equipment.

1926.402—Applicability, provides an explanation to construction employers regarding what installation safety requirements for electrical equipment, power and light are covered in subpart K and what procedures are covered in Subpart V.

1926.403—General Requirements, establishes general safety requirements for the installation and use of electrical equipment. 1926.403 addresses: Mounting and cooling of equipment; splices; arcing parts; marking; equipment operating at, less, or above 600 volts.

1926.404—Wiring Design and Protection, applies to construction employers engaged in electrical Info wiring operations. 1926.404 addresses: Grounded and grounding conductors; branch circuits; outside conductors and lamps; services; overcurrent protection; and grounding.

1926.405—Wiring Methods, Components, and Equipment for General Use, applies to construction employers engaged in electrical wiring operations. 1926.405 addresses: Wiring methods; cabinets, boxes, and fittings; knife switches; enclosures for damp locations; cord and cables; fixture wires; cables over 600 volts.

1926.406—Specific Purpose Equipment and Installations, applies to construction employers engaged in the installation of electrical equipment and wiring used in conjunction with: Cranes and hoists; elevators, escalators, electric welders—disconnecting means; and X-ray equipment.

1926.407—Hazardous (classified) Locations, sets requirements for electric equipment and wiring in locations which are considered hazardous (classified). For a definition of such hazardous locations, refer to 1926.449.

1926.408—Special Systems, applies to special electrical systems including systems over 600 volts, nominal; class 1-3 remote control, signaling and power-limited circuits; and communication systems.

1926.416—General Requirements, establishes general safety-related requirements for construction employers engaged in electric operations. 1926.416 addresses: Employee protection; passageways and open spaces; load ratings; fuses; cord and cables; and use of equipment.

1926.417—Lockout and Tagging of Circuits, applies to construction employers responsible for energizing or deenergizing equipment or circuits. This standard requires that deenergized electrical equipment be locked out and/or tagged to prevent accidental startup and employee injury.

1926.431—Maintenance of Equipment, requires construction employers engaged in electrical operations to maintain wiring components and utilization equipment in a safe manner.

1926.432—Environmental Deterioration of Equipment, requires construction employers engaged in electrical installation operations to make sure that wiring components or equipment is not compromised by environmental deterioration including damp locations, excessive temperatures and corrosives.

1926.441—Batteries and Battery Charging, requires construction employers who utilize batteries and battery charging devices to provide ventilation, PPE, eye wash facilities, proper storage and housekeeping.

1926.449—Definitions Applicable to this Subpart, provides definitions applicable to subpart K— safety requirements for special equipment.

1926.451—Scaffolding, applies to all construction employers who use scaffolds during construction operations. Scaffolds: Wood pole; tube and coupler; tubular welded frame; manually propelled mobile; elevating and rotating platforms; outrigger; swinging; etc.

1926.452—Definitions Applicable to Subpart L, provides definitions applicable to subpart L—scaffolding.

1926.453—Manually Propelled Mobile Ladder Stands and Scaffolds (towers), establishes rules and requirements for the design, construction, and use of mobile work platforms (including ladder stands but not aerial ladders) and rolling mobile scaffolds.

1926.500—Floor and Wall Openings, and subpart M cover workplaces, conditions or operations where fall protection is to be provided. Keep in mind that subparts L,N,R,S,V & X also contain fall protection requirements. Read 1926.500 to determine which operations apply to subpart M.

1926.501—Duty to Have Fall Protection, applies to construction operations in which employees are exposed to fall hazards. Employers must make sure that fall protection systems address unprotected sides and edges; falling objects, as well as requirements set in 1926.502.

1926.502—- Fall Protection Systems—Criteria and Practices, addresses specific fall protection systems including: Guardrails; safety nets; personal fall arrest, positioning device, and warning line systems. Also: Controlled access zones; safety monitoring systems; covers; fall protection plans.

1926.550—Cranes and Derricks, applies to construction employers using cranes (crawler, locomotive, truck-, overhead, gantry, floating), and derricks. Also addresses suspended personnel platforms.

1926.551—Helicopters, applies to employers who use helicopter cranes in their construction operations. Such cranes must comply with applicable

FAA regulations. Also addresses: Slings and tag lines, cargo hooks, PPE, hooking and unhooking loads, signal systems, etc.

1926.552—Material Hoists, Personnel Hoists, and Elevators, applies to construction employers who use material hoists, personnel hoists, and elevators during work operations. Employers must comply with the manufacturer's specifications and limitations applicable to hoists and elevators.

1926.553—Base-Mounted Drum Hoists, applies to construction employers using base-mounted drum hoists. Addresses manufacturer's specifications and guarding.

1926.554—Overhead Hoists, applies to construction employers using overhead hoists. Addresses manufacturer's specifications, safe working loads, installation, air hoists and air hoses.

1926.555—Conveyors, applies to construction employers using conveyors to move materials. Addresses operator and station requirements, emergency stop switches. References ANSI B20.1-1957, Safety Code for Conveyors, Cableways and Related Equipment.

1926.556—Aerial Lifts, applies to construction employers using aerial lifts, extensible boom platforms, aerial ladders, articulating boom platforms, and vertical towers. References ANSI A92.2-1969—Vehicle Mounted Elevating and Rotating Work Platforms.

1926.600—Equipment, provides general requirements for the use of heavy machinery, motor vehicles, earthmoving and pile driving equipment.

1926.601—Motor Vehicles, applies to construction employers using motor vehicles that operate within an off-highway jobsite, not open to public traffic. Addresses: Brakes, windshields, seat belts, reverse signal alarms, etc.

1926.602—Material Handling Equipment, applies to construction employers using the following types of earthmoving equipment: Scrapers, loaders, crawler or wheel tractors, bulldozers, off-high-

way trucks, graders, agricultural and industrial tractors, and similar equipment.

1926.603—Pile Driving Equipment, applies to construction employers using pile driving equipment. Addresses: Pile driving from barges or floats, boilers and piping systems, overhead protection, guarding, etc.

1926.604—Site Clearing, applies to construction employers engaged in site clearing operations. Addresses: First-aid treatment, hazardous irritants and toxic plants and general equipment provisions.

1926.605—Marine Operations and Equipment, applies to employers engaged in marine operations and equipment. Such employers engaged in material handling must comply with OSHA's longshoring regulations (CFR 29 part 1918). Addresses: Access to barges, working surfaces, first-aid, etc.

1926.606—Definitions Applicable to Subpart O, provides definitions applicable to this subpart O—motor vehicles, mechanized equipment and marine operations.

1926.650—Scope, Application, and Definitions Applicable to this Subpart, applies to construction employers engaged in open excavations, including trenches. Also contains applicable definitions.

1926.651—General Requirements, provides general requirements for construction employers engaged in excavations. Addresses: Underground installations; access & egress; exposure to vehicular traffic, falling loads & hazardous atmospheres; inspections; fall protection; etc.

1926.652—Requirements for Protective Systems, applies to employee protective systems for employers engaged in excavation operations. Addresses: Design of sloping and benching systems; design of support & shield systems; materials and equipment; installation and removal or support.

1926.700—Scope, Application, and Definitions

Applicable to Subpart Q, sets forth requirements to protect all construction workers from hazards associated with concrete and masonry operations performed in workplaces covered under 1926. Also contains applicable definitions to subpart Q.

1926.701—General Requirements, sets general requirements for concrete and masonry construction including: Construction loads; reinforcing steel; post-tensioning operations; riding concrete buckets; working under loads; and personal protective equipment.

1926.702—Requirements for Equipment and Tools, sets requirements for equipment and tools including: Bulk cement storage; concrete mixers; power concrete trowels; concrete buggies; pumping systems; concrete buckets; tremies; bull floats; masonry saws; and lockout & tagout procedures.

1926.703—Requirements for Cast-In-Place Concrete, applies to construction employers engaged in cast-in -place concrete operations. Addresses: General requirements for formwork; shoring and reshoring; vertical slip forms; reinforcing steel; and removal of formwork.

1926.704—Requirements for Precast Concrete, applies to construction employers working with precast concrete. Addresses: Support of precast concrete wall units, structural framing, and tilt-up wall panels; lifting inserts & hardware.

1926.705—Requirements for Lift-Slab Construction Operations, provides requirements for construction employers engaged in lift-slab operations. Addresses: Planning and design; jacks/ lifting units; leveling; and temporary connections, etc.

1926.706—Requirements for Masonry Construction, applies to construction employers engaged in masonry construction operations. Addresses: Limited access zones; masonry walls over eight feet; bracing, etc.

1926.750—Flooring Requirements, sets requirements for permanent flooring (skeleton steel construction tiered buildings) and temporary floorings (skeleton steel construction tiered buildings).

1926.751—Structural Steel Assembly, applies to construction employers engaged in structural steel assembly. Addresses: Final placing of solid web structural members; open web steel joists; steel framing and bar joists; longspan joints and trusses; tag lines; etc.

1926.752—Bolting, Riveting, Fitting-Up, and Plumbing-Up, applies to construction employers engaged in bolting, riveting, fitting-up, and plumbing-up operations with regard to steel erection. Addresses: General requirements; bolting; riveting; and plumbing-up.

1926.800—Underground Construction, applies to the construction of underground tunnels, shafts, chambers, and passageways. Addresses: Access and egress; check-in/check-out; safety instruction; electrical safety; emergency provisions; hazardous classifications; monitoring; etc.

1926.801—Caissons, applies to construction employers engaged in caisson work. Addresses: Shields to protect employees; hydrostatic or air-pressure testing; ladders, etc.

1926.802—Cofferdams, applies to construction employers engaged in cofferdam operations. Addresses: Flood control; warning signals for employee evacuation; guardrails; protection from moving vessels.

1926.803—Compressed Air, applies to the use of compressed air for construction employers engaged in underground construction and operations related to caissons and cofferdams. Addresses: Medical requirements; communication; recordkeeping; compression; etc.

1926.804—Definitions Applicable to Subpart S, provides definitions that apply to subpart S—underground construction, caissons, cofferdams and compressed air.

1926.850—Preparatory Operations, applies to construction employers engaged in demolition operations. Addresses: Engineering surveys; bracing and shoring; hazard identification; controlling electricity, gas, water, steam; etc.

1926.851—Stairs, Passageways, and Ladders, applies to stairs, passageways, and ladders used during demolition operations.

1926.851—Stairs, Passageways, and Ladders, applies to stairs, passageways, and ladders used during demolition operations.

1926.853—Removal of Materials Through Floor Openings, applies to construction employers who dispose of or remove materials through floor openings.

1926.854—Removal of Walls, Masonry Sections, and Chimneys, applies to the removal of walls, masonry sections, and chimneys. Addresses: The control of masonry walls from falling on floors; structural walls; retaining walls; floor openings; etc.

1926.855—Manual Removal of Floors, applies to construction employers engaged in the manual removal of floors.

1926.856—Removal of Walls, Floors, and Material with Equipment, applies to construction employers who use mechanical equipment to remove of walls, floors, and material. Such equipment must also meet requirements set in subpart N and O.

1926.857—Storage, applies to construction employers who store waste material and debris.

1926.858—Removal of Steel Construction, applies to construction employers engaged in the removal of steel construction. Cranes, derricks and other hoisting equipment used to remove steel must also meet the requirements of subpart N.

1926.859—Mechanical Demolition, applies to construction employers engaged in mechanical demolition operations. Addresses: Worker protection; demolition balls; crane boom and loadlines; inspections during demolition; etc.

1926.860—Selective Demolition by Explosives, applies to construction employers using selective demolition by explosives. Employers must also meet the requirements in subpart U.

1926.900—General Provisions, sets general provisions for construction employers involved in operations that require blasting and the use of explosives. Addresses: Qualified persons; fire hazards; warnings; handling; etc.

1926.901—Blaster Qualifications, provides OSHA requirements to determine whether an employee is qualified to work as a blaster.

1926.902—Surface Transportation of Explosives, applies to construction employers who transport explosives on the surface: streets, highways, railways, etc. Addresses: Other applicable agency regulations; driver and vehicle qualifications; placarding; etc.

1926.903—Underground Transportation of Explosives, applies to construction employers who transport explosives underground. Addresses: Quantity; transport vehicle qualifications; notification; authorized personnel; etc.

1926.904—Storage of Explosives and Blasting Agents, applies to construction employers who store explosives, blasting agents and related materials. Addresses: Internal Revenue Service regulations (26 CFR part 181); prohibition of smoking and open flames; distance for storage areas; etc.

1926.905—Loading of Explosives or Blasting Agents, applies to construction employers involved in the loading of explosives or blasting agents. Addresses: Safe procedures; tamping; deenergizing cables; warning signs; bonding and grounding; etc.

1926.906—Initiation of Explosive Charges—Electric Blasting, covers procedures for construction employers who are ready to begin electric blasting of explosive charges. Addresses: Wiring; firing from a power circuit; blasting machines; blaster responsibilities; etc.

1926.907—Use of Safety Fuse, applies to construction employers who use safety fuses in their blasting operations. Addresses: When safety fuses may be used; use of crimpers; care of unused detonators; length of fuse; burning rates; etc.

1926.908—Use of Detonating Cord, applies to construction employers who use detonating cord in their blasting operations. Addresses: Selection of detonating cord; cord connections; inspection; etc.

1926.909—Firing the Blast, covers warning, blast and all clear signals associated with firing the blast. Addresses: Use of flagmen; blaster responsibilities; etc.

1926.910—Inspection After Blasting, covers inspection procedures which must be conducted after blasting operations have concluded.

1926.911—Misfires, covers procedures to be followed in the event of a misfire. Addresses: Blaster responsibilities; prohibited activities; etc.

1926.912—Underwater Blasting, applies to construction employers involved in underwater blasting operations. Addresses: Blaster responsibilities; use of water resistant caps; warning signals; blasting near other vessels; etc.

1926.913—Blasting in Excavation Work Under Compressed Air, applies to construction employers who conduct blasting operations in excavation work under compressed air. Addresses: Storage of detonators; blaster/powderman responsibilities; tunnel excavation; etc.

1926.914—Definitions Applicable to This Subpart, provides definitions applicable to subpart U—blasting and the use of explosives.

1926.950—General Requirements, sets general requirements for employers engaged in the construction, alteration, conversion and improvement of electric transmission and distribution lines and equipment. Addresses: Clearances; deenergizing lines; first-aid; etc.

1926.951—Tools and Protective Equipment, sets requirements for the use of tools and protective equipment in the construction, alteration, conversion and improvement of electric transmission and distribution lines and equipment.

1926.952—Mechanical Equipment, applies to construction employers using mechanical equipment in construction of electrical transmission and distribution lines. Addresses: Aerial lifts; derrick trucks, cranes, and other lifting equipment.

1926.953—- Material Handling, applies to the handling of materials used in the construction, alteration, conversion and improvement of electric transmission and distribution lines and equipment. Addresses: Unloading; pole hauling; storage; tag lines; framing; etc.

1926.954—Grounding for Protection of Employees, sets requirements for grounding procedures used to protect employees involved in the construction of transmission and distribution lines. Addresses: New construction; communication connectors; voltage testing; attaching grounds; etc.

1926.955—Overhead Lines, applies to construction employers working on or with overhead lines. Addresses: Inspections; metal tower construction; stringing or removing deenergized conductors; stringing adjacent to energized lines; live-line bare-hand work; etc.

1926.956—Underground Lines, applies to construction employers working on or with underground lines. Addresses: Guarding and ventilating street openings; manhole work; trenching and excavating; etc.

1926.957—Construction in Energized Substations, applies to employers conducting construction operations in energized substations. Addresses: Work near energized equipment facilities; deenergized equipment; barricades/barriers; control panels; mechanized equipment; storage; fences; etc.

1926.958—External Load Helicopters, applies to construction employers who use helicopters to transport external loads. Employers must refer to **1926.551** in subpart N for specific requirements.

1926.959—Lineman's Body Belts, Safety Straps and Lanyards, sets general and specific require-

ments for the use of lineman's body belts, safety straps, and lanyards.

1926.960—Definitions Applicable to This Subpart, provides definitions applicable to subpart V— power transmission and distribution.

1926.1000—Rollover Protective Structures (ROPS) for Material Handling Equipment, applies to rollover protective structures (ROPS) used for material handling. Addresses: Equipment manufactured on or after 9/1/72 and equipment manufactured before 9/1/72; remounting; labeling; machines meeting existing government requirement

1926.1001—Minimum Performance Criteria for Rollover Protective Structures for Designated Scrapers, Loaders, Dozers, Graders, and Crawler Tractors, sets the minimum performance criteria for rollover protective structures for designated scrapers, loaders, dozers, graders and crawler tractors. Addresses: Facilities and apparatus; vehicle conditions; test procedures; etc.

1926.1002—Protective Frame (ROPS) Test Procedures and Performance Requirements for Wheel-Type Agricultural and Industrial Tractors Used in Construction, sets requirements for frames for the protection of operators of wheel type agricultural and industrial tractors to reduce the possibility of injury resulting from accidental upsets during normal operation.

1926.1003—Overhead Protection for Operators of Agricultural and Industrial Tractors, applies to wheel-type agricultural and industrial tractors used in construction work. Addresses: overhead protection; test procedures; performance requirements.

1926.1050—Scope, Application, and Definitions Applicable to this Subpart, applies to all stairways and ladders used in construction, alteration, repair and demolition workplaces. This standard also provides definitions applicable to subpart X— stairways and ladders.

1926.1051—General Requirements, sets general requirements for the use stairways and ladders. Addresses: Spiral stairways; double-cleated ladders; points of access; fall protection systems; etc.

1926.1052—Stairways, sets requirements for the use, installation and guarding of stairways. Addresses: Landing, stair specifications; temporary service; stairrails and handrails; etc.

1926.1053—Ladders, sets requirements for the use, installation and guarding of ladders. Addresses: Load support; specifications; cages & wells; portable ladders; maintenance; bracing; repairs; user requirements; etc.

1926.1060—Training Requirements, sets training requirements for employees who use ladders and stairways. Addresses: Nature of fall hazards; fall protection procedures; load carrying capacities; retraining; etc.

1926.1071—Scope and Application, applies to diving and related operations in all industries. Addresses: Standard exclusions; OSHA compliance in emergency situations; employer obligations; etc.

1926.1072—Definitions, provides definitions applicable to subpart Y— commercial diving operations.

1926.1076—Qualifications of Dive Team, requires each member of a dive team to have the training or experience necessary to perform assigned tasks. Addresses: CPR; assignments; designated person-in-charge.

1926.1080—Safe Practices Manual, requires employers engaged in commercial diving operations to develop a safe practices manual and to provide it to each member of the dive team.

1926.1081—Pre-Dive Procedures, sets requirements for pre-dive procedures. Addresses: Emergency aid; first-aid supplies; planning and assessment; hazardous activities; employee briefing; equipment inspection; warning signals; etc.

1926.1082—Procedures During Dive, identifies procedures which must be conducted during dives. Addresses: Water entry and exit; communications; decompression tables; dive profiles; hand-held power tools; welding and burning; explosives; termination of the dive; etc.

1926.1083—Post Dive Procedures, identifies procedures which must be conducted after each diving operation. Addresses: Precautions; recompression capability; record of dive; decompression procedure assessment; etc.

1926.1084—SCUBA Diving, applies to construction employers whose workers are SCUBA diving. Addresses: Limits; procedures; etc.

1926.1085—Surface-Supplied Air Diving, sets requirements for employers engaged in surface - supplied air diving. Addresses: Limits; procedures; etc.

1926.1086—Mixed-Gas Diving, sets requirements for employers engaged in mixed-gas diving. Addresses: Limits; procedures; etc.

1926.1087—Liveboating, sets requirements for employers engaged in diving operations involving liveboating. Addresses: Limits; procedures; etc.

1926.1090—Equipment, sets requirements for equipment used in diving operations. Addresses: Air compression systems; breathing gas supply hoses; buoyancy control; compressed gas cylinders; decompression chambers; gauges; masks; oxygen safety; etc.

1926.1091—Recordkeeping Requirements sets requirements for recording any diving related injury or illness which requires any team member to be hospitalized for 24 hours or more. Addresses: Availability of records.

1926.1092—Effective Date, lists October 20, 1977 as an effective compliance date for subpart Y.

1926.1101—Asbestos, applies to construction employers working with asbestos. Addresses: Exposure limits; communication among employers;

regulated areas; exposure monitoring; methods of compliance; respiratory protection; protective clothing; etc.

1926.1102—Coal Tar Pitch Volatiles; Interpretation of term, defines coal tar pitch volatiles as fused polycyclic hydrocarbons which volatize from the distillation residues of info coal, petroleum (excluding asphalt), wood and other organic materials.

1926.1103—13 Carcinogens, applies to any area in which 4-Nitrobiphenyl, alpha-Napthylamine, Methyl Chloromethyl Ether, 3,3'-Dichlorobenzidine (and its salts), bis-Chloromethyl Ether, beta-Napthylamine, Benzidine, 4-Aminodiphenyl, Ethyleneimine, beta-Propiolactone, 2-Acetylaminoflourene, 4-Dimethylaminoazobenzene, N-Nitrosodimethylamine is manufactured, processed, repackaged, released, handled, or stored.

1926.1117—Vinyl Chloride, applies to construction employers who manufacture, react, process, repackage, release, handle or store vinyl chloride. This standard does not apply to the handling, use or storage of vinyl chloride polymers in fabricated products.

1926.1118—Inorganic Arsenic, applies to all occupational exposures to inorganic arsenic except: Employee exposure in agriculture or resulting from pesticide application, the treatment of wood with preservatives, or the use of arsenic ally preserved wood.

1926.1127—Cadmium, applies to all work-related exposures to cadmium and cadmium compounds, in all forms, and in all construction work where an employee may be exposed to cadmium.

1926.1128—Benzene, applies to all work-related exposures to benzene. There are some exceptions, however. Please refer to paragraph (a) Scope and Application.

1926.1129—Coke Oven Emissions, applies to the control of employee exposure to coke oven emis-

sions. Exception: Other working conditions under the jurisdiction of other Federal agencies.

1926.1144—1,2-dibromo-3-chloropropane, applies to work-related exposure to 1,2-dibromo-3-chloropropane. There are some exceptions, however. Please refer to paragraph (a) Scope and Application.

1926.1145—Acrylonitrile, applies to all work-related exposures to acrylonitrile. There are some exceptions, however. Please refer to paragraph (a) Scope and Application.

1926.1147— Ethylene Oxide, applies to all work-related exposures to ethylene oxide. There are some exceptions, however. Please refer to paragraph (a) Scope and Application.

1926.1148—Formaldehyde, applies to all work-related exposure to formaldehyde gas, its solution, and materials that release formaldehyde. Addresses: Permissible exposure limits; methods of compliance; PPE; housekeeping; emergencies; medical surveillance; etc.

APPENDIX 3

Federal OSHA Regional Offices

REGION 1 — CONNECTICUT, MAINE, MASSACHUSETTS, NEW HAMPSHIRE, RHODE ISLAND, VERMONT

REG1 — BOSTON REGIONAL OFFICE

133 Portland Street, 1st Floor
Boston, MA 02114
617-565-7164

REG1 — AUGUSTA AREA OFFICE

40 Western Avenue, FOB, Room 121
Augusta, MAINE 04330
207-622-8417

REG1 — BANGOR DISTRICT OFFICE

Room 211
202 Harlow Street
Bangor, MAINE 04401
207-941-8177

REG1 — BRIDGEPORT AREA OFFICE

1 Lafayette Square, Suite 202
Bridgeport, CT 06604
203-579-5579

REG1 — CONCORD AREA OFFICE

279 Pleasant Street, Suite 201
Concord, NH 03301
603-225-1629

REG1 — HARTFORD AREA OFFICE

450 Main Street, Room 508
Hartford, CT 06103
203-240-3152

REG1 — NORTH BOSTON AREA OFFICE

Valley Office Park
13 Branch Street, 1st Floor
Methuen, MA 01844
617-565-8110

REG1 — PROVIDENCE AREA OFFICE

380 Westminister Mall, Room 243
Providence, RI 02903
401-528-4669

REG1 — SOUTH BOSTON AREA OFFICE

639 Granite ST., 4th Floor
Braintree, MA 02184
617-565-6924

REG1 — SPRINGFIELD AREA OFFICE

1145 Main Street, Room 108
Springfield, MA 01103-1493
413-785-0123

REGION 2 — NEW YORK, NEW JERSEY, PUERTO RICO

REG2 — NEW YORK REGIONAL OFFICE

201 Varick Street, Room 670
New York, NY 10014
212-337-2378

REG2 — ALBANY AREA OFFICE

401 New Karner Road, Suite 300
Albany, NY 12205-3809
518-464-6742

REG2 — AVENEL AREA OFFICE

Plaza 35, Suite 205
1030 St. Georges Avenue
Avenel, NJ 07001
908-750-3270

REG2 — BAYSIDE AREA OFFICE

42-40 Bell Blvd.
Bayside, NY 11361
718-279-9060

REG2 — BUFFALO AREA OFFICE

5360 Genesee Street
Bowmansville, NY 14026
716-684-3891

REG2 — HASBROUCK HEIGHTS AO

500 Route 17 South, 2ND Floor
Hasbrouck Heights, NJ 07604
201-288-1700

REG2 — LONG ISLAND AREA OFFICE

990 Westbury Road
Westbury, NY 11590
516-334-3344

REG2 — MANHATTAN AREA OFFICE

90 Church Street, Room 1407
New York, NY 10007
212-264-9840

REG2 — MARLTON AREA OFFICE

Marlton Executive Park Building 2
701 Route 73 South, Suite 120
Marlton, NJ 08053
609-757-5181

REG2 — PARSIPPANY AREA OFFICE

299 Cherry Hill Road, Suite 304
Parsippany, NJ 07054
201-263-1003

REG2 — PUERTO RICO AREA OFFICE

U.S. Courthouse & FOB
Carlos Chardon St., Room 559
San Juan, PR 00918
809-766-5457

REG2 — SYRACUSE AREA OFFICE

3300 Vickery Road, North Syracuse
Syracuse, NY 13212
315-451-0808

REG2 — TARRYTOWN AREA OFFICE

4th Floor, Suite 408
660 White Plains Road
Tarrytown, NY 10591
914-682-6151

REGION 3 — DELAWARE, DISTRICT OF COLUMBIA, MARYLAND, PENNSYLVANIA, VIRGINIA, WEST VIRGINIA

REG3 — PHILADELPHIA REGIONAL

Gateway Building, Suite 2100
3535 Market Street
Philadelphia, PA 19104
215-596-1201

REG3 — ALLENTOWN AREA OFFICE

850 North 5th Street
Allentown, PA 18102
215-776-0592

REG3 — BALTIMORE AREA OFFICE

Federal Bldg., Room 1110
31 Hopkins Plaza, Charles Center
Baltimore, MD 21201
410-962-2840

REG3 — CHARLESTON AREA OFFICE

550 Eagan Street, Room 206
Charleston, WV 25301
304-347-5937

REG3 — D.C. DISTRICT OFFICE

Suite 440
820 First Street, N.E.
Washington, D.C. 20002
202-523-1452

REG3 — ERIE AREA OFFICE

3939 West Ridge Road, Suite B12
Erie, PA 16506
814-833-5758

REG3 — HARRISBURG AREA OFFICE

PROGRESS PLAZA
49 North Progress Avenue
Harrisburg, PA 17109
717-782-3902

REG3 — NORFOLK AREA OFFICE

Federal Office Bldg., Room 835
200 Granby Mall, Drawer 486
Norfolk, VA 23510
804-441-3820

REG3 — PHILADELPHIA AREA OFFICE

U.S. Custom House, Room 242
Second & Chestnut Street
Philadelphia, PA 19106
215-597-4955

REG3 — PITTSBURGH AREA OFFICE

Room 1428, Federal Building
1000 Liberty Avenue
Pittsburgh, PA 15222
412-644-2903

REG3 — WILKES-BARRE AREA OFFICE

Penn Place, Room 2005
20 North Pennsylvania Avenue
Wilkes-Barre, PA 18701-3590
717-826-6538

REG3 — WILMINGTON DISTRICT OFFICE

1 Rodney Square
920 King Street, Suite 402
Wilmington, DE 19801
302-573-6115

REGION 4 — ALABAMA, FLORIDA, GEORGIA, KENTUCKY, MISSISSIPPI, NORTH CAROLINA, SOUTH CAROLINA, TENNESSEE

REG4 — ATLANTA REGIONAL OFFICE

Suite 587
1375 Peachtree Street, N.E.
Atlanta, GA 30367
404-347-3573

REG4 — ATLANTA EAST AREA OFFICE

Building 7, Suite 110
Lavista Perimeter Office Park
Tucker, GA 30084
404-493-6644

REG4 — ATLANTA WEST AREA OFFICE

2400 Herodian Way, Suite 250
Smyrna, GA 30080
404-984-8700

REG4 — BIRMINGHAM AREA OFFICE

Todd Mall
2047 Canyon Road
Birmingham, AL 35216
205-731-1534

REG4 — COLUMBIA AREA OFFICE

1835 Assembly Street, Room 1468
Columbia, SC 29201
803-765-5904

REG4 — FORT LAUDERDALE AREA OFFICE

8040 Peters Road
Building H-100
Fort Lauderdale, FL 33324
305-424-0242

REG4 — FRANKFORT AREA OFFICE

John C. Watts Federal Office Bldg.
330 West Broadway, Room 108
Frankfort, KY 40601
502-227-7024

REG4 — JACKSON AREA OFFICE

3780 I-55 North, Suite 210
Jackson, MS 39211-6323
601-965-4606

REG4 — JACKSONVILLE AREA OFFICE

Ribault Bldg., Suite 227
1851 Executive Center Drive
Jacksonville, FL 32207
904-232-2895

REG4 — MOBILE AREA OFFICE

Suite 100
3737 Government Blvd.
Mobile, AL 36693
205-441-6131

REG4 — NASHVILLE AREA OFFICE

Suite C-205
2002 Richard Jones Road
Nashville, TN 37215-2809
615-781-5423

REG4 — RALEIGH AREA OFFICE

Century Station Fed. Off. Bldg.
300 Fayetteville St Mall, Room 438
Raleigh, NC 27601
919-856-4770

REG4 — SAVANNAH AREA OFFICE

Suite J
450 Mall Blvd.
Savannah, GA 31406
912-652-4393

REG4 — TAMPA AREA OFFICE

Suite A
5807 Breckenridge Parkway
Tampa, FL 33610
813-626-1177

REGION 5 — INDIANA, ILLINOIS, MICHIGAN, MINNESOTA, OHIO, WISCONSIN

REG5 — CHICAGO REGIONAL OFFICE

Room 3244
230 South Dearborn Street
Chicago, IL 60604
312-353-2220

REG5 — APPLETON AREA OFFICE

2618 North Ballard Road
Appleton, Wisconsin 54915
414-734-4521

REG5 — CALUMET CITY AREA OFFICE

1600 167th Street, Suite 12
Calumet City, IL 60409
708-891-3800

REG5 — CHICAGO NORTH AREA OFFICE

O'Hara Lake Plaza, Suite 1010
2360 East Devon Avenue
Des Plaines, IL 60018
708-803-4800

REG5 — CINCINNATI AREA OFFICE

36 Triangle Park Drive
Cincinnati, OH 45246
513-841-4132

REG5 — CLEVELAND AREA OFFICE

Federal Office Bldg., Room 899
1240 East 9th Street
Cleveland, OH 44199
216-522-3818

REG5 — COLUMBUS AREA OFFICE

Federal Office Building, Room 620
200 North High Street
Columbus, OH 43215
614-469-5582

REG5 — EAU CLAIRE DISTRICT OFFICE

FOB & Courthouse, Room B-9
500 South Barstow Street
Eau Claire, WI 54701
715-832-9019

REG5 — FAIRVIEW HEIGHTS DISTRICT OFFICE

11 Executive Drive, Suite 11
Fairview Height, IL 62208
618-632-8612

REG5 — INDIANAPOLIS AREA OFFICE

Room 423
46 East Ohio Street
Indianapolis, IN 46204
317-226-7290

REG5 — LANSING AREA OFFICE

Suite 306
801 South Waverly Road
Lansing, Michigan 48917-4200
517-377-1892

REG5 — MADISON AREA OFFICE

4802 East Broadway
Madison, WISCONSIN 53716
608-264-5388

REG5 — MILWAUKEE AREA OFFICE

Henry S. Reuss Bldg., Suite 1180
310 West Wisconsin Avenue
Milwaukee, WISCONSIN 53203
414-297-3315

REG5 — MINNEAPOLIS AREA OFFICE

Room 116
110 South 4th Street
Minneapolis, MN 55401
612-348-1994

REG5 — NORTH AURORA AREA OFFICE

344 Smoke Tree Business Park
North Aurora, IL 60542
708-896-8700

REG5 — PEORIA AREA OFFICE

2918 Willow Knolls Road
Peoria, IL 61614
309-671-7033

REG5 — TOLEDO AREA OFFICE

Room 734
234 North Summit Street
Toledo, OH 43604
419-259-7542

REGION 6 — ARKANAS, LOUISIANA, NEW MEXICO, OKLAHOMA, TEXAS

REG6 — DALLAS REGIONAL OFFICE

Room 602
525 Griffin Street
Dallas, TX 75202
214-767-4731

REG6 — ALBUQUERQUE AREA OFFICE

Westbank Bldg., Suite 820
505 Marquette, N.W.
Albuquerque, NM 87102
505-766-3411

REG6 — AUSTIN AREA OFFICE

Grant Building, Room 303
611 East 6th Street
Austin, TX 78701
512-482-5783

REG6 — BATON ROUGE AREA OFFICE

Hoover Annex, Suite 200
2156 Wooddale Blvd.
Baton Rouge, LA 70806
504-389-0474

REG6 — CORPUS CHRISTI AREA OFFICE

Government Plaza, Room 300
400 Main Street
Corpus Christi, TX 78401
512-888-3257

REG6 — DALLAS AREA OFFICE

SUITE 420
8344 East R.L. Thornton Freeway
Dallas, TX 75228
214-320-2400

REG6 — EL PASO DISTRICT OFFICE

Commons Bldg. C, Room C119
4171 North Mesa
El Paso, TX 79902
915-534-7004

REG6 — FT. WORTH AREA OFFICE

North Star II, Suite 430
8713 Airport Freeway
Fort Worth, TX 76180-7604
817-885-7025

REG6 — HOUSTON NORTH AREA OFFICE

SUITE 120
350 North Sam Houston Parkway East
Houston, TX 77058
713-591-2438

REG6 — HOUSTON SOUTH AREA OFFICE

Suite 400
17625 El Camino Real
Houston, TX 77058
713-286-0583

REG6 — LITTLE ROCK AREA OFFICE

Suite 450
425 West Capitol
Little Rock, AR 72201
501-324-6292

REG6 — LUBBOCK AREA OFFICE

Federal Office Bldg., Room 422
1205 Texas Avenue
Lubbock, TX 79401
806-743-7681

REG6 — OKLAHOMA CITY AREA OFFICE

Main Place, Suite 300
420 West Main
Oklahoma City, OK 73102
405-231-5351

REGION 7 — IOWA, KANSAS, MISSOURI, NEBRASKA

REG7 — KANSAS CITY REGIONAL OFFICE

Room 406
911 Walnut Street
Kansas city, MS 64106
816-426-5861

REG7 — DES MOINES AREA OFFICE

Room 815
210 Walnut Street
Des Moines, IA 50309
515-284-4794

REG7 — KANSAS CITY AREA OFFICE

Suite 100
6200 Connecticut Avenue
Kansas City, MO 64120
816-426-2756

REG7 — OVERLAND PARK DISTRICT OFFICE

8600 Farley, Suite 105
Overland Park, KS 66212 – 4677
913-236-3220

REG7 — OMAHA AREA OFFICE

Overland-Wolf Bldg., Room 100
6910 Pacific Street
Omaha, NEBRASKA 68106
402-221-3182

REG7 — ST. LOUIS AREA OFFICE

911 Washington Avenue, Room 420
St. Louis, MO 63101
314-425-4249

REG7 — WICHITA AREA OFFICE

300 Civic Center, Suite B
301 N. Main Street
Wichita, KS 67202
316-269-6644

REGION 8 — COLORADO, MONTANA, NORTH DAKOTA, SOUTH DAKOTA, UTAH, WYOMING

REG8 — DENVER REGIONAL OFFICE

Federal Office Bldg., Room 1690
1999 Broadway
Denver, CO 80202–5716
303-391-5858

REG8 — BILLINGS AREA OFFICE

19 North 25th Street
Billings, MT 59101
406-657-6649

REG8 — BISMARCK AREA OFFICE

3rd & Rosser, Room 348
P.O. Box 2439
Bismarck, ND 58502
701-250-4521

REG8 — DENVER AREA OFFICE

1391 North Speer Blvd., Suite 210
Denver, CO 80204
303-844-5285

REG8 — ENGLEWOOD AREA OFFICE

Suite 209
7935 East Prentice Avenue
Englewood, CO 80111-2714
303-843-4500

REG8 — SALT LAKE CITY AREA OFFICE

1781 South 300 West
P.O. Box 65200
Salt Lake City, UT 84165-0200
801-524-5080

REGION 9 — ARIZONA, CALIFORNIA, HAWAII, NEVADA

REG9 — SAN FRANCISCO REGIONAL

4th Floor
71 Stevenson Street
San Francisco, CA 94105
415-744-6670

REG9 — CARSON CITY AREA OFFICE

Suite 435
1050 East Williams Street
Carson City, NV 89701
702-885-6963

REG9 — HONOLULU AREA OFFICE

Suite 5122
P.O. Box 50072
300 Ala Moana Blvd.
Honolulu, HI 96850
808-541-2685

REG9 — PHOENIX AREA OFFICE

Suite 100
3221 North 16th Street
Phoenix, AZ 85016
602-640-2007

REG9 — SACRAMENTO DISTRICT OFFICE

105 El Camino Plaza, 1st Floor
Sacramento, CA 95815
916-978-5641

REG9 — SAN DIEGO DISTRICT OFFICE

Suite 330
5675 Ruffin Road
San Diego, CA 92123
619-557-2909

REG9 — SAN FRANCISCO AREA OFFICE

71 Stevenson Street, Room 415
San Francisco, CA 94105
415-703-4341

REGION 10 — ALASKA, IDAHO, OREGON, WASHINGTON

REG10 — SEATTLE REGIONAL OFFICE

Suite 715
1111 Third Avenue
Seattle, WA 98101-3212
206-553-5930

REG10 — ANCHORAGE AREA OFFICE

Suite 407
301 W. Northern Lights Blvd.
Anchorage, AK 99503
907-271-5152

REG10 — BELLEVUE AREA OFFICE

Room 110
121 107th Avenue, Northeast
Bellevue, Washington 98004
206-553-7520

REG10 — BOISE AREA OFFICE

Suite 134
3050 North Lakeharbor Lane
Boise, ID 83703
208-334-1867

REG10 — PORTLAND AREA OFFICE

Federal Office Bldg., Room 640
1220 Southwest 3rd Avenue
Portland, OR 97294
503-326-2251

OSHA CONSULTATION OFFICES AND OTHER RESOURCES

OSHA/State Consultation Offices

Onsite Consultation Program

425 Martha Parham West
P.O. Box 870388
Tuscaloosa, AL 35487
(205) 348-3033

Division of Consultation and Training

ADOL/OSHA
3301 Eagle Street
P.O. Box 107022
Anchorage, AK 99510
(907) 269-4939

Occupational Safety and Health

Industry Comm. of Arizona
P.O. Box 19070
Phoenix, AZ 85005
(602) 542-5795

OSHA Consultation

Arkansas Dept. of Labor
10421 West Markham
Little Rock, AR 72205
(501) 682-4522

CAL/OSHA Consultation Service

Dept. of Industrial Relations
455 Golden Gate Ave., Room 5246
San Francisco, CA 94102
(415) 703-4441

Occupational Safety and Health Section

Institute of Rural Environmental Health
Colorado State University
110 Veterinary Science Building
Fort Collins, CO 80523
(303) 491-6151

Division of Occupational Safety and Health

Connecticut Dept. of Labor
200 Folly Brook Boulevard
Wethersfield, CT 06109
(203) 566-4550

Occupational Safety and Health

Division of Industrial Affairs
Delaware Dept. of Labor
820 North French Street, 6th Floor
Wilmington, DE 19801
(302) 577-3908

Office of Occupational Safety and Health

D.C. Dept of Employment Services
950 Upshur Street, NW
Washington, DC 20011
(202) 576-6339

Onsite Consultation Program

Bureau of Industrial Safety and Health
Dept. of Labor & Employment Security
2022 St. Augustine Road
Building E, Suite 45
Tallahassee, FL 32399-0663
(904) 488-3044

Onsite Consulting Program

Georgia Insitute of Technology
O'Keefe Building, Room 23
Atlanta, GA 30332
(404) 894-8274

OSHA Onsite Consultation

Guam Department of Labor
3rd Floor, ITC Building
Tamuning, Guam 96911
(671) 647-4202

Consultation and Training Branch

Dept. of Labor and Industrial Relations
830 Punchbowl Street
Honolulu, HI 96813
(808) 586-9116

Safety and Health Consultation Project

Boise State University
Dept. of Comm. and Env. Health
1910 University Drive, MG-110
Boise, ID 83725
(208) 385-3283

Illinois Onsite Consultation

Industrial Services Division
Dept. of Commerce & Community Affairs
State of Illinois Center
100 W Randolph Street, Suite 3-400
Chicago, IL 60601
(312) 814-2337

Division of Labor

Bureau of Safety, Education and Training
402 West Washington, Room W195
Indianapolis, IN 46204-2287
(317) 232-2688

Consultation Program

Iowa Bureau of Labor
1000 East Grand Avenue
Des Moines, IA 50319
(515) 281-5352

Kansas Consultation Program

Kansas Dept. of Human Resources
512 West 6th Street
Topeka, KS 66603
(913) 296-4386

Division of Education and Training

Kentucky Labor Cabinet
1049 U.S. Highway 127, South
Frankfort, KY 40601
(502) 564-6895

Consultation Program

Louisiana Dept. of Employment and Training
P.O. Box 94094
Baton Rouge, LA 70804-9094
(504) 342-9601

Division of Industrial Safety

Maine Dept. of Labor
State Home Station 82
Hallowell Annex
Augusta, ME 04333
(207) 624-6460

Consultation Services

Division of Labor and Industry
501 Saint Paul Place, Floor 3
Baltimore, MD 21202
(301) 333-4218

Consultation Program

Division of Industrial Safety
MA Dept. of Labor and Industries
100 Cambridge Street
Boston, MA 02202
(619) 969-7177

Michigan Dept. of Public Health

Division of Occupational Health
3423 North Logan Street
P.O. Box 30195
Lansing, MI 48909
(517) 332-8250

Michigan Department of Labor

Bureau of Safety and Regulation
7150 Harris Drive
Lansing, MI 48909
(517) 322-1809

Department of Labor and Industry

Consultation Division
443 LaFayette Road
Saint Paul, MN 55155
(612) 297-2393

Onsite Consultation Program

Div. of Occupational Safety and Health
Miss. State Board of Health
305 W. Lorenz Boulevard
Jackson, MS 39219-1700
(601) 987-3981

Onsite Consultation Program

Div. of Labor Standards
Dept. of Labor and Industrial Relations
3315 West Truman Boulevard
Jefferson City, MO 65109
(314) 751-3403

Dept. of Labor and Industry

Employment Relations Division
Safety Bureau
Arcade Building, 111 North Main
Helena, MT 59604-8011
(406) 444-6418

Division of Safety Labor and Safety Standards

Nebraska Dept. of Labor
State Office Building, Lower Level
301 Centennial Mall, South
Lincoln, NE 68509-5024
(402) 471-4717

Division of Preventive Safety

Dept. of Industrial Relations
2500 W. Washington, Suite 104
Las Vegas, NV 89158
(702) 486-5016

Onsite Consultation Program

New Hampshire Dept. of Labor
State Office Park South
95 Pleasant Street
Concord, New Hampshire 03301
(603) 271-2024

Division of Workplace Standards

New Jersey Dept. of Labor
CN386
Trenton, NJ 08625-0953
(609) 292-3923

OSHA Consultation

Occupational Health and Safety Division
1190 St. Francis Dr., Room N2200
Santa Fe, NM 87503
(505) 827-2877

Division of Safety and Health

State Office Campus
Building 12, Room 457
Albany, NY 12240
(518) 457-2481

NC Consultative Services

North Carolina Dept. of Labor
OSH Bureau of Consultative Services
413 North Salisbury Street
Raleigh, NC 27603
(919) 733-2360

Division of Environmental Engineering

ND State Department of Health
1200 Missouri Avenue, Room 304
Bismarck, ND 58502-5520
(701) 221-5188

Division of Onsite Consultation

Department of Industrial Relations
2323 West Fifth Avenue
P.O. Box 825
Columbus, OH 43216
(614) 644-2631

OSHA Division

Oklahoma Department of Labor
4001 North Lincoln Boulevard
Oklahoma City, OK 73105-5212
(405) 528-1500

Consultation Program

Dept. of Insurance and Finance/ADP
Labor and Industries Building
Salem, OR 97310
(503) 378-3272

Indiana University of Pennsylvania

Safety Sciences Department
205 Uhler Hall
Indiana, PA 15705
(412) 357-2396

Occupational Safety and Health Office

PR Dept. of Labor and Human Resources
505 Munoz Rivera Avenue, 21st Floor
Hato Rey, Puerto Rico 00918
(809) 754-2171

Division of Occupational Health

RI Dept. of Health
206 Cannon Building
75 Davis Street
Providence, RI 02908
(401) 277-2438

Onsite Consultation Program

Consultation and Monitoring
SC DOL
3600 Forest Drive
P.O. Box 11329
Columbia, SC 29211
(803) 734-9599

S.T.A.T.E. Engineering Extension

Onsite Technical Division
South Dakota State University
P.O. Box 2218
Brookings, SD 57007
(605) 688-4101

OSHA Consultative Services

Tennessee Department of Labor
501 Union Building, 6th Floor
Nashville, TN 37219
(615) 741-7036

Texas Workers' Comp. Comm.

Health and Safety Division
Southfield Building
4000 South I H 35
Austin, TX 78704
(512) 440-3834

Utah Safety and Health

Consultative Service
P.O. Box 510870
160 East 300 South, 3rd Floor
Salt Lake City, Utah 84151-0870
(801) 530-6868

Division of Occupational Safety and Health

Vermont Dept. of Labor and Industry
118 State Street
Montpelier, VT 05602
(802) 828-2765

VA Department of Labor and Industry

Voluntary Safety and Health Compliance
13 South 13th Street
Richmond, VA 23219
(804) 786-8707

Division of Occupational Safety and Health

Virgin Islands Dept. of Labor
Lagoon Street
Frederiksted, Virgin Islands 00840
(809) 772-1315

Voluntary Services

Washington Department of Labor and Industries
1011 Plum Street, M/S HC-462
Olympia, WA 98504
(206) 956-5443

West Virginia Department of Labor

State Capitol Building #3, Room 319
1800 East Washington Street
Charleston, West Virginia 25305
(304) 558-7890

Construction/Industry Associations

American Conference of Governmental

Industrial Hygienists
6500 Glenway Avenue
Building D-7
Cincinnati, OH 45211-4438
(513) 661-7881

American Industrial Hygiene Association

2700 Prosperity Avenue, Suite 250
Fairfax, VA 22031-4319
(703) 849-8888

American National Standards Institute

11 West 42nd Street
13th Floor
New York, NY 10036-8002
(212) 642-4900

American Plywood Association

P.O. Box 11700
Tacoma, WA 98411-0700
(206) 565-6600

American Society for Concrete Construction

1902 Techny Court
Northbrook, IL 60062-0270
(708) 291-0270

American Society for Testing and Materials

1916 Race Street
Philadelphia, PA 19103-1187
(215) 299-5400

Division of Health

Wisconsin Department of Health and Human Services
Section of Occupational Health
1414 E. Washington Avenue
Room 112
Madison, WI 53703
(608) 266-8579

Wisconsin Department of Industry

Labor and Human Relations
Bureau of Safety Inspections
401 Pilot Court, Suite C
Waukesha, WI 53188
(608) 266-1818

Occupational Health and Safety

State of Wyoming
122 West 25th, Herschler Building
2nd Floor, East
Cheyenne, WY 82002
(307) 777-7786

American Society of Safety Engineers

1800 East Oakton Street
Des Plaines, IL 60018-2187
(708) 692-4121

American Subcontractors Association (1966)

1004 Duke St.,
Alexandria, VA 22314–3512
Tel: (703)684-3450 Fax: (703)836-3482

Associated Builders and Contractors

729 15th Street, N.W.
Washington, DC 20005
(202) 637-8800

Associated General Contractors of America (1918)

1957 E St., N.W.
Washington, DC 20006-5199
Tel: (202) 393-2040 Fax: (202) 347-4004

Compressed Gas Association (1913)

1725 Jeff Davis Highway, Suite 1004
Arlington, VA 22202–4102
Tel: (703) 412-0900 Fax: (703) 412-0128

Construction Industry Management Board (1974)

P.O. Box 24140
Detroit, MI 48224
Tel: (313) 885-9495 Fax: (313) 885-3147

Construction Industry Manufacturers Association (1909)

111 E. Wisconsin Ave.
Milwaukee, WI 53202-4879
Tel: (414) 272-0943

Construction Management Association of America (1981)

1893 Preston White Dr., Suite 130
Reston, VA 22091-5432
Tel: (703) 391-1200 Fax: (703) 391-9323

Construction Specifications Institute (1948)

601 Madison St.

Alexandria, VA 22314-1791
Tel: (703)684-0300 Fax: (703)684-0465

Hazardous Materials Advisory Council

1110 Vermont Avenue, N.W., Suite 250
Washington, DC 20005-3406
(202) 728-1460 Fax: (202) 728-1459

Lead Industries Association Inc.

295 Madison Avenue
New York, NY 10017
(212) 578-4750 Fax: (212) 684-7714

Mason Contractors Association of America (1950)

1550 Spring Road, Suite 320
Oak Brook, IL 60521-1363
Tel: (708) 782-6767 Fax: (708) 782-6786

National Electrical Manufacturers Association

2101 L Street, N.W.
Washington, DC 20037
(202) 457-8400

National Fire Protection Association

P.O. Box 9101
1 Batterymarch Park
Quincy, MA 02269-9101
(617) 770-3000 Fax: (617) 770-0700

National Institute of Building Sciences

1201 L Street, N.W.
Washington, DC 20005
(202) 289-7800

National Safety Council

1121 Spring Lake Drive
Itasca, IL 60143-3201
(708) 284-1121 Fax: (708) 285-1057

Scaffold Industry Association

14039 Sherman Way
Van Nuys, CA 91405-2599
(818) 782-2012

Subcontractors Trade Association (1966)

570 Seventh Ave., Suite 1100
New York, NY 10018
Tel: (212) 682-8055 Fax: (212)867-9859

Underwriters' Laboratories Inc.

333 Pfingsten Rd.
Northbrook, IL 60062
(708) 272-8800

APPENDIX 4

OSHA WEB SITES

OSHA	www.osha.gov
OSHA standards & related documents	www.osha-slc.gov/OCIS/standards
OSHA-salt lake city	www.osha-slc.gov
Federal Register - OSHA	www.osha-slc.gov/OCIS/toc_fed_reg.html
Mine Safety & Health Administration	www.msha.gov
NIOSH	www.cdc.gov/niosh/homepage.html

STATE LABOR DEPARTMENT WEB SITES

Alaska Labor Standards and Safety Division	www.state.ak.us/local/akpages/LABOR/Div_Sec/LSS/LSS.htm
California Department of Industrial Relations	www.dir.ca.gov
Hawaii Department of Labor and Industrial Relations	hinc.hinc.hawaii.gov/hinc/dlir/dlir.html
North Carolina Department of Labor	www.dol.state.nc.us
State Labor Department Web Sites	images/osh.gif
Tennessee Department of Labor	www.inaugural.state.tn.us/hp/sundquist/labor.html
The Vermont Occupational Safety and Health Administration	www.quest-net.com/vosha/
Vermont Department of Labor and Industry	www.cit.state.vt.us/labind
Washington Department of Labor and Industries	www.wa.gov/lni

HELPFUL SITES

Asbestos standard for Construction	www.halcyon.com/ttrieve/asbestos.html
Centers for Disease Control	www.cdc.gov//cdc.html
Construction Standards	www.osha-slc.gov/OshStd_toc/OSHA_std_toc_1926.html
Fall protection	www.osha-slc.gov/Preamble/Fall_toc/Fall_toc_by_sect.html
International Occupational Safety & Health Information Center	Turva.me.tut.fi/cis/home.html
Occupational Injury & Illness Rates	www.osha.gov/oshstats/bls.txt
OSHA standards & related documetns	www.osha-slc.gov/OCIS/standards_related.html
OSHA statistics & data	www.osha.gov/oshstats/index.html
SIC search	www.osha.gov/oshstats/sicser.html

INDEX

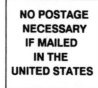

NO POSTAGE
NECESSARY
IF MAILED
IN THE
UNITED STATES

BUSINESS REPLY MAIL

FIRST-CLASS MAIL PERMIT NO. 73996 LOS ANGELES CA

POSTAGE WILL BE PAID BY ADDRESSEE

SILVER LAKE PUBLISHING
2025 HYPERION AVE
LOS ANGELES CA 90027-9849

NO POSTAGE
NECESSARY
IF MAILED
IN THE
UNITED STATES

BUSINESS REPLY MAIL

FIRST-CLASS MAIL PERMIT NO. 73996 LOS ANGELES CA

POSTAGE WILL BE PAID BY ADDRESSEE

SILVER LAKE PUBLISHING
2025 HYPERION AVE
LOS ANGELES CA 90027-9849